Pelican Books

The Art of Australia

Born in Sydney, Australia, in 1938, Robert Hughes studied arts at Sydney University, interrupted his degree course in 1956, and finally completed his studies in the faculty of architecture in 1962. In the meantime he had been contributing articles, criticism, and cartoons to Australian periodicals. Besides writing for the *Bulletin* and the *Sunday Mirror* and appearing on TV panels, he was made (1958) art critic and art editor of the Sydney fortnightly magazine, *Observer*. During 1959, when he visited Europe and the U.S.A., he contributed articles and cartoons to the London *Observer* and the *Spectator*. Back in Australia he devoted himself to writing and painting, and for four years was art critic of the *Mirror* group of newspapers in Sydney and for the *Nation* (Australia). He is currently living in London and is the regular critic of the *London Magazine*; he broadcasts frequently and appears on television.

Robert Hughes has written on art, politics, and travel for all the principal Australian journals and for many leading newspapers and magazines in England and the U.S.A. He is the author of *Donald Friend* (1965) and *Heaven and Hell in Western Art* (1968). At the same time his painting is represented in public and private collections throughout Australia, in London, Los Angeles, Ottawa, New York, and Rome.

D1531389

A

A

A

A

A

A

The *Art*

of *Australia*

Robert Hughes

Penguin Books

Penguin Books Ltd, Harmondsworth, Middlesex, England
Penguin Books Inc., 7110 Ambassador Road, Baltimore, Maryland 21207, U.S.A.
Penguin Books Australia Ltd, Ringwood, Victoria, Australia

First published 1966
Revised edition 1970
Copyright © Robert Hughes, 1966, 1970

Designed by Gerald Cinamon
Made and printed in Great Britain by
Fletcher & Son Ltd, Norwich
Set in Monotype Garamond

To Margaret and Douglas Carnegie
with gratitude

and to Georges Mora
who knows why dedications change

Contents

Acknowledgements

Innumerable people – critics, artists, collectors, dealers, and gallery staff – have helped to make this book possible. I cannot list them all. But I am very grateful for their help and encouragement.

Special aid was given by the following: Mr Hal Missingham, Director, and Mr Tony Tuckson, Assistant Director, of the Art Gallery of New South Wales; Mr Eric Westbrook, Director, Mr Gordon Thompson, Deputy Director, and Mr Brian Finemore, of the National Gallery of Victoria; Mr Robert Campbell, Director, and Mr David Dridan, of the National Gallery of South Australia; Mr Laurie Thomas, Director of the Queensland Art Gallery; Mr Frank Norton, Director of the Western Australian Art Gallery; and the Trustees of these five State Galleries.

The Executive Officers of the Museum of Modern Art and Design of Australia, Melbourne, have been most helpful, and I particularly wish to thank the Director, Mr John Reed; also Mr Georges Mora, Vice-President of the Museum, for his sympathetic help as well as his *pâté maison*.

Most valuable help was given by the following people and institutions: the Commonwealth Art Advisory Board and Mr James McCusker, Canberra; the Commonwealth Collection, Canberra; the Trustees and Staff of the Mitchell Library, and the Public Library, Sydney; and the Trustees of the British Museum, London. Also, by Mr John Brackenreg, Mr and Mrs T. Purves, Mr Terry Clune, Mr Kym Bonython, Miss Betty O'Neill, Mr Mervyn Horton, Mr Brian Johnstone, Mr Rudy Komon, Miss Mary Turner, and Mr Geoffrey Dutton.

I would like to thank two prominent Australian collectors – Colonel Aubrey H. L. Gibson, and especially Mrs Douglas Carnegie. Without their practical help and encouragement, at times when I needed both, I doubt that this manuscript would have been finished.

But my main debt is to Mr Daniel Thomas, of the Art Gallery of New South Wales. He supplied me with many points of detail, read the manuscript from its draft to its present form, and checked the proofs. Many of the merits of this book come from his generous cooperation. Its faults are all my own work.

List of Illustrations

The State Galleries are indicated by the name of the capital cities in which they are located.

Adelaide: The National Gallery of South Australia
Brisbane: The Queensland Art Gallery
Hobart: The Tasmanian Museum and Art Gallery
Melbourne: The National Gallery of Victoria
Perth: The Western Australian Art Gallery
Sydney: The Art Gallery of New South Wales

N.L.A. refers to the National Library of Australia, Canberra. Height precedes width in indicated sizes below.

88. Robert Juniper: *Landscape*, mixed media on hardboard, 36″ x 53½″, 1963, Melbourne *218*
89. Frederick Williams: *You-Yang Landscape I*, oil and tempera on masonite, 54″ x 71″, 1963, Mr James Mollison *219*
90. Sidney Nolan: *Figures in a Tree*, PVA on masonite, 60″ x 48″, 1957, Mrs Douglas Carnegie *225*
91. Sidney Nolan: *Leda and the Swan*, PVA on hardboard, 48″ x 60″, 1958, Mrs Douglas Carnegie *226*
92. Albert Tucker: *Gamblers and Parrots*, PVA on hardboard, 36″ x 48″, 1960, Mr Alan Boxer *230*
93. Arthur Boyd: *Reflected Bride*, oil and tempera on board, 48″ x 36″, 1958, Mr and Mrs Douglas Cairns *233*
94. Arthur Boyd: *Figure Turning into a Dragonfly*, oil and tempera on hardboard, 63″ x 72″, 1962, the artist *234*
95. John Perceval: *Dairy Farm, Victoria*, oil on canvas on hardboard, 36″ x 45″, 1960, Sydney *236*
96. Clifton Pugh: *A Crucifixion*, oil, 27″ x 36″, 1959, Mr Kym Bonython *238*
97. John Brack: *Five O'clock Collins Street*, oil on canvas, 45″ x 64″, 1955, Melbourne *239*
98. Robert Dickerson: *Straight Left by Griffo*, oil on masonite, 48″ x 54″, 1953, Rudy Komon Gallery, Sydney *241*
99. Robert Dickerson: *The Clown*, 44″ x 50″, *c.* 1954, Mr and Mrs W. McGrath *242*
100. Charles Blackman: *Suddenly Everything Changed* (from Alice in Wonderland series), oil and tempera on masonite, 48″ x 54″, 1957, the artist *244*
101. Ralph Balson: *Painting No. 9*, synthetic enamel on masonite, 54″ x 54″, 1959, Sydney *253*
102. Rah Fizelle: *Morning*, oil on canvas, 39″ x 26″, 1941, Sydney *254*
103. Frank Hinder: *Abstract Painting*, tempera on Swedish wallboard, 28⅞″ x 39⅜″, 1951, Sydney *255*
104. Eric Wilson: *Lambeth Street*, oil on board, 24″ x 18″, 1945, Sydney *257*
105. Eric Wilson: *The Kitchen Stove*, oil and collage on plywood, 57¼″ x 31⅜″, 1943, Sydney *258*
106. John Passmore: *Jumping Horse-Mackerel*, oil on hardboard, 48″ x 59″, 1959, Sydney *261*
107. John Olsen: *The Bicycle Boys Rejoice*, oil, 23½″ x 29½″, 1955, Mrs Brodie Knight *263*
108. John Olsen: *Dappled Country*, oil on canvas, 48″ x 60″, 1963, Mrs Helen Sweeney *266*
109. William Rose: *Painting*, oil, 72″ x 48″, 1961, Miss Betty O'Neill *268*
110. Eric Smith: *The Sermon on the Mount*, oil on masonite, 44″ x 31″, 1954, Mr Mervyn Horton *269*
111. Eric Smith: *Crucifixion*, oil, 84″ x 60″, 1961, Mr James Fairfax *271*
112. Frank Hodgkinson: *The Blonde Dark of Summer*, PVA on hardboard, 48″ x 36″, 1963, Mr Victor A. Kowalewski *275*
113. John Coburn: *Wilderness I*, PVA on masonite, 54″ x 72″, 1962, Mrs W. A Gordon *277*

Colour Plates

a. Sidney Nolan: *Quilting the Armour*, ripolin on masonite, 36″ x 48″, 1946–7, Museum of Modern Art and Design of Australia, Melbourne

b. Russell Drysdale: *Man with a Galah*, oil on canvas, 50″ x 40″, 1962, collection of Lady McNeice

c. Charles Blackman: *The Meeting*, oil on Swedish wallboard, 48″ x 48″, 1961, collection of Sir Warwick and Lady Fairfax, Sydney

d. John Olsen: *Portrait Landscape No. 2*, oil on masonite, 60″ x 48″, 1961–2, property of Bonython Art Gallery, Sydney

e. Ian Fairweather: *Epiphany*, synthetic resin on composition board, 55⅝″ x 80⅞″, 1962, Brisbane

f. Brett Whiteley: *Woman in a Bath 2*, oil and tempera and collage, 72″ x 74″, 1963–4, photograph by courtesy of Marlborough Fine Art (London) Ltd.

g. Leonard French: *The Crossing*, enamel on hessian-covered hardboard, 54″ x 48″, 1960–62, collection of Mr and Mrs Harold Holt, Melbourne

h. Colin Lanceley: *Free Fall*, painted wood and rice-paper, 98″ x 95″, 1965

Preface to the Second Edition

The manuscript of this book, in its original form, was completed some months before my twenty-fifth birthday in 1963. When the first edition was published in Australia, in 1965, I had already left and was living in Italy.

When the sample copies reached London, Penguin Books and I decided that the book, as produced, could not be published; the whole first edition, with the exception of a hundred or so copies which are still circulating, as far as I know, among rare-book collectors in Australia, was pulped.

Later I revised the text fairly drastically, mainly in the last chapters, in the hope that some of its more egregious *naïvetés* could be expunged. In time my interest in its fate inevitably diminished. Nevertheless, the text at least symbolized a nexus between Australia and myself and the impulse to publish it never quite stopped. For this, I thank Tony Godwin, Tony Richardson and Nikos Stangos: who, as successive Mothers Superior, nurtured the orphan I left on their doorstep. Appearing now it is, of course, somewhat out of date. *The Art of Australia* must not, therefore, be taken as an up-to-the-minute critical statement about Australian art from 1788 to 1969. Its period ends in 1964, and its few excursions up to 1966 deal principally with Australian artists living in London whose work I could see.

It now seems to me that the most interesting issue raised by Australian painting is the complex, partly sociological, issue of its pendant relationship to the European tradition, both old and new. A history of Australian art should be written in terms of its overseas prototypes. I did not write *The Art of Australia* in such terms because I was largely ignorant of those prototypes; and I only hope that some historian, in the near future, will perform on Australian painting since 1880 the operation which Dr Bernard Smith made on colonial art in *European Vision and the South Pacific*. The opportunity to study, in such plenitude of evidence, what uses a provincial culture (I use the word neutrally) finds for the art it produces in circumstances of conservatism and high economic boom is precious; it exists nowhere else in the world; and, one suspects,

it will disappear sooner or later. Already the isolation from the mainstream, which I lamented in the book, is diminishing; thus in 1966 the U.S. government (moved, it seems, by gratitude to its enthusiastic accomplices in Vietnam) sent out a large and important exhibition of American art from Pollock to Olitski; its traumatic and stimulant effect on young artists could only be compared to that produced by the French exhibition of 1938.

With all its deficiencies, I still hope that *The Art of Australia* may be of some interest. I doubt if I would now endorse everything about the twenty-four-year-old who wrote it. His luxuriant metaphors and tendency to jib at formal analysis are irritating. But I am still fond of him, and feel a certain responsibility for his first book.

ROBERT HUGHES
London, 16 March 1969

Introduction

The words 'authoritative study' have a doleful clang in the reader's ears, like the closing of a lid: one more subject wrapped up. When I began to write this book in 1962, I did not intend to close any discussions about Australian art. My one purpose was to keep them open.

There has in fact been very little informed argument about Australian painting. Indeed, I can think of no other cultural phenomenon which, considering the importance this one has in its own country, has called forth less systematic criticism. In 1961, the most recent book-length survey of Australian art was *Place, Taste and Tradition*, written by Bernard Smith in 1944. It has an honoured place in the historiography of local painting, and was the first study to approach its subject historically rather than simply descriptively – that is, to look at the underlying patterns and causes of Australian cultural developments. But *Place, Taste and Tradition* had no successors for seventeen years. Instead, there was a ditch. A shallow trickle of inept newspaper reviews ran down its walls; at the bottom, a litter of the kind of monographs and puffs which begin 'Little did the parents of Willie Wallaby, as they watched their laughing, sun-tanned infant frisking on the lawn of their bungalow in Moonee Ponds, imagine that one day his exhibition on the theme of Australian explorers would dazzle the sophisticated élite of the Sydney art world . . .'

So when Dr Smith's valuable study, *Australian Painting, 1788–1960*, came out at the end of 1962, it was, to put it mildly, welcome. My book presents a view of the history of Australian art opposed, in many aspects both of technique and of emphasis, to Dr Smith's. But, like any other writer on the subject, I stand indebted to him for the work which he has done to put the study of Australian painting on a systematic and coherent basis.

Art criticism is parasitical in the sense that it feeds off a larger body. It cannot live without art; and fundamentally, the history of painting is made of paintings, not words. I have not tried, in this book, to create a selective environment for Australian art by ignoring what I think should not have happened and emphasizing what

I think should. The task of a historian is to comment, with some degree of impartiality, on what *has* happened; he begins with the fact, and is a recorder, not a maker, of history. He may deal in categories, but not in imperatives. But a statement of opinion is not a command, and no more confusing idea than that of 'objective' criticism has been promoted to obscure the actual nature of criticism. Criticism is the record of a relationship between certain works of art and a personality. As I write, there is a large picture by an English artist, Richard Smith, on my wall. Its dominant motif is a blue ellipse, nearly sky-blue, framed by a dark viridian edge. It seems to me that the light blue advances closer to the eye than the green, so that the picture surface buckles out to meet my gaze. It also strikes me that this effect is one of the essential devices which Smith has used to project his image. But I cannot know that you see it that way. You may read the blue as receding. All I can do is describe my readings and then argue their coherence. So for brevity's sake, I have not prefaced every value-judgement in this book with the words 'I think'. None the less, they are there.

But factual analysis and critical investigation go hand in hand. The most fatuous definition of criticism was, perhaps, Paul Valéry's: 'Expression of one's soul in the presence of masterpieces'. No work of art is isolated like a chemical in a test-tube, and critics are not leaves of litmus paper which turn red with delight on immersion in art. A painting is more like an organism attached by nerves and muscles, however tenuous and atrophied, to the society, environment and climate of thought in which it was made. Art history and art criticism are steps in the same process: to place a painting in a social context is automatically to perform an act of criticism.

So I have tried, in *The Art of Australia*, to show relationships between art and environment. The grotesque cultural nationalism of the blue-view pastoral painters between 1920 and 1940, for example, becomes comprehensible when you note that it was part of a general insularity whose political symptom was the New Guard, and whose journalistic expression the *Bulletin*'s slogan 'Australia for the White Man and China for the Chows'. The rise of Norman Lindsay cannot be understood except as one result of the 'cultural cringe' which isolation from Europe engenders here; having missed out on the Renaissance in the fifteenth century, we decided to reconstruct one in Australia, in the manner of Texan *arrivistes* building replicas of the Palazzo Strozzi and the Trianon in downtown Dallas. Thus, too, with our apparently insatiable desire to enthrone culture-heroes as substitutes for tradition: Streeton, Lambert, Dobell, Drysdale. The

results are hilarious; but the desire has much to say about Australian society.

The question 'Why do Australians paint?' is readily answered: because they are men, and art is a social and perhaps a biological necessity. But ask why they have painted *in this particular way*, and your answer cannot always be given by scrutinizing their pictures. To take a tiny detail: in the late forties, Arthur Boyd and John Perceval were much influenced by Tintoretto. Neither of them had ever seen a Tintoretto. There are none in Australia. They were forced to learn about Tintoretto from the only available source: inaccurate colour plates in a post-war copy of *Life*. These plates erred on the yellow side. The ochreous varnish was emphasized. So it came about that Boyd's and Perceval's studies after Tintoretto were all invaded by a predominant yellowish tinge.

Consequently I have tried to indicate some of the very vexed questions surrounding the relationship between Australian and overseas art. This, I believe, is the chief interest which Australian painting holds for historians. About seven years ago, I took the view that Australian painting was purely a product of isolation, and that this isolation from Europe had conferred some mysterious vitality upon it. That, needless to say, was before I came to live in Italy. But in the meantime it became fashionable so to regard Australian art. The fact is that the past art of Europe, from the Lascaux caves to (say) 1800, has hardly penetrated Australian sensibility, because of the poor collections to be found in Australian museums. Apart from the collection of the National Gallery of Victoria, Australian galleries are provincial to a fault, both in space and in time: Rome may be represented by one chipped marble head of Apollo, Athens by a red-figure kylix found in Magna Graecia, and the court of the Sun King by an ormolu mirror, but even when exceptional examples of an artist's work or a period style are to be seen (like the Bonnard *Siesta – The Artist's Studio* in Melbourne, for instance) it is not possible to correlate them with other experiences of the same artist's work and so develop a fruitful relationship with the past. Every foreign work of art exhibited in Australia takes on the appearance of a relic; and what can one do in the presence of St Ursula's jawbone except utter some incoherent prayers to one who, however sanctified, is a stranger?

So most Australian artists, when they are not indifferent to the past art of Europe, either devote themselves to a flaccid eclecticism or, as with Max Meldrum's passion for Velazquez, cultivate a monomaniac adoration of one particle of the past. But however distorted these

contacts may be, they do not add up to isolation. Art circuitously manages to build on art. The links are mangled; but the *manner* of this distortion can be significant in itself. For this reason, I think it critically useless to see Australian artists as lone wolves. The nature of their relationship with other art is one of the themes of this book – but it will, I hope, be elaborated by future writers beyond the sketchy outlines I have given it, since no other country in the modern world provides so good a laboratory for the study of the impact of foreign *schemata* on a provincial culture.

Choosing the artists to discuss is always tricky. I hope I have omitted no painter whose work has substantially impinged on Australian sensibility; certainly I have left out none who moved mine. On the other hand, there are some artists like Horace Brodzky, who, though Australian, lived in England since Edwardian times and never exhibited in Australia; such work is not within the context of this book. For the same reason, I have forborne to discuss the work of European artists who, like Peter Kaiser, lived briefly in Australia, since the bulk of their work quite clearly belongs to a European and not an Australian context. I have tried to whittle down the area of 'You have X; why not Y?' but it can never be eliminated. This especially applies to young painters. The brevity of this text enforces many compressions and omissions. A cure might be to include a sort of batting-list of people one might be able to write about if there were space. But I think it would be worse than the disease.

The allocation of the number of plates per artist is not meant as a form of invisible criticism, like the distribution of Michelin stars. I only mention this because I have observed, in the course of preparing the book, a curious reflex, verging on paranoia, among certain artists over the issue. 'How many plates have you given Nolan?' one of them demanded over lunch in Melbourne in 1963. 'Five,' I replied. 'And how many,' he hissed, 'are you using of mine?' 'Three, I think.' He flushed; his jowls flushed, wrathful as a turkey. 'So you only think my work's sixty per cent as good as Sid's, you bloody little bastard,' he exclaimed.

Against such strictures, the critic has no armour.

The Art of Australia

In 1961, an English critic, reflecting on Australian painting, wrote: 'A nation based on an idea rather than on blood needs some transcendent image, to reveal itself.'

The colony of Australia *was* based on an idea; the English penal authorities were justifiably proud of it. At the end of the eighteenth century, English gaols were stuffed with felons. Their constant supply was ensured by one of the most grotesquely unjust penal codes in the world, which would consign a child to some reeking hulk moored off the Isle of Dogs for stealing a loaf of bread, and hang a man for filching a blue coat. By the simple expedient of creating laws, the Crown turned a high proportion of its people into criminals overnight. To relieve the sheer pressure of numbers, it was decided to found a penal colony on the eastern coast of unknown New Holland, recently traced by Captain Cook.

Transportation was better than hanging. But not much. New Holland was as remote as the moon. Indeed, it was more remote. You could see the moon. You could not see New Holland. It was 12,000 miles away, a desolate wilderness whose limits nobody knew, perched on the edge of a hypothetical map.

Nevertheless, the convicts went. (They were to go in great numbers. 'Damme, where's everyone?' demanded King George, in a broadsheet cut published in the 1790s. 'Transported, sire,' replied a flunkey.) In January 1788 the First Fleet, commanded by Captain Arthur Phillip, anchored in Port Jackson (now Sydney Harbour) and disgorged 565 male convicts, 192 women and 18 children. They were guarded by more than 200 marines and officers, who, as one of them wrote in his journal, 'left no room for those who were the object of the Order, but to remain peaceable, or perish by the Bayonet'. Soon buildings were going up, future roads and squares marked out, and a measure of contact made with the blacks. In one of those gestures typical of the eighteenth century, clay from Port Jackson was sent back to England and Josiah Wedgwood struck a celebratory medallion from it, called 'Hope Encouraging Art and Labour, Under the Influence of Peace'. Erasmus Darwin penned a dreadful ode to forecast the colony's prosperity, *The Visit of Hope to Botany Bay*.

Hope may well have encouraged Labour under the influence of Peace, but Art got little help. No official artist went with the First Fleet and there seem to have been no painters in the first shipload of convicts. But several marines, amateur draughtsmen, made drawings of plants and animals, which were sent back to Sir Joseph Banks in England. Banks was an amateur botanist, one of the most gifted dilettanti in England; he had accompanied Cook to Tahiti to observe the transit of Venus, and to Australia in 1770. Now he was president of the Royal Society, and advisory manager of the Royal Botanical Gardens at Kew. Banks welcomed any drawings of nature in the antipodes he could get. Now it was not uncommon for officers to be competent, if not expert, with watercolours. The Navy had a long tradition of topographical drawing, because accurate coastal profiles, showing landmarks, were an aid to navigation. The best of the First Fleet's draughtsmen is referred to as the 'Port Jackson Painter'; his name is unknown, and he never signed his drawings. He drew crudely but with an eye for detail – precise observation was more needed than elegant form; that could be left to the engravers in London – and a primitive's unconscious humour. The spindly blacks brandishing their spears at *The Hunted Rushcutter*, c. 1790 [1] are irrepressibly comic.

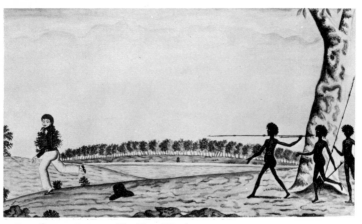

1. Port Jackson Painter: *The Hunted Rushcutter*, c. 1790

Other naval draughtsmen with the First Fleet were George Raper and William Bradley. Their studies of Australian flora and fauna, which Phillip sent back to Banks, created much excitement in London. This increased when Australian animals were sent back too.

Terra Australis, the antipodal land of strange inversion, was inexplicable but fascinating. One busker imported a kangaroo in 1790, and his handbill might have served as a description of Sidney Nolan in London 170 years later:

> The wonderful Kangaroo from Botany Bay (the only one ever brought alive to Europe). Remov'd from Haymarket, and now exhibited at the Lyceum, in the Strand, from eight o'clock in the Morning till eight in the Evening.
> This amazing, beautiful and tame Animal is about five feet in Height, of a Fawn Colour, and distinguishes itself in Shape, Make and true Symmetry of Parts from all other Quadrupeds. Its Swiftness when pursued, is superior to the Greyhound; to enumerate its extraordinary Qualities would exceed the common limits of a Publick Notice. Let it suffice to observe that the Public in General are pleased to bestow their Plaudits; the Ingenius are delighted; the Virtuoso, and the Connoisseur, are taught to admire! impressing the beholder with wonder and astonishment, at the sight of this unparallelled Animal from the Southern Hemisphere, that almost surpasses belief...

Bernard Smith's *European Vision and the South Pacific* – which is the indispensable text for studying this period of colonial art – traces in detail the results of English interest in the 'remarkable curiosities' of Australian nature. Because the unclassifiable fauna were freakish, they seemed to contradict the Linnaean theory of a 'chain of universal being' in nature. To meet this problem one observer suggested that Australian animals came from the perverse mating of established, but different, species; sharks with skates to produce sting-rays, for instance. (The same problem struck the first Europeans who looked at African animals, which is why the giraffe was at first called a 'cameleopard'.) Partly because of this, the discovery of the South Seas had a disruptive effect on eighteenth-century aesthetic thinking in England. Beauty, under Sir Joshua Reynolds's classic system, lay in the familiar. But shown an unheard-of beast like a platypus, one could answer neither yes nor no when asked if it were beautiful. Therefore a new category of experience had to be admitted into the canon of art: the 'exotic', a source of subject-matter which rapidly gained popularity in late eighteenth-century taste and became one of the central ideas of the Romantic Movement. So aesthetic and scientific interest in botany and zoology (and in exotic lands aesthetics and science could be hard to separate: a plant might seem aesthetically intriguing precisely because it contradicted known scientific fact) quite changed English ideas about Australian landscape. From 1790 onwards, visitors to Port Jackson expected to see a romantic tangle of strange, impressive vegetation. One of them, sailing through

Sydney Heads for the first time, claimed to have seen on the harbour's foreshores

charm'g seats, superb buildings, the grand ruins of stately edifices…at intervals the view being pr'ty agreeably interrupted by the intervention of some proud eminence, or lost in the labyrynth of inchanting glens that so abound in this fascinating scenery.

This was pure self-hypnosis. Sydney's foreshores were scrubby and flat, the nearest 'eminences' are more than fifty miles to the west, and the colonists lived in cottages and mud-brick huts. So the diarist was seeing the landscape as if it were a finished Claude. There was a reason for this. Cultivated thought in England, after news of the Tahitians on their island paradise, saw the South Seas as a reincarnation of the Virgilian Golden Age. Most visitors had their schema already fixed for them. This still happens, but the schema is different. Instead of the green Virgilian meadow with ruined gazebos and Noble Savages, we have the implacable desert of antipodean weirdness.

In this dry land there are no dark woods (I do not consider the jungle authentically Australian), no thick, sappy substances; the forms of gravity are continually denied by flying foxes and bounding kangaroos.

Thus Sir Kenneth Clark, in a tone more suited to Lord Monboddo. Another English writer, Colin MacInnes, went further: 'Everything about Australia,' he claimed, 'is bizarre,' and went on to describe the fabled sharks which 'cruise eagerly offshore at sixty miles an hour'.

Then as now, this thirst for the picturesque was reflected in the colony's art. The naval draughtsmen were unmoved by it – their job was not to satisfy taste – but in 1792 the first professional artist arrived, in irons. Thomas Watling, the young 'limner of Dumfries', was doing fourteen years' penal transportation for forgery. As a lover of the picturesque, Watling knew perfectly well what the landscape on this other side of the world ought to look like, and he managed to see it:

The poet may [on Port Jackson] descry numberless beauties, nor can there be fitter haunts for his imagination.… The Elysian scenery of a Telemachus: – the secret recesses for a Thompson's *Musidora*.… Mangrove avenues, and picturesque rocks, entwined with nondescript flowers: – In short, were the benefits in the least equal to the specious external, this country need hardly give place to any other on earth.

But life in the colony was always precarious, often wretched. Life hung on the regular arrival of supply ships. When these were delayed, convicts and keepers alike went on short rations. Of one such time,

Watkin Tench observed: 'Nor was another part of our domestic economy less whimsical....Even at the Governor's table, every man when he sat down pulled his bread out of his pocket and laid it by his plate.' Such trials puncture idealism, and soon the homesick Watling was lamenting that 'The landscape painter may in vain seek here for that beauty which arises from happy-opposed offscapes. Bold rising woods, or azure distances would be a kind of phaenomena.' But his training in a Claudian schema was too strong to be overcome by nature. And so, ignoring the flat, fly-ridden heat of the Cumberland plain, he started improving its prospects once more.

Thus to a bare and dull view over the west side of Sydney Cove, recorded in his pen sketch in the British Museum, Watling added large feathery *repoussoir* trees, which darkle attractively in the foreground and frame the vista. Other additions of poetic, and excisions of prosaic, material helped to produce the picturesque effect he sought in the final canvas, *A Direct North General View of Sydney Cove...in 1794* [2]. It is agreeably moody, but its likeness to Australian landscape is small. It is a composite image. Nature is reworked into a system which fits an existing schema; it is an ideal landscape.

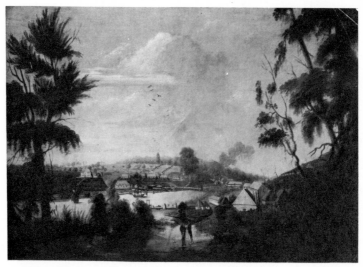

2. Thomas Watling: *A Direct North General View of Sydney Cove...in 1794*

Other artists extended this same idealism to those other curiosities of Australia, the aborigines. Thanks to Rousseau, the Noble Savage was (metaphorically at least) a guest in every London salon. The

Tahitians, innocent as apples in their *jardin exotique*, with their amiable sex-life and little vegetarian dogs, were much spoken of, and when Cook encountered the aborigines of New Holland he speculated on the rude honesty of their lives, and how free they were from the worries of civilization: 'They live in a tranquillity which is not disturbed by the Inequality of their Condition.' All that, Cook perceived, would die out when the white virus struck them, but in the meantime it was natural that these brave Indians should fit into an Olympian scheme, or at least a Hellenic one. Sydney Parkinson and his engraver gave *Two of the Natives of New Holland, Advancing to Combat*, 1773 [3] the physique and posture of *beaux-arts* Greeks,

3. Sydney Parkinson: *Two of the Natives of New Holland, Advancing to Combat*, 1773

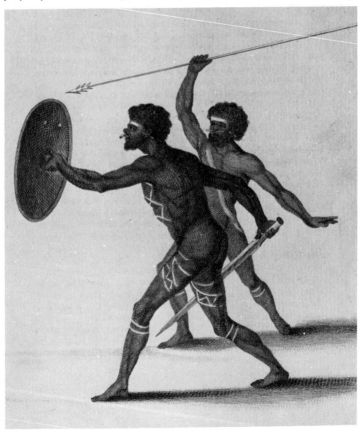

adorned with war-paint. Other draughtsmen followed suit. Medland, copying after Cleveley, depicted formidably noble and impeccably classical savages in *A Hut in New South Wales*, 1789 [4]. Even William Blake, who never went to Australia, engraved aborigines who, bleached, could have stepped into his own paintings.

But when the colonists had lived close to the aborigines for some time, and even fought them as the little town of Sydney pushed its expeditions further afield across ancestral hunting grounds, it became plain that the aborigines were not as noble as Medland and Parkinson thought. They suffered from 'weakness and ignorance'; they were frizzy-haired, spindly, dirty, intractable, thievish, and

4. Medland (after Cleveley): *A Hut in New South Wales*, 1789

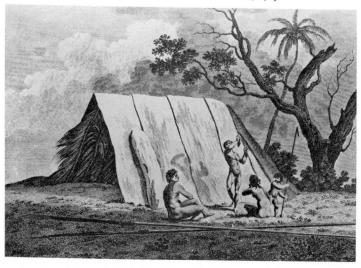

black. Some colonists viewed them compassionately, thinking to provide them, by force if need be, with the pleasures of Christian enlightenment. Others simply disliked them. And of course, the more contact there was between black man and white, the more ragged and pathetically drunken the blacks became. The destruction of the Australian aborigines had begun, and the shift in attitude can be gauged by comparing T. R. Browne's *Hump-Back'd Maria, a Female Native well known about Sydney*, 1819 [5] with [3] and [4].

5. T.R.Browne: *Hump-Back'd Maria, a Female Native well known about Sydney*, 1819

Aborigines recur in drawings sent to England between 1790 and 1820. But as the enthusiasm for the Noble Savage waned, landscape became the main interest of colonial painters. And in landscape, Watling's work in the nineties appears isolated, since the conditions of settlement were, as we have seen, no hot-house for the picturesque. Accordingly, landscape from about 1800 onwards was mainly topographical and descriptive.

John Eyre came to Sydney in 1801. A convict, with rudimentary art training, he had been transported for burglary. He made a number of watercolours of the harbour and settlement. Like the naval artists, Eyre was fond of minute detail and rather primitive in approach, but he was neither as skilful nor as imaginative as Watling. Like most other Australian topographers of the early nineteenth century, he has some interest as a historical specimen but none as a painter. Hardly one good painting was produced in Australia between the arrival of the First Fleet and the appearance of Tom Roberts at the end of the nineteenth century. A few John Glovers, a handful of watercolours by Conrad Martens, an Abram Louis Buvelot or two, the jolly commentaries of S. T. Gill – all the colonial period could muster was a modest provincial charm. But then nothing existed in Australia to entice good painters there. There was no market.

The watercolours of G. W. Evans resemble Eyre's in subject and treatment: there is also the same wooden stereotyping of figure groups, and the same incoherence of space and composition. John Lewin arrived in Sydney a year before Eyre, in 1800. He had been trained as a natural history painter, and had published two books of detailed drawings of Australian insects and birds, *Prodromus Entomology* (1805) and *Birds of New Holland* (1808). Later, he turned to the painting of 'views'. Governor Macquarie liked his work; and Macquarie, by colonial standards, was no bad patron, though his munificence took eccentric forms: a portraitist called Richard Read was enigmatically rewarded by an appointment as Coroner. In 1815 Macquarie commissioned Lewin to go as artist with the Governor's party across the Blue Mountains; and Lewin's most interesting work came from this journey.

The Blue Mountains, a rocky chain of densely wooded peaks and labyrinthine gorges, had hemmed the colony in until 1813, when Blaxland, Lawson and Wentworth's expedition crossed them and opened up the rich western pastoral country beyond. Lewin's scruffy watercolours of mountain scenes [6] are much broader and more atmospheric in treatment than his earlier landscapes. Though alert to picturesque features of the landscape, he used none of Watling's methods. The landscape is 'open', where Watling framed it in dark *repoussoirs*. Lewin tried to investigate the effects of light on the unique forms of Australian vegetation, and because of this one can see the earlier schema dissolving in his paintings. He noticed, for instance, that the leaves of a gum-tree do not pile in masses like an oak's, but are dispersed on branches wide apart, bunched and transparent. The formidable scrubbiness and sense of space one gets in

6. John Lewin: *Evans Peak*, 1815

the Australian bush as nowhere else is felt, tentatively but distinctly, in his work: perhaps for this reason, Bernard Smith held that 'the works which Lewin painted on the Progress are of considerable historical importance, for in them we may trace the rude but distinct beginnings of an Australian school of landscape painting.'

It is not strange that the first thirty years of settlement produced so little art; as we have seen, there was almost no patronage from governors, officers and nobility, while no bourgeoisie rich enough to guarantee a market existed; the only demand for pictures came from the Navy and the Government, and that was for topography alone. When a community has to struggle for its existence as early colonial Sydney did, most energies are used up in survival. A slight improvement appeared after 1820, as the settlement pushed north, south and west; the domestic economy became self-supporting and the social atmosphere became livelier. But it was quite to be expected that little colonial art, from 1788 to (at the earliest) Gill's goldfields watercolours of 1853, bore signs of indigenous character. It is meaningless to speak of an 'Australian' school of painters before 1885. Colonial watercolourists were merely applying English painting techniques of the early nineteenth century to an environment which they did not

'see' clearly – in other words, which they could not reduce to a code of painted signs. And these pictures were being painted by English-men for Englishmen: the only Australians were black. They hung in Georgian homes. Below them, Spode porcelain and Etruria urns stood on furniture executed after Sheraton's design-book. The broadcloth on the settlers' backs came from Manchester, and its cut, however unstylish, from London. The slabs of beef and sprouts and puddings the officers engulfed were a diet utterly unsuited to the climate, but they ate it back home. Society was governed by English law and enlaced by London's standards of morality, taste and eti-quette. In short, the idea of an 'Australian' culture was unthinkable; a resident colonel in Calcutta would as gladly have called himself an Indian. The chief merit, perhaps the one function, of art in Sydney was that it strengthened the cocoon of Englishness needed for cultural survival.

The topographical tradition went on in the work of James Taylor, James Wallis and Joseph Lycett. Taylor and Wallis were military officers; Wallis's *Corroboree at Newcastle, c.* 1817 [7] has a strong picturesque flavour disciplined by a rudimentary but engaging sense of design. In these rows of dancing blacks, one can see the first stage

7. James Wallis: *Corroboree at Newcastle, c.* 1817

of the collapse of the Noble Savage: his change into the Wild Man of the Frontier. London, by now accustomed to the floral exotica of Australia, was becoming interested in the manly rigours of frontier

life; and the colonists naturally liked pictures that mirrored their own situation. So from 1820 onwards, colonial art began to concern itself with the adventures and rigours of discovering a new country: hunting, exploring, heroic deeds. The time of classification was over, and the colonial painters devoted themselves to painting the relationship between the white man and his environment. But at the same time the need for topography was retained. This explains the work of Joseph Lycett, another convict-artist and, like Watling, a forger. He arrived in 1814, in a shipment of felons that included his far more distinguished contemporary, the architect Francis Greenway. Governor Macquarie employed them both: Greenway for his grand plans of city development (which, alas, came to nothing, and left Sydney one of the worst-planned urban messes in the West), and Lycett, between 1819 and 1821, to paint views of New South Wales and Tasmania.

Lycett's *Views in Australia* were published in London. Doubtless Macquarie meant them to attract settlers. Lycett's idealization of the bush is quite different from Lewin's direct looks at it. His landscapes conform to the tamest conventions of picturesque composition; they suggest a bland, fertile, pastoral Arcadia, dotted with European shrubs. The *Views* also contain architectural illustrations, showing the villas of wealthy colonists – a none too subtle way of telling the potential migrant what he could get in the antipodes. There was extensive tourist bureau propaganda for Australia in London, even then. It provoked at least one answer, *New Holland: Its Colonization, Productions and Resources*, written by one Thomas Bartlett, assistant surgeon, in 1843:

My heart has bled on witnessing the utter wretchedness of some poor emigrants, who have ruined themselves by giving too ready an ear to plausible representations of happiness to be attained by emigration.... When the settler abandons the land of his nativity, for a permanent residence in New Holland, he leaves, for ever leaves, behind him, the delicious carollings of birds that hail the glorious sun, or pour the witching vesper lay; and he seeks in vain in the land of his adoption, for the sweet blossoms of his native village. At night, no more he hears the delightful warblings of the queen of songsters – the charming nightingale. The hoarse croaking of the offensive bull-frog, and the incessant buzzing of the hideous mosquitoe, he takes in exchange for the gladdening tones of England's fairy songsters.

But the vision of Arcadia in the antipodes, despite its croaking, stinging and gargling inhabitants, was not so easily to be put down.

*

Augustus Earle was Australia's first mature romantic painter, minor figure though he was. He also seems to have been the first professional artist to mingle without embarrassment in the tight, snobbish layers of colonial Sydney society. Of course, he had the cachet of exhibiting at the Royal Academy. Having produced a number of historical blockbusters – *Burnings of Carthage* and the like – he devoted himself to painting, for the English market, scenes of countries never witnessed by European eyes. This led him to Brazil (he accompanied Darwin on the *Beagle*) and eventually caused him to be stranded on the rocky wilderness of Tristan da Cunha, where he projected his own loneliness into conventionally overwrought water-colours of stormy seas and crags beetling under dark skies.

Via Tasmania, Earle came to Sydney in 1825 and set up studio as a portraitist. He filled the colony's need for an artist with some social graces, and no convict taint, who could perform in the eighteenth-century English grand manner. On a superficial level, Earle could; his *Captain John Piper* [8], painted around 1826, showed it, despite limp drawing and rather cardboardy shapes. His landscapes were a

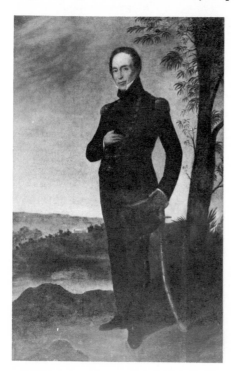

8. Augustus Earle:
Captain John Piper, c. 1826

little more impressive. In 1838 he exhibited a large colonial subject-picture at the Royal Academy. This was *A Bivouac of Travellers in Australia in a Cabbage Tree Forest, Day Break, c.* 1837 [9], and in it,

9. Augustus Earle: *A Bivouac of Travellers in Australia in a Cabbage Tree Forest, Day Break, c.* 1837

romanticism, frontier lore and topography are combined. Earle's brush conveys much information about the flora of the scene (a coastal forest at Illawarra), while the dramatic situation, with cute little figures grouped around a fire whose flickering glow lights up the overpowering trees, was appealingly exotic.

If Earle was a provincial Salvator Rosa, John Glover was an assiduous copier of Claude. Despite Bartlett and other disgruntled expatriates, there is no doubt that many settlers after 1820 did see parts of Australia as mellow pastoral Arcadias. Two conceptions of Australian landscape, one as a wasteland of perverse hostility, the other as a paradise for Virgilian graziers, have long managed to co-exist in Australian painting. Glover held the second view. Claude's tranquil prospects and serene skies gave him a schema for his own image of Tasmania. He settled there a wealthy man. Reputedly, he had made £60,000 from imitating – and forging – Claude's paintings in England. He was sixty-three years old. Tasmania was a haven for him in his dying years.

The curious thing was that this insignificant eclectic, who had never produced an original brushstroke during his life in England, fitted himself rapidly to the unfamiliar forms – if not the colour – of Tasmanian scenery; and that he consistently painted clear and vivacious pictures. *Australian Landscape with Cattle*, 1835 [10] is a

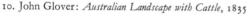

10. John Glover: *Australian Landscape with Cattle*, 1835

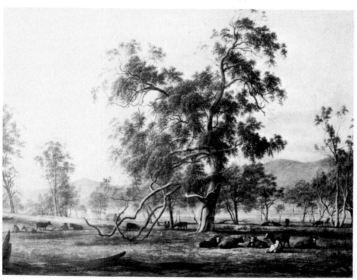

freshly observed idyll, though mannered in drawing: no earlier colonial picture equals it, and in the next forty years only Buvelot's do. As if for the first time, antipodean nature is really humanized. No longer an interesting but repellent gallery of vegetable and animal freaks, it has become a friendly world into which the European settler can move without strain. In this proper place for white men, Glover thought the blacks an error of taste and an intrusion: he painted them as nasty little cacodaemons.

His son, John Glover Jr, is thought to have painted too, but no pictures have been definitely attributed to him. One may be *My Harvest Home*: its style is a little less sophisticated than the elder Glover's, though the paint-handling and the general attitude towards landscape is much the same.

Between Glover and the next colonial artist of merit, Conrad Martens, fall a number of topographers and hunters of the picturesque. John Skinner Prout emigrated in 1840 – in England he had already published a book of architectural views. His Australian landscapes are not as laboured as those of earlier topographers, and he 'wrote' his impressions with cursive penstrokes, embellishing them with rapidly laid and summary washes. On his own lithographic press, he published three books of Australian views within seven years of his arrival. But the best lithographer of the forties was George French Angas. Angas's work is more factual than Prout's, but he was an illustrator of considerable talent. His best-known work had to do with the landscape and people of South Australia, where he arrived in 1843. In landscape, he was precise, uninspired and sound, but his studies of aborigines have been underrated: long after the Noble Savage myth had collapsed, and the native had become the butt of every oafish colonial wit, Angas was able to draw him objectively and with sympathy [11].

In Tasmania, besides John Skinner Prout, there were de Wesselow (a hack topographer) and that odd figure, Thomas Griffiths Wainewright. Wainewright later became one of the lesser phoenixes of *fin-de-siècle* thought, meditated on by Swinburne and Wilde: a dark post-romantic figure, the painter-poisoner. In London Wainewright had studied the works of Fuseli and Blake, but his imagination had none of their intensity. The Wainewright legend has been traced by Mario Praz in *The Romantic Agony*. But such Borgia fire as one may impute to him must have been spent on poisoning. There is none in Wainewright's simpering watercolours of elegant Hobart ladies, though some critics have read into their faces the look of Belles Dames Sans Merci.

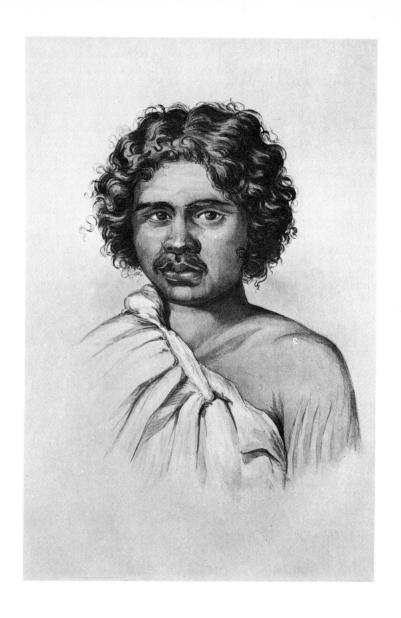

11. George French Angas: *Portrait of an Aboriginal Girl,
South Australian Type,* 1844

Among colonial watercolourists, Conrad Martens must occupy the highest place. Indeed, he is the only artist of this period whose work in Australia would qualify him for a position in the general tradition of English watercolour. In a lecture he gave at the Australian Library in 1856, his 'Lecture Upon Landscape Painting', Martens listed the people who had influenced him while he was a student at Copley Fielding's studio after 1816: Turner, Danby, Stanfield, Cox, and Fielding himself. 'Cox, above all, for his wonderful faithfulness in colour, form and texture.' He pored over Turner's *Liber Studiorum*, even comparing the master's engravings with their original scenes, and adopted Turner's theory of a compressed field of view:

fifty-five degrees of the circle is the most that should be included from left to right of the subject. Taking now...a smaller angle, say forty degrees, for the extent of the picture, grandeur and magnitude will be the result.

And so, as a later Australian artist, Lionel Lindsay, put it:

Conrad Martens was a product of the thought and taste of the days of his youth....The Turnerian Elevation of Theme was part of his mental texture, just as we today are unconsciously subject to the influences of French landscape.

It was not quite a new vision, only a different schema; but Martens's watercolours were a relief from the Claude-and-water diet provided by earlier painters. Martens left England in 1832 and arrived in Sydney three years later. Meanwhile he had sailed the world, and on that slow, monotonous voyage he had closely studied atmospheric effects at sea, noting them in his sketch-books. This detailed observation led to his later paintings of sun-effects over Sydney Harbour, in which he managed to show a wider range of response to the moods of nature than earlier colonial artists had done. With his habit of observation went Martens's academic insistence on the abstract basis of design. He emphasized that, by massing lights and darks, the picture should gain a breadth and general form independent of what it depicted.

Martens's romantic leanings were rooted firmly in a knowledge of pictorial structure, a combination missing from most colonial art. His major watercolours have some of Turner's appeal. What they do not have is Turner's colour, bravura and *expressive* design; still less do they possess Turner's comprehension of vast natural forces in turmoil. To compare the two men qualitatively is futile. Martens had a faint sense of the sublime, and used Turnerisms to express it. The mansions on the headland to the left in *Sydney Harbour from Point*

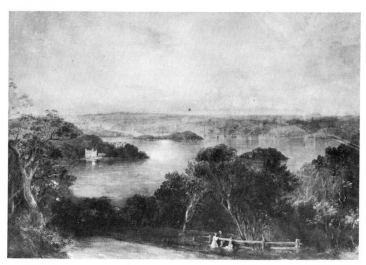

12. Conrad Martens: *Sydney Harbour from Point Piper*, 1866

Piper, 1866 [12] are theatrically spotlit by shafts of the fading sun,
unreally white against the smoky bush.

Martens's technique was impure. He relied on Chinese white for
his highlights, not letting the paper do the work; but over broad
areas of sky or land his touch was deft and luminous. No painters
until Roberts and Streeton so neatly caught the opalescent shifts of
colour over Sydney Harbour at sunset, the delicate mauves, pinks
and yellows. In short, Martens coordinated sensual verve with
inquiry, thus foreshadowing the streak of pragmatic lyricism in
Australian responses to nature and, through nature, to art.

Indeed, he maintained that nature could only be seen through art.
One of Martens's favourite complaints was that Australian know-
ledge of art was so grossly limited. No past works could be seen
there. In the late 1850s, Australia was a hopeless cultural backwater.
Not even the works of English watercolourists, the fathers of the
colonial school, could be seen. In Europe, when Reynolds directed
his pupils to study the Antique, the Antique was there to study. But
not in Australia, where any theory of art had to sustain itself without
one major painting or piece of sculpture with which to compare it.
Under these circumstances, the well-informed young Sydneyite of
1850 – if there was such a person – perused his Winckelmann and
yearned for the Apollo Belvedere in vain. There was little thinking

about art, and against this background Martens's fondness for theorizing is in itself unusual. From this blocked situation, one may turn to another phenomenon of the fifties – the popular or vulgar artists.

Colonial Australia had brought from England a crude but effective popular art, pamphlets, broadsheets, political satires. The first newspaper illustration in the colony was probably done by a Tasmanian convict-artist, William Buelow Gould, in 1829. It showed the survivors of the pirated brig *Cyprus* making a coracle. Gould also painted naïve still-lifes in an elaborate sharp-focus technique, which he may have learnt while working in the Spode potteries before he was transported. (Not long ago many old pubs in Hobart owned a Gould still-life. He was a hard drinker.) Primitive artists, like William Lancashire, a Sydney convict (*fl.* 1803), were at work. So were satirists and pamphleteers. Though affinities of style between these men and the goldfields artists are not easy to trace, there is no doubt that a tradition of popular art existed, which was independent of the tendencies towards the exotic and the picturesque, and immune to the typification of landscape. By taking their environment unfiltered by all this, the popular painters laid the groundwork for the most robust and 'Australian' of all colonial artists, Samuel Thomas Gill.

In 1851 gold was found in Australia. Colonial society, stable for sixty years in a pyramid from convicts through farmers, merchants, professional men and officers to the Governor, was thrown into flux by the diggers. Adventurers, cranks, foreigners, whoremongers, Flash Jacks and three-pea men crashed through it, oblivious of what their proper level should have been. Gold caused the most profound social upheaval in sixty years; and between 1851 and 1861 the population of Australia trebled.

Two new terms entered the colonial equation. The first was the *arriviste* rich, who had done well at the Bendigo shafts. Some drank their fortunes or gambled them away, but not a few invested and consolidated them, and emerged as powerful figures in Melbourne.

The second was the half-articulate, independent labourer, with his primitive socialist leanings and 'Who are you ? I know who *I* am' front: Lalor, leading the Eureka rebellion in 1854, was such a man. Suspicious of book-learning and chary of culture, they rarely looked at pictures. When they did, they liked the realistic genre, scenes of the life they knew and understood. And so compare this dedication of a book of goldfields drawings by T. Balcombe and G. F. Pickering, published in 1852 and entitled *The Adventures of Mr John Slasher at the Turon Diggings*, with the suave flattery of eighteenth-century dedications:

To none with more propriety, or greater sincerity of feeling, than our quondam fellow-labourers in the Gold Fields of this our common country, whether by nativity or adoption, can we dedicate the unpretending fruits of pen and pencil... we entreat them to view with no hypocritical eye the productions of either. We can claim no other tribute than a smile.

This our common country: a phrase as unthinkable to Watling, Lycett or Earle as it would have been to their patrons. The comradeship of the diggings was crudely sentimentalized by some Australian writers. But it existed, and it forms the background to the proletarian humour of S. T. Gill's goldfields series.

This is the best known, but not the only area of Gill's work. Born in England in 1818, he settled with his parents in Adelaide in 1839. There he opened a portrait studio: 'Correct Resemblances of horses, dogs, etc., with local scenery etc., executed to order. Residences sketched and transferred to paper suitable for home conveyance.' In other words, a journeyman sketcher: in which role he went, apparently unpaid, with the ill-fated Horrocks expedition of 1846. Later he set to work on two series, The Months and The Seasons. These rural scenes with their swelling pastures, waving grasses and jolly, rubicund peasants are quite unlike his raucous goldfields work; an Australian writer, Geoffrey Dutton, suggested in a monograph on Gill that they stand to one another as Rowlandson's village watercolours do to his gin-shop satire.

In 1851 Gill joined the rush to the Victorian diggings – a general exodus, which had drastic effects on the South Australian economy. There he turned to straight genre recording. Gill had the eye of a journalist, which slightly redeemed his messy and inefficient grasp of form. Everything on the goldfields was grist to his mill: in landscape, the scrubby gums, dark shafts and sunlit mullock-heaps, red clay banks, streams and sluices; the washing-troughs and racks of shovels, the furnaces and weighing-stations where miners brought their dust and watched out for rigged scales; the fights over claims, the diggers swinging picks or sleeping at the bottom of a shaft; the honkey-tonk pubs, with 'Seventeen NEW! Barmaids brought this Day from Melbourne'; miners in check weskits, cutting a dash in town and brandishing cigars over the gaming-tables; sweat and thievery, boozing and whoring, the very texture of the diggings – and, beside the track in one watercolour, a crow-picked skeleton, admonishing his audience against too happy a view of life in that rough decade.

Because it rang as true as a half-crown on a bar counter [13], Gill's work was instantly popular and remained so for fifteen years. His output was large (in all, over 1,500 works) and very uneven. At its

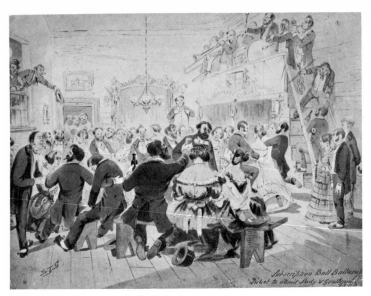

13. S. T. Gill: *Subscription Ball, Ballarat,* 1854

best it compares with the work of other contemporary social caricaturists in England, and was perhaps a fraction better than one recent opinion, 'Provincial Rowlandson without the genius'. But Gill became a sot, and in 1880, friendless and doddering with rum, he dropped dead on the steps of the Melbourne Post Office.

Had they known about it, the members of Melbourne's art establishment might have thought his death exemplary. The gold-boom indirectly caused Australia's first State collection, the National Gallery of Victoria, to be endowed in the 1860s. By then, official attitudes to art in Australia were dominated by the thick voice of evangelism. Any kind of pleasure, the disciples of the repulsive John Calvin held, was a snare to the just; therefore art was suspect, and in Australian urban society, with its upper caste systems backed by Victorian prurience, the favourite art forms proved to be a sentimental and pietistic genre, soggy with moral uplift. The collapse of the alcoholic Gill could have been taken straight from the story-paintings with which the National Gallery of Victoria was stacked. 'Art, then, to the Australian middle classes of the later nineteenth century, was *good* to the extent that it raised moral standards, inculcated patriotism and promoted commerce.' But local artists got little official support. On the other hand, the Australian collections did almost nothing to

buy major European pictures in those days when they were cheap. Victorian anecdote and brown landscape was the staple fodder. It is ironical that the trustees thought they were being progressive. To look at the dreadful sentimentality of Luke Fildes's *Widower* is to risk forgetting that, when it was bought, it was as new to them as a Rauschenberg is to us now. In the 1860s, wise collectors bought Raphael, progressive ones bought the Pre-Raphaelites, but Australians got the factory seconds. 'A picture,' ran an article in the *Illustrated Sydney News*, 'is a book for the entertainment or instruction of those who would peruse it, and the artist is an author seeking to propound a theory, to narrate a story, or to indite a poem, with the aid of the pencil instead of the pen.'

So Australian painting succumbed to an elephantine academism: official art without officers. Bombastic history paintings, like William Strutt's *Black Thursday*, 1862–4 [14], were much acclaimed, and the Tasmanian Robert Dowling produced monumental pictures of the dying race of Tasmanian aborigines as Noble Savages in red wigs. Strutt, an English genre painter who lived eleven years in Australia between 1850 and 1862, gave his paintings a laborious *beaux-arts* finish, but he is of some interest because he tried, by

14. William Strutt: *Black Thursday* (detail), 1862–4

means of heroic or melancholy incident, to typify colonial pioneer-
ing: in this respect he anticipated Tom Roberts's subject-pictures,
and his work is part of a general trend towards poetic melancholy in
Australian art and literature around the end of the nineteenth
century. Australians like local set-backs, like bush fires, floods, or
Anzac Day. They serve as substitutes for history.

In landscape, the chief figures were Chevalier, Piguenit, von
Guérard, and Buvelot. As their names suggest, they were European
émigré painters. Eugène von Guérard and Nicholas Chevalier
produced gloomy and indigestibly stodgy prospects of mountains
and lakes. W. C. Piguenit, like most minor romantics, enjoyed
a good crag; but his mist-shrouded *Mount Olympus*, 1874, is ineffably
dank, and the dust of the schoolroom lies thick upon it. The
only landscapist with even slight distinction between Martens
and the Heidelberg School was, therefore, Abram Louis Buvelot.

Born in Switzerland and trained in Europe, Buvelot lived eighteen
years in Brazil before coming to Australia in 1865. One may deduce
from this that he was not a particularly successful painter in Europe,
and, in fact, his paintings were for the most part a provincial
appendage to Barbizon landscape. But while they did nothing to

15. Abram Louis Buvelot: *Yarra Valley, Melbourne*, 1866

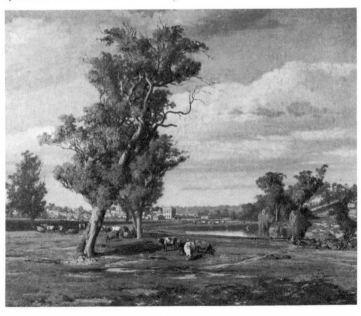

extend or revitalize that idiom, at least they had some merits of their own. His first works in the colony were low-keyed, relying on the disposition of broad masses of shadow and silhouette rather than the play of light over a number of specific objects. He composed in terms of tone, not colour, and this lent his landscapes like *Waterpool at Coleraine*, with its big tenebrous trees set against an opulent sunset, a firm structural weight. But this was a transplanted European landscape, and Buvelot took some time to adjust his schema to the characteristic forms of Australian nature. Even so, Arcadia prevailed. Painting outside Melbourne, in country which his successors – Streeton, Roberts, Conder, McCubbin – made familiar, he captured the open spread of landscape, the shape of gums and the translucent hazes of distance in a painting called *Yarra Valley, Melbourne*, 1866 [15]. The tonal key is higher, but Buvelot's paintwork remains thoroughly academic, licked and smooth; he neither achieved nor wanted the vigorous brushwork later used by Streeton.

It is usual to see Buvelot as a link between academic colonial landscape and the *plein air* movement of the Heidelberg School. Tom Roberts, it is true, was closely associated with Buvelot when a student. But Buvelot was no impressionist. He was a tight tonal painter, striving, not very successfully, to adapt the vocabulary of middle nineteenth-century French landscape to un-European scenery and light. On the other hand, Buvelot neither typified nor romanticized the exotic features of Australian landscape, though both Chevalier and von Guérard tried to: he does not belong, for this reason, to the general colonial pattern.

Those are the main lineaments of colonial art. It is a patchy design. No country in the West during the nineteenth century, with the possible exception of Patagonia, was less endowed with talent. Granted the minor exceptions of Gill, Glover, Martens and Buvelot, a whole century passed without producing anything but mediocre, amateurish or thwarted painters. There is little in the history of Australian art between 1788 and 1885 that would interest a historian, except the way that painters, set down in an environment for whose forms their training had not prepared them, accommodated themselves to it. But the struggle between schema and things seen only becomes dramatic when it happens in the mind of a great painter. There was no Australian Delacroix. But events after 1880 were more interesting. Within a decade, four young Melbourne painters were to give Australian art a direction, and form the first identifiable national school. These men, Tom Roberts, Arthur Streeton, Charles Conder and Frederick McCubbin, are commonly – and, I hope to show, wrongly – called the 'Australian impressionists'.

In 1883 four young Australians were on a walking tour in Spain. They were Tom Roberts, a young artist who had been Buvelot's pupil and had later taken the National Gallery School's first prize for landscape; John Russell, another painter, and his cousin Sydney Russell; and one Dr William Maloney, from Melbourne.

Outside Madrid they met two young Spaniards, Laureano Barrau and Ramon Casas. Both painters, still in their teens, voluble and bright, were fresh from a visit to Paris, where Barrau had studied at Gérôme's studio. Gérôme, an academic, had absorbed a little impressionist theory: 'In painting,' he taught, 'the first thing to consider is the general impression of colour.'

This hardly touched the central issues of French Impressionism, but it was new to Roberts. Reinforced by Casas's quasi-impressionist sketches, it impressed him. He was fresh from the National Gallery School, founded in 1870, and presided over by academics and hacks like von Guérard or the then incumbent, Folingsby, an Englishman to whom colour was anathema. He trained students to lay-in a portrait with a tonal underpainting of bitumen and vermilion, with black primary shadows, umber secondaries and white highlights. This frigid, muddy convention was the very one which so grated on the nerves of Toulouse-Lautrec at Cormon's in Paris, and Folingsby drilled it into his students mercilessly.

But Roberts had visited London before Spain, and there he probably saw paintings by Bastien-Lepage and James Whistler. Bastien-Lepage was a dull painter, and his link with impressionism was, to put it mildly, slight. He was a sentimental realist, an open-air *peintre du sol*. But his silvery-grey tonalities seemed, to the English, an agreeable variant on impressionist methods. Bastien-Lepage worked with a square-head brush, laying his areas directly and accurately without painting 'wet into wet' or retouching. This directness attracted Roberts: it was an adaptable way of working, suitable for depicting objects for which 'tradition had not yet prescribed a way of handling and regarding': like, in later years, the Australian bush.

Now having lived in England since 1881, Roberts may have encountered Whistler's growing reputation and come into the orbit of

his influence on the *avant-garde*. In 1884 Whistler exhibited 'Notes, Harmonies and Nocturnes' in London. This could have been the precedent for the '9 x 5' show of impressions in Melbourne in 1889, for Whistler's paintings were mostly small, spontaneous oil-studies on 9 x 5 in. panels. Certainly, Roberts's palette, shared by the whole Heidelberg School later on, was close to Whistler's tonal impressionism: cobalt, sienna, raw umber, Naples and chrome yellow, ochre, Venetian red and black.

Barrau and Casas, then, helped catalyse the effects of Whistler and Bastien-Lepage on Roberts: no set pieces, direct handling *en plein air*, no elaborate finish, informal tonal painting, no bitumen. Light never became a dynamic element in his art as it did in Sisley's. It did not transform nature; Roberts lacked the commitment to optical discovery which led Monet through his innumerable studies of Rouen Cathedral, or Seurat into his glowing tapestry of juxtaposed pure colour. Neither Roberts nor any of the Heidelberg painters used a divided palette, indispensable to impressionist method; the relatively unbroken surfaces of their paintings point directly to Whistler. Hardly a blue shadow is to be found in the Heidelberg School until Streeton painted *'Fire's On!' Lapstone Tunnel* [21] in 1891. Their only real point of contact with true impressionism was painting in the open air, straight from the motif. This, in turn, affected the spontaneity and freshness of their gaze, just as it did in the case of the French Impressionists.

Roberts returned to Australia in 1885. He withdrew from the city, and set up the first of a number of painting camps at Housten's Farm, near Box Hill, outside Melbourne. Frederick McCubbin, once his fellow-student, joined him there. They lived simply, painting all day and sleeping on hessian bags slung between saplings. Most of their pictures were small, often finished in half an hour. Roberts developed his taste for bush historicism and large set pieces later, and the sketches helped preserve the integrity of the moment, for 'Painting,' he said later, 'fixes one thing for you, one scene, one mood, one idea.'

His Box Hill 'impressions' were seen by two other young painters, Arthur Streeton and Charles Conder. Though later the compleat official painter, Streeton never quite forgot his debt to Roberts; they corresponded for years, and Streeton once called him 'the father of Australian Landscape'. Later he wrote of his meeting with Roberts, when he was working under Folingsby at the National Gallery School:

The impressions brought out by Roberts had the fresh air, true-tone-in-values idea, which was in conflict with the academic training at the art school under Folingsby. I was painting a head after the manner of Roberts when F. told me not to paint like that, but to put in the subject first with bitumen and vermilion. I didn't argue with him, but left the school and worked again with Roberts.

This happened in 1886. Later camps were set up in Heidelberg. In 1888, Roberts, Conder and Streeton moved into a large deserted farmhouse at Eaglemont, above Heidelberg, another outer suburban village; and there they painted incessantly, surrounded by younger artists who were attracted to their theories. Then, in 1889, Roberts, McCubbin, Streeton and Conder exhibited in Melbourne, with three other artists now obscure: C. Douglas Richardson, R. E. Falls, and Herbert Daly.

This was the crucial, and now legendary, '9 x 5' show, so called because the 183 paintings in it were small and most of them were done on cigar-box lids. The catalogue, with Conder's quaint *art-nouveau* cover depicting a female figure labelled *Convention* emerging from a wrapping of bandages, read:

9 x 5
EXHIBITION OF IMPRESSIONS
AT BUXTON'S
SWANSTON STREET, MELBOURNE
AUGUST 17, 1889

Open daily from 10 a.m. to 5.30 p.m.
On Friday evenings from 7 to 10
Tea will be served at 4 p.m.
Admission 6d.
Purchase-moneys will be received by the Attendant

'When you draw, form is the important thing;
but in painting, the *first* thing to look for is the
general impression of colour.'– Gérôme

TO THE PUBLIC:
An effect is only momentary; so an Impressionist tries to find his place. Two half-hours are never alike, and he who tries to paint a sunset on two successive evenings must be more or less painting from memory. So, in these works, it has been the object of the artists to render faithfully, and thus obtain first records of effects widely differing, and of a very fleeting character.

This, the first art-manifesto published in Australia, hardly seems extremist. But it does clarify the gap (bridged only by a semantic error) between the Heidelberg painters and the impressionists. When Streeton and Roberts called themselves impressionists, they meant only that they tried to capture fleeting effects by working *en*

plein air. They were still happy to accept the abrupt distinction between form and colour which Monet and others had rejected long before. Indeed, there is no mention of any theory of colour. The critics, with one exception, disliked the 9 x 5 show. But they said nothing about spotty faces or blue shadows: what they objected to was lack of 'finish', an academic virtue impressed on them by Dicksee, Tissot and their ilk. The *Argus* critic, James Smith, wrote:

Such an exhibition of impressionist memoranda as will be opened today at Buxton's gallery by Messrs Roberts, Conder, Streeton, and others, fails to justify itself. It has no adequate *raison d'être*....In an exhibition of paintings you would naturally look for pictures, instead of which the impressionist presents you with a varied assortment of palettes. Of the 180 exhibits catalogued on this occasion four-fifths are a pain to the eye.

To look at the charming, slight, fresh sketches today [16, 17] is to wonder what all the fuss was about. For though the big works of von

16. Tom Roberts:
Quiet Study, 1889

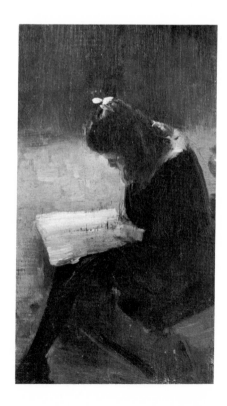

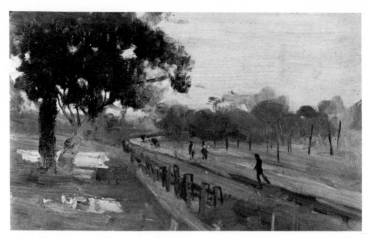

17. Arthur Streeton: *Impression, Roadway*, 1889

Guérard, Piguenit and others were invariably painted in the studio, *plein-air* painting was not imported by Roberts: Julian Ashton had already been advocating and practising it for years, as had several others. But critics mistook the 9 x 5s for indicative sketches, never imagining, it seems, that the paintings were meant to be thought finished.

Roberts's effects were direct and brilliant. He exploited the faceted marks Bastien-Lepage's square brush made: the colour went on crisply, and each brushstroke contributed to the structure of some element in the painting instead of effacing itself. After the anonymous surfaces of Piguenit and Buvelot, one felt the tactility. The small size of the paintings accentuated this. Though subdued, his colour was exact, and through the nineties it was in a higher key than that of earlier painters. It caught, with steely precision, the flickering bronzes and greys of eucalyptus leaves, the impalpable blue haze of distances, the bleached clay banks and dry grasses at Eaglemont, and above all the crystalline hardness of midsummer sunlight.

He also made subject-paintings. The earliest of them, *A Summer Morning's Tiff* and *The Reconciliation* (painted at Box Hill), were only excuses for painting a slice of bush; his major work in this field came after 1890, and dealt with heroic or sentimental aspects of rural life: *Shearing the Rams*, 1890 [18], *The Breakaway*, *The Golden Fleece*, *Bailed Up* and others. Here he revealed a recurrent trend in Australian imagination (seen in its purest form in Nolan's work, years later): he took his heroes from the past. People long for the old virtues. They

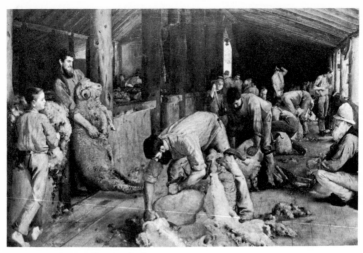

18. Tom Roberts: *Shearing the Rams*, 1890

go easily into art because, while remote from immediate experience, they hover at the back of the mind like a folk-myth and can be readily invested with the properties of a 'national' symbol, even framing an oblique form of social commentary.

Roberts perceived the drama inherent in putting a frontiersman in the bush and watching conflict develop between the two. He released this 'noble struggle' in *The Breakaway*, which depicts a stockrider galloping furiously across a dangerous slope to head off a flock of thirsty sheep, which are bolting towards a waterhole. Dr Ursula Hoff has suggested that such events were rare in Roberts's time – Victorian grazing properties were extensively fenced, the spreading railways were doing away with long-distance stock droving, and dangers of loss were remote. So it is unlikely that Roberts ever saw a breakaway, but the event seemed to him to typify the courage and perseverance of the settler. To paint it, he abandoned his fixed notion of working direct from the motif, but in the studio he tried hard to give the painting a spontaneous, *plein air* look, and succeeded. The immediacy of the experience still mattered as much as its symbolic overtones.

At work on *Shearing the Rams* in 1890, he wrote to Streeton, saying he wanted to portray a subject:

Noble enough and worthy enough if I could express the meaning and the spirit – of strong masculine labour, the patience of the animals whose year's growth is being stripped from them for men's use, and the great human interest of the whole scene.

A far cry from his on-the-spot studies of 1888–9, it involved over seventy figure studies, and Courbet's *Stonebreakers* has been said to have influenced it. The same kind of deliberation produced *Bailed Up*, Roberts's plainest piece of historicism. It illustrated a hold-up of the Inverell Road twenty years before. Roberts had been told about it by an old friend, a Cobb & Co. coach driver named 'Silent Bob' Bates. Now, Kelly apart, bushrangers were an extinct breed by the eighties and Roberts could not conceivably have seen one. But the romantic overtones of heroic outlawry – only ten years before, Australians were still referring to the bushrangers as *banditti* – appealed to him. He painted the landscape; later he posed the coach and driver at Inverell, finally getting models for the horses at a near-by station.

Roberts's imagination runs parallel to the prevalent tone of Australian writing in the nineties. His virtues of mateship, courage, adaptability, hard work and resourcefulness are the very ones Lawson celebrated in his short stories, and Joseph Furphy described in *Such is Life*. Their use indicates a growing sense of cultural identity. These virtues were thought distinctively – even uniquely – Australian. With the rise of nationalist sentiment went a shift in the political wind: egged on by the *Bulletin*, the chief tone of radical thought became anti-imperial, isolationist, rabidly white: the Chauvins ruled the roost. Super-patriotism was reflected in McCubbin's work as well as in Roberts's, and Charles Conder was the only member of the Heidelberg School indifferent to it.

Another but much inferior painter named Frank Mahony contrived scenes of murky bush through which bushrangers and stockmen galloped. Mahony (1862–1916) was a competent illustrator, and worked for the *Bulletin*, the *Sydney Mail* and the *Antipodean*. But it is unlikely that he influenced Roberts's choice of subject, though a good deal of his work was done before 1889 and some of it appeared in the *Centennial Magazine*, where Roberts could have seen it. Roberts also made his concessions to more customary kinds of genre: *Jealousy*, 1889, is a domestic story-picture, complete with wronged damsel and fan.

The third facet of Roberts's work is his portraiture, whose importance has been much glossed over by local critics. It brought him an early reputation – which, in view of the taste-mechanisms of Australia then, meant little in itself – and put him down to three

years of grinding labour when, in 1901, he was commissioned to do what he called *The Big Picture*: an immense canvas of the opening of the first Commonwealth Parliament. It contains over a hundred portrait heads, and is unrecognizably banal. But his more intimate portraiture has not had due attention. This is a pity, for Roberts, at his best, was excelled by no Australian portraitist until Dobell painted *The Sleeping Greek* in 1936. Some equalled him – Lambert

19. Tom Roberts: *Eileen*, 1892

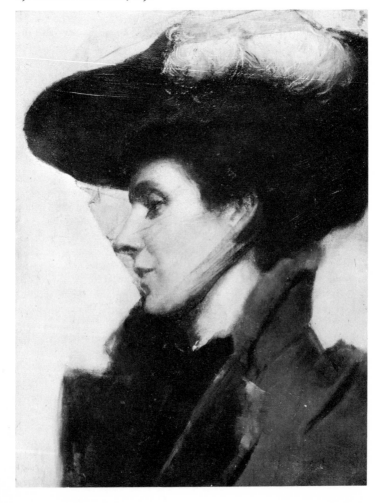

once, with his 1903 *Miss Thea Proctor* [33] – but Roberts never descended into the vacuous mannerism of Lambert's late grandmanner work, still less to the greasy slickness of today's academics like William Dargie.

Eileen, 1892 [19] has his typical qualities: firm, spare drawing, fluent but expressive brushwork. The girl's face is painted with absolute concentration, in delicate but never ingratiating modulations of tint and light, rendered with the fastidiousness of a Whistler. To set Roberts beside his European contemporaries in the field of painting beautiful young girls – Helleu, for example – is to see his ability to bend a tough stare on his subject and draw forth a masterful summary of the personality behind the type. He enjoyed the transparency of veils, the textures of silk, fur and feathers, and complicated lights on hair: but he painted them economically, not, as Lambert did, for a show of swaggering illusionism.

Roberts died in 1931. It was not an obscure death, but he had been overshadowed by the more prolific, and by then shallower, talents of his old friend, Arthur Streeton.

Critics and public thought that Roberts had merely initiated a mode of art which Streeton brought to a final pitch of incontestable maturity. This belief arose because Streeton's large output, twelve years longer than Roberts's, was composed entirely of landscapes. He paid little attention to portraiture, subject-painting or genre. When he tried, he was clumsy. Having become immensely successful in the process, Streeton was thus identified with the general idea of what the 'true' elements in the portrayal of Australian landscape were, and was credited with their discovery. It occurred to few that Streeton's vision expanded not a whit in the last forty years of his life, and that most of his work from 1900 on was stolid, repetitious, and brassily gross.

Streeton was already moving towards *plein air* painting when Roberts met him, sketching the rocks at Port Phillip Bay, in the eighties. But he had little interest in subject-painting. Figures in his landscapes were accessories, to define the scale or lend a focus, the blue dress or red shirt against the expanses of clay and grass. No broad implications stemmed from his use of the figure. Man was not the measure of landscape: for Streeton in the nineties, Australian landscape existed on its own terms and with its own unique grandeur. It was the Promised Land, whose receding vistas beckoned him in a way that Roberts's sweaty drovers and McCubbin's Noble Swaggies could never have done.

Painting *'Fire's On!' Lapstone Tunnel* in 1891 he wrote to Roberts,

One's eye sweeps across an extensive plain fertile with crops and orange groves...and man, he's nowhere to be seen, he's just out of it; yes, there's a real drama going on in front of me...so interesting and Australian altogether.

Streeton experienced the Australian bush as a romantic, feeling naked before it. But he expressed this in terms unlike the received vocabulary of colonial romantic painters. Not for him the precipitous crags, the storms and brooding lakes; he was obsessed by the still-ness and remoteness of the Australian landscape, its blinding light, and the contrast between its fertility and its ageless indifference to man. The letters from Smike to Bulldog (Smike was Streeton's nickname; Bulldog, Roberts's) are full of his sense of awe before this enormous, many-faceted repository of landscape experience un-touched by previous brushes. He wrote:

I fancy large canvases all glowing and moving in the happy light and others bright decorative and chalky and expressive of the hot trying winds and the slow immense summer. It is IMMENSE, and droughts and cracks in the earth and creeks all baked mud.

His thought was tinged by Arcadian notions of Australia Felix (this, in fact, was the title of one of his larger paintings); there are Rousseau-like echoes in his love of the simple life and his wish to escape the complexity of the cities for a larger sphere of elemental experience. Though his imagery was, for this reason, quite different from Roberts's, he was an intensely regional painter.

His palette, to suit his passion for light, was more high-keyed than Roberts's, Conder's or McCubbin's. It lay closer to French Impres-sionism – though still not very close – and shadows, in his work of the middle nineties, were often bright blue. He worked under the full glare of the noon sun, whose light isolated forms with absolute clarity and threw subtle, transparent shadows. Rapid modulations of colour, between lime-greens, pinks, yellows, light blues and browns occur within a few square inches, flicked in with an agile brush. The eye is led a cheerful dance over these complex areas. Like Roberts, Streeton used a square brush, but more aggressively, whether slashing in one face of a rock with one stroke or cutting the fine line of a twig with its edge. And thus he seemed more concerned with form itself than the play of light. Consequently the surfaces of his early paintings seldom looked smooth or licked.

Streeton enjoyed paint, its tactility, its sensuous variations be-tween a dry dragged scumble and a fat, glistening slab. Its oiliness, thickness, and shape under the brush were its personality as a sub-stance; for this reason, irritated by his limited skill as a draughtsman,

Streeton never handled watercolour well – compare *'Fire's On!'* *Lapstone Tunnel* with the mousy little watercolour version of it, both in the Art Gallery of New South Wales. Roberts and Streeton thus foreshadowed one major aspect of Australian art, its *malerisch* sensuality.

Streeton's finest work came between 1888 and 1896. It included the small sketches on panel in the 9 x 5 show; his very beautiful study, *Redfern Station* [20], done in 1893 after his move to Sydney;

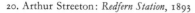

20. Arthur Streeton: *Redfern Station*, 1893

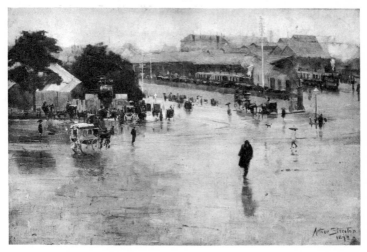

and isolated major works like *Still Glides the Stream* (1889), painted at Heidelberg, *'Fire's On!' Lapstone Tunnel*, *The Gloucester Buckets*, 1894, his numerous studies of waves and light on Sydney Harbour which culminated in 1895 with the large *Cremorne Pastoral*, and *The Purple Noon's Transparent Might*, 1896.

Of his large landscapes, *'Fire's On!' Lapstone Tunnel* [21] is arguably the best. In a railway excavation near Lapstone in the Blue Mountain foothills, a chance explosion killed a labourer. Streeton was there at the time, and wrote to Roberts about the pathos of the incident as the body, on a crude litter, was carried past him from the dark mouth of the excavation. There is no doubt that it set off in his mind a complex image of contrast between the deep gash in the hill, the looming gums erect on the hot ridge above, and the ant-like men scrambling below – depending, ultimately, on the same kind of

21. Arthur Streeton: *'Fire's On!' Lapstone Tunnel,* 1891

dramatic clash between men and their environment that animated Roberts and McCubbin.

The Purple Noon's Transparent Might was, despite its popularity – J. S. MacDonald, with Lionel Lindsay the second pillar of the critical establishment throughout the twenties and thirties, called it 'a work of genius' – the beginning of Streeton's end.

It is a bravura piece, no more: the illusionism is polished but slightly vacuous, the colour brittle and metallic, and the poetic quality of his earlier work is absent. These faults afflicted many of his Hawkesbury landscapes, and in 1898 he went to England and adjusted himself to the more diffuse light of Kent. But his vision weakened, away from an unhumanized landscape. Besides, he achieved little success over there; and he returned to Australia in 1907 determined (like some later artists) to cash in on a self-exaggerated overseas reputation and on his status as a Grand Middle-Aged Man. His Melbourne show was a *succès fou*. He even contemplated, later, writing a history of Australian art, designed, as he menacingly put it, 'to put everyone in his proper place'. His popularity snowballed; later he was made a war artist; when he came back again in 1920 and reverted to landscape work, hardly one painting until his death in 1943 shows the least trace of imagination. Like a hibernating bear, he lived on the fat of his early discoveries.

In the meantime he became a national institution; to attack him was unthinkable, especially since, from 1929 to 1943, he was an art critic himself. Lionel Lindsay, in 1919, placed him above the French Impressionists:

Streeton never succumbed to that worship of fact which, in the scientific impressionist, destroyed the passion of the creator and made him a mere transcriber of colour sensation. The French Impressionists were pure archivists of nature, they would document her from dawn till set of sun, with the same passionless energy – high priests of impersonality, we sense in their products the daily task, not the labour of joy...

Ratbaggery; but symptomatic. Yet Lindsay was among the few local connoisseurs who had been abroad and had the chance to see the paintings he spoke of. Presumably, then, his bland dismissal of Monet, Renoir, and Seurat was possible because, hotfoot after Velazquez, he never looked at their work, and nationalist insularity helped prevent him from weighing Streeton accurately against them. This helps explain his failure to discern, in Streeton's war-time work like *The French Siege Gun* and *Boulogne*, the dreary fog which turned him into a dilute Orpen.

By 1930 Professor Hancock was able to say quite truthfully that

'The painting of Arthur Streeton has become a national habit'; and a year later J.S.MacDonald clambered unparalleled heights of chauvinism with:

> If we so choose we can yet be the elect of the world, the last of the pastoralists, the thoroughbred Aryans in all their nobility,

and:

> Finally, it is the national chord that Streeton has struck which will be of value to us...for long it and its overtones will vibrate in our national being. For we are not only a nation, but a race, and both occupy a particular territory and spring from a specific soil. The racial expression of others will not be ours, nor the methods of interpreting their own country and folk. We will be mainly contented only with our own imagery expressed in our own independent-minded sons, and of these, in landscape, Streeton is the protagonist.

Despite these extravagances, the Heidelberg painters were basically disciples of 'natural vision': the unpretentious look at familiar things one associates with the landscapists of the nineteenth century, Corot, Constable, Daubigny. Roberts had praised the simplicity of Buvelot's subject-matter: 'Incidents by country roadsides, weather-worn farm houses, fields in which men are working, fences and wayward gum-trees, the effects of sunlight on a tree or shadow in a forest glade.' The closest adherent to this kind of subject-matter was Frederick McCubbin, who said that 'It is precisely the picture of things most familiar to us, of homely subjects...which most appeal to us.'

After Roberts's breadth and inventiveness, and Streeton's lightning wrist, McCubbin might seem a somewhat dull figure: the sentimental uncle of the Heidelberg School, cloaking his Victorian anecdotage in suggestive mists of paint. This is not fair; his position in the rise of an indigenous landscape idiom cannot be denied. It suffered in the swing from romanticism to 'hard' drawing which was precipitated by Streeton and Lambert at the beginning of the twenties; McCubbin's hazes and stippled treescapes were flung away in a search for precise contour, and they have not wholly recovered since. McCubbin was undoubtedly the indirect precursor of the atmospheric painters of the early twentieth century, Hilder and, more remotely, Gruner; he tentatively defined that romantic mood, the melancholy of the bush.

McCubbin could cantilever his imagination from a very small base of experience. Born in Melbourne in 1855, he rarely moved away from it; there was a visit to Tasmania, and in 1906, late in life, he took a trip to England. This was an important event for him; the

Turners he saw appear to have influenced the later Macedon land-
scapes. But most of his life was spent within a radius of a few miles
about the city; he moved to Macedon, in Victoria, in 1902. None the
less, frontier life was his favourite early subject, though one suspects
that the bush heroes in some of his anecdotal pictures were only an
excuse for painting gumleaves and wildflowers. By the nineties, this
legendary breed of men *was* a legend, real only in McCubbin's (and
Roberts's) imagination. And so he was not observing heroes, but
creating heroic types that neatly fitted a popular new belief in
Australian nationhood.

I have already indicated the link between bush historicism and
nationalist sentiment in Roberts's work. No doubt it was accelerated
by the centenary celebrations of 1888: a hundred years, Australians
felt, was too long for colonialism to linger. Whatever the catalysts,
McCubbin seems to have produced no historical subject-paintings
before 1889, though he was established by then, and had been made
drawing-master at the National Gallery School three years before. In
that year, however, he painted *Down on His Luck* [22], an impoverish-
ed swaggie making tea in the bush; in 1890, *Bush Burial*; in 1896, *The
Wallaby Track*. These all praised sweaty and steadfast virtues; his
admiration for mateship had ballooned into a near-religious mystique

22. Frederick McCubbin: *Down on His Luck*, 1889

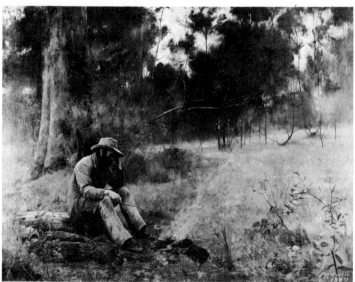

by 1905, when he painted *The Pioneers* in the manner of an altar triptych, showing the hard life, struggle, resourcefulness, achievement and death of the early settlers, and even supplying a vision of the future in the last panel.

McCubbin's presentation is more overtly sentimental than Roberts's, and a good deal more obviously nationalistic. McCubbin, when it came to human values, was able to be neither oblique nor subtle, and the morasses of late-Victorian English genre contain few scenes of more toffee-like bathos than the little boy in McCubbin's *Lost*.

But he was a Janus; his sentimentality and early fondness for ir-relevant detail faced back to the English academies, but his rendition of light and atmosphere came, in its limited way, closer to real impressionism than either Streeton's or Roberts's. He dissolved form in a tapestry of all-over light effects. Significantly, he did not use the square brush, which defined planes. His surfaces are crusts of juxta-posed dabs and dots, overlapping, overpainted, and generally close-toned: greens, grey-greens, browns and so on. Light is caught and evenly diffused in a world of soft edges. He had, therefore, the basis of a divisionist technique, without the brilliant and vivacious colour of the French. But in his Macedon landscapes of the 1900s, he heightened his colour; the pinks and blues and lime-greens, touched by autumn sunlight, were often very sweet. The impression his late work gives is of a humble soul, not very imaginative, distilling several pure drops of lyricism from a very close contact with nature; a painter of man's kinship with the earth, and thus a Millet in little.

A more promising, but less robust talent was lost to Australian art when Charles Conder left for England in 1890. He went home, at twenty-one, because Australia could not give him a living; Europe did. In the nineteen years until his premature death at Virginia Water in 1909, Conder cut a prominent figure among the European aesthetes. He was one of the select few friends allowed to visit Oscar Wilde in prison after his disastrous homosexuality conviction. To see Wilde, Conder brought his close friend Toulouse-Lautrec; on his London visits, the dwarfish genius depended on Conder for company, for they had known each other well in Paris before. Lautrec had put Conder's pale profile in several studies of the Moulin Rouge, and it stares from the foreground of his theatrical lithograph, *La Loge au Mascaron Doré*. Max Beerbohm caricatured him, all blunt chin and lank thatch of blond hair; Whistler and Rothenstein painted him; his dealer, Carfax, was one of the leaders of the London market.

In fact, Conder was bound in the very fabric of the *belle époque*. On 11 December 1896, Albert Jarry's explosive and scatological

play *Ubu Roi* opened at the Théâtre de l'Œuvre in Paris. In the whistling audience was a young Irishman, William Butler Yeats. He later wrote:

Feeling bound to support the most spirited party, we have shouted for the play, but that night at the Hotel Corneille I am very sad, for comedy, objectivity, has displayed its growing power once more. I say, after S. Mallarmé, after Verlaine, after G. Moreau, after Puvis de Chavannes, after our own verse, after the faint mixed tints of Conder, what more is possible ? After us the Savage God.

Conder's watercolours on silk fans, his pale ethereal ladies, his elegiac trees through which light sifted down on Watteau-like *fêtes galantes*, were soon to be left behind like wilted flowers after the party, in the swing from aestheticism which swept European thought and art. Today, the art of Conder's English years is remote from us. It is charming, delicate, and very mannered. His girls repose in graceful postures on the grass, fairy-like to the point of depersonalization: which is odd, for Conder was a voracious womanizer in Australia, and evidently insatiable in France. ('I'm afraid his flesh is against him a bit – poor old Conder and the girls,' wrote Tom Roberts, no saint himself.) Sealed in a perfumed conservatory, Conder's English work was altogether minor; which cannot be said of his whole Australian output.

Arriving in New South Wales in 1884, Conder was apprenticed as a surveyor to the Lands Department and spent two months in the bush. This apparently set off his interest in landscape; he began drawing; in 1887 he joined the artists' room at the *Illustrated Sydney News* and went on to night classes at the Art Society's school, then dominated by Julian Ashton. And so it is not surprising that Conder's first known oil, *Jamberoo Stockyard*, 1886, markedly resembles Ashton's earlier *Merri Creek*.

Like Streeton, Conder first heard about impressionism from Roberts. This is said to have happened in a Sydney wine-bar in 1888. Conder at once applied the theory of Whistlerian tonal impressionism to his own work; but he gave it a slightly formalized, decorative bias that Roberts's work never showed, so that he became a stylist virtually from the outset of his career. Two studies of Coogee Beach exist, one by Conder and the other by Roberts, painted from the same spot and probably on the same day in 1888. Roberts's panel is an accurate transcription of the scene, with little effort to re-order it: a precisely caught impression. But Conder's is more formalized, and consciously designed. The figures on the beach are carefully grouped, the recession of the headlands less pronounced and the plane of the

picture consequently flatter; there is a slight but distinct attempt to impose a decorative scheme on the colour.

Conder's interest in design is clearer in another painting of 1888, *The Departure of the S.S.* Orient [23]. The liner's sailing becomes a pretext for a lyrical investigation of harbour light and rain. Conder's

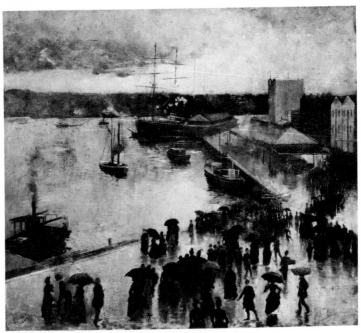

23. Charles Conder: *The Departure of the S.S.* Orient, 1888

fastidious handling of tone and colour, from grey to green and brown, with transparent crimson shadows and bright flecks of red and blue, recalls Whistler. Figures on the wharf, sheltering under umbrellas, dot out the formal focus-points of the space. They stand in carefully ordained groups, as consciously arranged as one of Whistler's beloved Japanese woodcuts.

It may be compared with an earlier painting by another Sydney resident. This was *The Voyagers*, by Girolamo Nerli. A *marchese* from an old Tuscan line, Nerli had come to Sydney in 1885, in command of the general methods of tonal impressionism and an advocate, like Ashton, of *plein air* painting. His work had some influence there in the eighties, and its finesse and lightness of touch helped compensate

24. Charles Conder:
How We Lost Poor Flossie, 1888

for the rather mediocre vision behind it. *The Voyagers* perhaps anticipates Conder's approach to sea-rain colours and light, and thus critics have laid emphasis on Conder's presumed debt to Nerli. 'From [Nerli],' Rothenstein wrote, 'Conder got the low rich tones and fresh and careful finish typical of his early Australian work.' Perhaps he did, but by 1888 Conder was in more refined control of tonal impressionism than Nerli, though both shared favourite devices – one of them, a single figure silhouetted in the grey mist of a city street, may be found in Conder's *How We Lost Poor Flossie*, 1888 [24]. (Flossie, incidentally, was not one of Conder's women; she was a pet dog.) *The Voyagers* is an attractive, not fully realized exercise; *The Departure of the S.S. Orient* [23] is a final statement, formidably sophisticated for a painter of nineteen.

In 1888, Conder also worked at Richmond, a village thirty miles from Sydney. He made numerous studies of orchards in bloom, sparkling froths of white and pink. He and his friends picnicked pleasantly there, 'making love in the usual way' with the farmers' daughters; a cow, which chased them and ate one of the girls' books, provided him with one of his few subject-paintings, *An Early Taste for Literature*. This light-heartedness could not have happened in the subject-paintings of Roberts or McCubbin. It stemmed from an idyllic, *dolce fa' niente* mood, which Conder carried south with him to Heidelberg in October that year; the parties at the artists' camp there put him in his element. Conder embraced the sceptical hedonism of the *Rubá'iyát of Omar Khayyám*, and was simply incapable of nationalist idealism. He had been born an Englishman, after all; what did all this fuss about the heroic past matter? And of what interest were a gaggle of horny drovers when you compared them to a sunny afternoon at Heidelberg, with a girl on the grass and a bottle of Kaludah hock cooling in the creek? Sometimes he came beneath Streeton's spell (*Under a Southern Sun*, with a harsh blue sky, a logger's tent and the bleached bole of a tree, is not unlike an early Streeton) but his best Melbourne work is cultivated and urbane. In *A Holiday at Mentone* we are on a beach, where elegant ladies and gentlemen stand about, carefully composed in space; a pier runs across the picture, and on a board at the end of it is seen the half-notice MENT. On the whole, a Boudin atmosphere, festive and civilized.

Conder's ideas on art and life were fertile ground for aestheticism, but his conversion seems to have happened when he was still in Australia and not, as is usually thought, after he encountered the Café Royal circle. It was induced by a friend, a now forgotten but then popular novelist named Mrs Kathleen Mannington Caffyn. Mrs Caffyn's oblivion is merciful; her characters dash about like

pasteboard silhouettes in a gale. But her main theme was the revolt and emancipation of Woman, a melodrama which, mingled with frequent references to the Sphinx – a habit of nineties literature which Mrs Caffyn doubtless caught from Wilde – intrigued Conder. He spent many evenings at the Caffyn home and, in 1889, painted *The Hot Wind*: a half-nude woman in Egyptian costume, lying in the middle of a sandy outback plain. She blows on a small brazier, watched by a large snake, and the fumes stream out across the desert, thus indicating how the Westerly begins. This painting no longer survives; it was presumably destroyed in England after the Royal Academy rejected it from Burlington House in 1891. A photograph exists. Plainly, however, Conder linked up with two parallel tendencies at the moment of his departure: the Aesthetic Movement in Europe, and the allegorical aestheticism practised in Australian art by Sydney Long and others during the nineties, and in literature by such bards as Adam Lindsay Gordon.

And so, at the break-up of the three-year Heidelberg School, its latent energy took three directions. The first, and the least important, was towards *art nouveau*. The soft-edged landscape reveries of McCubbin led to the 'poetic' approach of the romantic landscapists; and Streeton's dominant influence merged into a hard-edged nationalist convention.

[3] Landscape, with Various Figures

No painter is 'objective', though many think they are; and Streeton and Roberts were only objective painters in the sense that they caught their fleeting impressions as accurately as they could. Truth to observation was their first aim. Much has been made of the difference between them and the poetic impressionists who worked in Melbourne in the nineties – Walter Withers, John Ford Paterson and especially David Davies.

The gap between the two is not as wide as it seems. I have shown how the Smike–Bulldog letters reveal both Streeton's romantic awe at the unhumanized grandeur of Australian landscape and Roberts's interest in the 'typical' colonial hero-subject. To a traceable extent, both painters were romantics; but Davies, Withers and Paterson were romantics of a more familiar kind, and their work belongs to the final dilution of romantic curiosity about nature into a fondness for twilight and poesie which happened at the end of the nineteenth century.

They selected one aspect of nature and typified it as the image of 'sublime' emotion. Davies's place in Australian painting can easily be exaggerated, but his importance relies on one fact, that he was the first native-born artist to use landscape itself as the physical form of a human emotion: in his hands, the landscape turned into a metaphor of the psyche. Davies's contemporaries dimly realized this. Here is a local critic, J. S. MacDonald, in a booklet on Davies published around 1918:

[Davies's] pictures are always beautiful in themselves, but more than their actual beauty is the beauty that lies in their significance, for they hint of imperishable things.

In fact, Davies's art was central to the growth of a view of nature now common to a good deal of Australian painting: animism. During the nineties, artists constantly speculated on what made up the 'soul' of landscape. What spiritual quality made the Australian bush unlike the Black Forest or the Okefenokee Swamp? To say that the difference was one of vegetation, animals and climate was a little coarse for the poets. Instead, they supposed it lay in an

immaterial spirit, an allegorized essence of place which could take physical form. The origins of this idea are too well known to need discussing here: the dark woods of Europe were always peopled by monsters, the glades by nymphs, and when the Australians began to see wood-sprites bounding coltishly among the eucalypts they were only responding to a favourite tic of late nineteenth-century European art and poetry.

We have already met this conceit in Conder's painting of the spirit of the desert, *The Hot Wind*. Sydney Long's *art-nouveau* paintings will show more of it. The idea of a landscape's soul is – I need hardly say – meaningless. Its nearest equivalent would be an emotional extension of Aquinas's hoary distinction between essence and 'attributes'; the bush had a 'bushness' in which attributes like grass and trees inhered like so many pins in a cushion. Nature ceased to be a collective term for natural phenomena. It was personified, acquiring a capital N, feminine gender, and a personality to match.

Artists and writers of the nineties generally agreed that the soul of the bush was melancholic. This Marcus Clarke believed; so did Adam Lindsay Gordon, Kendall, Lawson, Barcroft Boake and other rural poets. They projected their own feelings into nature and endowed it with animistic overtones. In his way, Boake was a martyr to his own poetic theory. Having written a book of lolloping verses like

> Out on the sands of the Never-Never,
> That's where the dead men lie!
> Out where the heat-waves dance forever,
> That's where the dead men lie!
> Out where the Earth's loved sons are keeping
> Endless tryst; nor the West Wind sweeping
> Feverish pinions can wake their sleeping,
> Out where the dead men lie!

he suited the action to the verse and hanged himself from a tea-tree, with a stock-whip.

This sense of identity between man's moods and Nature's filtered (though not in its literary concentration) into David Davies's paintings. He was more of a poeticist than Streeton or Roberts, who usually confronted their landscape in the full midday glare. Davies preferred the elusive hour of twilight, with the rising moon and the shadows blurring the details of tree and rock into an evocative haze – one step further from the light-diffused forms of McCubbin.

During the four years he worked in Melbourne – between 1893, when he returned from Julian's Academy in Paris, and 1897, when

he left again for London – Davies contributed to the emergent idiom of Australian landscape a lyrical quality it never had before, and, except briefly in Gruner's hands, never regained. His low-pitched colours were subtle: misty greys, green and brown, a sky full of dying light, moons throbbing with whiteness. His close-packed, stippled paint recorded light rather than structure. It may be that this even pelt of pigment, its richness undifferentiated across the canvas, was a legacy from the impressionists, whose work he could hardly have missed seeing in Paris. The crepuscular mood is Whistler's. But despite its laden atmospherics Davies's best work – whether seascapes, or such canvases as *Moonrise, Templestowe*, 1894 [25] – never lost its grip on form. This was noted by Lionel Lindsay:

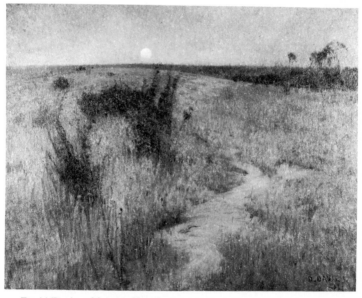

25. David Davies: *Moonrise, Templestowe*, 1894

'...what is so wonderful about *Moonrise* is the solidity of the earth under the receding light, when all shapes take on the mystery of the indefinite.' Like the later landscapes of Lloyd Rees, Davies's *crépuscules* make one aware of the earth's basic curve.

In a much smaller way, John Ford Paterson and Walter Withers shared Davies's lyrical quality. Paterson, however, lacked his intimate relationship with his subject. Withers was an inferior draughtsman who preferred not to take risks with atmosphere.

He was born in Staffordshire in 1854; he emigrated to Melbourne in 1882, farmed for three months, failed at it, settled in the city, and painted in his spare time while working as a commercial artist. In 1887 he left for England and Paris. In Paris, he met Emanuel Phillips Fox and Tudor St George Tucker, Australian students at Julian's Academy. Next year found him back in Australia, on friendly terms with Roberts, Streeton and Conder, and painting with them near Eaglemont.

He knew very little about French Impressionism, but his association with Streeton was close. Naturally, then, he leant more towards Streeton's approach to form than to the chromatic techniques of Davies or Phillips Fox. In any case, Davies did not arrive in Australia until Withers was well established: in 1893, the year of Davies's return, Withers was already teaching art at Creswick, with Norman and Percy Lindsay in his class. Except for occasional misty light-effects, glooms, and a general lack of precision, Withers's work is close to the Heidelberg School: witness his delightful *Tranquil Winter*, 1895 [26].

He died in 1914. Paterson's small star was waning by the end of the nineties. Davies, after going to London, dropped out of sight. And so romantic landscape in Australia was suspended until Hilder and Gruner, between 1907 and 1914, revived it. But Sydney Long is part of the nineties, and it was he who gave the 'soul' of the bush bodily form by turning the place into an *art-nouveau* Arcadia populated by

26. Walter Withers: *Tranquil Winter*, 1895

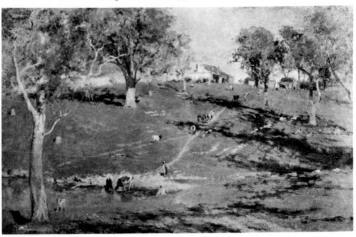

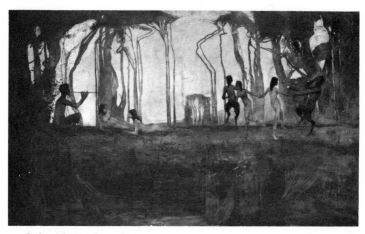

27. Sydney Long: *Pan*, 1898

nymphs and satyrs [27]. Like Davies, he drew sustenance from the prevalent idea of the melancholy bush, but unlike him he took the poets' mythological extensions of its 'personality' at face value. (Sydney Long was painting at much the same time as Davies, from 1893 to 1902.) Long's use of figures in landscape must be distinguished both from the heroic types of McCubbin and Roberts, and from the 'fatal woman' of Conder's *Hot Wind*. The Heidelberg painters' heroic figure became an effective image through conflict with its bush environment. But Long's naked, translucent nymphs – like adolescent swimmers with Pan-pipes – were, to him, a natural outgrowth of the bush, an extension of its soul. No conflict is implied. Conder's desert-woman is an image of *art-nouveau* evil; Long's sprites are naked and unsuspecting, as shy as trout. *By Tranquil Waters*, 1894, presents them laconically, as if their appearance by the waterhole were the most natural thing in the world. Anything in Nature was permissible if it imitated Art. *Decoration*, 1899, records Long's response to *art nouveau*: very formalized, it depicts a standing woman, her head bowed and the moon directly behind it; leaves and rushes, erect in ribbony lines, are effective decorative motifs; the verticality of the pose is exaggerated, and the general emphasis on organized line recalls Beardsley and Mucha. Its first title, possibly the longest ever given to an Australian picture, shows the poetical intent clearly enough: *Sadder than a Single Star that Sets at Twilight in a Vale of Leaves*. His most famous oil, *Pan*, 1898 [27], is pure *art nouveau*. Gums in the background are formalized

into rhythmic, sinuous convolutions; the foggy and mysterious colour works in a flat space, and the painting is a decorative frieze in two dimensions. On such work, Long has no claim to be a major painter, but he was a pure symptom of his times. Never did the influence of the *Yellow Book* and the *Studio* produce a more complete eclectic response than Long's. When he moved to England in 1910, however, he lost interest in *art nouveau*: and after his return to Sydney in 1920 his graphic work remained locally influential, and he became an accomplished topographical etcher.

From 1907 to 1910 Long taught in partnership with his friend Julian Ashton in Sydney. Thus he had some influence on the young watercolourist, J. J. Hilder.

Jesse Jewhurst Hilder was born in Queensland in 1881. Working for a bank, he moved to Sydney in 1904, settled in the suburb of Cremorne, and by 1906 was enrolled in Ashton's painting school. (Afraid that the bank would frown on his after-hours painting, he signed his student work 'Joyce' and 'Hood'.) He admired Long's paintings; the critic Bertram Stevens observed that Long's treatment of foliage, in flat masses with stylized contours, greatly impressed Hilder when he saw it in the Art Gallery of New South Wales. He also liked the watercolours of an Englishman named R. W. Allan, Streeton's *Australia Felix* and *'Fire's On!' Lapstone Tunnel* [21], and some mermaids by a now forgotten watercolourist, Tristram. 'There is an air of mystery about [Tristram and Long] which fascinated him,' wrote Stevens, and Long's flat shapes are echoed, more subtly, in Hilder's big areas of vibrating colour.

Hilder's achievement as a watercolourist has to be seen against what was, in his day, a total lack of any watercolour tradition in Australian art. The medium was thought to be oilpaint's poor relation, and a critic in 1919 claimed that Hilder had never seen a good watercolour by anyone else. (This may have been an exaggeration. He could hardly have missed Conrad Martens.) Certainly he saw none that fully exploited the medium. Hilder was the first Australian to take complete advantage of its diffusion, bloom and transparency. Like Turner, he began with light and worked through to the forms it enveloped. The shapes of trees and hills were only interruptions in a flow of energy; the pulsation of light dissolved the sharp edges of things, the evening shadows blurred them in a haze [28]. With his intense blues, vaporous greys, sulphurs and reds working in collusion, Hilder was a finer colourist than any Heidelberg painter except Conder, and more expressive and wider in range than Davies. But despite his taste and facility, he often sank to meretricious bravado. And because his vision was very simple and unsupported by much

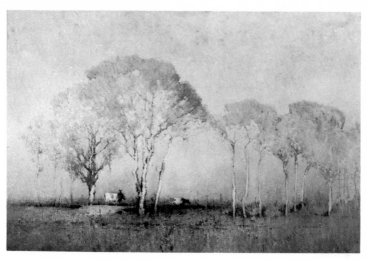

28. J. J. Hilder: *The Dry Lagoon*, 1911

intelligence, a lot of the purity of his response to nature evaporated before his early death in 1916.

Blamire Young, now all but forgotten, was equally esteemed as a decorative watercolourist. But he was a trivial figure, a greenery-yallery, Grosvenor Gallery painter, self-conscious in the extreme. Ashton prized Young's work in contrast to 'our sweating realists', referred to his 'infallible sense of design' (?) and noted that, with Hilder, Young was 'proving a powerful influence upon the water-colourists of the Commonwealth, an influence which will be valuable as it deepens and becomes more individual.' Young's design, which tended to break down into superficial techniques like a mania for irrelevant silhouettes, may have come from his early work with the Beggarstaff Brothers, an English firm of poster-makers. The Beggar-staffs were the first graphics firm to apply the design lessons of French lithographic posters, with their broad masses of colour and their Japanese influence, to English design.

The social conditions that helped set off English aestheticism also existed in Australia, and the work of Young, Long and Norman Lindsay must be seen against them. In the nineties, sentimental realism in all its most stickily pietistic forms was the norm. There were monumental costume-pieces, like Sir E. J. Poynter's *Solomon and Sheba*; patriotic tracts (*The Defence of Rorke's Drift*, in the Art Gallery of New South Wales, was the most popular of a number of

such paintings of pouter-chested dragoons mowing down cohorts of Kaffirs, Chinese or Indians); and, for those who liked their lusts respectably catered for, felons being justly flogged, Luminais's amputated Sons of Clovis being cast adrift, and husbands discovering their unfaithful wives. As late as 1949, Sir Kenneth Clark, on a visit to Australia, is supposed to have remarked that that the galleries had the worst paintings but the best Victorian pornography anywhere in the world. 'One of the most richly endowed galleries in the world,' cried a critic of the National Gallery of Victoria in 1922,

> that, with an annual bequest of seven thousand pounds, might gradually accumulate a collection of the world's greatest masters – Rembrandts, Goyas, Whistlers, Chardins, Millets, Manets – yet invests in the latest vogue from abroad or at home, some subject-picture from the Royal Academy.... A Gallery of Art! That at one time refused an offer of several replicas of Rodin's work at an extraordinarily low price, and then pays £1,000 for a conventional nude statue called Daphne, whose author was evidently determined to make it as indecent as possible by making it as unlike flesh as possible...

These were the English aesthete's very plaints against the tastes of his own officialdom. And so, much as its products owed to Europe, Australian aestheticism grew out of the same social compulsions as its overseas counterpart. No sane relationship between art and society existed in Australia in the nineties; art had become, in its received forms, a pompous instrument of bourgeois philistinism.

But the Australian aesthetes had no Wilde, and none of them could boast Whistler's impudent flair for polemic – let alone his gifts as a painter. They were inarticulate in public. So the butterfly grew teeth, but withdrew. 'Genius' was rejected; so the lot of genius was to starve; naturally, then, rejection was the indelible mark, even the proof, of genius. The artists' clubs that flourished in Melbourne during the nineties brought out the continentalism of the Aesthetic Movement, coupled with the values and sentimentalism of Murger, as a shield against rejection. 'I'm not fired,' the artists snapped, 'I resign.' They gathered for their shilling-all-in dinners at Fasoli's, drank, quarrelled, tearfully made up, painted, seduced laundresses, idealized the torpid barmaids of Collins Street, died resolutely of consumption, and in general lived out an antipodean replica of *la vie bohémienne*. 'To accuse an artist of painting pictures which the public really buys during his lifetime is to place an ineradicable blot on his escutcheon.' So said one writer on Hilder.

This meant rejecting realism. The Bohemians had no time for the Heidelberg School, because they distrusted the idea of *Australian*

painting as provincial and stupid. As a by-product of internationalism and those nymphs and satyrs, some artists became convinced that an Australian Renaissance was going to take place – in the full sense of the word: a return to the modes and forms of Graeco-Roman antiquity. Magically, their smocks and billycock hats were to be transfigured into Petronian togas and bay-wreaths. 'This is the last country on earth where paganism can flourish naturally,' one of them proclaimed.

And so the next phase of the eclectic adventure opened: a period of vitalist aestheticism, led by Norman Lindsay. Lindsay has some claim to be the most forceful personality the arts in Australia have ever seen. His energy was immense, and he scattered it across a wide field: painting, drawing, watercolour, etching; art criticism, polemics, philosophy; illustration and political cartooning; novels, occasional bursts of poetry, and writing for children. He even made model ships and cast-concrete fauns. It seemed that, wherever the Australian Renaissance was heading, a real *uomo universale* was leading it there.

Never was more fuss attached to a sprint up a blind alley. Lindsay's philosophy was a reworking of Nietzschean vitalism, to which bits of Rabelais, Boccaccio and Petronius had stuck like fluff on a comb. He believed, basically, in an élite of vision: the great artist was a superman, subject to no external compulsions, spurned by the society around him but, by sheer dynamism, bending its hostile will to his own. His actions revealed Life-Force, whose main impulse and ingredient was Sex. (The capitals are Lindsay's; he was fond of them.) Each great work of art was therefore a direct expression of sexuality.

As one might expect in a man capable of living by such a naïve theory, Lindsay was a figure of violent commitments and antipathies. He detested Sigmund Freud (for wallowing in the unclean depth of the subconscious; Lindsay's demons were always healthy), Samuel Butler (for his political views, and for criticizing Beethoven), George Bernard Shaw (for criticizing Shakespeare), and every kind of modern art. He also hated Christianity, which restricted the eruption of Life-Force.

A small man, throbbing with nervous energy, passionately honest, bird-like in looks, he worked with enormous intensity and had a gift for swaying others with conversation whose brilliance was, after the flat discourse of the art schools, mesmeric. But to the honest Australian burghers, this whooping adolescent was Satan incarnate. They reviled him as a pornographer, a perverter of the young and a diabolist. This in turn gave the growing herd of

Lindsayites, like the poet Douglas Stewart, one of their most often-used weapons. To criticize Lindsay meant that you were a 'wowser', a puritan enemy of art and its freedoms. Artist-critics were even more easily got rid of. Plainly, they must envy Lindsay's genius. Such was Sir William Orpen's fate when, in 1923, he unwarily said of an exhibition of Australian art in London:

> The serious intent of the new Australian school is greatly marred by the work of one man – Norman Lindsay. I understand there has been much talk in Australia about whether his work is indecent or not. Why anyone ever took any interest in Lindsay's work is beyond my comprehension. His works which are shown here are certainly vulgar, but not in the least indecent. They are extremely badly drawn, and show no sense of design and a total lack of imagination.

Orpen's most accurate charge was that Lindsay's art was vulgar but morally harmless. His creations are anything but diabolical and I doubt if they have promoted anything beyond a little masturbation; it would be hard to find anyone whom they have morally corrupted – whatever that phrase may be taken to mean. Nor did Lindsay's style affect younger painters, since the basis of his mystique was his inimitability. But Lindsayism did have disastrous effects on Australian poets in the twenties, reducing talents as diverse as McCrae's, O'Dowd's, Gellert's and Slessor's to vitalist bumbling about nymphs and shepherds.

Except in isolated cases, Lindsay's imagery is too naïve to bear comparison with the mannered but very real sense of romantic evil which the pale horrid Liliths drawn by his nearest English equivalent, Beardsley, exhale. Lindsay's melon-breasted, ham-thighed Play-mates are wholesome and dated. Their eroticism is depersonalized and cow-like; the very embodiments of adolescent sexual fantasy as it was in the days before teenagers were allowed to go to bed together, they smirk and pout and wiggle their elephantine buttocks [29] but never become human; they are no more than the furniture of an escapist, a provincial rococo day-dream. Lindsay lived in a pantomime world of cavaliers, troubadours, Greek gods, courtiers, imps, panthers and magi; his art was a costume party.

Bernard Smith, in 1945, noted the quasi-rococo basis of Lindsay's ideas in *Place, Taste and Tradition*. A passage from one of Lindsay's writings, *Man and Hyperborea*, runs:

> Newspapers, blowflies, spiders, and political illusions disappear in Hyperborea. You catch the hum of bees, of the wind muffled by leaves, the tinkling plumes of a fountain. Or perhaps, down a long avenue, you may see a white peacock, or Sir Pertinax Pincushion leading the Lady Delicia Majolica under a pink sunshade....Paths are designed only in

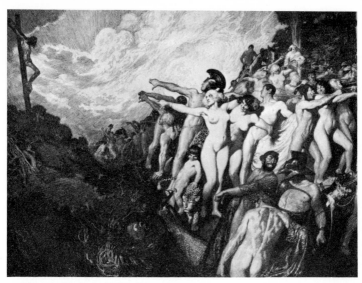

29. Norman Lindsay: *Pollice Verso*, 1904

places where it is felt essential to have people walking on them, and where it is felt desirable to centralize a vista there is always a fountain or a pergola, about which to group your figures. Whenever it is necessary to break a line, or fill a space, or decorate some otherwise bald portion of a prospect, an urn or a statue sprout in the spot instantly.

'Every detail in this description,' Smith commented, 'is pure rococo. The passage is an idealization of late feudal patronage during the period of the Enlightened Despots. It belongs in spirit to the pseudo-pastoralism of Marie Antoinette, and the vistas of Versailles.' Lindsay is the star example of a problem which is peculiar to isolated cultures like Australia's. He had no sense of history whatever but he disliked and distrusted the present. Therefore he tried to flee backwards into an illusory past whose true nature he could not and would not comprehend. He suffered, to an appalling degree, from provincialism in time as well as in space. And so he became a sort of Peter Pan, the adolescent who never grew up, living in a make-believe world of periwigs, shipwrecks and garden gnomes and issuing challenges to Picasso in Sydney newspapers.

But his art was very popular; and for good reasons. First, it was an efficient and genteel mode of libido-release for the middle-aged. Second, its technical excellence was much admired. He handled oils

badly, but no Australian surpassed his technique as an etcher; he
manipulated watercolour with dash, and his pen drawings were
spectacular, if sometimes congested with detail. He had no eye for
form and little capacity for expressive design, but neither of these
deficiencies affected the third reason, which was the most important
of all, though often ignored. Lindsay's art was a tradition-substitute.
The Australian public had little contact with past European art,
because the State galleries had not bought Old Masters when their
works were relatively cheap, and could not buy them later on their
small grants. Many local artists, as we shall see in the next chapter,
studied abroad. Therefore isolation was not complete, though their
attention was given over to a small group of painters, especially
Velazquez. But Lambert, Bunny, Phillips Fox and others reapplied
their overseas gleanings to a contemporary situation, thus leaving
Australia's thirst for a sanctified past unslaked. Thus it came about
that Lindsay, by using not only the illusionist techniques but even
the actual subjects – down to period dress – that were thought part
and parcel of 'real' European tradition, satisfied the widespread
desire for a past, *any* past that could dispel the terrors of provincialism.

Elioth Gruner was in the Lindsay circle. He figures prominently
in Jack Lindsay's memoir of the period, *The Roaring Twenties*. But
there is nothing of vitalism in his work. Though more important
than Hilder's, it is more conservative. Gruner stood to animistic
landscape as Withers did: his landscapes were often projections of
mood, but his method was superficially impressionist, and any
theory of bush myth was foreign to him. Nor does he suggest
Davies's intense concentration of mood. Gruner's spirit was one of
inquiry into the effects of light on a landscape whose physical
structure had already been articulated by Streeton. He was no
inventor, and his conventions were fixed by others; his analysis of
light, for instance, went along lines exhaustively explored, and
transcended, by the French Impressionists fifty years before. He
would have seen Phillips Fox's work, with its impressionist
influences, and acquired a mild divisionist technique from that. But
his best work came when, all around him, the idiom of pastoral land-
scape had broken down into an academic system. So Gruner may
look better than he really was.

For Gruner first exhibited in 1913. Conder was dead, Hilder had
three years to live, Streeton's best work was seventeen years past,
and Roberts was in Europe. Hans Heysen's popularity was climbing
but his work was descending into the rut which it occupied from
1920 onwards. Consequently Gruner may be regarded as the last
painter who brought any trace of creativity to the Australian con-

vention of open-air landscape painting. After his trip to Europe in 1923 Gruner's work evolved, very tentatively and timidly, towards post-impressionism; but all the impressionists of that time were so dim and timid that Gruner may at least be seen as a landmark in the conflict between 'soft' and 'hard' academic impressionism.

He was born in Gisborne, New Zealand, into a poor working family. In 1883, aged one, he was brought to Australia. He grew up a prickly man, thinking in we–them terms, with a chip on his shoulder. He disliked the values of polite society but longed for its privileges, and even when his work was fashionable he could snap at a client: 'Who do you think I am ? Whoever I am, I'm Jesus Christ to *you*!'

Norman Lindsay adored his work:

Light is the spirit of landscape...the divination of light in nature becomes a spiritual division between high and low minds, and a painter with power to reveal its greatest velocity in Art is one to stir the highest vitality in Mind, and thereby becomes a dynamic force in the regeneration of Life. I must say here in this relation, that I do not believe any other painter on earth has made such a profound analysis of light as Elioth Gruner.

No passage in Australian writing about art from this period gives a clearer impression of the provincial complacency, and the ignorance

30. Elioth Gruner: *Spring Frost*, 1919

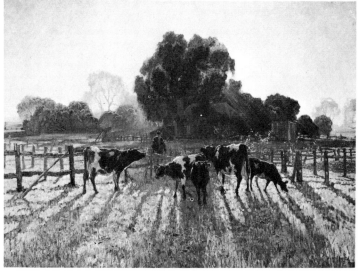

of history, which bedevilled the studios. Still, Gruner's light effects were more subtle than any of his local predecessors, except Streeton in the early nineties. Gruner was no draughtsman, but he was able to dissect light into its components and reassemble them as juxtaposed flecks of colour. His favourite painting time was morning, when the sun glittered through low haze, casting a shining rim around objects in its path; the long, pearly blue shadows slid forward to articulate the foreground space of *Spring Frost*, 1919 [30]. Gruner's pigment resembled Davies's in that it spread over the canvas in an even skin of impasto, many-layered and ridged, so that few aggressive brush-marks disrupted the continuous soft pulsation of light. And because there was no pattern of brushmarks to establish a closed design within the frame, Gruner's paintings, like Davies's, seem less formal than those of the Heidelberg School.

Gruner went to Europe in 1923 and his style changed before he returned. Before discussing that shift, it will be useful to look at the other convention of Australian landscape, which developed in contrast to the soft-edge pastoralists.

The September 1926 issue of *Art in Australia* ran an editorial headed 'A New Vision of Australian Landscape'. It referred to

those few landscape artists, who, while acknowledging the virtues of the traditional path, prefer to make minor divergences of their own...[which are] not of a particularly wild character...[since] this is no riotous group of mutineers yelling for the blood of Streeton.

What might have given Australian art some interest in those days would have been just such a mob of mutineers. However, the article went on to explain that

They congregate under no one banner, yet they have much in common, and the catch-cry to that would be 'Simplification and reduction to essentials'. Under the austere baton of G.W. Lambert they unite in offering the refrain.

Landscapes by Gruner, Lambert, John D. Moore, Roy de Maistre and Kenneth Macqueen were reproduced. A motley choir; but, as I will show in the next chapter, Lambert did lead a reversal against romantic mood, back to precisely observed form. So did Hans Heysen, another meticulous realist. As a result, the movement towards hard-edged landscape, based on internal structure and external contour, was actually two-pronged. One prong was academic: Heysen, Lambert, Meldrum. They wanted precise record-ing. The others sought precision of design, and looked towards post-impressionism by selecting some elements and rejecting others

to produce an effect not fully articulate in the landscape itself. Roland Wakelin, de Maistre, and Margaret Preston are in the latter category. Others, less adventurous, still brought a stronger formal sense to the pastoral tradition: Kenneth Macqueen, John D. Moore, the post-European work of Gruner, and above all Lloyd Rees.

Hans Heysen was born in Hamburg in 1877. His parents emigrated to Australia when he was six. In 1899 a syndicate of Australian businessmen, impressed by his early drawings, gave him a private scholarship. This took him to Paris where he studied at Julian's Academy and at the École des Beaux-Arts. Later he returned to Australia and settled in Adelaide. In 1959 he was knighted.

Heysen's large body of work was immensely popular; it has most of the textbook virtues and, for many years, no Australian business firm was considered quite solid unless it had a Heysen in its boardroom. As expert an advocate of 'hard' drawing as Lambert was in portraiture, Heysen made his pictures teem with facts about landscape. As botany, his interminable paintings of eucalypts are excellent though a whit redundant. His grassy hills and Central Australian rocks have their merits as topography. He loves his subject-matter. He was, in fact, the Alfred Munnings of the gum-tree. The only deficiency of his art is that it has no imagination, and as a projection of a man's spiritual structure on an external world it is suavely valueless.

Heysen prepared Streeton's *plein-airisme* for deflection into an academic system. His followers deflected it. Heysen's objectivity became a conventional formula for the Heysenettes, a dilapidated and creaky chorus line, bumping and grinding along in their blue and gold costumes: Harold Herbert, Max Ragless, James Jackson, Robert Johnson, Alan Grieve, Ernest Buckmaster, Erik Langker, and fifty more. Allowing for minor variations of handwriting and weather, their work is interchangeable. Ossified beyond the idealism of its origins in the Heidelberg School, this is an art form so standardized that, given the right tubes of Reckitt's blue, yellow ochre and flake white, a small computer could be programmed to produce it.

But Gruner preserved himself. Of his post-European paintings, Basil Burdett, a critic, wrote:

In Gruner, development has not spelt a denial of those qualities that originally made his work significant. . . . He has had the intelligence to see, however, that greater attention to form, more careful organization of design, greater reticence of sentiment, would purge his work of any sense of cloying and release those essential qualities to greater clarity of expression.

Between 1926 and 1930, then, Gruner cut down on detail. His paintings, with their simplified curves of hills, suggest receding space with a minimum of tonal shifts, and tentatively approach that severe reduction of form advocated, ten years earlier, by Wakelin and de Maistre. But Gruner never really developed the idea of formality in painting. The same applies to John D. Moore, a water-colourist. His experiments were equally timid: a change of tint in a cloud, detail left out, a slight flattening of volumes, a barely percep-tible compression of space. Other work in similar vein was done by Kenneth Macqueen, Daryl Lindsay, Vida Lahey, and Norman Lloyd.

When Gruner died in 1939, one would have expected the end of pastoral landscape and with it the Arcadian dream that haunted earlier painters. Only the hacks continued to widen the rut of Streeton's lurching progress through the fat paddocks of coastal New South Wales. Drysdale, leading others in the forties, preferred to gaze on the more forbidding prospects of the inland desert. In Melbourne, Nolan and others refused to emit that image of a friendly world required by pastoral convention. Yet the convention was not dead. In the ranks of its zombie acolytes was one man of real sensibility, who, working on his own, prolonged its life, stripped it of its absurd nationalist overtones, and gave it a new shape.

This was Lloyd Rees. His mature work, except in terms of its subject-matter, cannot conveniently be put into any Australian movement. His shapes were too massive to suit the vaporous effects of neo-romantic painting in Sydney in the forties. And in landscape, from Streeton to Gruner, we have traced a fairly constant thread of mild romanticism. It went hand in hand with lamentably poor draw-ing. Of the soft-edge landscapists, only Phillips Fox showed much ability with a pencil. Lambert and Heysen were skilled draughtsmen but their work had nothing much to express, except a *pompier*'s satis-faction with his own skill. So whether poetical or pseudo-classical, images of Australian landscape were drawn, if not painted, without distinction. But Rees was a fine draughtsman. His earliest drawings – around 1916–17, when, at Sydney Ure Smith's invitation, he left his native Brisbane to join the commercial art firm of Smith & Julius – are precociously accomplished for a man of twenty-one; a precise, cobwebby pen line describes an elaborate tonal structure.

Even at this stage, Rees tended to idealize. Sydney streets grew cupolas they did not own; harbourside buildings had a way of turn-ing themselves into Italianate *palazzi*. What started as escape from the commonplace turned, around 1918, into a strong romantic lyricism. Roland Wakelin, one of the group of young painters who forgathered at Smith & Julius, found Rees's new pen drawings

'remarkable in technical achievement, and romantic to the point of melodrama', though Wakelin's own somewhat purist attitude (he was then working with Roy de Maistre on their 'severely cubistic drawings') could have influenced his response. The soft tones were now plunged in deep chiaroscuro, and massive volumes replaced the dance of his earlier pen line. But when he first went to Europe in 1923, to study Renaissance painting, Rees's expressionist tendencies were calmed; his return exhibition in 1924 was composed of landscapes with houses and cathedral interiors, all at a clearly middle pitch of emotion. Italy profoundly affected him. The clear mild light of the Tuscan plain, with its soft but distinct contours, its grey-greens and Naples yellows and whites: these seeped through his Australian work, and Rees has tended, ever since, to see Australian landscape through Italian eyes. For the first time, confronted by the Tuscan hills with their patterns of olive and cypress, their terracing and ploughing, with every mark of human activity carried on the face of the landscape, he had entered a humanized world, where a perfect balance between natural form and man's activity had been struck.

31. Lloyd Rees: *The Road to Berry*, 1946–7

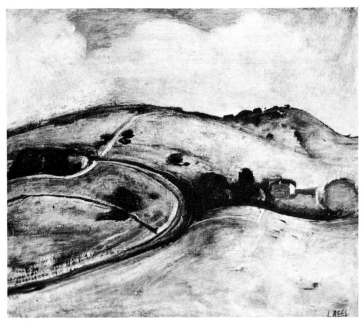

This is an experience which, even today, few Australians have been able to share, because their own countryside is not like that.

In 1927 illness stopped Rees painting. For seven years, he restricted himself to pencil drawing. In this valuable period of retrenchment and discipline, he examined the structure of the landscapes around him: the headlands near his north Sydney home, with their tumbled rocks and grainy clay banks; the slow, indifferent rise and fall of hills, the curvature and configurations of the earth. The pencil drawings of 1927–34 laid a basis for his remarkable landscapes of the late thirties and forties, whose hills fold and wrinkle like the skin of an animal. No landscapist except Drysdale has more convincingly suggested the monumental antiquity of Australian landscape, and its feel of arrested organic growth [31]. Were the Messiah to arrive, these hills would not dance; they might twitch like the hide of a grumpy elephant. The paint itself suggests age: laboriously scumbled, layer on layer, in subdued autumn colours, it could have grown there.

Though unique among other visions of pastoral landscape, Rees's preoccupation with basic forms and contours must be seen in the context of another movement, developing at the same time – post-impressionist painting in Sydney and Melbourne, from 1914 to the start of the Second World War. To complete our view of the background to modernism, however, the expatriates have yet to be considered: the Edwardian painters who left Australia between 1890 and 1900, and developed in Europe.

The first Australian painter to make a name abroad was John Russell, Tom Roberts's touring companion of the early eighties. But unlike later expatriates – Bunny, Lambert, Ramsay – Russell's name was never heard in the salons. He and Conder are the only Australian painters between 1880 and 1950 who are known to have had close personal contact with the European *avant-garde* of their times.

In Sydney in 1964, an artist who had at one time or another drunk with Dubuffet ('associated with *art brut* movement, Paris, 1950–56' would appear on the catalogue) would have been assured of a sale or two because of it. But Russell's close friendship with Van Gogh and Monet, and his association with Toulouse-Lautrec, Anquetin, Matisse, and others, passed quite unnoticed until it was discovered by Dr Bernard Smith, twenty-five years after Russell died. History and fashion have maligned him by neglect. History is full of ifs: what might have happened to Australian art if Russell had come back to Australia sooner and implanted his knowledge of impressionism and post-impressionism there ? Or if Roberts, the progenitor of the Heidelberg School, had stayed longer with Russell in Europe ? It is possible that the pastoral tradition of landscape might not have stiffened into its corpse-like posture of chauvinism; that the received values in figurative painting between 1910 and 1930 might have remained alive and supple.

Russell was born in Darlinghurst, a Sydney suburb, in 1858; at eighteen he went to England and was apprenticed to an engineering firm: his father was a well-to-do ironfounder. There he began to paint – inspired, it is said, to make his first picture by the sight of the towers of Lincoln Cathedral in mist – and in 1879 when his father died, he returned to Sydney to wind up the estate. There, he set up a studio and painted portraits.

In 1881, the inheritor of several thousand pounds a year, he left for Europe to study art. Though he went at the same time, and even on the same boat, as Roberts, it is likely that no close friendship existed between the two men at this stage. But after their Spanish walking-tour, Russell stayed on in Europe and enrolled at the select academic academy, Cormon's, in Paris. This was in 1886. Among his fellow-

students then were Louis Anquetin (the disciple of Seurat's *pointillisme*), Émile Bernard, Henri de Toulouse-Lautrec, and Vincent Van Gogh.

Van Gogh, at this time, was at a transition: the gloomy potatoes and dark landscapes of his years in the Borinage were behind him, the explosive cypresses of Arles were yet to come, and he was beginning,

32. John Russell: *Portrait of Dr Maloney*, 1887

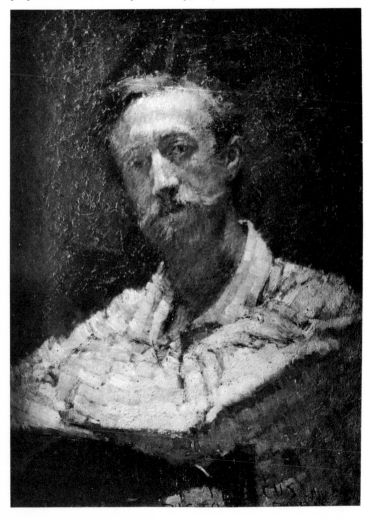

confusedly but enthusiastically, to understand impressionism. The Paris *avant-garde* could hardly have been less new and exciting to him than it was to Russell. Added to this, both men were exiles, neither had French as a native language (Van Gogh's letters to Russell were written in English), both instinctively revolted against Cormon's teachings, and each was under the spell of Anquetin's theories. A strong friendship sprang up. Russell painted Van Gogh's portrait; it now belongs to the Stedelijk Museum in Amsterdam. They addressed one another as painting equals, and it is plain that Van Gogh admired Russell's work; he often suggested they swap paintings.

A typical Russell from these years is his *Portrait of Dr Maloney*, 1887 [32]. The pseudo-impressionism of Heidelberg produced nothing like it: it has the true impressionist technique of divided colour, vivaciously set down in a high key of pinks and blues. The brushwork is as crisp as any early Streeton.

At about the time he painted it, Russell married a young Italian girl named Mariana Matiocco, who had modelled for Rodin's *Minerve sans Casque* and *La France*, and whom Rodin thought the most beautiful woman in France. Enviably equipped with a wife as luscious as his income, Russell left Paris at the end of 1887 and built himself a large home at Belle-Île, off the coast of Brittany. He continued to paint, influenced still by Seurat and Signac. He asked Van Gogh to stay with them, but his wife, nervous of the crazy Dutchman, refused; he continued his friendships with Lautrec, Anquetin, and Rodin.

Brittany was a favourite resort for painters. The work that Gauguin and the Nabis did there, for instance, is well known. Russell's *avant-garde* enthusiasms helped make 'the Englishman's castle' at Belle-Île a meeting-ground for artists, writers, and musicians. Monet stayed there; in 1897 (for Russell, despairing of the philistine atmosphere in Australia, stayed in France) Matisse met Russell, and was introduced for the first time to Van Gogh's work. It is tempting to speculate on what effect Russell, articulate and fond of theory as he was, may have had on this young man, fresh from the studio of Gustave Moreau.

In later years, Russell experimented with cubism, the first Australian to do so. His wife died before the First World War; he travelled about the Mediterranean; in 1919 he returned to Sydney. There is a rumour, current only since the late 1940s, which no records substantiate, that he offered a handsome collection of paintings by Van Gogh, Cézanne, Seurat, Monet, and others to the Art Gallery of New South Wales and that the trustees refused it. This story may have grown out of Russell's desire, recorded in an early

letter from Van Gogh, to bestow a major collection of European impressionist and post-impressionist pictures on Australia. No doubt if he had made the offer, the Gallery would have ignored it anyway: such work, at the time, was thought to be the vulgar effusions of five-thumbed psychotics. Russell died in self-imposed obscurity in Sydney in 1931.

Not all the other expatriates of the eighties and nineties were as attractive: none of them was as interested in current developments, and few paid any attention to impressionism at all. They left Australia to acquaint themselves with European tradition, to see the Old Masters they had no hope of seeing at home. They went to Europe on scholarships or private grants, perched themselves on stools in the frigid chambers of the Louvre to copy Poussins, and sought the recognition of the Royal Academy and the Paris salons. Returning to Australia, fortified sometimes with bronze medals, they brought the first breath of internationalism to the country and, with an 'I've seen it – you haven't' technique, established themselves beside Streeton as the Australian guardians of Art during the twenties and thirties. Between 1890 and 1930, the rise of the salon painters parallels that of the pastoral landscapists.

Some now appear negligible: John Longstaff, for instance, who arrived in Europe in 1888, and years later was knighted for his official portraits and putty-brown historical set pieces. And it is a mistake to think of the salon painters as a group, for they were an accidental confluence of sometimes opposed talents: nothing could be more remote from Meldrum's theory, say, than Bunny's or Fox's practice.

Emanuel Phillips Fox produced figure compositions, but his more intimate landscapes were, by 1915, the only examples of true chromatic impressionism by any native-born Australian except Russell. George Lambert studied Velazquez and Manet's *manière claire*. Rupert Bunny's work has affinities with Bonnard and Vuillard, and, through their common interest in Japanese prints, with Gauguin and the Nabis. He could do a monumental set piece in the grand manner, but he was happiest of all with Provençal landscapes and decorative figure-compositions. Hugh Ramsay, like Lambert, looked to Velazquez and Manet. Max Meldrum, the longest-lived of all, formulated a theory of tonal impressionism based on his mono-maniac adoration of Velazquez and the Spaniard's follower, Sargent. This taste for Velazquez was not, of course, unique to Australia. It sprang from the general overhauling his neglected reputation was then getting from European critics.

Of the five, Lambert was the most fashionable in his own day. When he came back he strode through Australian society with the *désinvolture* and raffish grace of a hussar. He became the Boldini of Point Piper and Toorak. He reigned invincibly till his death. After it, a Lambert Memorial Society was formed to buy his work for national collections; at the Memorial Exhibition in 1930, the year of his death, the immense sum (this was in the middle of the Depression) of £1,000 was asked for *Important People*.

Lambert was born of Anglo-American parents in 1873, at St Petersburg. His father died before the birth, and little George was taken to Germany, then England, and educated in Somerset; then his grandfather and mother emigrated to Australia. They settled on a relative's property, 'Eurobla', near Nevertire in New South Wales. Here Lambert worked as a station-hand. For a boy hardly in his teens, the work was tough, but it seems to have imbued him with a romantic sense of the bush. In 1888 he left for Sydney and worked as a draper's clerk in an underground office; sacked for drawing instead of working, he found another job with the Government Shipping Office, held it for two years, and went bush again.

Australia's agricultural economy was now starting to sag towards the rural depression of 1892. But between the long hours of station work, Lambert drew assiduously, and was soon getting illustration assignments from the *Bulletin*. Eight months later he was working for it full-time. This paper was a forcing-house of graphic talent; Phil May, David Low, and other notable cartoonists started there: so did numerous 'fine' artists, like Norman and Lionel Lindsay, B. E. Minns, and others. But in the eighties and nineties the now hard line between fine and commercial art was fluid. Artists had to apply the elaborate technical equipment of their serious paintings to a more menial task, and this confusion was further confounded by the powerful influence of American illustrators, Howard Pyle and Charles Dana Gibson, whose rapier facility and sparkling blacks were the envy of every *Bulletin* artist. It is possible that the manneristic bravura of Lambert's later work was implanted then.

But it was not to show yet; in 1896, Lambert painted his first oil, *A Bush Idyll*, a child with goats among gums. This pleasant if papery effort got him an entry, through the portraitist B. E. Minns, to the newly opened Julian Ashton School. He studied there at night; then, in 1899, he was catapulted into public recognition by his large painting *Across the Black Soil Plains*. It stemmed, like Roberts's and McCubbin's genre, from admiration for the pioneer spirit. It shows a team of horses dragging a wool wagon; the manner is rhetorical,

with accentuated perspective, strong tonal contrasts, and an emphasis on stress and violent motion. The colour owed more to Folingsby than to the Heidelberg School, and little to tonal impressionism: browns and bitumens prevail.

Well pleased with it, he jogged a local critic's elbow:

> It is strong, masculine if you like; the horses are well drawn and painted, the movement and action are 'all there', the teamster and his dog are realistic, the sky is good, the colour is harmonious and the subject is popular.

And in the next year this conceited fellow of twenty-six won the new Society of Artists' Scholarship. He married and embarked for London; another young Australian, Hugh Ramsay, went with him. They enrolled at Colarossi's academy in Paris. He studied in the Louvre, ignored impressionism (except Manet, whose *Olympia* delighted him), and elaborated a theory based on traditional techniques:

> In the end I convinced myself that the great painters had inherited or evolved a piece of machinery which one could almost liken to a perfect motorcar...[which] consisted in the carrying-out of their pictures at an early stage in a monochromatic parallel to the finished effect...sooner or later the pleasant blending of colours is bound to give way to the scientific formulas of technical modelling.

Yet this confusion of illusionist technique with the real substance of painting did his work no harm for five years; the theory needed time to percolate through his hand. Helped by a precocious grasp of Manet's *manière claire*, he pursued form for its own sake: in the low-toned *Guitariste*, 1902, the face and hands emerge with a restrained petal-like glow from brown gloom. Simple, firm shapes recur: the curve of an arm echoes the curved flank of a guitar. But his chief work of the European period was a portrait of his close friend *Miss Thea Proctor*, 1903 [33], done in London.

In a subtle range of browns, blues, and crisp whites, the paint is fluid; the brushwork, relaxed, almost languorous. Each element of the picture coheres with the next, and we are not (as we are in his later work) constantly interrupted by his anxiety to show how well he could imitate fabric, leaf, or skin. In the manner of Gainsborough, a landscape is visible behind the figure. But the foliage of the tree is outlined with a delicate regard for the negative shape worthy of Maurice Denis. The landscape runs in ordained curves, echoing the graceful line of the subject's pose. Whistler might not have disowned this exquisitely tender study, and Lambert never recaptured its

33. G.W. Lambert: *Miss Thea Proctor*, 1903

freshness of form. By 1906, his *Lotty and the Lady* was doughy and facile, though the tactility of paint remains. But it evaporated in 1912, when he began *Important People*, a chalky allegory which, he thought, summed up all he had learnt from antiquity. With characteristic modesty he called it 'Botticelli without the finish', though not an inch of Botticelli's line crept into it. Its four emblematic figures, a

mother, a businessman, a boxer, and an infant, cluster about in the frozen attitudes of extras on the wrong movie set.

From 1911 to the outbreak of war, Lambert did well in England; portrait commissions, ranging from Lady Beaverbrook to the Gaekwar of Baroda, were pressed on him and, when he was appointed as a war artist with the A.I.F. in Palestine, he was in command of an exact and rapid illusionist technique. His heroic accuracy, as a contemporary called it, suited him to the job; his young Australians died dramatically and hygienically as the bullets of the Turk tumbled them into suitable postures, with lots of smoke and a minimum of gore.

His return to Australia was welcomed. Lionel Lindsay wrote:

I have come to regard the return of George Lambert as the most important happening in Australian art since the departure of Streeton in 1896. [Lindsay's date is wrong: Streeton left in 1898.] Pure drawing, drawing for its own sake, these phrases were never used before Lambert's advent. We heard a lot about feeling, sentiment, emotion – little of that hard inexorable training of the eye demanded by the pencil point. . . . Lambert knew how to build, he took a delight in his medium; and his modelling, profound and suggestive, was streets ahead of anything seen before in Australia.

Lambert's 'hard' drawing braked the trend to poeticism – the watercolours of Hilder and Young, the oils of Davies, Long, and Withers. It was popularly supposed to be the very fount of classical values: contour draughtsmanship, steadfast objectivity. But a review of his elaborate portrait *The White Glove* spoke of its 'flashiness' and 'artifice', observing that, despite Lambert's technical resources,

he goes dangerously near convincing us that a vitalized automaton with a fine nervous system can be trained to transfix the stuff of dreams. . . we feel it is not quite proven.

Lambert's 'piece of machinery' was now working smoothly, capable of making any desired effect – including, in landscape, the inevitable nationalism. God was in His heaven, and the sheep were even woollier than last year's; the sun beamed on immaculate gentlemen, spurred and booted astride their geldings, showing to all the pastoral splendours of Australia and their corollary, the wealth of its squattocracy. His superficially impressive portraits leaned towards heroic poses – witness the almost baroque attitude adopted by Sir Baldwin Spencer while sitting in 1925 – and provided Australian bigwigs with their first chance to be immortalized in the grand manner; it was therefore vastly popular, and when the Lambert

Memorial Catalogue called him 'Australia's first unquestioned master' it was as right in fact as it was wrong in judgement.

When Hugh Ramsay died at twenty-nine, in 1906, Australian art suffered a bad loss. His less flashy talent was temporarily eclipsed by Lambert's reputation. A Glaswegian by birth, he emigrated to Australia young; at eighteen he enrolled under Bernard Hall at the National Gallery School in Melbourne. By 1900, soon after he and Lambert arrived at Colarossi's, he was reputed to be the most capable artist in the entire academy. He gamely submitted six paintings to the 'New Salon' (officially, *La Société Nationale des Beaux-Arts*) for its summer exhibition of 1902. Much to the enhancement of Ramsay's reputation, they were hung. Lambert admired him:

Ramsay's superiority could not be denied; and, when I brought myself not only to accept this, but to see the reasons for it, it interested me much to hear the comments of older and more experienced men. Some said 'Here is frank, straightforward modern painting – he will acquire soul later.' Others said, 'This is evidently modern painting, and the idea behind it is big; he will improve his soul later.' In actual fact Ramsay was simply

34. Hugh Ramsay: *The Sisters*, 1904

35. Hugh Ramsay:
The Foil, c. 1902

making an honest attempt to develop his talent within limitations that he considered sensible and right. He agreed with Puvis de Chavannes's comment on the glories of the Renaissance: 'All these wonders that I see would be annihilating, were it not that I am content with so little.'

Few young painters discipline themselves so stringently. Ramsay gave his imagination a very sober setting, and the most bravado he allowed himself was the virtuoso use of large masses of white pigment in *The Sisters*, 1904 [34]. The two flowing white dresses, with their triangular interplay of folds, shadows, and highlights, are handled with surprising assurance; the white paint holds its vivacity, becoming neither chilly nor clinical. The Sargent touch, gained by an intensive study of Velazquez, is obvious. Ramsay may have had a colourist's instincts, but he buried them under ochres, umbers, dark reds, and blacks. He paid searching attention to details of composition, but masked it behind a seemingly effortless grace of gesture. His space, like Meldrum's, is not articulated; one or two flat dark tones supply the background to the figures. What could look simpler than his treatment of *The Foil*, *c*. 1902 [35]? Yet the play of light over face and hands, the relationship of posture and drapery, and the broad masses of subdued tone combine in an image of singular maturity and finesse.

Ramsay, like other Australian Edwardians, was a convinced realist; this, coupled with his love of Velazquez and his firm grasp of tonal modelling, invites comparison of his work with Max Meldrum's. But Meldrum elaborated his method into a 'science'; Ramsay did not. Ramsay's objectivity stopped where conscious composition took over, but Meldrum insisted on recording appearances undisturbed by 'individualist heresies' like design.

Meldrum, a Scot too, came to Australia at the age of fourteen in 1889. Ten years later he won a travelling scholarship and stayed overseas until 1913, studying Velazquez. On his return to Melbourne, he started a school. 'The mad Mullah', as Lionel Lindsay called him, was the Calvin of the middle period of Australian painting: lean, bush-bearded, irascible, a purist fanatic, thumping his bible of Tone and hurling brimstone on impressionism, individualism, and nearly all his fellow-artists, he inspired in his students the devotion appropriate to a Messiah. He mercilessly drilled every shred of personal vision out of them, and they loved him for it. As one ex-student, Colin Colahan, put it:

The impressionist who insists on breaking up a flat tone into a heterogeneous mass of spotty colour is just as unscientific as the surgeon who would insist on removing the appendix through the back of the patient

simply because he likes to show his originality. The instinct of self-preservation, fortunately, would step in here to stop any such mad surgical experiments, but there is no bar to the most outrageous of pictorial experiments perpetrated under the guise of 'individuality'.

Curiously, much of the hostile criticism of Meldrum is because of the fact that he has 'spoiled the individuality of his students'. Great is the indignation because he has induced them to be true to their own visual sensations. Still greater is the indignation because his students repay this outside solicitude...with highly amused indifference. Indeed, it is to be feared that a great deal of the hostility towards Meldrum is caused by the unflinching attitude adopted by his students, in their outspoken propagation of their master's principles.

Meldrum was the first Australian painter to formulate a consistent theory of art, a gift not evident in the windy polemic of Norman Lindsay. His *Invariable Truths of Depictive Art* tried to render down the body of European painting to a skeleton, and inspect its essence. This, Meldrum held, was illusionism. 'All Great Art is a return to Nature,' and 'this return to Nature simply means the translation of optical impressions within the limitations of a medium, and in the scientific order in which these sensations come to the eye.' This is really chapter and verse of Monet, Pissarro, and Seurat, all of whom Meldrum derided; where does the difference lie ? In the 'scientific' analysis of tone, not colour, and in observing the 'correct' hierarchy of sensation. Here Meldrum becomes inconsistent. Admitting an artist must select the tones he uses, and that not all gradations of light and dark can be reproduced in paint, he advocated an 'average' tone. But he supplied no scientific means of hitting the average, and left it to individual taste. 'Tone alone is responsible for any illusion of space and distance we get from a flat surface...let [the painter] but evaluate his tones correctly and the planes reveal themselves.' In the hierarchy of sensation, Meldrum placed tone first, then proportion, and lastly colour: any reversal of this sequence automatically led to meretricious art. The unimportance of colour was attested to by works of art which had 'the hall-mark of...universal approval'. By this he meant the art of western Europe from about 1460 to Whistler, and Velazquez especially: which is rather harsh, one may think, on Gothic art, Giotto, the Pisani, the Flemish primitives, the Ravenna mosaics, and the Sienese *trecento*, not to mention the Orient – though Meldrum did grudgingly put Hiroshige in his *Temple du Goût*.

He had a quaint evolutionary view of art. Since its history was no more than the recorded progress of man towards a perfectly accurate rendering of his visual sensations, an artist had to be a *better* illusionist

than his predecessor to equal, let alone surpass, his predecessor's achievement. Canaletto, a grub, produced Whistler the butterfly. But woe to Whistler if his illusions were only as good as Canaletto's – he would be an inferior painter.

Despite his wide influence, not one graduate from the Meldrum School has made good (though some have made money) by strictly applying his theories. And the failures of Meldrum's own paintings occur through too strict an adherence to their own aesthetic. His mature portraits have a mechanical air, and their colour – when, rarely, it escapes its regimen of bitumen, brown, and boot-polish – is metallic and dry. He once said that the proper viewing-distance for his work was seventy feet; at this range the flat, separated areas of tone blend and one sees the flow of illusionist shadow. Viewed close up, their sharp planes stand out as faceted elements in a structure, acquiring a crystalline, airless precision which succeeds as painting in spite of its intention. Meldrum, apart from some early figure-paintings like the fine portrait of his mother in the National Gallery of Victoria, was at his best in landscape. *Picherit's Farm*, 1910 [36], in its subdued gamut of grey, white, and green, recalls Corot's 'natural

36. Max Meldrum: *Picherit's Farm*, 1910

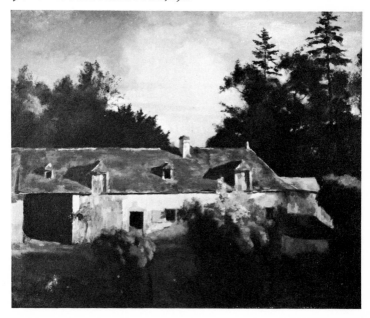

vision of humble things'. Though Meldrum admired Corot for his tonal structure alone, much of the lyrical subtlety that Hilder found so impressive in *The Bent Tree* seeps into Meldrum's landscapes, and during the twenties he produced numerous free tonal paintings, unconstipated by excess theory.

Nobody knows what Meldrum thought of his contemporary, Rupert Bunny, but it is not likely to have been printable. Bunny was his exact opposite. Meldrum thought colour unimportant; Bunny based his art on it. Meldrum was a fanatical illusionist; 'mere imitation of the object of nature was the purpose furthest from [Bunny's] thought'. Neither had a decisive effect on Australian taste, but to look at Bunny's work is to detect a true poetic sensibility – a rare thing, in those dundreary years from 1900 to 1937.

Rupert Bunny was born in 1864. He dabbled in engineering and architecture at Melbourne University, and then enrolled under Folingsby at the National Gallery School. In 1884 he left for England and worked briefly at Calderon's, the antechamber to the Royal Academy schools. But he was given an introduction to Jean-Paul Laurens, and he moved to Paris in 1886. Made welcome by Laurens's circle, he exhibited regularly with the Old Salon until 1900. His early work is academic impressionist in flavour, though with a French vivacity of colour quite unlike the Australian palette of the day. It included sentimental genre and portraiture, allegory, and fantasy. In 1904, perhaps in emulation of Millet, he turned to large religious panels. The energetic pose of *St Christopher*, a massive movement forcing itself through air and water, anticipates his 'primitive' figure paintings of the twenties; a superb early landscape, *Brignogan*, 1901, pulsates with red light, in billowing forms seeming about to melt in autumn heat.

Soon he was so much a part of the French scene that a critic called him *un peintre des plus parisiens*, no mean compliment in the ineffably self-centred Paris art world. His work was imbued with Gallic virtues of lightness, elegance, and, in the best sense, superb decorative taste. Bunny was a painter without theories, who relied on direct, optimistic responses to nature; his art was a luxurious dialogue with the visible. Women were his favourite subject. With their parasols and lace, sitting together under trellises or combing their hair before mirrors, they were taken fresh from life, with that unembarrassed glee in the 'unimportant' subject that delights us in the impressionists. Bunny saw some women as flowers, others as tawny young animals; but each is a playground for light. The informality of these paintings [37] is deceptive, for he laboured over their composition. Though an intimist, he could handle the grand manner, as

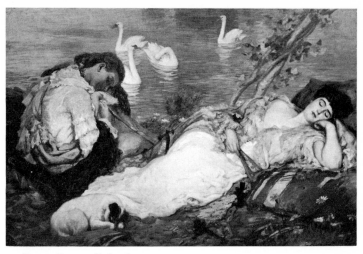

37. Rupert Bunny: *Endormies*, 1910

his Tiepolesque *Summer* in the Art Gallery of New South Wales shows.

By 1911 his paintings hung in nine European public collections, including the Luxembourg. But when he sent an exhibition of figure-paintings to Melbourne that year, it was a fiasco. None the less he kept exhibiting in Australia throughout the twenties and thirties. 'I wanted to bring these canvases especially to Australia because they represent the work I have loved doing best, and one wants to show that kind of work to his own people,' he said. Though he stayed in France he kept his Australian citizenship – despite an offer of a lucra-tive post at the Gobelins tapestry works, open only to French citi-zens, held out to him as bait for naturalization by the French Government. Bunny was caught between two worlds: only France could give him his subjects and light, only Australia deserved them, but Australia rejected them. In 1923 the *Australian Encyclopaedia* listed the most admired painters in the Art Gallery of New South Wales: from Europe, Luminais, Ford Madox Brown, Brangwyn, Greiffenhagen, de Neuville, Lavery, and Hoffbauer; from Australia, Streeton and Roberts, Longstaff, Gruner, and Heysen. An art based neither on anecdote nor patriotism has few prospects. No mural commissions reached Bunny, and he said in his last years in Melbourne:

All my life I have wanted to paint big decorative things. But I hated the pompous academic style. I wanted to make it more human. No one wants these things. They're only interested in the portraits of someone they've heard about.

Though a natural sensualist, Bunny felt drawn towards architectonic classicism. He kept art and nature separate, and admired Ford Madox Brown's theory of 'constructive beauty', which Brown took to be the essential quality of art, not to be found in nature and proceeding from intellectual ordering and intensifying of experience. Thus seeing himself as a decorative, not a descriptive painter, Bunny was much influenced by Puvis de Chavannes.

The conflict in him between the Mediterranean and the Gothic was not resolved until the middle twenties. Then Bunny evolved a firm and expressive formal structure which gave his colour much fuller play. His figure compositions abandoned the analysis of light by impressionist methods and confined themselves to localized colour sensation; space was defined by the advance and retreat of flat hues. One outstanding work was *The Rape of Persephone*, 1925 [38]. Here,

38. Rupert Bunny: *The Rape of Persephone*, 1925

starting from Puvis, Bunny was trying to go beyond impressionist colour into a system of 'primitive' form. He thought the Fauves bunglers, but the savage reds, lilacs, and greens of *Persephone* are as saturated with expressive vigour as any Matisse.

Other figures stand in profile, like Egyptian tomb-friezes, but touchingly awkward. Sexless and vulnerable, the *Nymph of Salamacis and Her Lover*, 1926, are bathed in Bonnard-like daubs of light, and exist on equal terms with amorphous forest and luminescent water. And it is really to Bonnard that one should look for the outside source of Bunny's mature art, especially the later Provençal landscapes and paintings like *The Rape of Persephone*. Three years older than Bonnard, he died in the same year, 1947, and the best explanation of the changes that overtook his work in the early twenties is that he studied Bonnard's paintings in Paris.

In Australia, only Bunny's landscapes were taken seriously until the forties, when Paul Haefliger, the critic of the *Sydney Morning Herald*, went so far as to proclaim him the finest painter who ever lived in Australia. He returned to Melbourne in 1933 and painted Provençal scenes from memory in a small flat in South Yarra. Though closer to nature than his Homeric and allegorical subjects, these cannot be classified as impressionism, academic or pure: he subjected them to decorative distortions, compressing or extending space, schematizing their colours. This helped him investigate the structure of landscape, its flow of forms and moods. An olive-tree becomes a linear arabesque, swinging one's gaze around its rhythmical branches before projecting it up the slow swell of a hill.

Many of these Provençal scenes are disagreeably soft, for Bunny's forms tended to be lax; but the best of them are robust, even under their delicate blooming of summer tints, and could have been a most valuable stimulus to the pseudo-tradition of pastoral landscape. But they were not, because their merit was ignored until their usefulness as a corrective to the landscapes of Streeton, Heysen, and Lambert was over. Bunny, dying in 1947, a disappointed but not embittered man, lived long enough to watch his reputation climbing to the level it deserved. But by then his work had been assimilated by critics into the weaker poeticism of Sydney's Charm School, and a different corrective was needed to that.

Emanuel Phillips Fox (1865–1915) is the link between Edwardian salon painting and the atmospheric landscapists who came after the Heidelberg School. He was also the first native-born artist to grasp the principles of an impressionist technique and apply them to Australian landscape. His only contemporary who resembled him, either in mood or visual approach, was David Davies. But Davies was a very restricted colourist, reticent, allusive: a painter of *petites sensations*. Fox ranged wider, and his vision was not tinged in the least by that melancholy which was bound up in the poeticists' view of Australian nature. His art was happy and vibrant, a continual

celebration of colour and light, whether filtered through rain on a landscape or flickering across the belly of a nude girl.

Fox was born in Melbourne. He studied at the National Gallery School, and went to Paris in 1887. There he studied under Gérôme and Bouguereau, the ideal luxury-artist for the French middlebrows, with his pneumatic rosy nudes and corpulent cherubs frolicking in Barbizon frames. Gérôme's dictum that 'in painting, the first thing to consider is the general impression of colour', which so impressed Roberts, was no doubt absorbed by Fox; but unlike Roberts, he was able to fill it out with first-hand study of the French Impressionists, so that he brought back to Australia in 1892 a developed technique based on a divided palette and the shimmering interplay of pure colour. This was apparent even in his more austere moments: *The Art Students*, 1895 [39] is low-keyed, but its divided colours mix in one's eye, so that its sober tonalities do not – as Lambert's and Meldrum's customarily did – turn into soup or boot-polish. Beautifully constructed, *The Art Students* is the first major impressionist work painted in Australia, and its ordinary subject, stained smocks, and the dirty studio, especially affronted Melbourne taste in 1895.

In 1893, with Tudor St George Tucker (a fellow-student at Gérôme's), Fox founded the Melbourne School of Art. Shortlived, it was the first Australian school run by 'modernists', and the last until George Bell's in the thirties. He painted at Heidelberg. His landscapes were intense in colour, with a fine feeling for the plasticity of paint as a substance, and generally based on a pervasive, rich green. Nothing of Streeton's 'heroic' approach was in them, and partly because they did not join the clamorous typification of *Australia Felix*, works like *Heidelberg Landscape*, 1895, have been underrated; but few local landscapists of the nineties can claim a more substantial achievement than Fox's. None surpassed the robust lyricism of his *Autumn Showers*, 1900.

In 1902 Fox went back to Europe. Unaffected by new directions in the Paris *avant-garde*, he continued refining his impressionism. *The Ferry*, 1911 [40], with its clean water-reflections, sparkling sunlight, bright patterns and fresh colour, is as fetching as an early Monet. 'The artist,' wrote Pierre Auger in a different context, 'by virtue of his constructions, transforms the world that surrounds him – a world which, without being deliberately hostile, is normally indifferent if not unfriendly – into a hospitable world in which we recognize at every moment the projection of our own internal structure.' It is a remark central to an accurate view of at least one branch of Western art; and it applies very well to Phillips Fox.

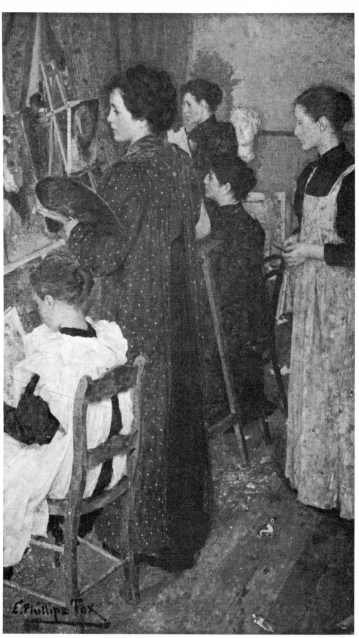

39. E. Phillips Fox: *The Art Students,* 1895

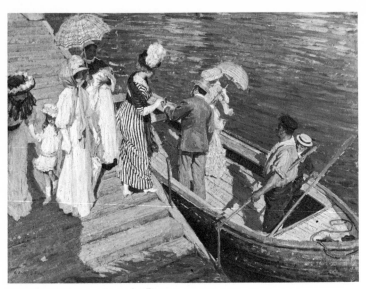

40. E. Phillips Fox: *The Ferry*, 1911

Without affectation or facile jollity, he constructed a friendly and vivacious world in which, as in a sunlit pool, we find ourselves mirrored.

Like most art movements, post-impressionism came to Sydney late.
It was lucky enough to sneak in by an unwatched back door.

Roberts, Streeton, Lambert, Bunny, Fox, and Long were all over-
seas in 1913; the remaining poetic landscapists were only just begin-
ning to make headway; the prevailing mode of art, therefore, was
still flavoured with Victorian anecdote, but its popularity was sag-
ging and it was unbacked by substantial critical writing. The periodi-
cal *Art in Australia* was not yet published, so that no specific forum
of art opinion existed. Thus the Establishment, epitomized in
Sydney by the Royal Art Society and the Society of Artists, was
marking time in its sleep. This helps explain why the early experi-
ments of Australian post-impressionists met with so surprisingly
little organized opposition.

Their laboratory was run by A. Dattilo Rubbo, an Italian academic,
teacher, and painter. Since his studio was virtually the only live one
in Sydney, a group of alert young painters gathered there. Rubbo,
himself a tonal impressionist, had seen and admired reproductions of
the work of Gauguin, Van Gogh, and Cézanne. Among his students
was a young New Zealander, Roland Wakelin, who had come to
Australia in 1912, aged twenty-five, and enrolled in the Royal Art
Society School where Rubbo taught. 'Rubbo, with his virile per-
sonality and tremendous enthusiasm, was an inspiration to us all,'
Wakelin later wrote, and added:

On Sundays we went out painting landscape and it was on one such
expedition to Pearl Bay...that we saw in the *Sunday Sun* a reproduction of
Marcel Duchamp's *Nude Descending a Staircase*, then showing at the
famous Armory Show in New York. That was our introduction to
modern art.

But out of its context in the Armory Show, Duchamp's celebrated
painting was exciting but quite incomprehensible. The main stimulus
to the Sydney post-impressionists was therefore Norah Simpson, an
Australian girl who, at eighteen, returned in 1913 after two years
abroad and enrolled at Rubbo's. She had studied at the Westminster
School under Gilman, Gore, and Ginner. Gilman had introduced

her to modern paintings and sculpture; he gave her letters to various Paris dealers, where she was able to see work by Cézanne, Van Gogh, and Gauguin. She also brought back numerous post-impressionist colour prints, which the students eagerly pored over. Norah Simpson became established as the 'star' of Dattilo Rubbo's, and her firm grasp of post-impressionist principles strongly influenced not only Wakelin, but two other students – Roy de Maistre and Grace Cossington Smith.

41. Norah Simpson: *Studio Portrait, Chelsea*, 1916

Unfortunately none of her 1913–15 pictures survive, and in 1915 she returned to England permanently. The only work of hers in Australia is therefore *Studio Portrait, Chelsea* [41], painted in London about 1916 but, according to Wakelin, directly similar to her Australian work. Tone, instead of being mixed flat on the palette, is suggested by juxtaposed strokes and daubs of pure colour: red and plummy violet, blue, lilac, green, and yellow, sometimes broken down with white but generally used at full strength. Its tonal struc-

42. G. Cossington Smith: *The Sock Knitter*, 1915

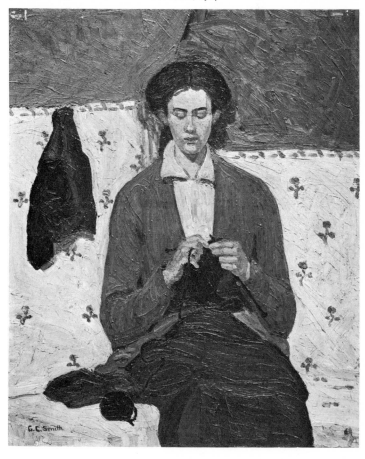

ture cannot be considered independently of its colour values, and in this lay its revolutionary effect. The light, subdued and Londonish, vibrates nevertheless with pointillist intensity. Forms are simplified; space is suggested by the advance and recession of pure colour, not by tonal gradation or perspective; the design is baldly emphasized.

Grace Cossington Smith came to Rubbo's at this time; she had visited Europe, studying at the Winchester Art School and later visiting Germany. But the prints she saw at Rubbo's were virtually her first glimpse of post-impressionist painting. 'We commenced to heighten our colour,' Wakelin recalls, 'working in stippling touches, and to make severe cubistic drawings.' She exhibited *The Sock Knitter*, 1915 [42] at the Royal Art Society show in August 1915. Her grasp of post-impressionist principles was evidently firmer than Wakelin's. The colour is simple and vivid; its dominant notes are alizarin crimson, lilac, white, green, blue, and red; the model's face is rendered in strokes of crimson, yellow ochre, green, and blue. An ornamental white arras with green motifs recalls Matisse; the modelling of face and hands is done in a sequence of defined planes, in imitation of Cézanne. The paint is applied in a vigorous impasto. Wakelin, meanwhile, was working along a semi-impressionist tack [43], influenced by Phillips Fox's divisionism:

At the end of 1914 I took the sketch I had made at Pearl Bay the year before and painted a new version, using only alizarin crimson, French blue, and cadmium yellow with white, and applying the colours in small dabs in imitation of the Impressionist method of simulating the vibration of light. Encouraged by the success of this experiment, I set to work on a 4 ft x 3 ft canvas of *The Fruit Seller at Farm Cove*.

Wakelin had no theories then about spheres, cones and cylinders. 'Modern art aims at the setting down of essentials in the clearest and most direct manner possible.' But what were the essentials?

Describing them, some years later, Wakelin came close to the nub of classical post-impressionism. He spoke of a Cézanne still-life in terms of its 'concentric feeling in the design, the feeling of radiation from centres which is a basic truth of Life itself.' What really mattered was to disclose the quintessential core of reality, not to imitate its externals:

The painter, in his desire to give his work qualities of life, looks on his subject (either in fact or imagination) and instinctively seeks in it the particular aspect of line, tone, or colour which will give that vital rhythmic unity which he feels to be inherent in Life.

This runs parallel to Roger Fry's analysis of creative intuition: a painter, Fry argued, looks at an object; some line or shape in it seems

43. Roland Wakelin: *The Fruit Seller at Farm Cove*, 1915

to hint at its essential qualities; the apprehension of this sets up a rhythm in his mind, and it is this rhythm, grown so vigorous that it distorts the 'real' appearance of the thing, which animates the work of art. The impressionist methods of Wakelin's 1915–17 paintings have under them a very close grip of basic formal relationships; the

44. Roland Wakelin: *Down the Hills to Berry's Bay*, 1916

air dances in *Down the Hills to Berry's Bay*, 1916 [44], but its weighty and simplified composition is independent of light.

This painting brought the opposition of the Royal Art Society to a sudden head. Dattilo Rubbo had cajoled its council into hanging the Wakelins and Cossington Smiths in their August show of 1915, but *Down the Hills to Berry's Bay* was rejected the following year. Rubbo was furious; he challenged a committee member to a duel, with pistols, swords or fists; the picture was hastily hung. In 1917 Wakelin joined the commercial art firm of Smith & Julius, where he met Lloyd Rees; he also encountered a Norwegian, Niel Gren, who made a small contribution to the post-impressionist movement. A sensitive but not compelling artist, Gren worked in a restricted range of colour, stressing planes and simplifying forms.

Up to 1918, Wakelin and Roy de Maistre had only 'casual contacts', though they had worked in the same studio. De Maistre's idiom had been impressionist. His *Interior with Mother and Child*, 1916, is a soft evocation of a light-filled room; though forms are simplified, they are dissolved in light rather than structurally hardened. Gradually, through 1917 and 1918, de Maistre pruned away excess detail, getting back to the basic forms of objects through the 'severe cubistic drawings' Wakelin spoke of. He painted a number of prismatic, rectilinear landscapes with houses; and then embarked on his colour-theory experiments.

Of de Maistre's life and work, Sir John Rothenstein has acutely observed that:

Roy de Maistre...is a painter not uniquely a visual man. The great majority of painters live, from their early years, through their eyes. Not only did the young de Maistre live chiefly through his ears, but his drawings and paintings, so far as I have been able to ascertain, were not expressions of things he saw or imagined: *they were schematic representations of his active analytical intellect.*

This last sentence (my italics) suggests what prompted de Maistre to work out his cerebral and idealistic theory of colour notation: he saw his own art as a process entirely rational, its laws and methods exactly controllable within an intellectual scheme. He had studied music. Why, he reflected, should painting not be done within a fixed range of colour notes, analogous to musical scales, and obeying equally fixed laws of harmony and dissonance ? He had already studied the psychological effects of pure colour, in a series of colour-therapy experiments conducted on shellshock victims in the Exeter Convalescent Home in New South Wales. Now, talking with Wakelin in Young's framing shop, he elaborated his theory:

I should like to trace its evolution from the first scale I experimented with. It was composed of 8 colour notes and was really nothing more than a natural scale based upon the seven principal colours of the spectrum, the 8th note being a repeat of the key note to form an octave musical scale. Having gone this far, it will be easy to see how the next steps come about. Seeing an obvious similarity between this 8-note colour scale and the ordinary well-tempered musical scale, and having no colours which would correspond to sharps and flats in music, I decided that it most resembled the scale of C minor. I also noticed that two of the most important notes in a musical scale – the 4th and 5th degree – were represented by degrees of colour complementary to the key note and so, fixing the key note as Yellow, the spectrum band developed into the key of Yellow major – the order of progression then being Yellow, Green, Blue, Indigo, Violet, Red, Orange, Yellow. It then only remained to insert a tone of colour between the 1st and 2nd degree, the 2nd and 3rd degrees, and between the 4th and 5th, 5th and 6th, 6th and 7th degrees; and a chromatic colour scale, such as the one we have here, was the result.

The next stage was inevitable. One had only to take the theory of music as it applied to the major and minor scales and transfer its system to the colour keyboard. The key note was decided upon and the intervals between the preceding notes being the same as those of the musical scale, I soon found that the colours representing the various notes bore the correct relation to each other, and that their importance in relation to the colour key note was much the same as the corresponding degrees of the musical scale – the most important feature being the relationship of the complementary colours to the key note, this colour invariably representing in a cold and warm degree the dominant and sub-dominant or 4th and 5th degree of a musical scale. In every scale a degree of each of the 7 colours of the spectrum is represented, and when these are used in their right proportions, the inevitable results are distinct colour harmonies, retaining the general tone quality of the key note, and an intense luminosity. Doubtless, this is due also to the phenomena of simultaneous contrast mentioned before, as each note is being balanced and made more brilliant by the juxtaposition of its complementary on some part of the canvas.

To put this intricate speculation into practice, Wakelin and de Maistre made a colour-disc machine for determining chromatic scales: a disc with 132 variations of the seven colours of the spectrum, with two rotating slotted masks. In 1919 they exhibited eleven 'Colour Music' paintings at Gayfield Shaw's gallery. These were figurative landscapes and interiors. There were also some exhibits showing the application of their colour theory to interior decoration. In the paintings, since the weight and relationship of coloured areas was all-important, the forms were drawn with hard-edged precision. The titles, naturally, were musical: *Synchromy in Red Major*, *Caprice in Blue Minor*.

Despite its oddity and militant avant-gardism, the critics liked their colour music; only Howard Ashton dismissed it as 'elaborate and pretentious bosh'. Its affinities with European synchromism were not noticed, but the *Telegraph*'s critic praised the vividness of the little panels: 'They hit; they attract; they are beautiful patterns and they "carry". No matter how brilliant each seems, it is played harmoniously.'

The next step was to apply their colour theory to abstract form. These pictures, painted later in 1919, were the first abstracts produced in Australia. Only one survives: *Rhythmic Composition in Yellow Green Minor*, by de Maistre [45]. But this elegant, sinuous object was

45. R. de Maistre: *Rhythmic Composition in Yellow Green Minor*, 1919

an experiment in a vacuum; by 1920, both de Maistre and Wakelin were back to 'reduced' natural form. Both came into the ambit of Max Meldrum and his theory of tone: the Scot's messianic eloquence was hard to resist, and Wakelin thought for a time that there was an analogy between Meldrum's system of visual analysis and Cézanne's dictum, 'Penetrate what is before you and persevere in expressing yourself as logically as possible.' However, flat-toned illusionism conflicted with Cézanne; Wakelin felt constricted by Meldrum and finally rejected his theories. Then, in 1922, he left for London to study post-impressionist originals at first hand.

The following year de Maistre, who had slowly and painstakingly evolved – he told Rothenstein later that, before 1918, he was virtually incapable of making a realistic drawing – won the Society of Artists' Travelling Scholarship and set off for Europe too. George Lambert, the judge, gave it to him; though his own work was academic, Lambert was by no means opposed to post-impressionism, and deplored the restrictions imposed by official academies. Grace Cossington Smith also went abroad.

Meanwhile, a woman who was to become a central figure in Australian post-impressionism had come back from Europe, in 1920. This was Margaret Preston, *née* Rose MacPherson. Born in South Australia, she had studied at the National Gallery School in Melbourne and imbibed the prescribed dose of tonal impressionism from Bernard Hall. She next travelled to Munich and Paris, studied there, and returned to Adelaide within a few years. Her account of it suggests this first trip only showed her the scope of her own ignorance. But in 1910 she left again for Paris, and stayed there a year. Then she moved to London until the end of the war.

During these eight years, fauvism was at its height in Europe, and Margaret Preston was immediately infected by it. Her still-life paintings shed their umbrous gloom. *Anemones*, 1916, is a transition picture: interest in design is developing, but the composition is soft and weightless, its charm coming from the harmonious colour. Preston was an instinctive colourist. 'From [1916] on, she allowed herself full licence in colour,' she wrote of herself, 'only letting her subjects appear as realistic as her aesthetic feeling allowed.' The abstraction of her work over the next ten years was actually milder than this suggests. By 1921 she was eliminating highlights, imperceptibly flattening her shapes, and formalizing colour into an overtly decorative system. Her still-lifes of 1924–5, with their bright wildflowers, checkered tablecloths and blue china, were designed with unobtrusive authority – her charming hues never broke down into atmospherics, being restrained by strong forms drawn with a robust feeling for contour and relationship. No painters of the twenties emphasized design with more grace than she.

In London, Wakelin met the critic P. G. Konody, who showed him his first Cézannes, Renoirs, and Manets. He visited Paris with his Australian friend John Young, and on his return to London encountered two successive major retrospectives, one of Van Gogh and the other of Gauguin, at the Leicester Galleries in 1924. 'I now had no doubt about the direction my work should take.' The next year, he returned to Sydney and exhibited a group of overseas paintings. Their design had expanded; the planes of face, fruit, or land-

scape were handled more plastically, suggesting stronger and more tactile volumes. They were, of course, lampooned by the local critics led by Howard Ashton. Meanwhile, de Maistre worked in London for six months and in Montparnasse for eighteen, finally moving to the French coastal village of Saint Jean de Luz before his return to Australia in 1926. His first exhibition, composed, like Wakelin's, of European work, was unexpectedly sober and restrained, deliberately designed, and methodically painted in a low key. His response to nature was more direct than in his colour music or 'cubistic' landscapes; and the colour, though closer in tone, was more resonant. The paintings were nevertheless reviled, and the controversy provoked from Basil Burdett a perceptive defence of de Maistre.

By 1926, the 'modernists' had built up such a bow-wave of critical hostility that most doors were closed to them. At this point George Lambert and Thea Proctor – Lambert's ex-student, who confected decorative little watercolours in a superficially post-impressionist style – stepped in, and invited a group of them to share an exhibition with them at the Grosvenor Galleries in Sydney. Among the exhibitors were Wakelin and de Maistre, Grace Cossington Smith, Margaret Preston, Adelaide Perry, John D. Moore, Kenneth Macqueen, and Elioth Gruner. There is no doubt that the presence of Lambert – 'Mr Art' himself – helped move a segment of public sympathy towards the new men. From this exhibition the 'Contemporary Group' formed and was able to have regular yearly shows.

Things looked up. Modern pictures began to sell; and that surest indication of a rising market, the chichi variants, prospered. 1927 may be put as the year in which post-impressionism got a firm handhold in Sydney. It saw some admirable, though still sober, new de Maistres; and Wakelin painted one of his most developed pictures, *The Red House*, with its complex interplay of organic and geometrical shapes and its finely controlled space. Margaret Preston became interested in the machine age, and produced a kind of kitchen-sink purism:

> She knows that the time has come to express her surroundings in her work. All around her...is machinery – patent ice-chests that need no ice, machinery does it; irons heated by invisible heat; washing-up machines; electric sweepers, and so on. They all surround her and influence her mind.

Preston rejected her bright, fetching colour, replaced it with greys and blacks, and reinforced this new austerity with a hard-edged, faceted view of a mechanical world that approached cubism: *Implement Blue*, 1927 [46] is a satisfyingly classical image, and *Gum Blossoms*, with its interplay of sharp triangles, anticipates Sydney's

46. Margaret Preston: *Implement Blue*, 1927

experiments in geometrical abstraction during the forties. Owing to
the popularity of her decorative flowerpieces of 1921–6, which,
though better paintings than Wakelin's, never quite took on the
solemnity of his vision, Preston's new work was swiftly accepted:
Art in Australia ran a special Margaret Preston number in 1927, and,
though the Art Gallery of New South Wales bought nothing from
Wakelin until 1935, its trustees asked Preston to present a self-
portrait to the collection in 1930. In 1929 there was even an exhibi-
tion of *avant-garde* furniture and decoration, in which de Maistre,
Thea Proctor, Adrian Feint, and Margaret Preston took part; book-
cases and chairs were shown, inspired by skyscrapers and other
emblems of modernity.

But meanwhile de Maistre, who, reticent by nature, was ill-fitted
as a crusader for modernism, decided Europe would give him a more
liberal atmosphere for work. He left Australia in 1930, never to

return; and spent the next six years painting in France, mainly at his beloved Saint Jean de Luz, and in England. His work, always geometrical and linear, developed steadily towards analytical cubism; its emotional resonance deepened as its formal system grew more assured. His most intimate friend at the time was the English painter, Francis Bacon (who, like de Maistre, showed little early talent for drawing), and he briefly shared Bacon's interest in metaphysical and alarming imagery: *Conflict*, 1932 [47] has affinities with

47. R. de Maistre: *Conflict*, 1932

Italian *pittura metafisica* and its forms have an obvious sexual reference – an unusual theme for de Maistre.

But *Conflict* is an isolated picture. Normally de Maistre's imagery has no irrational – and especially no sexual – flavour. His forms are neither metamorphic nor allusive. The constant character of his European work, from the late thirties to the present day, is its lucidity. We sense, beneath the sometimes tired-looking cubist gestures, a force: a capacity to make decisions, pressed forward and articulated by a governing intellect. The paintings are carefully worked out, usually starting from a realist sketch, thought over, and then decisively registered, much as a philosopher might enunciate some theory, the fruit of long speculation, in a low voice. When de Maistre settled permanently in London in 1936, the misty grey light blurred decisive shapes and drove him indoors, there to contemplate the distinctly lit objects of his still-lifes; but, as Rothenstein noted,

there are about them none of the cosy overtones that mark the work of most *intimistes*, no attempted creation of a 'little world of Roy de Maistre'. On the contrary there are, even in the gentlest, intimations of energy, of harshness.

The quality of de Maistre's art (not found, by the way, in the later work of his contemporaries: Wakelin developed scarcely at all after 1927, while Margaret Preston, under the influence of aboriginal art, changed, but not for the better) stems in part from its personal value to him as an expression of faith. His religious images stem from a profound belief, as a Roman Catholic, in what they represent. It would be unwise to claim that de Maistre's work has added anything to the existing vocabulary of cubism; and one would hesitate even to describe him as a particularly inventive artist. But though Australian painting from 1930 onwards contains pictures more dramatic than de Maistre's, and many with a richer content of imagery, it is certain that no Australian-born painter (for de Maistre was only Australian in the sense that T. S. Eliot was American) has produced a more formally articulate and *classical* body of work over a comparable span of time. In Australia it has generally been ignored and, as far as I know, it has never been exhibited in quantity.

After Sydney's 'Colour Music' exhibition in 1919, it took six years for the sparks of post-impressionism to glow in Melbourne; none of the Sydney painters was interested in exhibiting interstate. The tinder, in Victoria, was provided by two painters, Arnold Shore and William ('Jock') Frater. The fire did not catch until the middle thirties, when George Bell fanned it; but when it did, it was all-consuming, and produced the hottest conflagration Australian art

had experienced as the Old Guard and the New clashed, unremit-
tingly, for five years. The Sydney painters held quietly to their
principles; a more vociferous bunch than the Melbourne modernists
could scarcely be found.

Arnold Shore (1897–1963) was born and educated in Melbourne,
studying art first at the National Gallery School and later under Max
Meldrum. Meldrum drilled him to the very letter of tonal impres-
sionism, and Shore was apparently quite gifted in that tedious gamut
of lamp black, raw umber, and Stockholm tar. For some years after,
he worked as a stained-glass craftsman. William Frater, seven years
older, was a Scot; he had been trained at the Glasgow School of Art
under Maurice Greiffenhagen; he briefly visited Australia in 1911,
returned to Europe, studied in Paris and then went back to Glasgow.
Thus his education was most conservative; the dour academies of the
north had no time for the Misanthrope of Aix. He settled in Aus-
tralia in 1914. But it was not till the middle twenties that Frater and
Shore – together with another Melbourne painter, Horace Brandt –
saw their first reproductions of post-impressionist work, in the
newly released *Outline of Art* by Sir William Orpen.

48. Arnold Shore: *The Vegetable Garden*, 1940

Shore was attracted to Van Gogh's work, which released his hitherto suppressed feeling for colour. 'Large areas of mixed-on-the-palette tone colour were shunned; instead I allowed some of the components to show, thus producing a vibrating chord.' (It will be remembered that, of all Meldrum's hates, the 'breaking up of a flat tone into a heterogeneous mass of spotty colour' was the strongest.) Shore handled his pigment freely and with passion, loading his canvases with primary colour and heavy impasto [48]. Brandt, who found the presence of a subject distracting and preferred to paint landscapes from imagination in his studio, helped generate Shore's new sense of 'intoxicating freedom'.

Brandt's painting career was short but, as an influence, fruitful. His disregard for the mere accidents of place was such that he exhibited, around 1933, a picture entitled *Afternoon in Sydney and Melbourne*. 'Horace,' his friend Adrian Lawlor wrote later,

was used to being told to his face by all his admirers – some three, I think – that he was a genius. Naturally that gave him lots of *schwung*. He was fond of playing Liszt and Berlioz in the most headlong fashion on the piano; of producing frenetic and unrecognizable pastiches on the violin; of squirting

49. William Frater: *The Red Hat*, undated

his discourse with little douches of French...but he *did* give up painting. ...'The Muse has left me,' he said.

He was also audacious enough to get Frater and Shore to send paintings accompanying his to the 1927 Paris *Salon d'Automne*. Brandt's and Frater's were rejected, but one flowerpiece by Arnold Shore was hung. Frater's sense of structure was not as strong as Wakelin's, but his modelling of form was never, as Wakelin's unhappily tended to be, independent of the colour values [49]. None the less, the three of them were committed to an aesthetic they knew very little about because they had no contact with its sources. Their contact was restricted to fragmentary reproductions and photographs. 'We were none of us very erudite,' wrote Lawlor in *Arquebus*,

but we had the intelligence, and I suppose the will, to understand that Cézanne and everything that proceeded from him was 'good'. And if this involved a certain 'hook-line-and-sinker' attitude, as must happen among neophytes, at least we were saved from a sticky end amidst the slush and slither that has since engulfed most of our orthodox contemporaries.

A fuller understanding of the general principles of post-impressionism, and of Cézanne in particular, came from George Bell, who helped galvanize the modern movement into concerted action. Bell was not as good a painter as Frater or Shore; his academic vision lacked the former's delicacy, the latter's exuberance; but his influence as a teacher was immense.

The Establishment found Bell unforgivable. He was a turncoat: a well-established academic painter who suddenly went mad and flung bricks through the window of his own comfortable club. Young modernists, like Frater and Shore, could be waved aside as immature or incompetent; but Bell was past fifty, and in 1921 he had been lauded by that archangel of reaction, J. S. MacDonald. Born in Melbourne, Bell studied under Hall at the National Gallery School, and from 1904 to 1906 under Jean-Paul Laurens in Paris. He toured the galleries of Italy, exhibited all over Europe and in the United States of America, and was a foundation member of the Royal Society of Portrait Painters. And so, by the outbreak of the First World War, Bell's position looked enviable. He had the full box of academic-impressionist tricks within reach; his reputation had spread back to Australia; he understood, or thought he did, the scope and meaning of European tradition. When he returned to Australia in 1920, it seemed likely that he would find his slot in the Establishment of returned expatriates, and prosper right up to the final race between Death and a Gallery Trusteeship.

But he disliked the art climate of Australia; there was 'no tradition except that of the best-seller'. To correct this, he started an art school in Melbourne in 1922. But,

from the time I started studying art I had about thirty years of believing that the aim of the artist is to make a perfect representation of the object before him – which is the gospel of impressionism

and his doubts were plaguing him by 1925. He had seen a little post-impressionist work in Europe, and he began to suspect that his own art was as fundamentally invalid as the Victorian anecdotalists', and that a painter's real task was to extract the 'underlying truth' from the chaotic appearances he saw. He fiddled with this idea for nine years, leaning more and more towards post-impressionism. In 1931 Frater and Shore approached him with the idea of forming a school to teach modern art. He accepted; then, in 1934, he left for Europe, leaving his partners to look after the school, announcing in a phrase as naïve as it was defiant that he would 'find the golden key to Modern Art'. He was the first Australian to go abroad specifically to study modern painting.

For sixteen months he travelled in Europe; he studied at Iain McNab's school in London, and visited galleries in Paris and Spain. The painters he paid most attention to were Modigliani, Derain, Braque, Matisse, Picasso, and especially Cézanne – the classical wing, therefore, of post-impressionism, as distinct from the expressionism of Soutine and Van Gogh, which Shore favoured. *Ordo in tranquillitate* was his goal, a calm analytical research into the nature and structure of experience. He perceived, more clearly than his contemporaries at home could, the basis of Cézanne's vision and method, and how it could be applied without slavish copying. Though he admired Van Gogh, he was not drawn to expressionism; surrealism passed him by altogether; he had no interest in subject-matter except as a neutral vehicle for 'pure' painting. These preferences contained the seed of his later disagreements with the younger Melbourne painters and with John Reed, in the early years of the Contemporary Art Society.

Back in Melbourne, he worked again with Frater and Shore. He remained a realist, but accommodated his idea of reality to the demands of internal structure and 'significant form', through simplification and reduction to essential planes. An article in *Art in Australia*, 1938, mentions that around this time he painted 'abstracts', but that 'abstraction he regards...chiefly as a formal exercise.' The idea of abstraction, at that time, had a very diffuse meaning in

Australia; it even embraced cubism – Eric Wilson, in 1942, titled a recognizable cubist still-life *Abstract, the Stove*.

Other painters joined the contemporary classicists: Isabel Hunter Tweddle, who evolved from a nodding acquaintance with Matisse's work a delicate style, tenuously drawn but free in colour; Ada Mary Plante, Mary Cecil Allen, and Moya Dyring; and Lina Bryans, some of whose portraits [50] resemble Van Dongen's.

50. Lina Bryans: *The Babe is Wise*, 1940

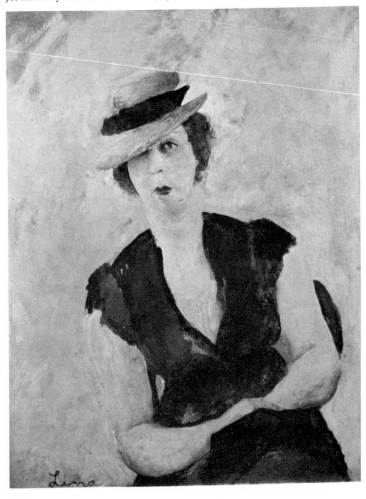

To look at their paintings today is to appreciate the gulf fixed between Australia and Europe. Time slipped a cog crossing the Equator. By 1935 all the great post-impressionists were dead, and Picasso was nearing his sixtieth birthday; Braque, Léger, the cubists, and the Fauves were growing old; Soutine had less than a decade to live, while de Kooning and Jackson Pollock were already at work. But Australia's attitude to the momentous visions which convulsed and revitalized Western art was summed up by a trustee of the National Gallery of Victoria, who murmured: 'I gather there is some upstart called Picasso...'. Cézanne, then thirty years buried, seems much more *avant-garde* than his Melbourne followers. Small wonder, then, that their efforts to brush the cobwebs off the Sleeping Beauty were resisted. Bell's effect was explosive. His was the only specifically modern art school in Australia.

By 1937 the growing influence of the moderns was plain to all in Melbourne. It was viewed with alarm, and counterforce was clearly needed.

It came as a move to establish an Academy of Australian Art, complete with a Royal Charter. The conservatives hoped this would have the power of the Royal Academy in London, setting an official imprimatur on taste which the moderns, needless to say, would not get. The genius behind this project was Robert Gordon Menzies, then the Attorney-General of the Commonwealth. Opening an exhibition of the Victorian Artists' Society in 1937, Mr Menzies said:

You all know of the proposal to form an Academy of Art in Australia. I must admit that I was the prime mover in this idea. I feel definitely that some authority or body should be formed here as in other countries. Every great country has its art academy. They have set certain standards of art and have served a great purpose in raising the standards of public taste by directing attention to good work....Great art speaks a language which every intelligent person can understand. The people who call themselves modernists today talk a different language. – *Argus*, 23 April 1937.

But James Quinn, R.A., the president of the Victorian Artists' Society had invited Bell, Shore, Frater, and other moderns to take part in this show, and had even given them a wall to themselves. At the end of the speech, Quinn sprang up in a huff and dissociated himself from Menzies' remarks. The battle was now publicly joined. Adrian Lawlor's larrikin wit raked the traditionalists. *Arquebus*, an anthology of the year's art polemic he got together, is by far the most entertaining (if not the most objective) document in Australian art; his attack on the fashionable landscapist Buckmaster and his schooling at 'Slitherboys Hall' is a little masterpiece of invective.

Looking back today, the whole affair seems like two Siamese fighting fish tearing one another apart in a small glass bowl. The provincialism was amazing. Attacked by Bell for lack of professional knowledge, Menzies replied that he was an average man of good education and blood, with no pretence to be an art expert, but none the less 'with all my individual defects, I represent a class of people who will, in the next one hundred years, determine the permanent place to be occupied in the world of art by those painting today.' Gallery directors, critics, tastemakers, and pastoral academicians turned round with bemused alarm, like a herd of cows assaulted by a small furious dog, and mooed. The cumbersome mechanisms of the proposed Academy groped onwards. An R.A. was dangled in front of Frater's nose and he bit, thereby coming into line with other supporters of modernism, like Thea Proctor, who thought it best to accept the Academy as inevitable and liberalize it from within. But Bell was furious, and became his lifelong enemy. The Academy never got its Royal Charter. It held five exhibitions, the first in 1938, the last in 1943; then it collapsed altogether.

13 July 1938 saw the formation of the Contemporary Art Society in the rooms of the Victorian Artists' Society. The moderns now had a voice and an organization, a crucial event for local art. Membership was open to laymen and artists alike. George Bell was elected president, with Rupert Bunny as artist vice-president, and John Reed, a wealthy young lawyer, as lay vice-president. Adrian Lawlor was secretary. Soon after its inception, the Contemporary Art Society was rent by a triple schism, between George Bell and the classical post-impressionists, John Reed and the figurative expressionists (like Nolan and Tucker, whom he championed throughout the forties), and the social realists led by Noel Counihan and Josl Bergner. Bell quarrelled with Reed over the basis of selection committees for the Contemporary Art Society shows. The chief disagreement was over two paintings by Sidney Nolan, *Rimbaud* and *Portrait of John Sinclair on St Kilda Beach*, better known as *Moon Boy*. Bell refused point-blank to hang them, and eventually resigned from the Contemporary Art Society presidency.

But in the last assessment, Bell's place stands clear of such vicissitudes. It does not even depend on his merit as a painter; it rests with the understanding of art he gave others. Bell was arguably the most influential single teacher who ever worked in Australia, a seminal figure. It is ironical, then, that his work germinated in Sydney rather than Melbourne. Because his students – Russell Drysdale, Sali Herman, David Strachan, and others – moved to Sydney either before or soon after the formation of the Contem-

porary Art Society, Bell's classicism took root there and combined
with other, already established tendencies, such as Wakelin's and
Preston's post-impressionism and the early work of Dobell. The
split between the formal and restrained poetic reveries of Sydney's
painting in the forties, and the uninhibited 'psycho-expressionism'
that rampaged simultaneously through Melbourne's *avant-garde*,
starts from this point.

In the late thirties, a new tone of discontent was heard among the
artists in Melbourne. It was summed up by a young critic, J.M.
Keon, in 1941:

The artist today has to accept the idea of an interregnum of chaos, and
be a law unto himself. I mean that he must evolve his own laws out of
himself and his experience. He must seek his sanction neither in society
nor in his contemporaries nor his predecessors.... We have to strip our-
selves of predisposition and mechanical acceptance, and present ourselves
in all the nervous and naked avidity of our stripped senses to the incessant
waves of shock that will pour from the new, breaking life. Then when we
have taken deeply and intensely and wholly of the age, when we are
trembling and full-to-sickness with the burden of experience... we can
open ourselves to the subconscious, not of the night-dream, but the day-
dream, and out of that we will evolve a new art, a new consciousness.

Here, in Melbourne, were the issues whose resolution had been
the history of European painting in the previous thirty years. Spon-
taneity against rules; rejection of all existing schemata; the lure of
the irrational; the artist versus society. The myth of innocence – the
idea that innocence was both possible and desirable – had come back
to the South Seas, along a circuitous route that led from Marinetti,
Tristan Tzara, André Breton and Herbert Read. And so had the idea
that art affected society. This never appeared to the Australian post-
impressionists *as* an issue. George Bell was perfectly content to
paint his Cézannist still-lifes without expecting them to change the
way people responded to one another and to their institutions. Not
so the new Melbourne painters. Their art was a tool of protest
against a world which had spun off its axle, and now, like a flywheel
gone amuck, was smashing all values with its ponderous momen-
tum: the world of the Depression, the Spanish Civil War, and the
Second World War.

The existing conventions of Australian painting meant nothing to
them, or very little. This was not because the conventions had been
taken over from European painting – as we will see, theirs were too.
The reason was that they seemed devalued. Pastoral landscape had

atrophied completely, and this was the official art of the time. As for the Australian post-impressionists, they were only interested in the internal poetics of painting: Bell's subjects, or Frater's, were neutral, purged of all emotional overtones that did not stem from 'significant form'. The young Melbourne painters, quite rightly, distrusted the theory of significant form. What was it meant to signify? No answer came.

The chief artists involved were all painters: Albert Tucker, Sidney Nolan, Danila Vassilieff, John Perceval, Arthur Boyd and Josl Bergner. They were all irritated by the complacency of the society they lived in. It was an extraordinary complacency – a dream of comfort experienced on a couch outside history. Australians found it difficult to imagine that anything in the world outside could affect their continent. When the news of the Wall Street Crash came in 1929, a Melbourne newspaper ran a cartoon with the caption 'Humpty Dumpty Had a Great Fall', a cracked egg with the stars and stripes on it; it didn't occur to the editor that what happened in New York was going, as it so drastically did, to have its impact on the Australian economy. Not even the Depression shocked Australians out of their insularity into a sense of world community. By the late thirties Australians may have been dimly aware of Europe's impending Gethsemane, but for most of the population Spain was only a squabble between generals in a comic-opera republic, while Hitler was a Chaplinesque housepainter with a moustache. They did not want to know more. The isolationist view had now become a tradition – migration was not encouraged, the iniquitous White Australian policy had been in force a long time, and (most important of all) Australia's sprawling middle-middle-class had never experienced invasion, conquest, or rule by a foreign power. Indifference is a form of self-protection. In 1937 an Australian could think that the walls of his cocoon were the walls of the world, and push to the back of his mind any events that threatened their flimsy sanctuary. He had even inherited a vocabulary which made this easy. For instance, it is only in the last five years that Australians have got into the habit of thinking of the Far East as the Near North.

Timidity after the jolt of the Depression (which was the one moment between 1914 and 1939 when Australia found itself involved willy-nilly in a world situation) added to the prevailing mood of insular pragmatism, which now, in the late thirties, swamped Australian attitudes to politics, economics, and all forms of human discourse, including painting. What but ingrown national pride led the *Bulletin* to rebuke Sali Herman for painting slums in Sydney? From our distance now, it seems possible that some Australians were

dimly aware that the disasters of 1914–18 were to be repeated on a more catastrophic scale in their own lifetimes, and that this fear set off the ostrich's reflex. Heads plunged into the sand of chauvinism. Intellectual insularity helped maintain one's emotional poise.

But the Nolans, Boyds, and Tuckers in Melbourne rejected this situation; they wanted to 'present ourselves ... to the incessant waves of shock'. They also perceived the connexion between insularity in society and conservatism in art; how society will get the art its social and ethical standards imply. But, in order to bring their revolution into effect, they had to overcome severe difficulties.

First, they were poor. Tucker's father was an undergear repairer in the Melbourne railway yards. Nolan's drove a tram. Boyd was the son of an obscure artist-potter, who was widely regarded as an amiable crank. Bergner was an adolescent refugee from the Warsaw ghetto, and Vassilieff, the wandering Cossack, had nothing but his painting. They were also self-educated, or nearly so. Tucker and Nolan, the most articulate of the group, had been to school but not to university. This point is a little more significant than it may appear (after all, only a minority of painters have been to universities) because it probably affected the type of imagery they chose to use. Public schooling and a university degree were the received proofs of intellectual status; being intellectuals raised outside an academic framework, it was natural that the two painters should embrace an aesthetic theory which rejected the classical role of the intellect in art. Their patron saint was Herbert Read, whose association with the surrealist movement, together with his writings on the role of the subconscious in art, affected the painting of the 'Angry Decade' more profoundly than any art theory has influenced a movement in Australian art since.

The public refused to buy or see their work; this indifference was occasionally relieved by a bout of vandalism, as when a visitor threw green paint at some of Nolan's pictures. Only one critic, Basil Burdett, gave them any support from a position outside the group, and even Burdett's admiration was mainly reserved for Tucker. Poverty and rejection scraped them raw. It was an experience that some of them never quite got over: when Tucker returned to Australia in 1960, one phrase recurred in his conversation – 'I've come back to collect my back pay.' And so their art became a sort of kamikaze charge; having no weapon except their sensibility and a few reproductions of what had been painted in Europe in their time, they had nowhere to go but forward against an entrenched Establishment. It has been said of Yeats that 'mad Ireland hurt him into poetry'. Mad Australia stung Tucker into art, and mad Europe,

Bergner. So too with Arthur Boyd and, later, John Perceval; and to some extent with Sidney Nolan and Danila Vassilieff, though they both had such purely lyric talents that their imagery seldom aimed at social comment and when it did the aim was oblique.

They were stuck on a limb, isolated from European painting and European thought, anxious not to be. What contact they had with Europe was only nominal. It came from reproductions. Other sources were seized on with excessive and touching eagerness. Bergner, who had *lived* in Europe, was thus able strongly to influence men ten years his senior, Tucker and Counihan, though he was only a boy of seventeen, an art student with a transparently immature style. Vassilieff, a mature artist on arrival, aged forty-one, was even more influential.

So here, as with the post-impressionist movement but in a more concentrated form, we have the usual problem. Painters, starting from scratch, try to construct from fragments a cultural pattern which already existed overseas. It is like inferring a dinosaur from one tooth. Of course, they do not invariably succeed. Most of Melbourne's expressionism in the forties was unskilled painting, done by confused men, and by no means very inventive. As form, it was crude – and not always because of some intentional crudity of image. The shock tactics were often wilful. They were more like propaganda *about* art than works of art. But they helped to jolt Australian painting from its warm pastoral complacency; and, for all its derivative aspects, the 'Angry Decade' was not merely ten years of plagiarized expressionism. There is nothing more depressing than the sight of a painter using expressionism as a style, without the experience to feed through the convulsions. But it could be argued that, granted the interests and social experiences of the Melbourne painters then, expressionism was an unusually suitable form for them: there is no doubt that Tucker, for instance, went through the same *angst* in the face of a corrupt environment as Grosz and Kirchner did. One can discover endless style borrowings in the forties – Nolan from Schwitters, Picasso, Ernst and Klee, for instance. These are only to be expected. Art builds on art. The difficulty was in assimilating the influences. Here, the Melbourne painters were less successful. Gobbets of undigested style protrude from their paintings, like bones in a stewpot. And yet they founded a style; nearly every painting that was produced by significant figurative artists in Melbourne during the fifties – Charles Blackman, for instance – bears traces of its origin in the 'Angry Decade'. There was a common ground of imagery, whose existence has to be remembered in even the most general of contexts.

It was affected by literature. In the forties in Melbourne, as never before or since elsewhere in Australia, artists and writers worked along a more or less united front, even without a café culture to tie them together. Nolan read avidly and widely, and produced a perceptive note on Rimbaud; the sources of his imagery were very often literary, and one of his most beautiful early paintings – *The Sole Arabian Tree* – was done to illustrate a poem by Ern Malley, and was printed on the cover of the group's magazine *Angry Penguins* to mark its special Ern Malley issue. Malley, in fact, was a hoax – a fictitious surrealist poet, concocted by two poets of more traditionalist leanings, James McAuley and Harold Stewart. But the scandal which ensued when the hoax was revealed did not, perhaps, spring from issues as clear cut as those implied by an Ossian or the eighteenth-century Shakespeare forgeries. McAuley and Stewart had written Malley into existence by an impeccable surrealist procedure – free association and careful exclusion of logical sense. Indeed, there was a great deal more control in their method than the Dadaists would have liked; they did not, like Tzara, pick letters and words at random out of a paper bag. The editors of *Angry Penguins* contended that, far from writing nonsense, McAuley and Stewart had really managed to write better poetry than they had ever done before, thanks to the relaxation of strict conscious control. Some of the Malley poems – though not all – made perfectly clear sense: 'Dürer, Innsbruck, 1492' is one, with its concluding lines:

> I had read in books that art is not easy,
> But no-one told me that the mind repeats
> In its ignorance the vision of others. I am still
> The black swan of trespass upon alien waters.

Despite the efforts of *Angry Penguins* to keep the debate on a serious level, it rapidly degenerated into journalese and mud-throwing. Its most obvious effect was that, in the words of a later Australian critic, 'it brought the whole craft of poetry into disrepute' – as far as the Australian public was concerned. Needless to say, this happened against the wishes of the hoaxers. Its effect on the group in Melbourne – Max Harris, John Reed, Alister Kershaw, Geoffrey Dutton, Tucker, Nolan, Boyd and others – was to magnify both their sense of isolation and their conviction that their role was a revolutionary one. Crammed together as on a raft, they watched the widening gap between themselves and the rest of Australian society with something akin to exhilaration, mixed with self-pity.

1937 is an arbitrary beginning for the 'Angry Decade', 1947 the obvious end. In 1937 Bergner and Vassilieff arrived in Melbourne.

Tucker began to exhibit in 1936, Nolan in 1939, but Arthur Boyd was still painting conventional *plein air* landscapes and John Perceval was only thirteen. In 1947 Arthur Boyd's expressionism calmed and solidified appreciably, and so did Perceval's; Nolan painted the climactic works of the decade, his Ned Kelly series; Tucker left for Japan, and Bergner for Paris.

But one of the chief precursors of the movement had already left by 1937. His name was Samuel Atyeo.

51. Samuel Atyeo: *Organized Line to Yellow, c.* 1934

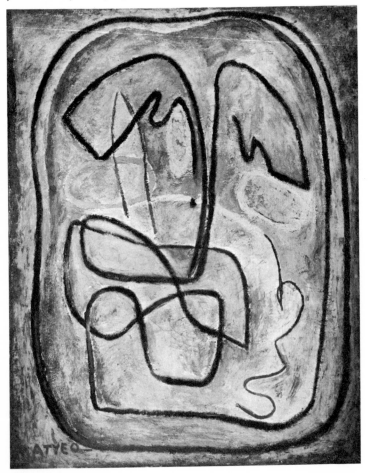

Atyeo's painting life was short. He was a student at the National Gallery School in 1930, and gave up painting after 1937. (He began again in the early sixties, and exhibited a series of abstract water-colours in Melbourne in 1963.) But his work's influence was out of proportion both to its span and its quality.

Bernard Hall, the director of the National Gallery School, thought Atyeo his star pupil. Great, then, was his consternation when Atyeo submitted a painting in the 'modern' manner for the school's travelling scholarship. It no longer survives, and so its modernity cannot be tested. But a portrait by Atyeo, dated 1933, is mildly Cézannist, probably influenced by Frater, and it is not likely that his scholarship entry would have been more advanced than that. Hall, nevertheless, was outraged, and would not hang it. Atyeo countered by putting it in a Collins Street shop-window, where it is said, perhaps not apocryphally, to have stopped traffic.

His work became abstract after 1933; Atyeo had seen reproductions of paintings by Kandinsky, Picasso and Klee in the Leonardo Bookshop, a firm run by an expatriate Italian art critic named Gino Nibbi. Paintings like *Organized Line to Yellow*, c. 1934 [51] are heavy pastiches of Klee, but they had, in their context, a liberating effect. They were obvious links with the overseas *avant-garde* and the local painters could read them as such; whereas earlier abstractions, like Wakelin's and de Maistre's synchromist compositions of 1919, seemed in their day nothing but experiments in a vacuum, since there was no known body of abstract work to which Australians could relate them.

Had all the new arrivals been like him, the course of Australian art might have been radically different; the paintings of Atyeo, Eric Thake, Ralph Balson, Grace Crowley, Frank Hinder, Eric Wilson and other abstract or semi-abstract painters might have merged with the Cézannism of Bell and Frater, leaving Australian images with none of their surrealist and symbolist edge. Four linked events, between 1937 and 1939, prevented this. They were the arrival of Bergner and Vassilieff; the introduction of German expressionism, through Albert Tucker; a spurt of interest in surrealism, helped by Nolan and Gleeson; and the *Melbourne Herald* exhibition in 1939. This was Australia's Armory Show, twenty-five years late. It was financed by a press magnate, Sir Keith Murdoch, who sent his art critic Basil Burdett to Europe to assemble a comprehensive show of modern French and British painting. Burdett was the only man in Australia qualified to carry out this project. He was widely travelled, and apparently he had at least a nodding acquaintance with Gertrude Stein, James Joyce, Picasso and Léger.

The show, after a trial run in Adelaide, opened in the Melbourne Town Hall late in 1939. In its first few weeks it attracted some 40,000 visitors. Nothing like it had been seen in Australia before, and it is a depressing reflection on the exhibitions policy of Australian State galleries that no exhibition of comparable importance has been sent there since. It included Picasso, Braque, Léger, Matisse, Modigliani, Derain, Cézanne, Van Gogh, Utrillo and many others; the most disputed picture in a very controversial show was Salvador Dali's *L'Homme Fleur*. Conservatives and die-hards entangled themselves in apoplectic contradictions over this painting, claiming (*a*) that it was meaningless but that (*b*) its sexual and coprophilic symbolism would corrupt the youth of the city. J. S. MacDonald, the director of the National Gallery of Victoria, fulminated against the exhibition, but his trustees by-passed him and bought several of the milder works for the collection. Lionel Lindsay, whose prejudices had not mellowed with age, flew into a hysterical anti-Semitic fit and wrote a book about modern painting, based on the show, entitled *Addled Art*. In it, he set out to prove that Picasso, Matisse and the surrealists were pawns in a vast Jewish conspiracy.

For the artists, the show was an event of unparalleled importance; it was their first glimpse of major French post-impressionist paintings, and it brought them face to face with the European values they so urgently wanted to comprehend, giving their own work both a context and a standard of comparison. A door had opened briefly. But then it shut; the war broke out, and, although the paintings could not be returned to Europe, they were kept in their crates until 1946 and not shown at all, half in the basement of the Art Gallery of New South Wales, the other half in the National Gallery of Victoria.

L'Homme Fleur helped consolidate a growing interest in surrealism. But it did not bring that movement to Australia. As far back as 1932, Eric Thake had been toying with surrealist imagery. James Gleeson exhibited a surrealist painting, *Attitude of Lightning Towards a Lady Mountain*, at the first Contemporary Art Society exhibition in June 1939. Earlier in 1939, Tucker had painted *The Futile City*, a rolling, empty landscape with a large key standing in the foreground. In fact, few of the painters who were working out alternatives to Cézannism failed to flirt with the surreal. Nolan painted monsters unknown to any zoo; Boyd filled his paintings with strange beasts, flying cripples, and figures bursting from chimneys; Perceval's jack-in-the-box leapt raucously over St Kilda at night.

But of them all, James Gleeson worked closest to the accepted idea of surrealism – that is to say, he imitated Dali so closely that he became a *pasticheur* [52]. But he only went through the motions of

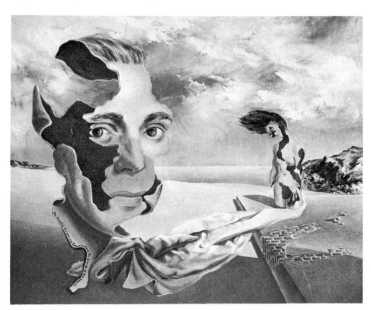

52. James Gleeson: *We Inhabit the Corrosive Littoral of Habit*, 1941

53. James Gleeson: *Across the Threshold*, 1958

Dali's 'paranoid-critical' processes, remaining, fundamentally, a
painter of allegories and literary symbols. He wrote in 1945, of two
paintings he had completed,

> In *The Citadel* I have substituted for wartorn brick and stone a symbolic
> pattern of human flesh, bone, teeth, hair. In *Landscape with Funeral
> Procession* I have tried to catch the moment when physical life rejoins the
> earth, again represented by human flesh. These are the horrors of the con-
> centration camp and the battlefield, seen through the eyes of a surrealist.

Plainly, irrational processes were not of prime importance to him;
once you had the symbolic code, the paintings could be deciphered
at once. Later, Gleeson's work shed its more doctrinaire aspects. He
turned briefly to lyrical and fantastic abstractions, using surrealist
techniques like *frottage* and *fumage*, sponge-marks and accidental
staining; these swirling lunar visions [53] were sometimes inhabited
by tiny figures from Greek mythology.

The work of Josl Bergner and Danila Vassilieff did strike a quicker
response – if not from the public, at least from the writers and
painters. Bergner, a young European Jew, came to Australia at
seventeen. The work he did there was both angry and sentimental;
the anger was clarified, and the sentiment somewhat mitigated, by a
perverse, ironical richness of temperament. His art was dark and it
had a macabre streak; he projected his images into a framework of
Yiddish folklore. Bergner was merely an eclectic, and a minor one at
that. His sources were Daumier, the early Van Gogh, and Picasso's
blue period. But he was a painfully bad draughtsman. This made it
impossible for him to digest Daumier's forms and, by the same token,
all that he retained from young Picasso's already mannered vision
of the poor man as outcast was a bloated, caricatured sympathy for
the underdog. His tones were dark. Domestic subjects emerged from
an abnormally deep range of dark blue, brown and black. His
figure-compositions, like *The Pumpkin Eaters*, 1943 [54], were
simply held together by a viscous pall of muddy paint. But if
Bergner had so little *formal* vitality, why did he attract attention in
Melbourne ? The reason, I suspect, is twofold. First, he gave the art
world there an acceptable pastiche of Northern expressionism.
Secondly, he had the cachet of being a European, and therefore a
man encrusted with history – even though he was only in his teens.
Bergner's dramas were enacted by rejects and flotsam: street-
cleaners, bums, empty women clustered at street corners, or
persecuted aborigines. Now the nature of Australian society, which
is a long bourgeois sprawl, has produced a queer reflex in its art
audience. The Australian who paints social injustice will be dis-

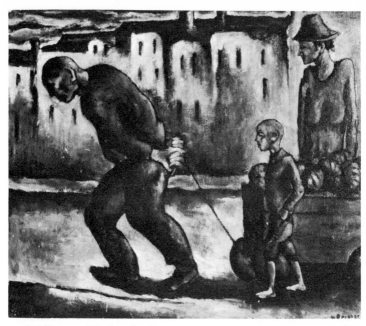

54. Josl Bergner: *The Pumpkin Eaters*, 1943

missed as an unrealistic agitator. It can't happen here. But if a
European does so in Australia, he will have a better audience. The
Australian intellectual's fear of being thought insensitive to a world
situation will at once begin to tick. Or so it did, on Bergner's behalf,
in the forties. Unfortunately, most of the paintings by Bergner which
were most admired by his contemporaries have disappeared. These
were the Warsaw Ghetto suite. Apparently they were a good example
of the way a painter can produce images without direct experience of
their content: when he was in Australia, the Germans razed the
Warsaw ghetto – where Bergner had spent some of his adolescence –
and murdered its inhabitants, while (or so the story then went) the
Russian Army stood by and refused to intervene. Bergner turned
this into the subject of some twenty paintings. They proved unac-
ceptable to the Australian Left. So Bergner resigned from the
Communist Party and was duly denounced by its Stalinists as a
Fascist. He left Australia in 1947 – a year in which several other
painters departed from Melbourne.

Meanwhile a group of social realists had formed. They were all, in
varying degrees, influenced by Bergner. Victor O'Connor and

Herbert McClintock painted the expected slums and breadlines. But McClintock also produced crude surrealist paintings, which he signed 'Max Ebert'. The pseudonym was perhaps made necessary by the very strict line which the Australian Communist Party took on modern art in general and surrealism in particular. It was 'obscurantist', and painters, in time of war, had better things to exercise their imagination on than mere fantasy. Art should help the war effort by inculcating patriotism. This was the motive behind the Anti-Fascist Exhibition, held in Melbourne in 1942, in which all the painters – surrealists, expressionists and social realists – participated. (We do not, alas, know how many Melbournites were inspired to shoot Germans by Noel Counihan's paintings of firing-squads, Tucker's *Children of Athens* and Nolan's *Dream of the Latrine Sitter*.) But this concord between factions was brief. The social realists felt that, even though Hitler banned modernism in Germany, modernism in Australia was potentially Fascist: it confused and distracted the public. On these grounds, Counihan, O'Connor, Bergner and McClintock, aided by Bernard Smith, argued against the Nolan–Tucker–Reed–Harris group. 'The swastika,' Bernard Smith stirringly proclaimed, 'now flies from the top of the ivory tower.' In fairness to the social realists, one should remember that their paintings were not always as silly as that. This was especially so in Counihan's case; in his early paintings, like *At The Start of the March*, and *Pregnant Woman, c.* 1943 [55], the slow, vehement forms could be quite moving.

In Danila Vassilieff, we come to the most oddly neglected artist in recent Australian history. No critic since Basil Burdett has paid much attention to his work. 'Melbourne,' Burdett wrote, 'may have as ample cause to be ashamed of its neglect of Vassilieff in the fullness of time as Paris for its former scorn of Gauguin or Van Gogh.' This strikes me as wishful thinking, since there is nothing in Vassilieff's work to suggest that his talent approached the level of Gauguin's or Van Gogh's. But even if one puts Burdett's remark down to partisan gush, which it was, Vassilieff is still worth looking at.

His life fulfilled most popular ideas of Cossack behaviour. Born in 1897, twelfth of a farmer's family of eighteen children, reared on the black soil of the Don basin, he was trained in the Imperial Military Academy at St Petersburg; he fought as an officer with the 8th Don Cossack Regiment in the First World War, then with Denikin's army against the Reds; captured by the revolutionary forces, he escaped from prison, stole a horse, rode bareback 150 miles to the Black Sea, and, helped at first by Tartar freebooters, made his way to India, to Shanghai, and thence to Queensland. There, in 1923, he began to paint, but none of the paintings he did have survived. Six

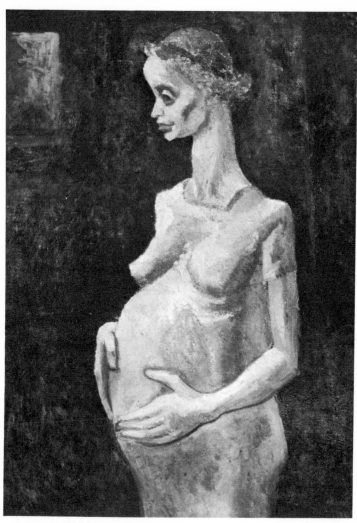

55. Noel Counihan: *Pregnant Woman, c.* 1943

years later, anxious to get some formal art training, he went – of all places – to Brazil, where he studied under an old fellow-officer turned jobbing portraitist, Dmitri Ismailovich. In Ismailovich's studio, Vassilieff acquired a skimpy knowledge of academic draw-ing, but, soon bored with this discipline, he presently left on an

expedition up the Amazon. When he returned he barnstormed the West Indies, working, it seems, as a kind of sidewalk artist; he reputedly produced up to a hundred paintings in a week and sold seventy in an afternoon. It would be difficult to imagine a background in art which could have been more superficial or ludicrously strained than this. But Vassilieff next went to Europe. He spent two years travelling in England, France and Spain; he visited museums assiduously, and held several exhibitions, though the story one often hears in Melbourne that he was on the way to making a European reputation is, as far as I can discover, without any foundation. Finally, in 1936, he decided to go back to Australia. In 1937, aged forty-one, the wanderer Cossack arrived in Melbourne.

Bergner and Vassilieff were both expressionist artists, but their minds were quite differently cast: the extrovert, sprightly Vassilieff, with his indifference to popular social issues, had little in common with Bergner's gloomy sense of injustice. Vassilieff was a remarkably spontaneous artist, or, more precisely, he was able to preserve an illusion of spontaneity in paintings which were often meticulously considered. For instance, in 1953 he produced a suite of twelve gouaches, to illustrate the Russian fable of Peter and the Wolf. They capture the innocence and profusion of a child's world [56] and they looked quite unpremeditated; yet he painted over 200 versions before he was satisfied. But often Vassilieff's desire for innocence

56. Danila Vassilieff: *Peter and the Wolf* (1st series), 1953

led to a hurried and far too cursory treatment. The street-scenes and portraits of the forties are painted with a touch which is almost too light; form is weak, and the gestures are summary in the extreme. Vassilieff's pale brisk pigment was 'written' on to the canvas with a cursive brush [57] but his calligraphy tended to be incoherent. One has only to compare Vassilieff's lyrical scribbling with

57. Danila Vassilieff: *Fitzroy Street Scene, c.* 1937

Nolan's later Dimboola landscapes, which were influenced by Vassilieff – the scrubby, dotted gums, the sense of transparency within apparently solid forms – to see how the Nolans work as shapes where the Vassilieffs do not. However, much of the beauty of Vassilieff's best work – especially of his first major Australian series, the Carlton streetscapes – does stem from a combination of free gesture and controlled structure.

It has been said of Vassilieff that his Australian years were a search backwards for the values of his childhood. Australian rivers, the Murray and the Darling (he liked calling them 'Father Murray' and 'Mother Darling'), replaced the Don, beside whose sweeping currents he had lived; the folk-heroes of his youth, like Stenka Razin, a legendary Cossack brigand – a kind of Ned Kelly, in fact – recur in

his paintings and sculptures. His style and images became more and more *faux-naïf* towards the end of his life, without altogether succumbing to that posed infantilism which waits to entrap painters who imitate child art. He had been close to children since he arrived in Melbourne. Two friends, Clive and Janet Nield, ran a progressive school named 'Koornong' at Warrandyte, a country district outside Melbourne where Vassilieff had built himself a large, rambling, troglodytic stone *dacha*. Vassilieff became their art teacher. The school was a remarkable experiment, and its disciplines were permissive in the extreme. The pupils virtually ran the place. Even the prefects were democratically elected. 'Don't vote for Wendy,' a rival candidate proclaimed at one such poll, 'she's pregnant.' The emancipated infants swarmed over Vassilieff's house for nine years, and he saturated himself in child art, with its vivid, uninhibited and inaccessibly pure imaginative life. The myth of the innocent eye was one which Vassilieff believed. A myth it remained; but this contact with children sustained Vassilieff's fascination with untrained, direct, conceptual images, which was also one of the preoccupations of the 'Angry Decade' as a whole.

As early as 1936, Albert Tucker – who had no academic training, and, having been born in 1914, was then twenty-two – drew Burdett's attention. By 1937 his work was prefiguring some aspects of German expressionism, with its harsh green and red-hatched brushmarks and its violent dives between light and shadow. I say 'prefiguring', because, as far as is known, no reproductions of German expressionist paintings – certainly no colour prints – had reached Australia by 1937.

However, in 1939 Tucker found prints of the paintings of the *Blaue Reiter* group in the Fine Arts room of the Melbourne Library. In imitation of these, Tucker painted a number of small, vehement canvases. The first of his expressionist pictures was *City Lane*, 1939, a rather crude pastiche of expressionist style whose heavy planes of colour were tied together by a thick, lifeless black line. Other studies of the city followed, with heads – mostly self-portraits – and a few interiors, whose emphasis on pattern (newspapers, linoleum, wallpaper) distantly recalled cubism.

These pictures now look simple enough, not to say banal, but they were obscure experiments in the context of Australian art then. Tucker felt that they were leading him into a purely aesthetic position, and he wanted to produce art which could carry violent social criticism. To ensure this public catharsis, he entered a phase of social realism in 1940. But his social realism differed from Bergner's or Counihan's in that it was not 'political' – that is to say, not Marxist.

It had no programmatic content. Tucker, in those years, was a non-party man, an anarchist with leanings towards Trotsky. The sufferings of the people in his paintings were treated as symptoms of a general moral decay, not of specific political movements. And this obsession with *moral* evil came to dominate Tucker's work. For a time it became exclusively sexual.

Tucker therefore found no favour with Melbourne's vigorous Left. He and Counihan tussled acrimoniously across the pages of *Angry Penguins*. 'Intellectuals of the world unite!' Tucker snapped in an issue of 1943. 'You have nothing to lose but your brains!' He studied Eliot's poetry, especially *The Waste Land* – from whose surface he and his contemporaries, like Gleeson, were able to mine a significant part of their imagery:

> And I, Tiresias, have foresuffered all
> Enacted on this same divan or bed:
> I who have sat by Thebes below the wall,
> And walked among the lowest of the dead...

Blind Tiresias could prophesy but not act, and it must have seemed to Tucker that Tiresias was a metaphor of his own condition. He was trapped in a hostile environment, able neither to change it nor to get out. This frustration, which verged on paranoia, lent his social realist paintings an oppressive, sealed atmosphere of evil and despair, which glares through the crude paint, the inept drawing and the naïve and literary imagery. *We Are the Dead Men*, 1940 (a reference to Eliot's 'Hollow Men'?) is a strained allegory distantly related to Grosz, where a wedding-party is confronted by a fiddle-playing skeleton in a trench coat. Tucker's dissatisfaction had its most piercing expression in the skeletal figures of *Children of Athens*, 1942, and *Spring in Fitzroy*, 1941, a seated figure in workpants and singlet staring vacantly into a drab street.

For some years afterwards Tucker's art oscillated between expressionism and social realism; indeed, in most of these paintings, there is no line between such categories. He took part in the Anti-Fascist Exhibition in 1942, and the paintings he exhibited there were among the last of his works in which a surrealist flavour was not present. In 1941 he had taken the first step in the development of his present iconography, which derives, ultimately, from surrealism.

This was the series entitled Images of Modern Evil, some thirty-five paintings which ran from 1943–6. (Later they were entitled Night Images, and were exhibited as a group at the now defunct Museum of Modern Art in Melbourne in 1961, and at various State galleries in 1962.) They may be considered, together with Nolan's

first Kelly series of 1947 and Drysdale's outback paintings of 1941-5, among the most important achievements in the formative years of modern Australian art. As paintings, they do not approach either Nolan's or Drysdale's; plastically, they are far less articulate. But their value lay in what they implied about the use of imagery.

In 1941 the war was in full swing and Australian troops were in action, while their home cities were gripped by the usual patriotic hysterias. Army uniforms, as they always do in war-time, became erotic images. In Melbourne, part-time prostitutes, nicknamed the 'Victory Girls' (some of them made a point of wearing red, white and blue skirts), went looking for heroes.

One of the figures in a picture Tucker produced in 1941, *Pickup in the Dark*, threw a crescent-shaped shadow under a street-lamp. The latent sexual content of this crescent-form now became apparent in the curved, red, distorted mouths of his *Victory Girls*, 1943. Soon, Tucker was isolating this crescent-mouth and using it as an independent 'sign'. It gave its surroundings – the dark streets of Melbourne – a peculiar symbolic charge; it emotionally transformed them, and it so obsessed Tucker that he found that none of his paintings would work without it. The red crescent became his main structural symbol. It was the first appearance, therefore, of a true symbolic form in Australian painting. This use of imagery derived from, or at any rate resembled, the obsessive images of earlier surrealist painters, which likewise came from deeply rooted and sometimes disagreeable experiences – Max Ernst's bird, for example, or Chirico's dummies, or the cherries and faeces which recurred in Dali's paintings. It was from this symbolic procedure that Tucker's Images of Modern Evil were born.

The Images of Modern Evil were all set in familiar places – the beach and promenade at St Kilda, a cast-iron balcony at Jolimont. Against these banal sets, Tucker painted astonishing confrontations: parodies of the human figure, with the red crescent hovering above them or growing on a stalk from their bodies. One of these is set on the St Kilda tramlines [58]; a tram clanks along, its yellow headlamp glaring down on a stack of these lumpish homunculi, piled in grotesque embraces beneath the curlicued, and oddly sinister, green cast-iron of a street-lamp. The colour of the light is raw, edgy, a concretion of noise. The surrealist technique – setting a fantastic image in an everyday streetscape – is obvious enough.

Like most young Melbourne artists at the time, Tucker had met George Bell, who introduced him to Modigliani's work and Cézanne's. His interest in Cézanne led him to cubism, but the aspect of Picasso that interested Tucker most was not so much the cubist

58. Albert Tucker: *Night Image* (Images of Modern Evil No. 11), 1945

pictures as the surrealist 'Anatomies' and the paintings of Marie-
Thérèse Walter which Picasso produced in the thirties. Their
influence appears in some paintings which Tucker made in 1944, on
the theme of murder. They concerned an American soldier, named
Leonski, who sexually assaulted and then murdered some women in
Melbourne when he was stationed there during the war. Tucker
broke the image down into a small range of symbol-forms: large,
rhythmically drawn limbs, drums, the American flag, and a hand

crushing a dove. ('She twittered like a bird,' said Leonski, when the military police asked why he had killed his last victim.)

In 1942, aged twenty-seven, Tucker was drafted into the Army. He was posted to a training-camp at Wangaratta in north-eastern Victoria, where he was assigned to make detailed medical drawings of wounds in the military hospital. This was the first time that Tucker had actually *seen* real pain and disfigurement, and the experience strongly affected his later images – particularly the Antipodean Head, whose fissures and craters derive from memories of gas-burns and bayonet wounds almost as much as they derive from Dubuffet. A painting named *Cratered Head*, for example, which he painted in 1958, was directly projected by a submerged memory, sixteen years old, of a man whose nose had been sliced off by shrapnel.

It is impossible to find a light-hearted or even a sensually attractive painting from Tucker's early years in Australia. Even after the Images of Modern Evil finished in 1946, he kept hammering at his obsessive theme, moral degradation. For example, he painted a string of portraits of criminals and madmen from newspaper photographs. One was a young man who had killed his mother, cut her up,

59. Albert Tucker: *Portrait of a Sadist*, 1946

and tried to cremate her in the living-room fireplace; another, a sadist who was found kicking a dog to death in a suburban street. The news photograph – whose hallucinatory objectivity Bacon has brilliantly exploited – registers a grey impact, freezing an instant of life with the utmost immediacy. Tucker's *Portrait of a Sadist*, 1946 [59], with its dramatic shadows, expressive drawing and relentless 'grip', is one of the best portraits – indeed, one of the few good portraits – ever painted by an Australian. The criminal's face becomes a psychological chart, on which Tucker tried to decipher the motives of the act and the social pressures behind the motives. One feels that, to an unusual degree, he has identified with this man. And in fact, he had come to believe that art had a lot to do with madness: that the madman's will to absolute action, and the artist's right to complete freedom of invention, had much in common. Both men are free because, and only as long as, their private worlds of fantasy do not touch their environment until they explode into action.

When Tucker left Australia in 1947 the environment had beaten him. 'I am a refugee from Australian culture,' he said on the wharf.

After the prickly fantasies of Tucker's early work, so anti-poetic despite its sophistication, knotted with self-pity, raucous with contempt, and totally anti-humanist, it seems a relief to turn to Arthur Boyd. Tucker rejected his origins, and when he realized it ten years' later and tried to recapture them his art was strengthened. Boyd, a slower, less articulate man, never lost grip of his. This, in no small part, made his steady, consistent development possible. The root of Boyd's art is a pure, lyrical sensibility, to which all other aspects, including social protest, were subordinated.

This, in part, was a family legacy. His father was Merric Boyd, a potter. His uncle, Penleigh Boyd, was a talented landscape painter. And the whole family environment was self-enclosed, an enclave within society, very private and, though not in a formal sense, intensely religious. Towards his death, Merric Boyd withdrew more and more into private contemplation. He was an eccentric old man, and extremely devout; his world was populated by the imagery of the Old Testament. This is part of the background to the folksy religious paintings and ceramics which Arthur produced between 1947 and the middle fifties.

Boyd's conversion to expressionism came later than Nolan's or Tucker's. But it is interesting that he *was* converted to it. Between 1936 and 1941, Boyd had developed quite precociously as a 'straight' landscape painter. His rolling hills, bathed in wintry sunlight under an ice-blue sky, were painted with an incomparably more developed technique than either Nolan or Tucker had at their disposal. To

divest himself of this facility was a brave act, and in Boyd's earliest expressionist paintings, the first of which was *Progression*, 1941, you sense the painter trying, dutifully, to be graceless and get rid of his vocabulary. Space is compressed, the figures – one in a wheel chair, the other pushing him down a street – stare out of the painting with melancholy expressions, and their eyes are huge, the focus of the whole painting – a constant tendency in Boyd's work.

Between 1942 and 1944 he painted his first groups of expressionist– surrealist images. These had an urban setting, often the beach and parks of St Kilda. This noisy, lonely strip of sand, ferris-wheels, Big Dippers, neon lights, ugly bungalows, trams, and crumpled chocolate-wrappers, clanging with traffic, smelly and packed with people in the vibrating heat of summer, deserted on rainy nights, haunted the young painters. For Nolan it was the garish background of a child's dream. But to Boyd it was an arena for madness, where innocence and experience grappled. He peopled beach and park with half-formed figures, locked in desperate embraces, hobbling on crutches, flying, or gesturing in despair. Strange beasts appear: rams, goannas, butterflies, crocodiles walking erect, obscene pig-like mutants. This demonic zoo of private symbols recalls Bosch and the 'Hell' of Brueghel, whose work Boyd especially admired. Though

60. Arthur Boyd: *The Butterfly Man*, 1943

their recurrence gives them a certain consistency, these animal-images cannot be wholly deciphered. The butterfly being chewed by the dog – if it *is* a dog – in *The Butterfly Man*, 1943 [60] is certainly an image of innocence, just as Boyd's cripple is an emblem of innocence destroyed. (It may, on another level, refer to his close friend John Perceval, a polio victim.)

In the close and frenzied world of Boyd's St Kilda and Fitzroy paintings, fragments of normal experience only heighten the tension. Thus the frills of Victorian cast-ironwork became obsessive patterns whose regularity pushed hysteria further. Nothing is held back; the emotional display is utterly explicit, and as a critic remarked, 'All passions stand on an equal footing....Expressiveness carried to the point of extremity, whether of pleasure or pain, leads us in each case identically to the despair of complete isolation.'

Thus Boyd, like Nolan, Perceval and Tucker, found that a violent form of fantasy could express his own sense of being cut off within society. This impulse continues in his next two series, the Hunters and the Lovers.

Drysdale and Nolan have produced the popular image of romantic Australian landscape: a desert, dry as a red bone. But if one wants the primeval, more of it is to be found in these forest paintings of Boyd's than in, say, Nolan's aerial views of the Central Australian ranges: for Boyd painted a damp, opulent tangle of elemental trees, a vegetable morass in which all life, in its most delicate or monstrous forms, is emerging for the first time. His paint was appropriately dark and gluey, applied in a heavy impasto. It is a pity that the Hunters and Lovers series have been overlooked, for in them Boyd formulated one of the few original visions of landscape ever seen in Australia, which – surprisingly enough – owed nothing to Nolan's rediscovery of the outback scene in his Dimboola and Wimmera paintings. In the dark forests, mole-like figures scurried and embraced, apparently made of the same material, and animated by the same sap, as the trees. In these paintings, such as *Lovers by a Creek*, 1944 [61], Boyd evoked an intense correspondence between figure and landscape – a sense of undisciplined, sprouting life which is also at the centre of his most recent works.

Boyd's religious paintings and ceramics, which he produced from 1947 onwards, are less pregnant with awe than these forests. They have the peasant flavour of Brueghel, but none of his intimations of disquiet. Each event – Nativity, Crucifixion, Expulsion from the Garden – happens in the background of a swarm of other activities: the bustling village in the foreground, the distant crosses on the hill. Boyd's Christ, an amiable brisk bar-tender, strolls over the gunwale

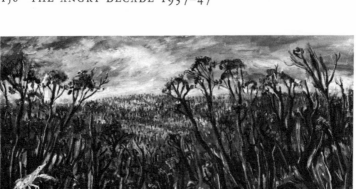

61. Arthur Boyd: *Lovers by a Creek*, 1944

of the Apostles' skiff on to the Sea of Galilee. The great patriarchal figures of the Old Testament, Moses and Abraham, emerge from Arthur Boyd's ceramic panels looking very like the painter's own father, Merric Boyd. Even God the Father is a vigorous, paunchy old chap in a flapping smock. It is all domesticated, earthy and cosy, and one is put in mind of Stanley Spencer's vision of the peaceable kingdom come to Cookham. To have Jacob sleeping in a landscape of tangled gum-trees, with the galvanized iron vanes of a pumpmill in the distance, sounds like an eccentric conceit; yet to look at *Jacob's Dream*, 1946-7, is to sense the rightness, and the genuine religious force, of such an image.

John Perceval appeared in 1943, when John Reed, the backer and co-editor of *Angry Penguins*, reproduced several of his paintings in that magazine. Perceval, born in Western Australia in 1923, had little art training – he went to an art school but left after a few weeks – and that was perhaps fortunate, since the hall-mark of

his work has always been its unreflective spontaneity, arising from a complete, instinctive identification with the subjects he paints. His paintings before 1943 were influenced by Tucker; a battlefield allegory of 1942 is done in a style close to Tucker's *Children of Athens*, with skeletal figures rendered in brusquely slabbed-out planes. Perceval and Boyd were close friends, and there was a steady give-and-take between their paintings. Thus the St Kilda funfair recurs in Perceval's art, though the animal monsters do not. Perceval's imagery was congested, swarming with dissociated symbols. His recent work has been compared to John Olsen's – falsely, I think,

62. John Perceval: *Hornblower at Night*, 1944

though there is a similar immediacy of gesture – but it is not gener-
ally realized that, fifteen years before Olsen hit on his way of indicat-
ing the flux of experience by recording individual incidents in
profusion, Perceval had developed a similar method in his St Kilda
paintings. It is interesting to compare Perceval's *Hornblower at Night*,
1944 [62] with Olsen's *Portrait Landscape No. 2*, 1961–2 (d).
Perceval's favourite images were masks and a jack-in-the-box. They
were the stage-props of a child's world, but infused with menace. The
masks float in the corner of a room; the Jack springs ferociously
over the city at night. *Hornblower at Night* also anticipates the work
Perceval was to do fifteen years later, his ceramic angels; Hornblower
has the face of one of these winged urchins, and, like most of the
faces Perceval painted in the forties, it is partly a self-portrait too.

Often, Perceval's distortions were functional: he is a highly tactile
artist. The animal's claws in *Boy with Cat*, 1943, are made huge, so as
to emphasize their power to scratch and hurt. The brutal paint
handling of such pictures led critics to think Perceval a crude
technician – which, at the time, he was. 'Perceval's pictures,' wrote a
fellow-artist, John Brack, 'resemble furniture made with an axe.'

But within two years after the war, Perceval's expressionism was
settling into *bonhomie*. While Arthur Boyd had his two loves,
Brueghel and Rembrandt, Perceval began to look at Tintoretto.
This was difficult, as he had no means of seeing a Tintoretto in
Australia; consequently what he could find out about the great
Venetian came entirely from bad magazine reproductions, notably a
series which appeared in *Life* magazine. It is an ironical comment on
the way schemata get formed in isolation that one feature of the
'Tintorettos' which Perceval painted in 1947 was based on an error of
printing – their uniform yellow tone. Here, in any case, was a calmer
view of the world (no trace of Tintoretto's own intensity): through
swirls of fat paint, Joseph and Mary jogged along on horseback, in a
decorative serenity that no war-time stress could disturb. Though
late in 1948 he all but gave up painting for eight years, the 'Tintoret-
tos' defined a new direction in his work, which still persists; and
though other gains are undeniable, one may regret the extent to
which Perceval sank his fervour in amiability.

We now come to that singular and mercurial artist, the only
Australian painter with a large overseas following, hailed variously
as the outstanding lyric talent of the fifties and as the Bernard Buffet
of Bond Street: Sidney Nolan.

At one time, it was customary to regard Nolan as a *naïf*, untutored,
unsophisticated, the billycan poet among the taxicabs. This illusion
grew because Nolan's early work had not been seen in London. In

fact, Nolan's 'innocence' – if one takes the word to mean the innocence of the primitive or the child artist, who draws conceptually, with no existing styles at the back of his mind – was always a fiction. His earliest work shows this clearly. Of all the artists in Melbourne, he was the one most in touch with what had been happening in Europe. From 1937 to 1940, he assiduously imitated Klee, Picasso, and – in a series of Christmas Collages which he assembled, in December 1939, out of newsprint, cloth and coloured paper – Kurt Schwitters. The primitive figuration we now associate with his work came much later.

It was in 1938 that Nolan came into contact with Sunday and John Reed. John Reed was a lawyer, a graduate of Cambridge, and heir to a Tasmanian fortune. His wife came from a wealthy family of Melbourne financiers. Neither was an artist; both were passionately interested in the arts. The only sustained appreciation and patronage that Boyd, Nolan, Tucker, Perceval and Vassilieff, not to mention the young poets like Max Harris, received during this crucial decade came from the Reeds. Sunday Reed, in particular, was prompt to recognize Nolan's talents. He became a central figure in the close-knit, symbiotic group that revolved around the Reeds' house at Heidelberg. In fact, he lived there for several years, supported by John Reed and supplied with all the materials he wanted. This, in turn, made his enormous output possible during the forties; other artists like Tucker were often hampered by the fact that they could not afford to buy paint. Nothing prevented Nolan from painting incessantly, exploring every dimension of his fantasy.

He was drafted into the Army in 1942. He ended up in a training-camp at Dimboola, in the wheatfields of the Wimmera district of Victoria. This country, its golden miles of grain shimmering under the brassy sun, deeply affected Nolan, and for sufficient reason: in the boredom and frustration of Army life, he had nothing else to look at, and after his childhood in the city he was, virtually for the first time, thrown in close contact with landscape. He discovered it with unskinned eyes, and produced a series of paintings which captured the peculiar slide and glitter of light, the ambiguity of distant objects and the multiple reflections of sun. These, the Dimboola and Wimmera paintings, were a surprising achievement: Nolan rescued Australian landscape, at one stroke, from the blue-and-gold limbo into which it had fallen, and his paintings exhale that magical sense of first-time confrontation one sees in an early Streeton or Roberts.

The Crashed Aeroplane, 1943, a Dimboola painting, illustrates this, and so does a figure-painting called *Boy in Township*, 1943 [63], but

63. Sidney Nolan: *Boy in Township*, 1943

from a different aspect. Nolan had heard about a child mummified by the heat of a bushfire, and in the painting the small body floats, still in its bright clothes, above the wreckage of buildings. Here a curious but typical aspect of Nolan's imagination showed itself. Were Drysdale to tackle such a grisly subject, the drama would come from an allusive naturalism. But Nolan gives no detail of disaster; he presents us with a doll, and puts us several removes from drama. This detachment is an essential effect of Nolan's work; it extends itself in many ways, even to the sexlessness of Mrs Fraser or his androgynous Leda. Under another aspect (of which we will see more later) it is part of Nolan's refusal to admit time as a dimension of his work.

Concurrently with the Wimmera paintings, Nolan produced some violently distorted heads of soldiers, thus working the remnants of Picasso's influence out of his system. One, now owned by the Museum of Modern Art and Design of Australia, was reproduced on the cover of Reg Ellery's *Psychiatric Aspects of Modern Warfare*. Then, in 1945, out of the Army and back in Melbourne, he turned

64. Sidney Nolan: *Under the Pier, St Kilda*, 1945

out a spate of pictures which, for the generic source of their imagery, are called the St Kilda series. (In this brief survey, I cannot trace Nolan's transitional work between Dimboola and St Kilda in detail. One example of it was *The Sole Arabian Tree*, 1944, whose flowing colours recall the Wimmera chalk drawings.) Nolan's view of St Kilda, as I have already remarked, lacked the wild melancholy of his fellow painters' [64]. Even his most eccentric improvisations maintained a certain degree of flyaway lyricism: one thinks, at random, of the image in a funfair distorting mirror, *Giggle Palace*, 1945; or four studies of bathers on St Kilda Beach, 1945, whose stick limbs and dislocated postures show the same careless spirit of pure experiment as Picasso's drawings for his abstract–surrealist anatomies, rendered in vivid greens, blues, and burning yellows.

Thanks to the uninhibited anti-stylism of his responses, Nolan, like Vassilieff, could use child art without posing. No doubt he had seen plenty of it at Vassilieff's home in Warrandyte. The bold flat patterns of child art, the clumsy organic line, the sudden shifts of

scale between figures and their surroundings: all these are present in *Catani Gardens* and *Under the Pier, St Kilda*, 1945 [64]. The contrast between the huge and tiny bathers in the latter painting was to become an effective device in the Kelly series, where Kelly (in Glenrowan) is a monster overwhelming the doll-like troopers and blacks. In these St Kilda pictures there is little formal composition by mass. Their cohesion comes rather from shifts of space, induced – as in the toyland *Picnic, St Kilda* – by advances and recessions of pure colour; or from linear emphases, like the insistent zigzag of flags along St Kilda Road in *Carnival*.

With the St Kilda pictures came a number of landscapes, which amplified his Dimboola images and prepared his vision of the bush for the arrival of Ned Kelly. *Narcissus*, 1947, stares moonlike from a misty background of grey-green scrub: an exquisite record of romantic sensibility, whose mood is carried forward into a number of Gippsland landscapes, painted around 1945–6.

At that time, Nolan set to work on Ned Kelly: the first of his outsider-heroes.

Kelly was the last of the bushrangers. He was hanged in Melbourne, for murder and theft, in 1880. But he occupies a most complex position in Australian imagination, and has been transformed into a folk-hero. I doubt if any criminal has so effectively become a myth in so short a time as this young, crudely idealistic, vengeful Irishman. To understand why, one needs to observe an unfamiliar but essential aspect of the Australian character: its 'Camusian' streak. This comes from a basic split between a strong sense of purpose, and a fundamental inability to believe that purposive action has any ultimate value. Max Harris wrote:

> The world of personal 'becoming' is neither purposive, rational, nor tragic in failure, but absurd. Faced with the depressing conviction that human purposiveness results in absurdity rather than meaningfulness, Camus advocates an 'as if' attitude to living...from the impermanence of life in Australia, from the intractable environment, weather, and seasons, the migratory conditions of work, the feeling of isolation from the European mainstream, the Australian has developed instinctively a world-view that correlates with Camus' ideas.

You do something vigorously, but not from a real faith in its *raison d'être*; colloquially, 'a bloke might as well give it a burl'. The hero is not diminished by the philosophy of the absurd; instead he is given exquisite stature, for what is heroism but absolute action? The man who knows the final absurdity of his actions is, under this aspect, the only free one. Now this idea of action, graven on the Australian

social personality at a level deep enough to be inarticulate, was summarized by the short life of Ned Kelly and epitomized by his last words as the noose went over his neck, 'Such is life'; a shrug that echoes through Australian history.

And so Australians have always had a most ambivalent attitude to the memory of Kelly. On one level he is talked about as a folk-hero. But the implications of that myth go deeper than the mere fact of his being a felon into a sensitive area of self-disclosure: every prison is full of anonymous crooks, many of them guilty of worse crimes than Kelly ever committed. To celebrate Kelly, the rebel, is to deny the existence of ultimate values of action and to uncover for a raw moment the basic streak of existentialism instinct in our society.

To Nolan, Kelly was 'a natural part of my growing'. His armour, black and dented, was to be seen in the Melbourne Aquarium. Though he had done a number of Kelly monotypes in 1944, his immediate decision to paint the series was precipitated by two things. One was a cheap booklet called *The Inner History of the Kelly Gang*; the other, a long walking-tour with Max Harris through the 'Kelly country' in Victoria, tracing, as it were, the bushranger's progress through his own landscape. 'I realized that the bush and the Kelly helmet belonged together.'

Nolan's slotted helmet-mask is close to the original armour, but still a highly abstracted form. By conflict between this flat black shape and the bush around it, painted with extreme delicacy, it endows its environment with numerous unexpected overtones. The parallel that springs at once to mind is Tucker's red crescent-form in the Images of Modern Evil, which, though more cryptic and abstract, also worked as a 'metaphysical radiator'. It is a remote comparison, and not to be thought of in terms of cause and effect: but it indicates a common ground of symbolical technique, and a shared interest in iconographic form: an issue which had never arisen in Australian art before.

But no more than a shared interest: it would be impossible to find two series more dissimilar than Tucker's and Nolan's. To begin with, the 1947 Kellys are narrative pictures – a mode of art which was thought to have vanished with Roberts. Each illustrates an episode in Kelly's life. Superficially, this appears to be done in a mock-primitive style. But to call them 'primitive' is to abuse the term. The Kelly series exists in absolute clarity, beyond style or classification. Barrie Reid described the effect perfectly:

On Fraser Island there is a stream which flows out of the sunlight across the white sand and into the shade of the tea-trees. There, walking

across the sand, you touch its coldness before you see the stream. It is hidden by its own lucidity. Trace the stream to its source and you will not uncover the secret of its identity: for there the same clear mirror reflects the surprise of your first encounter....Painting at a certain level contains this same beautiful dimension, the same miraculous element. Nolan's art, in its source and in its extent, has this rare quality.

I can think of no other heroic image whose effect one is finally driven to describe in terms of its own evanescence. Because in the second Kelly series (1954-5) Nolan stressed the heroic and religious extensions of his myth, it is surprising to find so much purely lyrical content in the first. Some have the whimsy of old sporting-prints. *Steve Hart Dressed as a Girl* is an androgynous, wistful spectacle, in line with the recent floating Anzacs and neuter Ledas. In other paintings, like *The Alarm* (a trooper's horse startled by a peacock), *Landscape* (an opalescent evening in the bush), or *The Questioning* (troopers coming upon a naked farmer bathing in a dam, to interrogate him), the Kelly mask does not appear at all, and we are left with a magical rediscovery of the Australian landscape as such.

In contrast to these gentler images, the helmet generates an ineluctable drama. Few totemic forms contain more savage force than the Kelly-figure in *Siege at Glenrowan*, half fire and half black metal, bisected by a pole, presiding over the blazing hotel and dying men. Such is the 'presence' of this form that it can work well in the most corny of contexts: consider the cinematic device of having it visible through a window while Constable Fitzpatrick flirts, unknowing, with Kate Kelly in the kitchen. Perhaps the finest expression of the emotional range of the Kelly helmet, however, occurs in *Quilting the Armour* [a]. I doubt if any of Nolan's later paintings have surpassed its plastic ingenuity, luminous colour, and emotional subtlety.

With these paintings of an eccentric hero Nolan brought the 'Angry Decade' to its close. It was, as I have tried to show, a crucial time in the history of Australian painting, because it laid a common ground of myth, attitude, and symbolic technique on which the younger post-war figurative painters, like Charles Blackman and Robert Dickerson, have taken root. Critics, local and overseas, have tended to ignore this fact: so that these men are presented as exotic, kangaroo-like talents hopping from no past into a roseate future. This puts them in a wrong historical perspective, which ignores both the exploitive aspects of their art and at least one reason for its vigour, namely, its access to a short-lived but identifiable local tradition, where no overseas traditions can be grasped.

Consider, by way of example, implications of time-sequence in Melbourne figurative painting of the forties. Generally, there are

none. Tucker's paintings are utterly static. The raging gestures of Boyd's figures are quite fixed; no moment before this point of action is implied, and none afterwards. Nolan's Kelly paintings, despite their scenes of violence, are the most static of all. A horse tumbles from a cliff; it is frozen in mid fall with snapshot precision. Constable Scanlon, at the instant of death, is levitated into the air. If we imagined that he were about to rise higher or fall lower, the image of his destruction would lose its point. This timeless quality preserves itself in the same artists' later work: in Nolan's birds arrested in mid flight, or Leda and the Swan in mid copulation; Tucker's Antipodean Heads are as immovable as the ancient landscape from which they seem to be made; Arthur Boyd's aboriginal stockmen are monumental in their stillness. This effect comes, not only from the selection of a particular moment, but from certain techniques of formal composition which present the painting as a closed and complete world. Nothing goes on outside the frame. The picture is not a slice taken from an endlessly moving flux of time and change. Unlike Heraclitus's river, you can step into it twice.

These are the very characteristics of the paintings done by the new men of the fifties in Melbourne and, very occasionally, Sydney – Pugh, Brack, Blackman, Dickerson, and others; a similarity which, in view of the closely-knit and clannish Australian art world, is no accident. The Sydney linear abstractionists were the first to take up where Perceval left off in 1947 and extend their art into implications of time-flux. In the work of John Olsen, for instance, time is frequently as active a dimension as space.

There are other strands and links. Before inspecting them, it is instructive to look at art in Sydney during the time of the 'Angry Decade'.

The war disrupted Australian painting. Patriotism only reflected itself, in art, on a vulgar level; the worthwhile painting on war themes, like Tucker's or Nolan's, came from disgust with the whole apparatus of destruction, our side as well as theirs. In Sydney, where (unlike Melbourne) artists neither thought nor cared about politics, the war provided no themes and did nothing to talent except thwart it or leave it to rot. War presents artists with demands they cannot fulfil without eroding themselves: patriotism, reducing intensity and substituting melodrama; 'easy' communication; all the ugly requests of emotional totalitarianism, for which communal effort is only a mask.

The Melbourne painters in the forties fought social hysteria with personal rage. The Sydney painters, more urbanely, withdrew. There was little stress on vitality, a great deal on tradition and craft. Melbourne, from Heidelberg to St Kilda, had a tradition of experiment, sometimes dormant but never wholly lost. Sydney had none, and no art movement except the post-impressionist work of Wakelin, Simpson and de Maistre originated there between 1850 and 1950. Only isolated figures came forward, and none of these, except for Drysdale, could be called an innovator – except in a very timid way – of either form or attitude. Their public and critics were sometimes sharp enough to pick an obvious phoney, but they were not so adaptable as to recognize a rough, unformed but genuinely interesting vision: that is why Sydney, in the forties, refused to look at Melbourne's expressionists.

This situation persisted until the end of the war. The Ure Smith publication, *Present Day Art in Australia*, reproduced the work of some moderately interesting painters: Drysdale, Dobell, Friend, Lymburner. It included plates by others not so interesting: Joshua Smith, Elaine Haxton, Arthur Murch, Hal Missingham, Anne Weinholt, Mitty Lee Brown. But the insight this gives into Sydney's art taste is also provided by the ones left out – Boyd, Nolan, Perceval, Vassilieff, Tucker, Bergner. This was due partly to isolation from Melbourne (the two cities are 600 miles apart), and largely to a widespread conviction that Sydney painting was the best in Australia.

Actually the choice between the two was not inspiriting: it boiled down to whether you preferred provincial surrealism and expressionism, or an antipodean echo of English neo-romanticism.

Sydney, in the forties, succumbed to the latter. It produced a decade of luxury art: the romantic poeticism of the forties, to give its official name: or, more succinctly, the Charm School.

Times of luxury art recur. Their feature is that art loses its ritual and dynamic character. It becomes decorative. Pictures are passive; no longer outlets through which emotion and ideas are directed on experience with intense force, they exist on pleasantly equal terms with the bureau above which they hang. Both are simply objects. Art abdicates its true role, which is to intensify experience; instead, it makes life more ingratiating by giving it a little twist here and a tweak there, drawing what sustenance it has from simple material values. The spiritual life of its society is not strong enough to insist on some kind of expression through symbols.

Luxury art, then, is a conventional form of display. Elaine Haxton's natty Campigli-like children, or Jean Bellette's wooden Oedipuses, reveal equally predictable values; the emotional stance is quite ordained, and we are given a reminder of a familiar world of cliché, not an exposition of a new one. Even an angry man like Counihan fell within the category of luxury art; his paintings are not made up of dynamic symbols, but are flypaper for whatever emotions we may have about breadlines or dole-victims. Few people, I imagine, can have seen an exhibition of Soviet social realism without being struck by the banal passivity of its imagery – luxury art masked as commitment.

But because we do sense a ragged commitment, however badly articulated as form and colour, we may prefer the breadlines of the social realists to the costume-parties of Sydney's poeticists. Whatever their limitations, Counihan and Bergner did not share two debilitating outgrowths of luxury art. These were a concern for art as prestige; and, worse, the exaltation of 'good taste' as a standard of judgement.

The idea of taste did much to vitiate what Sydney painted in the forties. The word crops up over and over again in the critical writing of the time. But as Sir Kenneth Clark remarked:

> The concept of good taste is the virtuous profession of luxury art. But one cannot imagine it existing in the twelfth century, or even in the Renaissance; and without going into the complex question of what the words may mean, I am inclined to doubt if a completely healthy relationship between art and society is possible while the concept of good taste exists.

Good taste feeds on the past. It invokes the glories of antiquity to justify its own pastiche of past forms. Being nostalgic, it is a useless instrument for measuring the worth of the new. If an artist depends on it, as nearly all the Sydney painters did, his ability to expand his consciousness will gradually atrophy, his style will close in on him like Poe's shrinking room, and in the end he will be left with nothing but copied variations on a prototype he barely understands.

In a sense, nostalgia was forced on the Sydney painters by war. They wanted to preserve, by imitating it, a style they were barely acquainted with – the elegant eclecticism of European life in the late thirties, the subculture of *Vogue*, the Russian ballet, decorative cubism, frothy camp. All that was menaced by movements of history in which they confusedly felt they had no part. They felt it was going to disappear before they had the chance to experience it – most of them had never been to Europe. So they tried to reconstruct a model of it. As an exercise in *haute couture*, it was a failure; but as a style, it stuck, because it partially satisfied the Australian desire to be part of an international situation. So Australian easels were filled by the same Picassoid harlequins, the same mottled ruins, and the same hip-swishing sailor boys as Paris and London produced. The difference was that the Australian public mistook it all for modern painting. It was also during the forties that homosexual style appeared prominently in Australian art – the image of the persecuted queer forming his self-protective enclaves in society merged into the other image of the outsider artist.

Turbulence, then, was not a feature of the Sydney scene. Between 1939 and 1950 Sydney resembles less a cultural maelstrom than a tinkling brook, meandering its gracious way between those two sturdy gums, Drysdale and Dobell. Yet rocks, like the 1944 Dobell case, lurked beneath its tranquil surface, and though the work of the Sydney school – Sali Herman, Donald Friend, Francis Lymburner, Justin O'Brien, Adrian Feint, Eric Wilson, Wolfgang Cardamatis, Paul Haefliger, Jean Bellette and others – kept a bland façade, it looks blander now than it did then. Painters, in Sydney as in Melbourne, were facing outwards to Europe. But while Melbourne absorbed German expressionism, surrealism, primitive art, social realism and even American eccentrics like Elshemius, Sydney concerned itself with the general intimist tradition of the École de Paris, with cubism, and, rather remotely, with the Italian painters of the fourteenth and fifteenth centuries. (You drew your studies after a colour print of Masaccio, without having been to the Brancacci Chapel and with the disturbing reflection that the Carmine might have been bombed last night.) This contrast was magnified by the

effect of George Bell's teaching, which was based on Cézanne and Modigliani. Bell worked in Melbourne, but many of his students, unable to take Melbourne's art-politics, moved up to Sydney: Drysdale, Herman, David Strachan, and others. Bell's ex-students were the ones who, through their grounding in post-impressionist form, gave keel and hull to the neo-romantic movement.

To say that Sydney was more concerned with the mechanics of painting than the poetics would, therefore, be a distortion. Though the imaginative level of its art was not often high, it was by no means negligible, and its ways of operation are too easily ignored. Unlike Melbourne, it emphasized the formal aspects of painting: and especially, personal style. Men like Nolan tended towards anti-stylism: his paintings are magically informal: their *faux-naïf*, deeply authentic poetry is the result. Their patterns are not ordained. How different this is from the work of a comparable painter in Sydney, Russell Drysdale, whose vigour places him quite outside the Charm School! Trained to the fingertips, a careful composer, Drysdale cultivated a distinct and accomplished 'handwriting' early in his career. Dobell was a stylist too; and to lesser painters, style was a paramount issue. Having so little to say, they navigated endlessly in the corner of personal gesture.

One painter widely thought a stylist of the first rank was Donald Friend. How elegantly drawn, cried the clients of the Macquarie Galleries through the forties, those native boys are! With what grace he handles a pen! Such tact of colour! How delightful a wit! All these ecstatic squeaks are true: Friend is a brilliant draughtsman and a good colourist, and as a wit he has no equal in Sydney – but they touch only the periphery of his vision. His work is animated by a real passion. But this is generally ignored; and then his paintings and drawings of the male figure seem no more than graceful decorative friezes, full of people passing mangoes to one another or lying on the beach beneath a treeful of owls [65]. Thus emasculated, it is easy to see his work as dominated by its style and dexterity.

Often it is. But to the objective eye, Friend's art can radiate an innocent sensuality comparable to Modigliani's nudes, and coupled with a similar mannerism of line. It is generally agreed that there is little point in painting a female nude deadpan, as if it were simply an object with no more capacity to rouse us than a still-life. A naked body *is* desirable, and sex is a part of the experience when one looks at it. It cannot be ignored by the painter, even when the nude as an art-form is in an idealized state.

But other assumptions surround the male nude as an art-form. It is assumed, for instance, to be as close to sexual neutrality as the human

65. Donald Friend: *The Sleeper II*

nude can get. It approximates to pure form, and its muscles, bones,
ligaments, the light playing over skin, facial expression, posture, and
action are observed, as Plato put it in a different context, 'free from
the itch of desire'. Only rarely have Western artists invited us to
look at the male nude with actual cupidity, as in Caravaggio's
Young Bacchus. During the Renaissance, for instance, the male
nude embodies ideas quite distinct from the fertile sensuality
reserved for the female. These are strength, courage, vitality,
nobility, energy, intelligence: the true qualities of the *uomo di virtù*.

Donald Friend's figure-paintings, therefore, are midway between
sensuality and the traditional idealism of the male nude. The latter
aspect is often dominant. He has a strong belief in the Noble
Savage, analogous to that of the late eighteenth century. After
the war, he lived for some time on Thursday Island and drew
the Torres Straits natives incessantly; one day in 1947, he wrote after
a day at the beach, 'I was disgusted by the white bodies, like
maggots.' In this remote tropical setting, the trappings of the
civilization he had been born in seemed repulsively artificial. The
innocence of the natives became his emotional *pied-à-terre*.

But his love of the primitive was not new. In London in 1935,
studying at the Westminster School under Meninsky, Friend haunted

the smoky Negro jazz clubs, and found there a real vitality: indeed, his first exhibition, which was held in London, consisted entirely of drawings of native models. In 1937 he left for Africa, and lived in the native village of Ikeri – a treasure-house of primitive art, where he worked as financial adviser to the Ogoga or chieftain. But his taste for the elemental coexisted with an irrepressible graphic wit, which lent deftness, charm, and piquancy to his work but, from time to time, plagued it. After watching his friend Russell Drysdale paint *Sofala*, the finest of his country-town streetscapes, Friend felt depressed enough to write:

Somewhere in the pigment there lies...a wonderful abyss, a chasm filled with a great soul, weeping and laughing and shouting and praying. But not in my pictures. In mine there is no chasm, but a sort of rabbit-hole from which issues a calm amused voice saying, 'Nice weather, isn't it?'

None the less, he did feel – as did other painters at the time, Dobell among them – that prevailing attitudes to art were too solemn. And so it is hard to draw a firm line between Friend's caricature, his parody, and his serious work. Even in major pieces, urbanity prevails, and they are enlivened by the same wit we find in Friend's satirical war-time drawings for his books, *Gunner's Diary* and *Painter's Journal*. Melbourne had its anti-Fascist show in 1942, but Friend's war-time experiences stayed cool. *The Gallant Captain* is a stylized figure, elegantly posed in a greatcoat against a darkling sky, a document in one hand and an antique cannon to the left. War wreckage induced such Piperish images as *The Ruined Tower*, 1944; despite romantic chiaroscuro, well-tempered decorative effects prevail.

His pen drawings of nudes and heads are his most consistently successful work of the forties. Some are flashy, with an over-scratched, tinny surface. But most of them exhale a spirit of monumental calm. They resemble studies for sculpture. The bounding line evokes, not flat areas, but modelled volumes; it is precise and delicate, and washes of colour are fastidiously laid. Friend was clearly one of the most accomplished realist draughtsmen of the forties, and at his best a luminously expressive colourist.

With Friend in the forties may be mentioned other, less significant, figurative romantics.

Francis Lymburner, when just out of art school, attracted considerable interest. Paul Haefliger wrote on him in *Present Day Art in Australia*, 1944:

Lymburner's forms may be feverish or brooding; they may sum up with one swift movement or linger sadly, even the quality of humour may touch

his shapes, because an artist's interests are manifold, but all is subordinated
to a vaster conception which is as yet felt only with uncertainty and which
only maturity can attempt to realize. It is the very beginning of a mood
which finds its highest achievement in the paintings of Tintoretto and
Delacroix.

The mood, one might add, never got past its beginnings. Lym-
burner's early pictures have a mild romantic flavour; mood posses-
sed form; turbulent shapes alternated with shrill moments of light

66. Francis Lymburner: *Cortège*, 1939

[66]. Yet harshness itself repelled him. After a childhood in outback
Queensland, Lymburner was bored by the Australian landscape.
His world was urban, bounded by the beach, the zoo and the theatre.
Elegant and witty, tinged sometimes with mystery but never dis-
quieting, his work shares the decorative bent of the forties – colours
more often pretty than sonorous, tone breaking down into vague
atmospherics.

In fact, the word 'romantic' that was so often tacked on to such
painters – not only in Australia: the same misconception arose about

English painters like Christopher Wood and John Minton – barely applies to them at all. Try measuring the Sydney painters against this excerpt from Jacques Barzun's *Classic, Romantic and Modern*:

[The romantics] tried to meet the claims of every existing reality, both internal and external.... As against poetic diction and 'noble' words, the romanticists admitted all words; as against the exclusive use of a selected Graeco-Roman mythology, they took in the Celtic and the Germanic; as against the uniform setting and tone of classical tragedy, they studied and reproduced the observable diversities known as 'local colour'. As against the antique subjects and the set scale of pictorial merits prescribed by the Academy, they took in the whole world, seen and unseen, and the whole range of colours. As against the academic rules prohibiting the use of certain chords, tonalities and modulations, they sought to use and give shape to all manageable combinations of sound. As against the assumption that no civilization had existed since the fall of Rome, they rediscovered the Middle Ages and the sixteenth century and made history their dominant avocation. As against the provincial belief that Paris and London were the sole centres of human culture, they travelled to such remote places as America and the Near East and earned the name of 'exotic' for their pains. As against the idea that the products of cosmopolitan sophistication were the only subjects worth treating, they began to treasure folk literature and folk music and to draw the matter of their art from every class and condition of men.

Now with the exceptions of Drysdale, Dobell, and Friend, the main characteristics of the Sydney Charm School in the forties were: prescribed 'poetic' subjects, emphasis on sophistication of style and technique, admiration for the *classical* past, narrow range of emotional projection, and belief that London and Paris *were* the sole centres of human culture. Too close a comparison is, of course, unnecessary: Barzun is speaking of the late eighteenth and early nineteenth century, and not all parallels apply. None the less, the word 'romantic' assumed a number of false meanings by being applied to the Charm School. It came to signify 'poetic', 'mysterious', 'glamorous', or even just plain 'vague'. More often it was synonymous with 'a bit stupid, but rather nice': the ludicrous but common idea that romanticism is emotion and classicism is intellect and never the twain shall meet was pressed into service to pigeon-hole an art without intellectual commitments.

The background to it was supplied by a revival of interest in European tradition. For the first time, Australian painters began to look, as best they could, at the Italian Renaissance. The *Sydney Morning Herald*'s art critic Paul Haefliger, and his wife, the painter Jean Bellette, were instrumental in this.

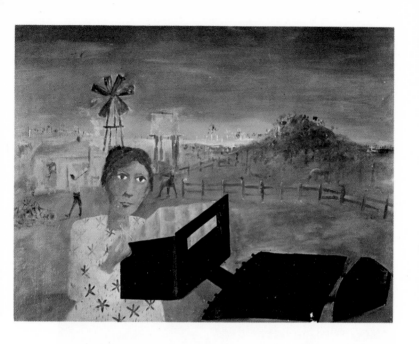

a. Sidney Nolan: *Quilting the Armour*, 1946–7

b. Russell Drysdale: *Man with a Galah*, 1962

c. Charles Blackman: *The Meeting*, 1961

d. John Olsen: *Portrait Landscape No. 2*, 1961-2

e. Ian Fairweather: *Epiphany*, 1962

f. Brett Whiteley: *Woman in a Bath 2*, 1963-4

g. Leonard French: *The Crossing*, 1960–62

h. Colin Lanceley: *Free Fall*, 1965

Jean Bellette took her subjects from classical drama and myth-
ology. Electras and Medeas and Oedipuses clustered about, in static
set pieces, reminiscent of the blue-chinned Brutuses of the French
Empire salons. These groups were carefully arranged, but without

67. Jean Bellette: *Electra*, 1944

generating a very coherent space, as in *Electra*, 1944 [67]; indeed,
Drysdale and Orban apart, and not excluding Dobell, no Sydney
painters at this time showed much feeling for spatial complexities.
Though her drawing was stereotyped, Bellette manipulated pigment
sensitively. Her surfaces were rich, the textures refined, the colours
subtly stippled and broken, generally in a muted range of warm
browns, greens, and ochres. Because they were encased in a stylistic
straitjacket, these paintings had a very restricted emotional life. Still-
life was the most successful area of her work.

This mild neo-classical revival did not parallel the aestheticism of
Long or the rococo vitalism of Lindsay. Long's nymphs were meant
to personify the mystery of the bush; Lindsay's hammy chorines
symbolized, however crudely, the idealized sexuality at the core of
his aesthetic. But Bellette's classical figures were neutral *personae*,
pegs to hang a painting on. Their imagery was passive, and a calcu-
lated poeticism arose from it.

Eclectic historicism took another form in Justin O'Brien's work. After the war – captured in Greece, he was imprisoned by the Germans – he first exhibited his religious paintings in Sydney. They caused an immediate stir: O'Brien was the first Australian painter to concentrate on religious imagery. His bright vibrant colour (vermilions, bright greens and blues, even gold leaf) produced a kind of palatial sweetness, which was given backbone by an obsessive use of patterning: floor tiles, arched windows, frieze-like repetitions of

68. Justin O'Brien: *The Virgin Enthroned*, 1951

figures [68]. His style derived from the early Sienese masters, Duccio and Guido da Siena; and from Greek mosaic. But O'Brien seems to have treated these sources as style only, a fount of ready-made iconography which absolved him from working out his own. But as in Australia, even in 1947, tinted plaster statues showing Christ as a pink bearded lady, holding a burning tomato indicative of the Sacred Heart, were the sentimental norm, O'Brien's approach to Christian imagery seemed striking, and even original.

But the distortions of pattern, the ceremonious richness of colour in Sienese painting sprang from an inner necessity: they were the unique shapes of a unique content, projected through fourteenth-century sensibility and belief. We get none of that urgency before one of Justin O'Brien's Resurrections or Entombments. The traditional forms are not recreated by a passionate apprehension of the link between form, image, and religious experience. They are borrowed; then diluted by mannerisms, a lank elongation of the figures

as if they had just emerged from a toothpaste tube, a refined vapidity on the faces. Art is taste, taste is antiquity: and religious painting in Australia had to wait more than a decade after the war until two men, Eric Smith and Leonard French, quickened it.

A promising young artist of the forties, who held consistently to his style and developed it in Paris and Italy between 1945 and 1960, was David Strachan. Strachan's work is characteristically serene and atmospheric, a little awkward in drawing, fey rather than surreal [69].

69. David Strachan: *Young Girl,* 1948

There were various decorators and designers, whose work is generously regarded as painting – Elaine Haxton, Loudon Sainthill, Wolfgang Cardamatis and William Constable. Sainthill, now a prominent stage designer in England, was a member of the 'Merioola' group (named after an old mansion in the eastern suburbs of Sydney, where they all lived). The group included Donald Friend, Peter Kaiser, Justin O'Brien, Edgar Ritchard, Jocelyn Rickards, the sculptor Arthur Fleischmann and the writer – now the art dealer – Harry Tatlock Miller. The Merioola group held one show, at David Jones's in 1947.

So far I have left Desiderius Orban and Sali Herman out of this account of the Charm School, because, formally at least, neither fits its characteristics. Both preferred bulky, solid forms to evanescent areas and flat patterns; both came to Australia from Europe, and were reasonably mature artists when they arrived. Orban enjoyed some slight European reputation. He had left his native Budapest to study in Paris in 1906; he had exhibited in Paris, Hungary, Czechoslovakia, the Balkans, and Holland, and one of his still-lifes, derivatives of Marchand, had won a gold medal at the 1929 International Exhibition in Barcelona. Endowed with a vigorous plastic sense, he had

70. Desiderius Orban: *Kiama Township*, 1949-50

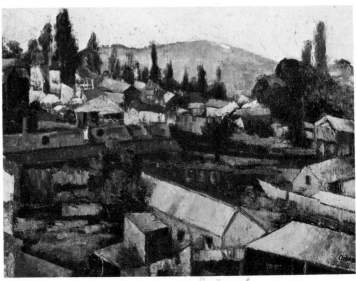

absorbed post-impressionism; yet what might have become a purist severity of structure was counterbalanced by his innate emotionalism. His forms were full of weight, imbued with the slow rhythms of the earth [70].

Sali Herman, a Swiss, arrived in Australia in 1937, aged nearly forty. Though he was already a trained artist, he enrolled in George Bell's school in Melbourne. This strangely humble act (he was, in some ways, better acquainted with post-impressionism than Bell himself) is best explained by the circumstance that he had painted very little in the fifteen years before. However, the only effect Bell had on Herman's work was that, for a time, his forms grew slightly more abstract and linear.

His fellow-students, Drysdale, Purves Smith and others, influenced him very little. He campaigned tirelessly in the controversies over modern art that went on in the late thirties in Melbourne, and a letter of his was quoted by Lawlor in *Arquebus*. Paintings like *The Dead Christ*, 1938, based on Holbein's picture which he had seen at Basle, led Burdett to approve of Herman as 'a minor poet of modernism'.

A minor poet he remained. But Herman is known best neither for such paintings, nor for his schematic beach-scenes of 1938–9, but for his pictures of Sydney houses. No artist has made an area of Australia more distinctively his own. It extends from Paddington, round the back of King's Cross, west to Redfern, and north to Potts Point and Woolloomooloo. These are the slums: cleaner and brighter than real slums, but heavily tenanted: an ants' nest of people, crowded into Victorian tenements and terraces, their brickwork mellowed by sunlight, the ornamental cast-iron thick with paint. Timber warps, the bright awnings fade, and lace curtains yellow tattily. By Sydney standards, they are old buildings, put up between 1840 and 1890. From the Woolloomooloo docks, long flights of stone stairs crawl up the cliff to Victoria Street, tenements hanging precariously above.

It was all a visual feast, but Herman was the first to 'see' it. The slums conflicted with the mercantile dream of Australian prosperity; they reminded collectors of the Depression, and were unfit stuff for art. Thus when Herman took the 1944 Wynne Prize with a painting of McElhone Stairs, there was a public outcry and the *Bulletin* rebuked him for his 'melancholy portrayal of one of metropolitan Sydney's slummiest aspects'.

Of course, melancholy has nothing to do with Herman's style. Paul Haefliger came closer to the point when he said that Herman painted 'Swiss Australia' – a toyland of hygienic pleasantry. This

good humour became facile towards the end of the forties; perception turns into a formula. 'Is not happiness itself a philosophy?' was Herman's indignant reply to Haefliger; but the answer, of course, is 'no'. No emotion is. Still, the vivacity of colour and texture did not always blur Herman's sense of form. His houses confront us with their vigorous interplay of void and solid, defining

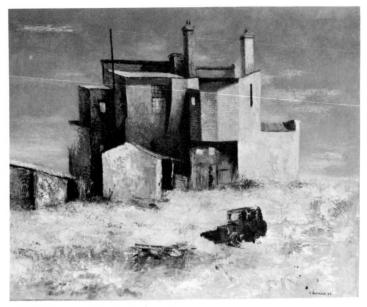

71. Sali Herman: *Colonial Castle*, 1958

space. Occasionally, as in *Colonial Castle*, 1958 [71], a quiet contrast is suggested between these old places standing in the middle of vacant lots, and the accretion of urban detritus around them: the junked cars, old iron, and waste boxes. But it is a thin poetry, nostalgic and decorative. Herman is no antipodean Hopper, for his work lacks any hint of mystery; but the jollity of the world he creates goes a little way to make up for its shallowness.

But in Sydney, William Dobell and Russell Drysdale were the dominant men of the forties. Dobell, of course, is a touchy subject. No living Australian painter has been so grotesquely over-praised. It is not uncommon to hear people talking about Goya, Rembrandt, and Dobell; when one critic lately told us that Dobell 'reanimated

the whole tradition of portrait painting', and another claimed his art was 'superb by any standards, and unique in Australia', few jaws dropped. It is thought ill-mannered, if not downright heretical, to examine claims like these.

The reason, of course, is that Dobell is the next-in-line to Streeton in the twenties and Lambert in the thirties. He is a culture-hero. Audiences freeze like rabbits before his reputation; the viperous tongue of criticism is stilled by his name. The normal processes of looking at a picture are suspended: it's enough that it is signed Dobell. In his work, the past glories of Europe are summarized: he is an Old Master already. And this conforms to the pattern by which Australian culture-heroes are created. They must provide a tradition-substitute for a society isolated from European tradition. The difference between Dobell and, say, Lambert, in this respect is that Dobell never tried to create a mystique. He is, if anything, embarrassed by the bovine herd of status seekers who scramble for the least of his sketches. He is a shy and retiring man, indifferent to argument, theory, or self-promotion.

But to see how this painter who, on an international stage, would be regarded as an occasionally interesting but always minor eclectic, with his small output of uneven quality, has come to be thought Australia's greatest artist, we must look at his work in some detail.

Born in Newcastle in 1899, Dobell came to Sydney in 1924 and enrolled at art classes at Julian Ashton's, while working for a manufacturer of building materials. Five years later he won the New South Wales Travelling Scholarship and, in London, enrolled at the Slade. Its heads were then Wilson Steer and Henry Tonks. By 1933 a picture was hung at the Royal Academy. This was *Boy at the Basin*, and it suggests little of the mature Dobell. The interior is filled with subdued light, which evenly outlines domestic shapes: a kettle, a dresser, a milk-bottle. This is an attempt at Vermeer's light in a classical Dutch interior: Dobell had gone to Holland in 1930 to study seventeenth-century Dutch painting. He was drawn to Rembrandt; and at The Hague he stayed with a local painter, Rient van Santen, a cousin of Van Gogh. Through him, he came to know the work of modern European painters; in later trips to Belgium and Paris he was especially impressed by Chaim Soutine.

From 1931 to 1936 he advanced towards a style, trying to integrate these elements without noticeable success. In landscape, there is little advance between *St Paul's from Waterloo Bridge*, 1931, and the feathery park-scenes of 1935. In *Consuelita*, 1933, his familiar linear rhythms tentatively make their appearance; *Woman in a Restaurant*, 1934, has a mild satirical bite, but the Slade chalkiness remains.

But the year 1936 brought a burst of small pictures which out-lined nearly every aspect of his mature art: humour linked with a sense of the macabre, vulgarity, but, above all, an interest in people and a swift, summary penetration of character. At thirty-seven, he was approaching Europe with an adult's eye; most other Australian painters travelled first in their early youth, with less chance of mature assimilation. He remained fundamentally eclectic – Renoir, Goya, Soutine, Rembrandt and Daumier were consumed, one after the other – but there is one undeniable quality in his paintings be-tween 1936 and 1943: their robustness. After the war, he never quite recaptured this confidence. It began to dissolve into mannerism.

Macabre was the word for *The Dead Landlord*. Its mood is Goya's: a fat white corpse, still in its wool combinations, lies on a bed; behind it, a woman combs her hair before a mirror. As Patrick White observed (and he later wrote his play, *The Ham Funeral*, around this painting), there is no tragedy that cannot be given a red nose.

Social satire: *The Duchess Disrobes*. This grotesque view of a swag-bellied madam struggling into her bathrobe came, oddly enough, from the London Zoo, where Dobell drew pelicans and afterwards made one of their waddling bodies human. In content and treatment, *Miss Tatty* and *The Charlady* prefigure the fine head of *Mrs South Kensington*, 1936 [72]: the paint lies in strings and loops, presenting a casual graphic façade. Skating thus on the edge of control, holding the work together by a web of linear gestures, Dobell was able to develop his use of immediate reactions to form and, in portraiture, to personality. All these 1936-7 paintings are subdued in colour; the grey London light seeps into them, and umbers, madders and ochres, acid greens and cold blues predominate. But the major work of this year, one of the five or six surviving Dobells that can ac-curately be called a masterpiece, was *The Sleeping Greek*. His assimila-tion of Rembrandt's sculptural tactility was now complete: a grainy impasto absorbs and sheds warmth like stone in sunlight. The ridged lines of paint work directly as modelling, by tracing the swell of cheekbone and eyelid-like lines on a contour map.

This tactility informs his next major portrait, *Mrs South Kensington*, but the contour impasto is carried even farther. Sardonic comment projects an image Daumier might not have disowned. The old gossip, sharp-eyed, beak-nosed, her mouth a compressed slit of vinegary rectitude, with her three chins and flesh sagging over the cheek-bones, is assimilated into the aggressive life of the pigment. This raucous, Hogarthian side of Dobell kept bobbing up. 1937 pro-duced *The Red Lady*, a bulging harridan amid the tatty finery of a sideshow, in dissonances of red and green. Then came *The Irish*

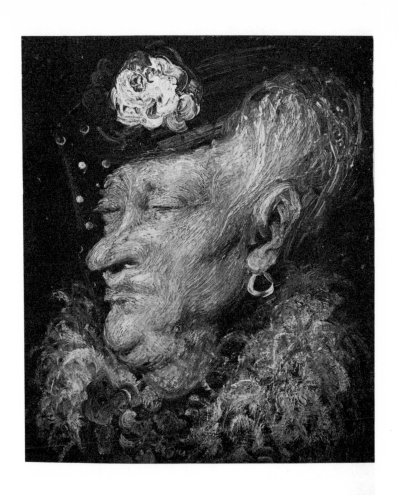

72. William Dobell: *Mrs South Kensington*, 1936

Youth, 1938 [73], staring out with canine aggressiveness. The chief
debt was to Soutine: odd angles, the awkward arms and peaked
shoulders, snapping eyes, and beak-nose, were stressed. The brush-

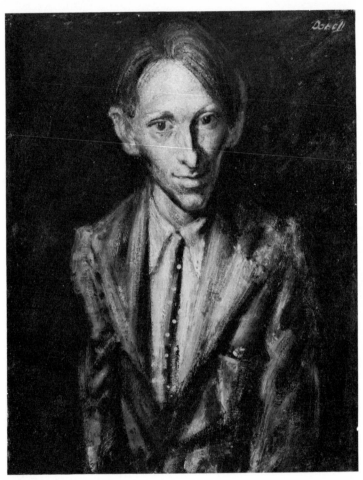

73. William Dobell: *The Irish Youth*, 1938

work was freer and more open than before. This acrid and brilliant
image prefigures his experimental *Joshua Smith*, 1943 [74], five years
later.

In 1939 Dobell returned to an Australian art world where portrai-
ture was much sought, but dead. Sterile appearance-mongering pre-

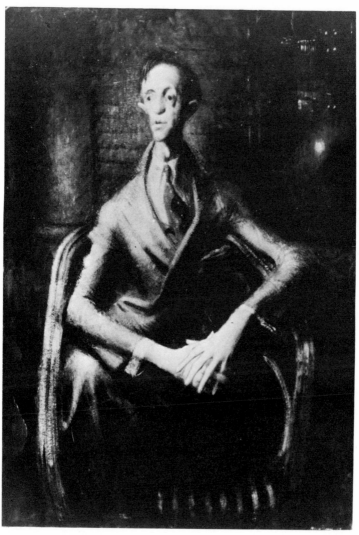

74. William Dobell: *Joshua Smith*, 1943

vailed: portraiture had become photography of strangers. But in any case, Dobell was reluctant to work to commissions. Every portrait in his London period was a document of love, hate, or fascination, an image of the type behind the individual and the individual behind the type, projected from close knowledge of the sitter.

In 1940 he summed up his love of Rembrandt with *The Cypriot*. The pose is monumental, *en face*, in an ornate chair. Light picks out the head, with its five o'clock shadow and the withheld pride of an El Greco grandee; it illuminates the fulgid blue shirt front and broad crimson tie, and falls upon the long, pale, exquisitely sensitive hands which droop over the arms of the chair. The drawing is a *tour de force*, and the technical means suit the image: compare the vigorous impasto of Dobell's 1936 work to *The Cypriot*'s cool, translucent washes of colour.

Other experiments in elongation followed: *Scotty Allan* and *The Strapper*, 1941, were the most important. But now hints of flossiness, the result of overworked divisions of colour and tone, crept into his work. *Elaine Haxton*, 1941, was to *The Cypriot* as Coca-Cola is to burgundy. The demands of luxury portraiture began to sap him. *Mrs Blaxland and Toni*, a fortunately obscure work, is cloyingly predictable. He recovered in 1943, with an overripe portrait of his friend Brian Penton, the editor of the *Daily Telegraph*, who supported him through the *Joshua Smith* controversy and the subsequent court case. Penton emerged as a pirate; the reds and ochres glow like a baroque furnace, and looping rhythms animate the space and seem to carry the picture beyond the confines of the frame. Though a curious piece of baroque art, more than any previous Dobells it is out of touch with its contemporary situation: the attitude is nostalgic.

In 1943 Dobell painted a portrait of his fellow-artist Joshua Smith, entered it for the Archibald Prize, and won. This was a vividly experimental painting and its expressive linear distortion was again reminiscent of Soutine. With the verdict, the bitterest Press controversy ever seen in Sydney painting exploded. J.S. MacDonald denounced the painting as a travesty, a gross and impertinent caricature. It was as hotly defended by Paul Haefliger and Ray Lindsay, critics of the *Sydney Morning Herald* and the *Daily Telegraph* respectively. The *Bulletin*, livid, informed the ghost of Mr Archibald that his name had been besmirched. The Gallery's attendance figures increased twentyfold.

The free-for-all might have died sooner had not seven artists, all competitors in the 1943 Archibald Competition and headed by two obscure academic painters named Mary Edwards and Joseph Wolinski, issued a writ against the judges of the competition – the Trustees of the Art Gallery of New South Wales – claiming wrongful award of the prize to a caricature.

The court case, heard in 1944, was quite Gilbertian; the majestic processes of His Majesty's law were about to decide the difference between a caricature and a portrait. The prosecution opened with its

biggest gun, MacDonald, who told the court that the Dobell, though competently painted, was no portrait: it contained 'distortions', and the Old Masters never distorted. Moreover, he knew Joshua Smith by sight, and was sure that Dobell's 'stricken creature' was not he. This antipodean Ruskin's testimony lasted two days; other witnesses appeared for the prosecution, including a Dr Vivian Benjerfield, whose presence is explained by the court transcript. Frank Kitto, for the defendants, cross-examined:

Q. I was not quite clear this morning. There is something about this portrait that struck you as different ? – A. Yes, that the lips of a man who is dead and desiccated were retracted and brought back showing the teeth. The other one was that the eyes would also be evaporated and dried up to smaller than their normal size.

Q. As a matter of fact those eyes are very much smaller than a living man's ? – A. No, I think they are dead.

Q. What is the point you make about the eyes ? – A. Lack of expression. They are quite dull.

Q. What is the point you make about this representation ? – A. The complete loss of subcutaneous tissue.

Q. That is the point you make ? – A. Yes.

Q. Do you know anything about art ? – A. No.

The judge brought in a verdict for the defendants. Mary Edwards was dumbstruck; later she tearfully told the Press that she had meant no spite, and it had all been intended for the good of art. Wolinski, confronted by costs exceeding £1,000, was less generous. The only solution seemed to be that one of them should win the next Archibald Prize. He spoke darkly of a big Melbourne businessman who 'jellyfished like the rest...we had to stand alone'. Mary Edwards went back to the South Seas and to painting native fishermen; meanwhile, in Paddington, children continued to draw with chalk on the pavement, but now their *graffiti* were merrily signed *Dobell*.

No more diffident war-horse could have carried the cause of modern art than Dobell. He did not, in the first place, think of himself as a modern artist. 'In London,' he said, 'I was regarded as an academic,' and 'My great love has always been Rembrandt.' But his painting and the trial had made modern art a public issue for the first time in Sydney, and the die-hards and tastemongers of the thirties had ignominiously been routed in open court. *Joshua Smith* made Dobell a public figure; but like Garbo, he wanted to be left alone, and he was unable to handle the spate of commissions that inundated him. Suggestible because battered, he reverted to academism, and his 1944 portrait of Lord Wakehurst was a conventional

grand manner effort, coloured like a sweet-wrapper in flowing greens and blues; while the companion portrait of Lady Wakehurst resembled a Gainsborough held under a tap.

Dobell's recovery from this collapse of vision was incomplete, and the Wakehurst portraits mark the second, and downward, phase of his work. His fire and romantic energy began to leak away, and his work began to conform to the requirements of a luxury art. Mannerisms, considered to be 'typical Dobell', encrusted it. The most pronounced of these was his habit of painting eyebrows raised in quizzical interrogation, while the eyelids droop in faintly amused, or sleepy, cynicism. Useful, as in *Jimmy Cook* or *Billy Boy*, 1943, for revealing the satyr or the hippo beneath the skin; but when repeated invariably in later portraits from *Professor Giblin*, 1945, to *Doctor McMahon*, 1959, it becomes fatuous as a response to character. His paintings for the Allied Works Council, whose official artist he was during the war, suffered from the defects of stylishness. The formulations of action were typically rococo: extremes of posture were stressed, *contrapposto* became a favourite device, and the composition – usually in diagonals and crosses – became laboured, as in *Erecting Camouflage Tree, Menangle*.

Little worthwhile portraiture came from his brush between 1945 and 1948, when he won the Archibald Prize again with a portrait of Margaret Olley. Drysdale also painted her that year; one could hardly find two more contrasting conceptions. Drysdale's Olley is acutely understated. The face is modelled from dry, scraped, and thinly washed layers of pigment; the tonalities are close and subtle, within a range of reddish-browns, pinks, reds, and whites. The image, as is usual with Drysdale, arises from a very spare lyricism: not lacking in richness, but devoid of flourish.

By contrast, Dobell's Olley, but for the impressionist dissolution of form in light, might have stepped from the eighteenth-century grand manner. Posed seated in *contrapposto*, with an elaborate dress floating with draperies, in a picture hat and wearing the expression of a faintly ribald young countess, Margaret Olley has become a spectacular decorative object. But the forms are chaotic; and what has happened to the analytical stare with which, ten years before, this most expensive of all Australian portraitists transfixed his Irish friend?

Russell Drysdale's work, over a comparable period (1937-50), did not suffer from the ups and downs which afflicted Dobell's. First, Drysdale received his stimuli from a wider range of experience than Dobell. But the most obvious reason is simply that there was no Drysdale Case to disturb his life, shatter his confidence and catapult him into unwelcome notoriety.

Over a working life of nearly thirty years, Drysdale has articulated a consistent vision which draws its sources directly from his environment. Though Nolan's Wimmera landscapes surpass Drysdale's paintings of the early forties in sheer poetic invention, Drysdale, by 1945, had become the first *widely known* Australian artist with a real alternative to pastoral landscape. It is no exaggeration to say that, between 1940 and 1947, Drysdale made it possible for other painters to react freshly to their environment by showing them new relationships with it. With Nolan, he pulled Australian landscape from the limbo of fleece and gum-tree in which it had lain stiffening for thirty years. In the public eye, Drysdale's schema of landscape, with its ideal distances, one-point perspectives, theatrical space, spindly townships and scraggy aborigines, came out on top. Drysdale was an established, even a popular artist by 1947, when Nolan's Kelly paintings were still ignored. But this relatively quick penetration did not happen because Drysdale's paintings were formally superior to Nolan's, still less because of any greater intensity of image. The fact was that Drysdale's relationship to his environment was *easier to grasp* than Nolan's. It was often sentimental, always pragmatic; it had a touch of the theatre, to which Australians react favourably; and it emanated from the scion of a grazing family, who not only knew the land but was known for knowing it. In every way, it was unlike Nolan's irrational poetry. As Nolan himself said later, 'Drysdale is the most Australian of us all.' His paintings looked like Art, whatever oppositions they may have aroused during the war; their careful drawing and underpainting and glazing and scumbling, their air of caution and painterly discipline, helped the public's desired image of the Master. And his images rang true, within what Australians thought their experience to be: which was, in fact, a dream of innocence.

To imagine a typical Drysdale, think of a piece of Arcady, painted by a disciple of Claude, with the thermostat turned up to 106°. Drysdale's space is simply the spatial recipe of the 'ideal' eighteenth-century landscape, minus the boskage and temples of Flora: a long theatrical procession of red earth and rocks in which the successive planes, like the wings of a stage, are marked by the presence of a waterhole, a placed and posed figure, a telegraph pole, or a stark tree. To look at Drysdale's first outback paintings of 1941, like *Man Reading a Paper* [76], is to enter a very stylized and conventionalized environment. But how did this relationship to nature arise in Australia?

Drysdale was born in England in 1912. His family came to Australia in 1924, and he was educated at Geelong Grammar School,

near Melbourne. He had no interest in art, and assumed that he would go on the land. But in 1932 his left eye, already weak, worsened, and while in hospital after a corrective operation he began to draw. Some of his sketches found their way, through Daryl Lindsay, to George Bell, who detected a talent worth encouraging.

But Bell did not convince Drysdale. Post-impressionism was still only a word in Australia, and to most people a dirty word, given fragmentary meaning by the occasional print; art meant Streeton, Lambert and Heysen. But later in 1932 Drysdale went to Europe, studied the paintings of the School of Paris, and was swept away by them. He went back to Australia and enrolled at Bell's school in 1935. Returning to Europe in 1938, Drysdale studied under Iain McNab at the Grosvenor School in London and later under Othon Friesz at La Grande Chaumière in Paris. Matisse, Soutine, Braque and Derain were the chief influences on his work; he denies that he was affected by the surrealists, although some of his later paintings have a consistent, if mild, surrealist flavour. His still-lifes of 1938-9 show some grasp of cubist principles. However, his volte-face from the 'international style' to regional images was abrupt; it happened after he went back to Australia in 1939, and its rapidity has led some critics to assume that Drysdale was influenced by the regional painters of the American Middle West, like Benton. But there is no evidence that Drysdale knew about their work then. He had, after all, grown up in the outback, and traversed it often. Much of his work in the early forties could have passed for social realism. While Tucker and others made their angry comments on the impact of war on Australian sensibility, Drysdale (who had settled in Sydney, for he detested the febrile art-politics of Melbourne) saw it obliquely reflected in home towns. Recruits queued for a Volunteer Defence Corps parade, soldiers snored under the cavernous awning of Albury Station, and outside Moody's pub knots of men loitered, dragging their toes in the dust. And his human figures became etiolated, lank, like dry saplings of flesh.

They inhabit Drysdale's landscapes of the forties. These have a surrealist air, which he may have assimilated from his close friend Peter Purves Smith. Purves Smith, a fellow-student at Bell's, had been influenced by the English painter Paul Nash, whose canvases, typical of the dilute forms surrealism assumed in England, had affinities with Italian *pittura metafisica*. Thus Smith's art was an idiosyncratic amalgam of folk-art and 'disquieting' elements, reinforced by a well-implanted formal sense. *The Nazis, Nuremberg,* 1938 [75] demonstrates this mixture of irony and formality. Around 1939 he painted a landscape with kangaroos which anticipated Drysdale's

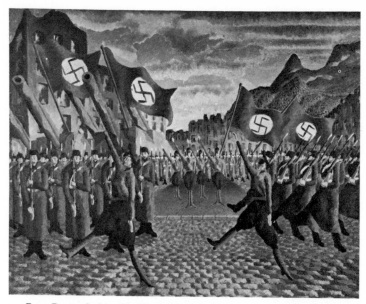

75. Peter Purves Smith: *The Nazis, Nuremberg*, 1938

Australian subjects. What Smith might have become is, alas, beyond speculation: he died in 1949, and his output had been curtailed by military service and acute illness. He was one of the few talents of the thirties who might, given the chance, have developed into a first-rate painter. In any case, his effect on Drysdale is beyond doubt. Drysdale's 'disquieting' images have at least a syntactic affinity with Smith's paintings. Exaggeratedly thin figures, near-caricatures of the mythical six-foot Aussie, stalk around in a landscape flat to the horizon; every form is mannered; there is even a punning wit in the way that Drysdale, in *Man Reading a Paper*, 1941 [76], equated the man's posture with the shape of a chair.

Later, the skeletal figures of 1941 filled out – as in *Woman Filing Her Nails*, 1943. Drysdale also worked on paintings of main streets in country towns. Their buildings, all iron roof and sun-peeled weatherboard, stare vacantly at the hot air of the street, impermanent as stage-sets. Windows and doors are punched in a painted façade; the rooms within are black and empty as charcoal. Drysdale seized on this odd obsessive quality, the sense of expectation when the curtain goes up and nothing has moved; and one is tempted to think

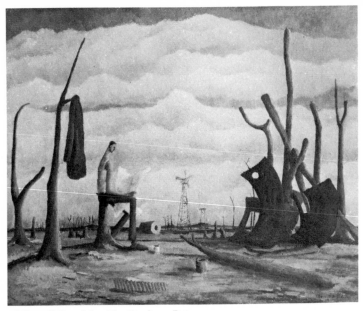

76. Russell Drysdale: *Man Reading a Paper*, 1941

that this was as much a tribute to Chirico's colonnades as to his own experience of outback towns.

1944 was a drought year. Rivers dried out, winds excoriated the earth, and horizons lay under red walls of suspended dust. Trees fell as the wind cut the earth from under their roots; thousands of cattle and sheep died of thirst at the rims of empty tanks. The *Sydney Morning Herald* sent a special correspondent to cover the disaster, and commissioned Drysdale – now thirty-two, and twice rejected from the Army for partial blindness – to illustrate the articles. These drought drawings, and the paintings based on them, made Drysdale's name; a wide public had his work thrust under their noses at the breakfast table by Australia's leading newspaper.

His forms, based on rocks, stumps, dead organisms, and burnt houses, took on an organic complexity reminiscent of, because derived from, Graham Sutherland and Henry Moore. A new animistic view of nature had entered his work. Wrecked trees, windcut in fantastic patterns, implied the natural disasters that formed them. For Drysdale was now a painter of aftermaths, the relics left in the wake of drought or fire. This is plain to see in *Bushfire*, 1944; instead

77. Russell Drysdale: *Landscape with Figures*, 1945

of the fire running, we see only the charred remains of a homestead, with sheets of galvanized iron hanging in dead air. A similar impulse pervades *The Walls of China, Gol Gol*, 1945, and *Landscape with Figures*, 1945 [77]. It recurs in his work until 1953. The significance of tragedy, Drysdale apparently felt, can only be extracted in the moment of calm, when the disasters have run their course. At such moments the relics of an event, wreckage and heat and flat earth, blur for a moment; their featurelessness accepts, like wax, an impressed stamp of meaning. Time is arrested; these paintings have the stillness of Nolan or Boyd, and suggest no flow of events. Human figures are merely stage-props. They posture theatrically in the distance and give scale to the vista. But otherwise they contribute little to the painting; and, in *Landscape with Figures*, they distract from it.

1946 to 1950 were years of recapitulation and consolidation. In 1947 he painted *Sofala*, the most impressive of his town street paintings. Its colour is very rich and sonorous, and the articulation of its space (even within the somewhat worn framework of Hobbema's

Avenue) is masterly. Later came several portraits, including the Olley. *The Rabbiters*, 1947, and *Road with Rocks*, 1949, were his last experiments with a small, mannered figure in a painting whose chief emphasis lies on landscape rhythms. In the latter painting, one's eye is led through a series of looping curves to the horizon. *Maria and Joe*, 1950, are solid, pensive Greeks, set as the one tangible point in a floating world of heat-haze, dust, and rickety verandas. *Emus in a Landscape*, 1950, is the last though not the best of his near-abstract assemblages of torn galvanized iron, which irradiate the landscape around them with menace.

These were the last of his subjects taken from north-western New South Wales. In 1950, he travelled widely in Northern Australia and his imagery shifted and expanded.

In 1950 Russell Drysdale began travelling in Northern Australia. This vast tract of land, with its stupefying physical contrasts, stretching three thousand by one thousand miles from Dirk Hartog Bay to Cape York Peninsula, from Heavitree Gap to Wild Man River, drew him back again and again. In his own words,

Magnificent in dimension, old as time, curious, strange, and compelling, it rests in ancient grandeur indifferent to the challenge of men. Within this vast region exists an infinite variety of people, places, and things. The tropical swamps and coral coasts of Arnhem Land, the great red deserts of the centre, the broken mountains and ravaged gorges of the Kimberleys, and the long, slow spread of the plains. This is a land, mysterious and unknown until the last century, that held within itself curious forms of life that in the rest of the world had long ago passed into the remote darkness of time. There are still men of stone-age culture living a forgotten pattern of life. Nomads of the desert, roaming as their ancestors roamed unhindered in the dawn of history. In rock and range and river is the meaning of their life and the rhythm of their way. In the poetry of their legends is the story of mankind, in the paintings of their caves the ancestry of art. Into this thin ownership, spreading far and wide, came first the outposts, then the settlements of a new incongruous partnership. The wild man and the overlander. Homesteads and settlers, cattle kings and drovers, miners and policemen. The store keeper and the artisan, the publican and the poet. Camp fires and townships, cattle runs and mining booms. Cadillacs and camels, flying doctors and brolgas, corroborees and cinemas, the tucker box and the deep freeze. There was room for them all . . .

Comment is hardly needed. The Australian black dropped out of general favour as an art-subject by 1850, and Drysdale reinstated him. He had first been treated as an ideal philosophical type, a *beaux-arts* Greek drawn in the posture of the Dying Gaul. Then, as the squatters' runs pushed outward, he became a nuisance; the more he came in contact with the whites, the closer the whites observed him – and the more he succumbed to such blessings of civility as rum, the funnier he seemed. Browne's *Hump-Back'd Maria*, 1819 [5] marks the end of the Noble Savage in Australia; the grog-soaked, ragged blacks drawn by later popular artists like Carmichael dispelled even his memory.

78. Russell Drysdale: *The Rainmaker*, 1958

And so Drysdale was the first to make the Australian aborigine a major theme of his art, while neither elevating him into a romantic stalking-horse nor degrading him into a figure of fun. He approached aboriginal myth and legend sympathetically, as a mysterious complex of religious and poetic forces, not as a sample of what Neolithic throwbacks must push through to reach our standards. And so in his northern paintings from 1950 to the present day, aborigines share the landscape on terms of equal importance with white settlers. They are scrubby, scrawny, and dark; their shirts are torn and their arms hang slackly by their sides; they face outwards, emotionless; but they are pervaded by a moving dignity as human images. When Drysdale groups them together, as in *Mullaloonah Tank*, 1953, we acutely sense a correspondence between men and landscape; the two form one image. When they stand isolated, this relationship becomes even closer. The lonely figure in *The Red Shirt*, 1958, and the man with camels in *Native Dogger at Mount Olga*, do not merely interact with the desert, red hills, and vibrating air; they are projections of the landscape itself, sharing its old structure, lit by its scrabbled ochreous colours.

Having integrated figure and landscape through their natural affinity, Drysdale now began to link the nature-worship myths of the natives with the forms of nature itself. This tying-together of a total regional ethos was achieved in one painting: *Snake Bay at Night*, 1959. Its predecessor was *The Rainmaker*, 1958 [78], a half-dissolved figure webbed with allusive calligraphy. *Snake Bay at Night* presents a rich image, precisely because it is ambiguous. Masked and painted dancers weave among enormous graveposts which work both as abstract form and as painted simulacra of abstract objects. Hovering between painting itself and a painting-of-a-painting gives the picture much of its disquieting lyrical power: painted totem merges into painted thigh, and the dancer cannot be distinguished from his surroundings. The colour is low-toned, in browns, parchments and deep reds, with occasional moments of yellow and white. No longer emphatic and tight, the brushwork is scribbly, allusive, linear, suggesting an ambiguous and shifting space. This tendency remained throughout his paintings of 1960 and 1961, such as *Man and Woman, Melville Island*, whose fugitive but palpable figures emerge from, yet are not fully defined by, a network of scrubbed brown lines.

With Drysdale's refreshed interest in the figure came, from 1953 onwards, a number of portraits. Most of them are bad pastoral sentimentality – the Noble Swagman as flypaper for nostalgia – though occasionally the sentimentality does work: *Old Larsen*, 1953, is such a painting [79].

79. Russell Drysdale: *Old Larsen*, 1953

It is obvious that Drysdale has added a dimension to Australian painting, and given his audience a means of self-realization. But what, precisely, is it ? Not tragedy, although the 'tragic' qualities of his work are often invoked. Tragedy arises from a clash of will: man versus God, the state, or his fellow man. Without this reciprocal conflict, tragedy turns into pathos: and pathos is the most extreme

emotion one ever finds in a painting by Russell Drysdale. Drysdale expresses no moral conflicts. He has no vision of evil whatever. The outback, killer of explorers and defeater of early settlers, becomes Arcadia because it is a refuge of innocence. To Drysdale, it is the last resting-place of moral simplicity on the broad, primitive, Wild West scale. It emerges from his paintings as an ideal world past which the last fifty years of history have gone without leaving a trace, where man is neither terrified nor bruised, where no horrors occur, where the only disasters are blind events like drought and fire, and nothing is *willed* against you. Drysdale's aborigines [b] and stockmen are un-intentional images of Australian man as he would like to be – inno-cent, protected by desert and sea from the Auschwitzes and Dresdens at the other end of the world. They are removed from history. But that does not make them universal images. On the contrary: nostalgia renders them parochial. But his work cannot be said to exist in terms of tragedy. A landscape is merely a collection of rocks, sand and trees; it is not a personage; it is not hostile, or even 'indifferent'; it simply *is*. To see landscape animistically, as both Drysdale and his critics do, is to enter into a metaphor – the tragedy-substitute of animism. But by perfecting the animist view of nature, Drysdale brought to its peak a tendency which, as we have already seen, has long been central in Australian painting. There is no sense in which he can be said to be a metaphysical painter. Drysdale's true success lies in constructing a coherent, self-enclosed world of bodily experience, so well laid out that twenty years of laymen and painters in Australia would have had a struggle *not* to think of their country's shape in terms of his paintings.

William Dobell's art developed very little over the same dozen years. It fluctuated around the level of his 1948 *Margaret Olley*, some-times well below – witness his portrait of Hedley Marston, in the Queensland Art Gallery – and only rarely above it.

By the early fifties he had taken his silky, Renoiresque brushwork to the limit. Where once his forms billowed and sagged with acid fullness, they were now polished and ribbony, and one's eye skids over them as if on oiled linoleum. In 1949 and 1950 he visited New Guinea, painting native rituals, exotic landscapes, groups of figures, and portraits. In *Kanana*, figures pose sinuously in soft coils and glazes of translucent pigment; but harking back once more to Sou-tine, Dobell treated the natives with a more vigorous brush in *Giluwa*, 1953. Their figures are slashed in with broad angular strokes, in extreme contrasts of acid greens, yellows, and reds. With isolated exceptions – *Giluwa* is not one of them, though a quiet *Seated House-boy* is – Dobell's New Guinea colour was either sugary or raucous.

Nor did he penetrate character as of old: his natives are dummies, and he was capable of producing slick little tourist views like *Scene at Koki*.

Up to 1957 there were, perhaps, too many pressures upon him to let him concentrate properly. Civic worthies and their charity-organizing wives clamoured for sittings, and the unspoken demands of the society commission – eliminate that wart, smooth out the third chin, Mrs Jacoby likes green and purple – were heard. Despite the time he spends on his canvases, Dobell is basically a painter of first impulses, so that the tiny oil sketches, which rapidly and cruelly fixed his initial insight, were often far superior to the laboured final portraits. Few Australian artists have been more sorely troubled by the *doppelgänger* of their own skill. When it rode him, the results, like *Wangi Boy* in 1954, were ingratiating and, despite the bravura, trivial.

But in 1955, Dobell was commissioned to paint the Grand Old Lady of Australian poetry, Dame Mary Gilmore. When the portrait was unveiled two years later, it was plain that Dobell had recovered some of his original fire, no doubt because the personalities of artist and poet clicked. Its colour is lucid and forceful: in a scheme of bronze-green and blackish verdigris, the old tortoise head, tobacco-brown and lined with age, rises from a froth of white lace. The drawing is more crisp than *Margaret Olley*, and the composition, a simple triangle whose corners are the head and the two white-gloved hands, is refreshingly austere.

None of his portraits since have been so concentrated. Only one has approached Dame Mary Gilmore; this is *Helena Rubinstein*, 1957. (Even so, a number of dreary replicas followed this painting, adding nothing to it – a kind of obsessive tinkering with unrecoverable freshness.) Dobell's vision of the tough old dictatress of the beauty market is fittingly opulent, and its barbaric rhythms hark back to the portrait of Brian Penton; its slashing vehemence is in marked contrast to the delicate impasto, restrained colour and static pose of *Dame Mary Gilmore*, showing that despite his mannerisms Dobell could still adapt his images – sometimes. But Dobell remains a cultural fetish to most Australians, an Aladdin's Lamp which is pulled out and rubbed whenever someone wants to prove that Australia has produced a major artist. This is an investor's myth. Critics invite the public to compare him with Rembrandt and Goya, but they did the same with another portrait painter who was just as mannered and hollow – George Lambert. Dobell (through no wish of his own) has become a caricature of inflated provincial reputation. When this myth has vanished, and the inevitable over-reaction against Dobell's work has gone too, it will be possible to see him in better

perspective than that which leads Australian collectors to write cheques which could buy them a number of drawings by major sixteenth-century mannerists, instead of a minor twentieth-century one.

*

1947 to 1955 were, on the whole, slack years for Australian painting. No concerted direction appeared outside Melbourne. In Sydney, the poeticists continued to rule: the ranks of the Sydney Group, formed in 1945 by David Strachan, Paul Haefliger, Francis Lymburner, Eric Wilson, Wallace Thornton, Wolfgang Cardamatis, Jean Bellette, Justin O'Brien, Geoffrey Graham, and Gerald Lewers, opened to receive Nolan, Arthur Boyd, Donald Friend, and others. Roland Wakelin kept to his classical post-impressionism, by now decidedly softened; Lloyd Rees continued to paint his monumental hills, and Orban his harbour scenes. In Melbourne, the Contemporary Art Society collapsed in 1947, as did the art world generally after the exodus of Nolan, Tucker, Bergner, and others. Painters there marked time, living off the borrowed glories and remembered stimuli of the 'Angry Decade', or slipping into a greasy charm worse than the most ingratiating fantasies of the Charm School. Discussion of the arts virtually ground to a halt.

In the wake of the war years' poetic topography, Jeffrey Smart emerged in Sydney. A careful but wooden draughtsman, whose

80. Jeffrey Smart: *Stilt Race*, 1960

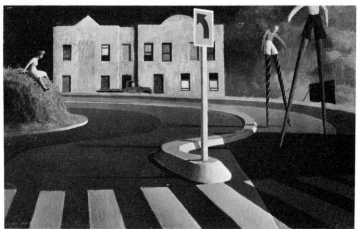

shapes are always stolid but never strongly volumed, Smart recorded precise details of deserted bandstands, terraces, street signs, the Bondi promenade, beach cubicles, and municipal swimming-baths [80]. His compositions took on the deadpan mysteriousness of Hopper's *Sunday Morning*. Their flavour often verges on the surreal. But instead of getting shock-effects by putting incongruous objects together, Smart relies on incongruous incident: a waterspout near the end of a pier, or two bathers watching lightning strike the sea from a deserted swimming-pool. The most extreme emotion in his repertoire is a rather urbane dread: his scenes are often as chilling as waxworks – stuffed suburbs, neither dead nor alive, and tinted with menace.

In the absence of innovators, Sydney painting underwent only one change in the early fifties. This was a revival of interest in colour: a reaction from the elegant browns and greys of the forties. After the war, the Government began its mass-migration policy. Refugees came from all over ruined Europe. Among them were artists: Maximilian Feuerring, the brothers Dutkiewicz, J. S. Ostoja-Kotkowski, Henry Salkauskas, Stanislaus Rapotec, and a dozen more, including a Ukrainian named Michael Kmit.

'Of all the foreign aspirants to art who have visited these shores since the war,' Paul Haefliger wrote in 1953, 'Michael Kmit is the only one who has made an impression on the present generation of local painters.' He had been born in Stryj, a town in the Western Ukraine, in 1910. He studied art in Poland, graduated from the Academy of Arts in Kraków, and afterwards worked in Germany, Vienna, Paris, and Italy. Kmit arrived in Australia in 1949. Two years later his work began to draw attention and was being encouraged by Haefliger. In 1953 he won the Blake Prize for religious art and found he had become fashionable.

Kmit's was a new voice. Sydney was now used to stippled textures and broken areas, with close, subdued colours: Bellette's scumbled browns, the greyish mists of Lymburner, Drysdale's dark reds and dirty ochres. Formalized patterns – stripes, dots, or any geometrical shapes – were unpopular. But Kmit ranged across the spectrum, and his pictures vibrated with the purest oranges and fruitiest viridians he could lay hands on. He broke forms down into sharp facets, or built them up from irregular blocks of colour, stressing the linear structure of the decorative patterns he produced.

Kmit was called a neo-Byzantine. So he was, in a shallow way – his squares of paint imitated the tesserae of Byzantine mosaic, his forms superficially resembled Byzantine forms – but his paintings were never more than an ingratiating re-hash of these elements.

81. Michael Kmit:
Woman and Girl, 1957

They went down well with a public that wanted the smile of the Cheshire cat without the cat. In Kmit's work – as never in Ravenna – the human figure became a tailor's dummy to drape iridescent swathes of colour on: a vapid pink doll, emotionless and bland [81].

But Kmit's flamboyance helped release colour on other palettes. Even Sali Herman changed perceptibly in the early fifties. His tenements became gayer and more toylike, his trees greener, his sky bluer, his clotheslines whiter. Wallace Thornton imitated Bonnard. Eric Smith (his work is discussed in the next chapter) came into prominence, with his broadly painted, monumental Christs and formalized still-lifes. The interest in *belle matière* and post-cubist abstraction was, undoubtedly, strengthened by the French Exhibition in 1953; and we shall see more of this later. But while the reveries were in mid strophe, a more important figure sidled quietly back to Sydney. This was John Passmore, who had gone abroad in 1933 and stayed there seventeen years.

Passmore, a Sydneysider, was born in 1904; he studied painting sporadically with the Julian Ashton School between 1918 and 1933, thus getting little schooling in fields other than art. Only fragments of his student work survive: a portrait in Ashton's, and a few wood-cuts printed in the *Art Student*, a magazine put out by pupils of the Sydney Art School. These depict diving swimmers – an image he returned to years later.

He met Keith Vaughan in London; both men were working for Lintas, an advertising firm. Vaughan introduced Passmore to Picasso's work (see, in this connexion, a reference to Passmore in the catalogue to Vaughan's 1962 retrospective exhibition at the White-chapel Gallery in London); the two of them made cubist drawings at neighbouring desks during working hours. A brief autobiographical note by Passmore – who is a most reticent painter, unwilling to make public statements about his own work – runs:

> From [Vaughan] I learnt the significance of what was being done in painting in France. Influenced first by ideas of Picasso, and later by Cézanne which could be endless but for one eye being forced towards the greater creative forces felt in work of Tintoretto and Rembrandt – *conflicto necessario*.

What were the 'greater creative forces'? According to Passmore, the baroque amplitude, the sweep, the passion: the commitment, then, to painting as an emotional process leading to romantic imagery. But Passmore is a painter who proceeds slowly, and during his early years his talent extended itself as warily as a snail's eye on its stalk. No vision could be less baroque or expressionist than the early Passmore's. Throughout the forties, the graces of painting were edged aside to make way for his reticent but unswerving analysis of form. Landscapes with trees were assimilated into nervous thickets of brushmarks, turning their facets this way and that in a pervasive filtered green light. Figures, blocked-out in their essential planes with dabs of pigment, were grouped in action or repose like jointed dummies. And as he penetrated deeper into 'endless' Cézanne, Passmore proceeded from analysis of solids to analysis of atmosphere, extracting permanent form from evanescent things. Clouds turn slowly; you can look at them from all sides. A tree displaces air; mysteriously, as if by friction, the atmosphere solidifies around it and becomes the negative projection of the tree's shape. Cézanne's *Mont Saint-Victoire* demands that we look at it from one spot and digest its structure and solidity. But Passmore's *Miller's Point, Morning, c.* 1952 [82] does not give us a world of structure, nor do we feel that we are looking at the harbour from a fixed point. The

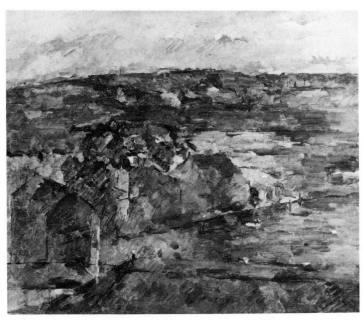

82. John Passmore: *Miller's Point, Morning, c.* 1952

landscape is seen, as it were, from the centre. There is nothing soft or indecisive about the play of its forms. Yet they do not add up to a cumulative structure. They confront us with a world of subtly differing resistances.

Passmore's art is in that rare middle ground where all experiences are equal because each is totally assimilated. His pictures of early 1953, like *Poppies, Limes, and Glass of Water*, or *Poppies, Fruit, and Skull* imply that art is a state of being, not action: art takes over when the investigation of form has ceased to be a conscious process. Passmore's 1953 still-lifes are highly sensitive pastiches of Cézanne, but this is not a sufficient account of them. They were painted to investigate the extraordinary discovery to which Cézanne gave plastic form, and which constitutes the revolutionary effect of his art: that we do not experience an object from one viewpoint. We apprehend it by means of a whole series of tiny shifts. Each of these shifts reveals a different angle. Our experience of a scene is based on the sum of these shifts and facets, as our eye travels across it. And so the total reality of an object is never its appearance from any given point.

This idea seems to have obsessed Passmore, and he was prepared to accept it as a metaphor – that is to say, that one should paint not only the sum of different angles from which one sees an object, but the implied relationships between different things in one scene: the way they are knit together by something other than form. And this notion of 'total experience' gave the cue to the younger abstract artists, like Olsen and Rose, who studied under him.

By the end of 1953 Passmore's gestures were getting broader. His paint, no longer applied in crisp washes of green, thickened. Though by no means aggressive, it assumed a distinct physicality. Beneath its surface, the influence of Tintoretto was beginning to emerge. Chiaroscuro, much abstracted, appeared. Such are the more obvious characteristics of a series of paintings of boys and fishermen on wharves, piers, and beaches. These images were projected with the same meditative totality as his still-lifes [83]. The quarrelling

83. John Passmore: *Southerly*, 1953

figures in *Fish Stealer*, or the informal yet energetic grouping of *If You Don't Believe Me Ask the Old Bloke*, 1953, do not read as human dramas. Fishermen, air, pier, and water are all concretions of the same nameless substance, subtly knit together. Postures are deliberately clumsy and angular, the bodies are lumpish. Passmore's

line, with muffled eloquence, runs forward, stops, thickens, gropes, turns a corner, and fades again. The awkward figures repeat the ungraceful carriage of most Australians: more important, however, their gawkiness is a deliberate guard against too florid or fluent a gesture of the brush.

Passmore kept using marine imagery. For him the pull of the tides determined the rhythms of existence: boats rising and falling on Sydney Harbour, fishermen going out and coming in, the shoaling of fish, the endless circle of death and regeneration: these relationships pulled life by the sea into an indivisible fabric. The idea of 'seaport' could not be broken down into parts. All its facets, from gulls to barnacles, were meaningful – but only within the total experience.

It will now be useful to look at another painter whose work started, at least, from similar premises. This was Godfrey Miller. Before his death in 1964, he occupied a peculiar place in Australian art. No painter, except Ian Fairweather in his grass hut on Bribie Island, was more of a recluse. There was – and doubtless still is – a cult of Miller, to which his eccentric, diffident personality lent itself admirably: the great painter who would not show paintings or sell them to private collections, retentive, quiet, and dotty enough to collect interpreters. He exhibited nothing in Australia until he was nearly sixty, when an oil called *Unity in Blue* was seen at the Macquarie Galleries in 1952. (On the other hand, he did not need to exhibit, since he was the heir to a large shipping fortune, and died worth more than £100,000.)

Godfrey Miller was born in 1893, in Wellington, New Zealand. He joined the Australian Light Horse in the First World War, fought at Gallipoli, and afterwards saw service in Egypt. Here, for the first time, he encountered antique Egyptian painting, sculpture, and architecture. Miller has always possessed a love of 'perfect' forms. In his youth the snowy cone of Mt Egmont near Wellington held for him the same kind of attraction – without the religious overtones, needless to say – that Fuji did for Hokusai: an ineluctably complete shape. So, too, with the Pyramids of Egypt, and with the noble and fixedly monumental forms of Egyptian sculpture. He travelled in China after the war, and similar recognitions occurred: in a traditional society art's metaphysical aspect becomes paramount, and its forms are not so much 'invented' as naturally produced by spiritual introversion: they are the result of long meditation conducted within a tradition in which no divorce between art and thought has happened.

If any idea is useful for understanding Oriental art, it is that objects are not to be valued for their own sake. They are manifestations of a

continuity, or flux, of existence. *All* exists, not *each*. Hiroshige's bridge on the way to Kyoto is not independent of the figures passing over it. Nor is it in closed relationship to those figures. It is part of an immense continuum, of which the figures are also part.

Miller's work looks intimist, but it is not altogether so. Intimism implies concentrating on one aspect of the world at the expense of the rest; for Miller, any simple thing, like an orange or a guitar, becomes a shape through which the whole universe plays. One can see this happening – though at an incomparably higher level of achievement – in the way Bonnard painted a peach on a sideboard: suddenly one's whole experience of setting suns and breasts is involved with that rich, soft, luminous globe of paint.

Miller's paintings were records of a concentration more finicky and obsessive than any other Australian painter's. They were endlessly reworked, added to, and changed. The canvas is traversed by innumerable straight lines, ruled in black ink; this grid encloses small lozenges and rectangles of colour which simultaneously construct and flow across the shapes of guitar, nude, fruit and table. Miller analysed the inflections and warping of form with infinite patience. The weakness of his style was, however, his colour, which

84. Godfrey Miller: *Still-Life with Musical Instrument*, 1962

he was rarely able to use expressively. The interplay of colour was so constricted by the grid that it did not work as space – the jump forward of a red, the recession of a blue, were clamped down on the same neutral plane by the net of lines.

Some critics have imagined a reference to Seurat in these vibrating tapestries, but Seurat was primarily a colourist; the only thing the two painters have in common is their desire for stable, almost Platonic form. Miller's facets of tint set up an even pulsation across the canvas. By breaking form down into a continuous flux, he was trying to show that experience is a continuum. His style cannot be separated from the intellectual impulses behind it, while his subject-matter was the neutral material of classical post-impressionism. In this, his achievement was quite different from that of other Australian painters whose work gets its metaphysical structure, on the level of folk-myth, from the subject itself – Nolan, for instance, or Boyd. In *Still-Life with Musical Instrument*, 1962 [84], the tiny even-sized particles of form are in constant tension, one against the next, gaining equilibrium by the balance of stress; they coalesce into the shapes of mandolin and fruit, which have no physical substance.

Certainly, no figurative painters of like stature emerged in Sydney during the fifties. In the hangover from Charm School poeticism, most Sydney figurative painting became chichi and oily to a quite nauseating degree. The impetus which propelled Bellette, Friend, and others during the forties was not felt by their imitators, so that one was left with work plagiarized from eclectics. Furniture-painting remained: a residue of standard attitudes and 'figures': the sensitive boys fingering lutes in front of Paddington houses, the innumerable imitations of Sali Herman and Donald Friend, the flowerpieces, costume designs, and Mediterranean still-lifes, the natty boudoir-pictures, the portraits of the patron's wife's poodle, the little chuffing ferries on Sydney Harbour, all dissolved in a pretty sludge of *belle matière* and churned out by the bucket to gratify minked-up house-wives.

It would not be a significant phenomenon elsewhere. But in Australia, the idea of a stratified art community is only just beginning to emerge, and during the fifties painters tangled in a scrum on one level. Having a wide popular appeal was normally confused with having something to say. There was little serious or informed collecting. It is easy, now as then, to pass effortlessly from ignorance through dilettantism to being thought an 'authority' on Australian art if you have £2,000 to spend on a roomful of the right pictures. George Bell's gibe about 'the tradition of the best-sellers' held brutally true in the last decade of Sydney taste. The idea that

paintings could be a subject for serious intellectual speculation was lost, and fashion became the guiding light.

Furthermore, there was no bulkhead to prevent the dominant modishness from contaminating the painters themselves. Thus the Art Gallery Society (an organization founded to promote intelligent interest in art and to financially assist the policies of the Art Gallery of New South Wales) held two functions in that Gallery. One was called 'Fashion as Art': a dress parade, a promotional stunt for a local couturier, featuring sacks and dirndls with names like 'Fantasy on a Theme by Klee' and 'Gauguin Tropicana'. The other was 'Rare and Beautiful Things', which provided 'twenty of Sydney's leading connoisseurs' with an opportunity to exhibit old lutes, Dresden shepherdesses, and flower-arrangements in circumstances even more public than their own drawing-rooms. There was an Ideal Bathroom by one of them, and a collection of Victoriana by another; there were even wall-plaques of tinfoil armour and pink ostrich plumes, as though Charles the Bold had collaborated with Oliver Messel; and James Gleeson, the surrealist painter and a prominent critic, was trapped into contributing a display called 'Snuff and Surrealism', wherein antique Chinese snuff-bottles of exquisite workmanship were displayed behind celluloid in Gothic niches cut in the torso of a decapitated wax mannikin.

And so it would not be unjust to say that scarcely one new figurative artist of importance – except Bob Dickerson, whose work is discussed in the next chapter – presented himself in Sydney during the fifties. Charles Doutney, who died prematurely at forty-nine in 1957, might have been an exception; he was not a gifted draughtsman, but his genre scenes of King's Cross (one of which, *Dita*, won a major portrait prize in 1957) showed some of the satirical appetite for urban life that Dobell had in his London years.

Donald Friend's work steadily developed. He lived in Ceylon for several years and returned to Sydney in 1961. Though some commentators have seen fit to regard him as a coelacanth-like remnant of the forties ('Ah, Donald,' one of them said to him soon after his return, 'I've been reading a most interesting essay by Dr —, and he shows how painters who leave Australia *always come back to die*') his present work is plainly the best of his career. His early split between wit and humanism is now closed; and though his oils tend to be over-sweet and without vibrancy, his Sinhalese gouaches and pen drawings are a combination of amusing and forceful images, registered with dash and technical facility. Sometimes, his pyrotechnic displays of penwork and overlapped washes are little more than decorative in their effect, and no matter how strong the emotion

behind the painting it is always seen, as it were, through a glass window of skill. If this slightly urbanifies the drama of his work, it also prevents his innate sentimentality about Noble Savages from being too dominant. The wit glosses, but does not obscure, the fascination of the primitive. When Friend deals with New Guinea cargo-cults, for instance, one eye is on the exotic patterns of Sepik masks, the sinuous bodies of dancers, and the big silver bird roaring in to disgorge tinned fish on the tribesman; but the other stares into the darkness of the jungle. Sometimes it might do better if it stared at form a little more attentively – Friend's most recent gouaches, of surfies, have been oddly summary in their drawing of the nude; their jollified flurries of ink ornament form but do not reveal it. The less said of his pseudo-Sienese panel paintings, the better.

The art community in Brisbane presents, in an extreme form, the familiar Australian problem of isolation; it is more remote from contemporary currents of Australian – let alone overseas – art than any other city except, presumably, Darwin. The hot tropical town on stilts beside its tepid river is cut off by distance, lack of incentive ('Where's the market?' ask the artists, though not always with justification) and slow-fading public philistinism: in 1961, for instance, when John Olsen won the H. C. Richards Prize with his rollicking *Journey into the You Beaut Country*, it was lampooned in the Press for nearly a week, and the director of the Queensland Art Gallery was obliged to write a patient article pointing out, in the sort of language one uses for ten-year-olds, that modern art was here to stay. The Gallery, like other State galleries, is too much hampered by its Trustees, stout businessmen who alone determine what shall be bought.

Naturally, then, the Queensland art community is self-contained. It is also composed almost entirely of figurative painters – the exceptions being Bronwyn Yates, Roy Churcher, and, as a kind of grey eminence, Ian Fairweather.

Broadly, the Queensland figuratives fall into two groups. One consists of decorative artists, like Margaret Olley and Ray Crooke, whose work is really an extension of the attitudes of Sydney painting in the forties, and with similar stylistic quirks.

The second, and more interesting, branch of Queensland painting is led by Jon Molvig.

Molvig is a wildly eclectic painter, and his work has been criticized for its lack of consistency: but it is the restlessness of a strong vision. His art exalts the vitality of the first moment of perception, and, in the twelve years since he began to exhibit, he has been on the move, one step ahead of the classifiers, proceeding from one image to the

next and finding different forms to fit each circumstance. In this respect, as in their expressionist style, Molvig's paintings are closer to Melbourne's 'Angry Decade' than any other Australian painter's. (There is no traceable historical link here, only a recurrence of attitude, and a common admiration for painters like Kirchner.) He is no butterfly jinking from style to style: the changes are not lightly made, and they penetrate to the core of his experience. As much as the vehemence of his imagery, they indicate the painter's active self-confrontation, more abrasive and interrogatory by far than the usual practice of building a market on typecast style and safe gestures endlessly repeated.

Molvig was born in Newcastle in 1923: the birthplace, if not the preferred barracks, of a surprising number of younger Australian painters. During the war, he served with the Army in New Guinea and the Philippines. After it, he enrolled as a student at East Sydney Technical College. He went overseas in 1949, and studied painting in Europe until 1953.

His early work had a post-cubist basis; but by 1953, a *Crucifixion* showed expressionist leanings. These became articulate over the next five years, in landscapes, large symbolical compositions, and a sequence of portraits: *Mrs 'O'*, *Madame Y*, *Lillian and Julie* (1955-6), *Self-Portrait* (1956), culminating in the remarkable study of Russell Cuppaidge, 1959 [85]. Form was assimilated into colour, and re-created with untrammelled, muscular sweeps of the brush. A powerful draughtsman, with a developed sense of contour and negative volume, Molvig also showed himself to be one of the few original colourists in Australian painting.

Molvig's colour, with its harsh energy and violent juxtapositions – blue and orange, red against green, purple over yellow – resembles Kirchner's, but it has a delicacy, even a sweetness, totally unlike the colour of the German expressionists. His reds are sometimes inflamed, but just as often they are gently modulated down through a scale of interwoven pinks and oranges; his range of blues, from tints as delicate as an eggshell sky to a menacingly fulgid, electric ultramarine, is very striking. His colour has a general flavour of acid opulence, suffusing the space with an all-over light; and it is supported by a strong tonal structure.

Molvig has no theory of colour. He uses it intuitively, in correspondence with his emotional state. In portraiture, it can be almost as incisive and revealing as drawing itself: looking at the reds, lilacs, and greens in which they are painted, one feels his avid-eyed models could teach Norman Lindsay's corpulent floosies a good deal about

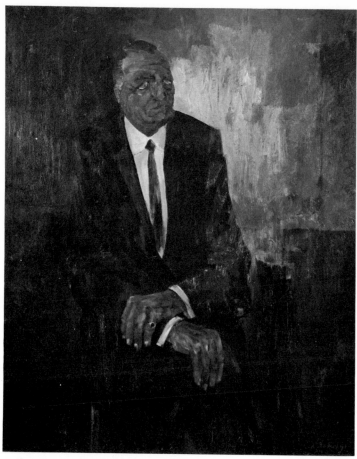

85. Jon Molvig: *Portrait of Russell Cuppaidge*, 1959

sex. In *Portrait of Russell Cuppaidge*, 1959 [85], the sombre, blockish tactility of hands and facial structure is echoed in the prevalent colour, mud-green through tobacco to dirty red.

Up to 1961, Molvig's work had different levels of intensity, and his portraits – disciplined, though not wholly subdued, by the need for physical and psychological likeness – seem almost underplayed beside other paintings. His vision of landscape, from 1955 onwards, was harsh and compelling; in *Coast Landscape*, 1956, one is battered

by the turbulent conflict of earth, sky, and trees, and a later group of Centralian Landscapes range from violent images of red earth to the moonwashed calm of *Nocturne Landscape*, 1958. The ruthless vitality of Molvig's gesture – impatient, even arbitrary – found its counterpart in the imagery he chose. He does not paint landscape to humanize it. There is no effort to subdue it, or even to make it palatable. Painting becomes a way to disinfect experience, freeing it from the gentility often associated with art. We are not in a friendly world; and with his major figure-paintings of 1957-8, it is as if we are back, on a far higher level of articulation, drawing, and technique, in the frenetic St Kilda world of the 'Angry Decade'.

Specifically, I refer to *The Lovers*, 1957 [86]. This is perhaps the hinge work of Molvig's middle development; it looks back to, and sums up, the violent expressionism of paintings like *Lunatic*, *Primordia*, and *Hotel Lounge*: but at the same time, its gigantic presence, a writhing totem of flesh, anticipates the monumental air of the

86. Jon Molvig:
The Lovers, 1957

figures in his Ballad of Native Stockmen paintings and the massive
scale of the Eden Industrial suite. But, unlike these, there is no com-
pression of the image. Sweeps of grey, black, and white paint roll
furiously upwards and coalesce into the figures of a man and a
woman, who clutch at one another with the insatiable despair of
Boyd's early lovers. It is a fearful painting; not because of its sexu-
ality, which is extreme, but because its emotional content is extended
to the outer limits of possible intensity. Nothing is held in reserve.
All emotions are equal, being totally extended. We have reached a
Camusian absurdity, from which heroic beauty and energy are wrung.

The Centralian Landscapes followed, in 1958–9. Late among
them was a small painting, *Ballad of the Snake*, whose striped, seg-
mented forms have some connexion with the striped figures in the
Ballad of Native Stockmen suite. These are more restrained than
the 1956–7 figure-paintings. In *Ballad of the Dead Stockman II*, 1959,
the three standing figures are mute, impassive, and rendered spectral
by the shifting bars of colour across their bodies, which dissolve their
human structure and evoke memories of dust, streaming air, and
ambiguous light.

In 1961 Molvig's style abruptly changed, and he produced the first
paintings of a series which still continues: *Eden Industrial, The
Garden*, 1961 [87]. His forms became hard-edged and totemic. Stiff,

87. Jon Molvig: *Eden Industrial, The Garden*, 1961

enormous figures of man (Adam) and woman (Eve) loomed against a background of factory chimneys. Abandoning oils, he turned to synthetic resins, building up dense textures and burning them with a blowlamp, producing pitted, heavy, decisive surfaces. Light became more localized, and a more schematic and abstract space was generated. Seen in the context of the earlier Ballad of Native Stockmen group, these new paintings were a logical development in Molvig's handling of *personae*, his obsessive human images. But they did not seem so at once. The broad theme of the Eden Industrial paintings is the preservation of human personality and values in a technological age. The 'dark satanic Mills' become, ironically reversed, a garden wherein innocence clumsily reveals itself and is trampled; even the flowers are shaped like cogwheels.

Like the legendary infant, when Molvig is good he is very very good; and when he is bad he is horrid. His output is uneven, much of it composed of swings and over-corrections. But the energy of his imagination proved to be a rallying-point for younger artists in Brisbane in the early sixties, such as Andrew Sibley.

In Perth and Adelaide, little significant figurative painting was produced during the fifties. The best of it was obviously derivative – Guy Grey-Smith from de Staël, for instance. Robert Juniper is also

88. Robert Juniper: *Landscape*, 1963

concerned with landscape [88]; his work oscillates between abstract and figurative imagery, overtones of Klee are often present, and, although he is a skilled colourist, his forms are too mannered and attenuated to constitute a really convincing image. In Adelaide, there were James Cant and the brothers Dutkiewicz; and a pleasing lyrical sensibility was evident in the low-toned paintings of Jacqueline Hick, and the landscapes of Horace Trenerry.

By far the most interesting new painter seen in Melbourne during the latter half of the fifties was Frederick Williams. Williams was born there in 1927. He was trained, first at the National Gallery School, and between 1951 and 1956 at the Chelsea Art School and at the Central School in London.

He came back to Australia thoroughly versed in etching techniques. He is, today, the country's best etcher. A good Williams etching has the perfect spontaneity of a sketch; this bloom is not diminished by the involved additional techniques he employs. In Europe, the main influences on his work were Daumier, Gauguin, Gromaire, the drawings of de Segonzac, and Degas; what impressed him in these five very different painters was their control of tonal relationships, and the discipline of their forms – the ability to suggest a totally expressive shape with the minimum mark. And these

89. Frederick Williams: *You-Yang Landscape I*, 1963

are the virtues of Williams's best work. Landscape painting is the major aspect of his art. He brings to his landscape images an austere concentration, so tightly focused that its self-imposed limits have been taken for timidity. Today, after the vulgar formulas of the Heysenettes, there could hardly be a less promising subject than the gum-tree. But looking at the delicate palisades of tree-trunks Williams painted between 1957 and 1960, one is reminded of Giorgio Morandi and his dusty bottles – a similar humility and fear of declamation breathes from Williams's work: and the same exact control of form. In *Sherbrooke Forest*, 1961, the figurative element nearly vanishes, so that trees and leaves become submerged in a many-layered green space, jerked into register by an occasional projecting twig or tiny slot of sky. In other paintings, like *You-Yang Landscape I*, 1963 [89], the trees are mere dots of paint, hung on a neutral ground. But the relationships of these spots, the way they form knots and runs of space, so that the implied landscape tenses and relaxes its forms like a live membrane, is admirably articulated. Williams's work carries the same kind of concentration that marks the paintings of Miller and Passmore. His range is narrow, but he is not an intimist.

In 1947, the Kelly series behind him, Nolan went to Queensland for a year. He spent most of it hitching through the outback, then lived for several months on Fraser Island, well south of the Barrier Reef and a few miles off shore. Each locale suggested a new series of paintings.

The Outback pictures took for subject the Queensland country towns, scattered across the dry inland hills, the north-west black soil districts, and down the immense arid bed of Lake Walloon. Most of them are no more than a main street of weatherboards and a pub; the bright lettering fades, paint flakes on the veranda posts, the once sprightly Victorian cast-iron curlicues rust and are painted brown again. Frame buildings warp; in hot air, the street becomes a mirage, as if the dust took solid form for a moment. In the middle of nowhere, a few hundred yards off the road, the geometrical carcase of a seed-drill lies among the pebbles.

Nolan stressed this landscape's ambiguity, as it wavers in the heat. His country towns are blurred, their planes and buildings casually rubbed on with streaky paint. Space, like the light, slides and shimmers. But almost always in the Outback series there is one fixed thing, which stands out in sharp clarity against the rest of the painting. It may be a palm-tree, growing at the end of the main street of *Queensland Township*, 1948, and arresting the flow of space like an exclamation point. Or an old agricultural machine, drawn with the precision – and much of the graphic wit – of Steinberg, sits on the hotel roof. More commonly the fixed point is a bird in the sky. Now the Kelly series sometimes used false attachments between objects to disrupt space and promote their disquieting lyricism. The Queensland paintings use a more subtle variant of this. The fixed point is in the distance, where one would expect it to be indistinct: but the foreground is blurred instead. Queensland parrots flash by like brilliant projectiles; but Nolan's birds stop in mid-air, sometimes upside down, and are painted with the detail of a primitive. But figures in the landscape are as lacking in structure as the landscape itself; in Victorian dress, with beards and mutton-chop whiskers, they have the quaint look of Holtermann's photographs of Hill End in the

1870s. The paint surface is still skin-like and untextured, as in the Kelly series, and Nolan kept 'cutting out' forms with Ripolin background.

On Fraser Island, he heard of the curious adventures of the woman whose name it bears: Mrs Fraser, survivor of the wreck of the *Stirling Castle* in 1836, who fended for herself six months among the blacks, and at last met an escaped convict, Bracefell, who had gone bush with them too; he agreed to guide her back to civilization if she would intercede with the Governor for his pardon, but at first sight of white settlement she betrayed him and he fled back to the bush.

Nolan's Fraser paintings, a brief series, were the most interesting treatments of the figure (Ned Kelly apart) he had hitherto achieved. *Mrs Fraser*, 1947, straddles on all fours in the bush, naked, defenceless, and androgynous: one thinks of Shakespeare's 'poor, bare, fork'd animal'. It is a shocking and unforgettable image. There were also a number of paintings of Bracefell, done throughout 1948. In striped convict's garb, he hops jauntily through the spinifex. Here Nolan returned to patterns, the wallpaper of Glenrowan or the striped figure of Kelly in *The Chase*, 1947: indeed, the figure of Bracefell was anticipated by *Fullback, St Kilda*, 1946, whose broad-striped guernsey standing out against an amorphous mass of spectators' faces prefigures the horizontal bars and heat-dissolved background of the Bracefells. But the convict has none of the footballer's solidity: often he is no more palpable than a vibration in the air, another of Nolan's evanescent, oddball heroes.

The Kelly paintings, shown in Melbourne in 1948, were ignored; John Reed then arranged their exhibition in Paris, where (thanks in part to the support of Jean Cassou, director of the Musée d'Art Moderne) they created considerable interest. In that year, 1949, Nolan travelled further in Australia and flew over the Central Australian Ranges. His paintings of these endless pink hills – many of them directly transcribed from photographs in *Walkabout* magazine – made his first popular success. However, this series, which lasted until 1950 and covered more than 200 paintings, is repetitive and dull after the work that went before. They are not close enough to the real thing to take on the actual grandeur and terrible humpiness of, for instance, Ayers Rock; they are less moving than photographs; and they are not far enough from the real to become symbols. In short, the Central Australian aerial landscapes hover in the limbo of half-developed experience.

His Explorer paintings do not, though their statement of relationship between figure and landscape adds nothing to the 1947 Kelly series. Burke and Wills have been called heroes, but they do not

emerge from these paintings as heroic figures in the Ned Kelly sense. Max Harris, I think, was the first to observe that people who try but do not succeed become figures in the Australian imagination: the Anzacs beaten off from Gallipoli, or more ludicrously Warburton, the South Australian explorer, who went sandblind and returned to Adelaide strapped backwards on his lurching camel to avoid facing the dust-filled wind. To this breed of anti-heroes Burke and Wills belong. Their discoveries were of little value, their expedition was bungled, and their deaths were pointless. But the streak in Australian character which denies any ultimate value of human action puts them among its favourites. Though its formal structure – as in *Burke and Wills Leaving Melbourne*, 1950 – often fails, the series is a scrubbily poetic evocation of frail man in an ancient landscape; even the humps of the camels become assimilated with the ancient hills on the horizon.

In 1951 Nolan visited Europe briefly, and was especially impressed by the frescoes of Masaccio. In 1952, after his return, the Brisbane *Courier-Mail* commissioned him to make drawings of that year's disastrous drought. Like Drysdale on a similar job in 1944, Nolan was a painter of aftermaths, but he restricted himself to close-up views of the contorted, sun-dried carcases of dead stock. The geographical banality of his Central Australian landscapes was echoed by the anatomical banality of his bullocks. And for like reasons: they were neither sufficiently close to nor remote from their originating experience, and so none attained the lyrical force of Drysdale's drought pictures, still less of his own Kelly, Outback, or Fraser paintings. It is worth noting that Nolan's images since 1945 only succeed when they are remote from their original events: the first Kelly series, Bracefell, Fraser, the Outback paintings with their deliberate Victorian archaizing, some of the second series of Fraser–Bracefell pictures, and Leda and the Swan. The comparative failures have been the Central Australian and Drought series and, for related reasons, the second Kelly series.

Nolan went back to England in 1953 and started these latter paintings soon after arriving. Some were merely second versions of the first series: *Kelly*, 1954, 'perhaps Nolan's most famous painting', was one, and the second adds little or nothing to the first. In theory, these could have been of equal force to the originals; but they were not, for the original image had gone rather stale over the intervening six years. But other Kelly paintings complicated and embellished the first impulse: they were overlaid with elements of Greek or Italian landscape, and cross-references to his European heads and religious studies of 1951 occurred. Thus the Kelly mask visibly changed.

Where once it confronted the viewer as an uncompromising black rectangle, with a slit in it showing landscape behind, it now softened ambiguously. A mouth appears in the metal, or the mask changes into a face; eyes appear where the blank slit was, or it becomes two shuttered windows. In *Kelly at Glenrowan*, 1955, the fanciful naturalism of Kelly's original environment has disappeared, and the wreckage of the burnt hotel, its charred joists and patterned wallpaper, has assumed the look of an abstract structure. Even the colour is less referential. The London critics felt that Nolan, by stressing the abstract elements of his new series, designing them with greater sophistication, cross-breeding them with European experiences, and sometimes presenting Kelly as a Christ-figure, was seeking to universalize his myth. But instead of returning as a personage, Kelly veered towards puppetry. This was manipulation, not invention, of an image; too often, as in *Kelly and Drought*, 1957, *Kelly, Spring*, 1956, or *Kelly with Horse*, 1955, the once heroic image deflated itself to a predictable gesture.

In 1955-6 Nolan worked in Greece, producing numerous landscapes and small studies, involving Cretan decorative motifs, the bull of Minos, and figures drawn from Hellenic mythology and sacrificial rite. These recovered a good deal of the inventive purity lost in his welter of Kellys, and this was reinforced by later paintings, embarked on after travels through Turkey, India, and Cambodia: a second sequence of Frasers and Bracefells.

Experiences in Queensland rainforests were overlaid by memories of the Cambodian jungles; to capture that filtered, underwater green light, flickering with glooms and transparencies, Nolan abandoned his opaque Ripolin and took up polyvinyl acetate, a synthetic emulsion which could be scraped back to expose innumerable transparencies. It dries fast and demands fast execution. Reflections, highlights, double-images can be summarily dealt with, on the very edge of control. Like watercolour, it is not a retouchable medium.

When he was not dealing with jumpy vistas of overlapping palm fronds, but restricted his too fluid gesture with big dense forms, Nolan produced some exquisite images registered with the naked immediacy of a flash-photo. Mrs Fraser and Bracefell are insect-like among the gross limbs of swamp baobabs. In *Figures in a Tree*, 1957 [90], the trunks have a fleshy softness, quite unlike the scrubby eucalypts of the first series; the waterlogged garden of Eden where his convict Adam and naked traitress Eve disport themselves has an enveloping sexual flavour. In other pictures Mrs Fraser, a transparent wraith, her one solid attribute a striped sash, floats in dark water or wades through pools dissolved in Monet-like light. She is

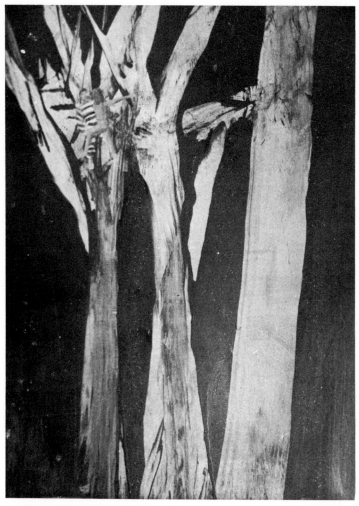

90. Sidney Nolan: *Figures in a Tree*, 1957

divested of personality, even of sexual character; her hair, as in the earlier and more violent image of 1947, obscures her face. Bracefell, transmuted into a striped butterfly, hovers above her.

This neuter, remotely observed body floating in water or suspended in light merged naturally into the Leda and the Swan series, 1958–60. The Leda paintings were anticipated by a *Bird*, 1957, across

whose body amorphous blots of colour drift, and a Leda of very dif-
ferent character, where figure and bird are fused in one ambiguous
form, also painted in 1957. According to Nolan, this new image was
stimulated by the sight of his daughter swimming; Bryan Robertson
has plausibly suggested that the drifting areas of primary colour,
reds, blues, and yellows, which invade the pale subaqueous forms of
girl and swan, were provoked by neon reflections on the river
Thames at night [91]. With this allusive and metamorphic flavour (so

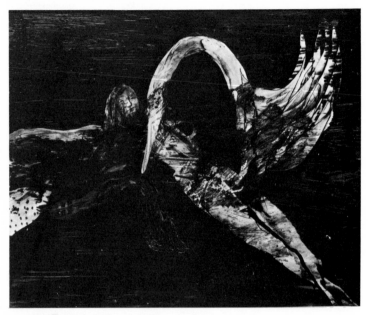

91. Sidney Nolan: *Leda and the Swan*, 1958

unlike traditional presentations of the Leda myth: one has only to
compare the opulent physical 'presence' of Cesare da Sesto's *Leda*,
after Leonardo) there went a casual dispersion of the forms; in the
larger (48 ins. x 60 ins.) paintings, the composition breaks down
and space floats unresolved.

Yet to feel that the picture just 'happened' is intimately part of the
magical effect Nolan's best work has: where, then, is the difference?
Perhaps in the gentle, non-obsessive nature of the image itself, and
the dangerous glibness of its presentation. The big Ledas abhor a
vacuum; their surface is scratched, stained, endlessly elaborated in an
irritating virtuoso display of handwriting, but the smaller paintings,

in dye on glossy paper, tend to avoid this fault: their size, and the natural scale of the gesture, compress their images and give them point. In short, the Leda series is vulnerable to analysis, but at its core lies something which eludes the most ravening critic – Nolan's lyricism, weightless and intrinsically pure.

Though diminished, it continues in his recent Gallipoli series. Here, again, the love of heroes who do not quite get there; for Nolan, then, an image of similar structure to Kelly or Burke and Wills. But the Gallipoli pictures generally lack heroic content. Nolan's soldiers are mere disturbances in the air, arrested in ephemeral poses; their flesh has no corporeal existence. If they carry rifles they hold them like walking-sticks. Their plumed Light Horse hats might have come from party crackers; they are naked, but vulnerably so, not heroically nude. The lyrically swirling landscape they inhabit suggests nothing of the suncracked Gallipoli rocks; it is as eerily soft and runny as a Dali. Only in isolated larger paintings does a sense of vigour or drama break through: *The Mythrider*, 1960, is one.

Now one may very well applaud the ingenuity of this treatment: who else would have thought of doing it ? Still, it has the flavour of a gimmick, and recognizing Nolan's inventive skill does not solve the problem of what happened to his capacity to realize a heroic narrative image. For it has certainly evaporated: through lack of contact, I am inclined to think, with the myths he paints – if the Anzacs' struggle at Gallipoli can be called a myth at all. Nolan's work appears to be in crisis. Where before the 'style' of his pictures, the handling of paint and line and colour, and especially the emotional stance towards their images, grew organically from the events and objects he dealt with, the Gallipoli paintings are simply a transference of moods, ideas, and forms fixed by Leda and the Swan; and they evade those visual and iconographic problems which, before, were central to his art. It may be too sweeping to suggest that Nolan's paintings since the Gallipoli series have done little to recover that focus. Yet I suspect it to be true. As one passes from his African paintings to his Antarctic series to his latest Australian landscapes, one becomes uncomfortably aware that a cast-iron technique is being applied to a sequence of superficial tourist views. And poor Kelly, saddle-sore from riding through so many paddocks of hardboard, is on the verge of losing his point altogether; all you can say is that he belongs to Nolan as that white rabbit belongs to Hugh Hefner. And yet I can think of no Australian painter about whom one would less willingly write such things, for Nolan's is an exceptional sensibility, fine and lyrical, yet constantly marred by his failure to give his new images a sound formal structure.

Albert Tucker's development, from 1947 to 1962, is markedly different from Nolan's – slow rather than coruscating, it is the growth of a most restricted set of forms which, too early, seem to have ossified.

When Tucker, disgusted with Australia, left for Japan with the writer Harry Roskolenko in 1947, he was determined to repudiate Australia altogether. There was a brief visit to Australia six months later; then he left for London and, early in 1948, moved to Paris.

Between Japan and Paris, he did little work. The transition paintings are small and dull – the strain of resettlement, and the sudden stimulus of Europe, saw to that – but one shows the final expiry of his red crescent-form: *The Footballer*, 1947, an abstract–surrealist exercise whose central form (half goalpost, half figure) is slitted by a number of small red gashes; the mouth-form has merged into the fissure, later to be vital in his repertoire of images. But he did not develop it immediately.

In Paris, he returned to his interest in cubism, or, more precisely, in the expressionist cubism of Picasso's work of the late thirties. He did not analyse the objects he saw. This would probably have been beyond his powers as a draughtsman – his grasp of Picasso's style was superficial in the extreme, but the paintings he did in Paris in 1948–50 had, for all their crudity, an unmistakable violence and conviction. The colour was harsh: soiled purples and blacks, jumping suddenly to a raucous yellow or a pink. Most of his subjects were prostitutes and their pimps. His old obsession with sexual evil was back.

At about this time, Tucker saw paintings by Jean Dubuffet; and it is to Dubuffet that one must look for the origins of his mature style, with its thick craggy impastoes, its coarse punning between organic and mineral matter (flesh and earth), and its self-conscious brutalism. The lumpish forms of *art brut* can be traced in a painting of 1950, *Maquereau of Place Pigalle*, in which he stumbled on the form which led to his present 'Antipodean Head' shape. The head is rapidly drawn, with an exaggerated nose and chin; its contour may be traced back through earlier paintings of Paris prostitutes to the red crescent-form in the Images of Modern Evil [58]. He worked on this shape for a year, and in 1951 moved to Germany, settling in a village near Frankfurt. Here he crystallized his experiments in a small painting, *Head of Man*: dark, in profile, staring fixedly, its features ravaged by scars and fissures, it directly anticipates the Antipodean Head. But the bombed cities of northern Europe depressed him, and in the winter of 1951 he returned to Paris, built himself a caravan and migrated to Italy. There he settled in the small Ligurian hamlet

of Noli, three kilometres from Spotorno, where D.H.Lawrence once lived.

Life there was easy and relaxing, after the corrosive tensions of Paris. His paintings changed with the landscape, acquiring a new sensuality of colour and plasticity of form, and began to reflect the religious beliefs of the local peasants, with their hybrid cults of intermingled Virgins and Earth Mothers, in images like *Job*, *Entombment*, *Judas Iscariot*, and a curious *Betrayal* with Caiaphas's men dressed as French police. In 1953 he moved to Frascati, outside Rome, where his imagery shifted once more: this time, closer in spirit to the Images of Modern Evil, he became interested in uniforms, street-signs, traffic-lights, and the like. These stamped-out objects, faceless categorical imperatives, took on the character of urban totems; in a brown wasteland of streets, Tucker's figures fought and copulated, hacking at one another among the mechanical hieroglyphs of a city at night. In tune with this schematized subsidiary imagery, the heads became more abstract and began to acquire their present form.

His problem was to find the right environment for the Antipodean Head; the image of place with which it could most fruitfully interact. It was an iconographic form, but in embryo: it needed both to irradiate its surroundings with metaphysical properties and at the same time to sum up their inner nature, just as the red crescent had done in the streets of St Kilda. Over four years he tried different contexts: a blank space, water, streets; once, with ludicrous effect, he put his heads on the leaping bodies of Italian footballers. Meanwhile, in Rome, he began to use polyvinyl acetate. Using it as a glue mixed with sand and raw pigment, Tucker was able to build up thick aggressive pastes: instead of painting fissures and wounds into the faces of his *personae*, he now modelled them directly. This hypernaturalistic illusion became central to his method thereafter; and, in 1957, he produced a small purplish-brown head, silhouetted against a flat plain of Australian saltbush. For the first time, the head-image worked as a projection of the scarred, inhuman landscape. Tucker's old environment had come irresistibly back to him, after ten years of rejection.

After this his work developed along a strictly defined path, with little variation of form, hardly any change of subject, and a slow expansion of imagery. His central point was the Antipodean Head. There were also landscapes, built up from slabs of hard paste, craggy and remote as the far side of the moon: suggestions, intensified to the point of melodrama, of the geological antiquity and implacable remoteness of inland Australia. He went from Rome to London,

and, in 1958, to New York; in 1960 he returned to Australia. Though the lights of Times Square caused him to experiment with some stencilled paintings of flickering neon signs, this was not a significant diversion. Five principal symbols were developed to reinforce his head-form.

The first of these, being the longest-used, was a light bulb in an open shade. He first used it around 1943, in *The Vaudevillean*; later it underwent curious modifications, once appearing with the shade changed into the wings of a bird, descending on a group of figures in an ironic parody of the Pentecostal Dove. Parallel with this run Tucker's two main conflict-images: the gun, suggestive also of phallic energy; and playing-cards, brilliantly employed in *Gamblers and Parrots*, 1960 [92]. Then there are the fissures, whose origins and

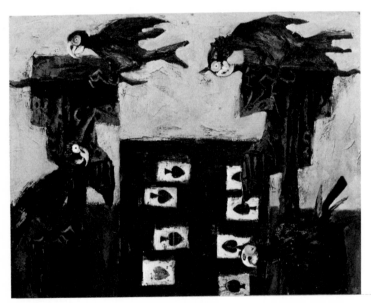

92. Albert Tucker: *Gamblers and Parrots*, 1960

implications I have already discussed, and the parrots, in red and green plumage, which become tiny winged piranhas and slash with horny beaks at the impassive face of an explorer.

Tucker's art is crass and heavy-handed. It is not inherently sentimental, but the excess of its violence can generate its own sentimentality, acid and brutish. One is easily put off by its perpetual

fortissimo; and once belief has been suspended, it is hard not to experience Tucker's paintings – especially his more recent ones, with heads of Pan and parrots – as mere image-shuffling. Certainly Tucker is not a fluent painter, and his shapes are repetitive, but what is interesting about Tucker's work is his statement of human dilemmas, or rather of one dilemma: the survival of identity. Tucker celebrates man's minimum function, which is to survive. His figures go through disasters and come out ravaged, but they do come out. His work is full of the exhilaration of starting from scratch. Such an image only becomes urgent after wars and suffering, and there's little doubt that the two formative experiences of Tucker's art were the mood of Paris – and Europe generally – in the cold late forties and early fifties, and the peculiar mixture of frustration, self-pity and exaltation in which all the young painters in Melbourne lived in the early years of the war.

After 1947 the Melbourne art world went slack. Nolan married for the second time in 1948 and settled in Sydney. With Tucker and Bergner abroad, the Contemporary Art Society lost two more of its mainsprings, and the interdependent group of artists and poets around John and Sunday Reed broke up. Artists whose potential development was arrested by the war – John Brack and Clifton Pugh, among others – were still doing their formal study. Other figurative painters, like Bob Dickerson (in Sydney) and Charles Blackman, had yet to develop.

Arthur Boyd continued to work in ceramic, producing both painted religious panels and pottery sculptures. The robust, folksy shapes of his patriarchs seemed momentarily to be softening; accordingly he approached them in a more linear manner, with reference to cubism.

Between 1947 and 1958 most of his paintings were landscapes. He visited Central Victoria, and painted numerous evocations of its blond wheatfields, light, and wheeling crows; others were less violent renderings of the primeval gum-forests in the Hunters and Lovers series. At their best, these were exquisitely reflective:

> If he paints distance and the horizon it is always in a spirit of *sensitivity*, he wishes to reveal the appeal and delicacy of far-off things. The effects of great distance and extreme clarity of light are nostalgic, and the most everyday objects and happenings become transfigured. It is like looking down an alpine pass to a village miles below one in the valley: one sees the tiny paradise of childhood.... It is almost overpoweringly sweet; and sweetness is one quality, amongst others, which we find very often in Arthur Boyd's landscapes...it could probably be defined through such concepts as self-absorption and completeness.

Many of Boyd's landscapes, especially between 1953 and 1958, are the bread-and-butter work of a skilled professional; this does not diminish their charm, but it makes them incomparable to his major series of the fifties, which revolved around the love, marriage, and death of an aboriginal stockman and his half-caste bride. This is generally called the Love, Marriage and Death of a Half-Caste suite, and it occupied him from 1958 to 1960.

It evolved from earlier paintings of 1957-8. One of them, *Half-Caste Child*, shows an aborigine looking mournfully outwards while a half-caste girl embraces him in an attitude of supplication. The treatment retains the rich Brueghel detail of landscape, rocks, birds, and subsidiary figures characteristic of his earlier work, but the general effect is as sentimental as a McCubbin story-painting. Here, then, is the germ of the Half-Caste Bride suite: affinity and rejection between pure and halfbreed blacks, the disruption of racial equilibrium by the coming of the whites: and, behind it all, just as it lay behind the St Kilda paintings, the search of man for love.

Boyd reverted to his surrealist expressionism, but without the original savagery of 1943-4. The prevalent mood is dreamy, melancholic, disquieting rather than frightening. It is close to Chagall, both in effect and in symbolism. In *Groom Waiting for His Bride to Grow Up*, 1959, the phantom of the mature bride sits, like Chagall's Bella, in a tree. A blue bouquet sprouts from the ear of *Drowned Bridegroom*, 1958. Beetles cling to the cheeks of the bride and the man with the shotgun in *Persecuted Lovers*, 1958. The imagery is naïve, though not archly so, very sentimental, and somewhat literary: its surrealist elements, in conformity with the general trend of Australian pseudo-surrealism, are transcribable into verbal concepts. Thus the moths fluttering round the lantern in *Shearers Playing for a Bride*, 1958, are also suffering from their own kinds of fatal love. When a recent film entitled *The Black Man and his Bride* showed *Persecuted Lovers* to the accompaniment of a soupy ballad which ran

> The White Man shoots me like a dog,
> Flowers grow from my head...

it was a mawkish moment, but in line with the actual intention of the image. Everything in these pictures conspires to have them teetering on the brink of the ludicrous: the woebegone golliwog face of the black stockman, the squat ugly bride with her wailing tunnel of a mouth, the long bridal veils and trains in which her groom's feet keep getting entangled.

The changes of style within the series may be seen by comparing *Reflected Bride*, 1958 [93] with the later *Drowned Bridegroom*. The

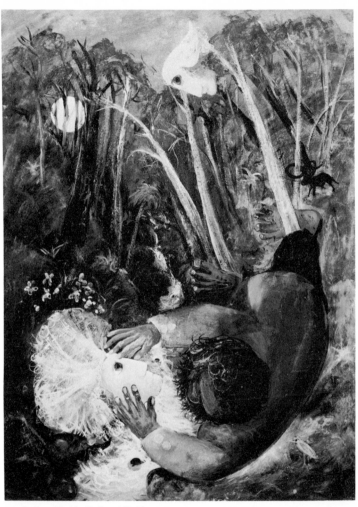

93. Arthur Boyd: *Reflected Bride*, 1958

former picture recalls Boyd's forests; the same soft gluey trees are there; natural detail, the wildflowers and the froth on the creek, is seized on, and the images of the painting are dispersed: a floating bride's head in the branches echoes the moon, a ram stands in the middle distance, birds and beetles hop and skitter about, space is distorted by a false attachment between the bridegroom's right foot and

a gum-tree. All this confuses both the composition and the emotional direction of the painting. However, *Drowned Bridegroom* is reduced to essentials. The background is two schematic browns, the figures are pared down to their minimum form – an austere picture, heavy with pathos. As the series progressed, Boyd's shapes became more rigid still: *Bride Watching Soldiers Fight*, 1959, is drawn with crystalline precision. It also borrows one of Tucker's favourite images of evil from the forties, the flared nostril.

In his more recent work, Boyd continues to tap the sources of puritan tradition. His new paintings generate their own frame of reference much as Stanley Spencer's did, by an eccentric involvement with life based partly on religious experience. Spencer's sexual fantasy was veiled by his village-prophet religious imagery; Boyd's spiritual impulses are encased in images of flesh, gross and even kinky, through which he works out his theme of the damage done to love in a world of sex. He recapitulates elements of his St Kilda series of 1943–4, and of the Hunters and Lovers paintings. The

94. Arthur Boyd: *Figure Turning into a Dragonfly*, 1962

bride is replaced by a pink moon-faced nude; the zoo of private symbols which inhabited his vision of St Kilda has come back. Salamanders recall the crocodiles on crutches; the leering frogs and grotesque hybrids (ram's head, cat's claws, man's torso) have all been seen before. These tormented effigies gyre and gimble through a darkly glutinous forest of paint, antipodean monsters in a damp Eden. But the main link between Boyd's St Kilda paintings and his more recent ones is emotional rather than iconographic. The Bride paintings were by turns morose, elegiac, and wistful; they erected a poetic barrier against too much self-extension. Not so with the new pictures, whose lovers grapple destructively and find no release; we are back in the St Kilda world of sexual battle, and it is projected with an expressionist vigour as violent and as confused as the 1943 paintings. All emotions become so explicit that they end up in complete isolation; the wandering islands never meet because there is nothing to make contact with. Boyd's figures constitute no myths, they are *personae*, and meta-morphic images at that: one of the preoccupations of the new paint-ings is with change of state, between figure and figure, figure and landscape, and so on: the ambiguity is obsessive. This is plainly to be seen in one of Boyd's best recent works, *Figure Turning into a Dragonfly*, 1962 [94].

John Perceval, after ten years away from the easel, took up in 1956 where he left off – in landscape. Unlike his earlier expressionism, however, this was a roly-poly art, full of gusto and bounce. This sensual anti-symbolism was quite unlike anything other Melbourne painters had to offer, and possessed, within its obvious limitations, considerable originality.

Perceval works *en plein air*, a rare thing among Australian artists, painting into the light so that the dense, matted interlacing of his gum-forests can be seen more clearly in silhouette. This is all done at breakneck speed: three to four hours, if that, suffice. Consequently Perceval relies on the expressive qualities of gesture more than any other local figurative painter. He is quite indifferent to iconographic form. It has no relevance to him, for there is no gap in his work between perception and act: only a lyrical, and essentially physical, immediacy of direct involvement. His images hold no subtleties that are not engendered by the act of painting itself. Consequently anti-stylism goes hand in hand with anti-symbolism [95].

Were this not so, his paintings would be intolerably banal. Con-sider the subject-matter. Slices of bush, pink with wildflowers and jinking butterflies; vistas of waterpools and gums, with contented cows munching the outrageous, arsenic-green grass; blue water at

95. John Perceval: *Dairy Farm, Victoria,* 1960

Williamstown, tugs and ferries merrily bobbing like children's toys in the bath. This is Disney-fodder: innocent, childlike, pleasant. But Perceval, though keeping an innocent eye, wastes no time as a cute kid; his innocence is projected through the emotional depth of an adult. His work, owing to his unreflective spontaneity, is uneven; but at its best its voracious appetite for stimuli and its good humour are matched by few of his contemporaries. This is as true of his ceramic angels as of his paintings.

The angels are a special case. Though sculpture, they form a continuum of imagery with his paintings. His choice of clay as a medium befits his direct and spontaneous working methods: it can be moulded directly and changed at whim. And unlike other sculptural materials – bronze, wood, stone, steel – it takes colour; traditional usage links ceramics and polychrome glazes.

The angels extended the orotund gusto of Perceval's landscape forms into images of human beings. Half urchin and half cherub, with their knowing eyes and mischievous grins, they are bawdy cupids. One plays a lute; another, a harp; a third makes a cat's cradle; a fourth and fifth wrestle; and a sixth, out of high spirits,

stands on her head. The influence of South German baroque has been attributed to them, and they closely resemble medieval *misericordia* carvings. The glazings are rich – gold, *sang-de-bœuf*, and verdigris predominate.

Clifton Pugh was born in Victoria in 1924, fought in New Guinea with the Australian Army, was invalided out in 1944 and, in 1947, enrolled at the National Gallery School, where for three years he learnt tonal impressionism from a society portraitist, William Dargie. In 1951 he moved out of Melbourne to a country district, Cottle's Bridge. With a group of friends he set up an artists' colony there. His motives were the same as those of Streeton and Roberts when they pitched camp at Heidelberg: dislike of the city, a wish to be in the most intimate relationship with their landscape subjects, and pleasure in simplicity. Pugh's work shares the animistic view of nature which runs, so much modified, through Australian landscape painting from Davies and Long. The animals in his pictures embody the 'spirit' of the landscape they live in: grace of heron, delicacy of butterfly, shyness of wallaby, fierceness of native cat. But his pictures undergo odd stylistic changes because, within the same canvas, observation and stylized form clash. For instance, in *Memory of a Feral Cat*, 1961, the beast's shape is simplified to a few formal lines and then filled in with careful fur; it stands on semi-abstract rocks interspersed with Pre-Raphaelite grass. These shifts diminish the impact of his view of nature, leaving us with what too often looks like a painting of a not very good semi-abstract statue found in the bush. Sometimes the sentimentality of Pugh's paintings is appalling, the forms incoherent, the situations melodramatic; this is the result, as much as anything else, of Pugh's unselective *naïveté* about nature. For his confrontation of nature, though sometimes active, is not entirely so.

This split between two worlds of experience proceeds from his uncritical love of nature. He cannot resist the smallest wild flower; if it is beautiful, in it goes. His response to the landscape is pure, and (despite its elaborately imposed overtones) very naïve. Nature is a personality – a force, a lover, and a killer; its capital N is written large across the gentlest of Pugh's canvases.

His landscapes are the embodiment of human emotions – an expressionist projection, a willed act of humanization. The passivity comes from the superficial flourishes, the occasional failures to select *significant* aspects of his subject, and from his own private nature-myth: 'Sometimes I feel,' he once remarked, 'that man has a suicidal tendency, as if he had overstepped the limits of his place in the order of Nature and now God or the Life-Force or whatever you want to

call it is pulling him back to destroy himself.' Thus man, in Pugh's world, remains a victim of inscrutable forces; the landscape remains untamed and, because untamed, partly unpaintable.

The harsher side of Pugh's work reads best when its forms of menace are ambiguous, producing an effect allied to surrealism. *Swamp Form*, 1958, with its half-eaten, decomposing object (a human being? an animal?) prefigures this, but it is most articulate in an interesting sequence of Crucifixions, 1959–60, based on the corpse of a wallaby caught and decaying among sticks [96]. Pugh's most

96. Clifton Pugh: *A Crucifixion*, 1959

generally successful paintings lie, at present, in a quiet vein: his portraits, and such landscapes as *Presence of the Strathbogies*, 1960. As a portraitist he has been troubled by the difficulties of forming a *total* conception of the sitter: heads are academically painted, but imagination takes over from the neck down. Yet at best his grip on character is firm, surpassed by none of the younger Australian painters except Jon Molvig. His studies of his wife, in particular, are suffused by an almost neurotic tenderness.

With Pugh, John Brack studied under Dargie at the National Gallery School; it would be hard to imagine two courses more divergent than theirs. In the general context of Australian painting,

and Melbourne expressionism in particular, Brack is an eccentric. His paint has no 'presence'; it is a muddy substance for filling in the gaps between his wiry, precise lines. His colour is unpleasant: limey greens, browns, strident yellows, brick-red. When he essays sensuality he fails. The *angst* has a slightly fabricated look, and his paintings exhale donnish wit and well-bred claustrophobia. But his spleen has a target in the sprawling suburbs of Melbourne, and whether the painting he lets fly with is good or bad it normally strikes home as satire.

97. John Brack: *Five O'clock Collins Street*, 1955

He ignores myths and bush fables. The world of his paintings is populated by non-heroes at their most squalidly vulnerable: fat clerks in felt hats, sweating race crowds, grim Sunday outings, the young–old faces of jockeys with their silk caps and lizard eyes, hamcutters, thin yellow nudes, and skinny brats squabbling in the wire-fenced asphalt yard of a State school. One of his more acid inventions was *Five O'clock Collins Street*, 1955 [97].

The 'Boucher nudes', as they were called, were parodies of such fleshy pleasantries as Miss O'Murphy, with the same props and poses, but transferred to the nasty brown–cream–green interiors of Camberwell and Hawthorn. Thin, altogether unpleasant, they slump

and sprawl; the impression is not of sensuality, but puritan genitality; yet, scraggy as they are, these figures retain a battered dignity. More recent paintings, exhibited in 1961, verged on the abstract. They were about suburban weddings, whose tinselly pink *schmaltz* Brack detested; but he released his dislike in a number of spotty bladder-like forms, in the middle of which dislocated eyes, port glasses, and dentures swam. It was not a successful series, but it contributed to his most recent works, which have reverted to his previous style, an expanded sense of pictorial construction.

Robert Dickerson's paintings also frame, though indirectly, a type of social comment. But to see them as social realism is to miss their point. In the public eye, this tends to happen, for judicious publicity has strummed up an image of Dickerson as the Wild Pet for the Supercultivated, the tough but tender ex-pug: his big-eyed slum children are as eagerly sought as Bambi dolls. Such sentimental corn adds nothing to an understanding of Dickerson's significant work, and indeed detracts from it: his best pictures are acridly explicit. Within their narrow range, they drive straight to the heart without allegory or fuss.

Born in Hurstville, a suburb of Sydney, Dickerson had little education and had to go to work at fourteen. After two years in a factory he turned to boxing, became a professional fighter in 1940 – 'for health reasons', he ironically put it – and fought under the name of Bobby Moody. In 1942 he joined the Royal Australian Air Force, and while on ground-crew duty in the East Indies he began to paint. After the war he went back to factory-work, and spent eight years in a gas-bottling plant.

He began to paint 'seriously' in 1950, helped and advised by a commercial-artist friend, William Sewell. Otherwise he is self-taught. He has been called, for this reason, a natural painter. This is not exact: he is certainly a natural image-maker, but his images are pushed, with difficulty, through a very limited technique. It is so limited that Dickerson has almost no facility in using his medium; and this difficult emergence of form gives his paintings much of their presence, an authority verging on the primitive. His earliest pictures were done in house enamel, still his favourite medium. They concerned life in streets, cafés and tenements; forms were isolated with abrupt edges, there was little modelling and no differentiation of light. His work very seldom displays the dramatic use of shadow and positive–negative images that characterizes the dreamlike fantasies of Charles Blackman. Space was crudely evoked by flat tones. *Straight Left by Griffo*, 1953 [98] is typical, with its pathetic melancholy: the Loneliness of the Long-Distance Boxer.

98. Robert Dickerson: *Straight Left by Griffo*, 1953

The emotional core of his work is loneliness, isolation, inarticulate-
ness. His outsider heroes emerge stripped of personality, their col-
lapsed souls intent on the impossibility of making contact with
others. Dickerson paints not people, but the gulfs between them. He
harps maddeningly on this one string, and his best work makes a
virtue of single-mindedness by turning it into a cult. *Race-Course
Tout*, 1959, or *The Clown*, *c*. 1954 [99] are drawn with a line precise as
a knife. Yet *The Clown* is hardly naïve painting. It is taken straight
from Rouault's etching in the Miserere suite, '*Qui ne se grime pas?*', to
which it is quite inferior in point of form. It is as a formal painter
that Dickerson usually fails. His colour almost never works as space
– in other words, the advance and recession of colour areas is not
coherently organized; and the shapes themselves tend to be either
lumpish and hasty or (in his later work) so soft that they are diffuse.
Yet the emotional power of some Dickersons – particularly those
painted between 1954 and 1959 – is undeniable. Their laconic draw-
ing controls the very dramatic situations they describe, a discipline

99. Robert Dickerson: *The Clown, c.* 1954

enforced by the unseductive enamels, lying in a cold flat skin on the hardboard. One was flung a piece of an idiosyncratic and alarming world, with nothing to cushion its impact.

Near-melodrama abounds in recent Australian figurative painting – Nolan, Tucker, Boyd. Two things check it: a fierce indissolubility between image and experience, and control of this image even as it

skates on the edge of bathos. This control was admittedly easier for Dickerson than for Boyd or Nolan, because his images were simpler: he feels neither as deeply as Boyd, nor as forcefully as Tucker did, nor over as complex a range of experience as Nolan. But if Dickerson's paintings have become so candied and repetitious that they now appear utterly predictable, this is as much due to the circumstances of his development as to anything else: the insoluble problem of a painter without formal training growing up in a country whose museums failed to offer him a range of past works to look at, so that he was forced to paint without wide references and rely on a style, a schema, that set too early and was far too narrow to contain his experiences.

Charles Blackman has often been compared to Dickerson. This is not a fruitful parallel, since its only basis is that both painters are chiefly concerned with the human figure and present it under a hallucinatory aspect, with intimations of melancholy. But Blackman's imagination, remote from the desperate world of Dickerson's art, is lyrical, poetic, rich in fantasy, and sometimes gently close to a kind of provincial surrealism. This is in turn related to the *faux-naïf* treatment of Nolan's St Kilda and Kelly paintings: no accident, for Blackman built his art around Nolan's between 1950 and 1956, the formative years in which he lived in Melbourne and formed a close friendship with John and Sunday Reed at Heidelberg.

In the late forties Blackman left his job as a Press artist with the *Sun* newspaper of Sydney, and travelled extensively in the bush. The outback paintings he later based on his experience there run from 1951 to 1953; aesthetically they are unremarkable, and draw heavily on Nolan's St Kilda and Dimboola paintings – flat mask-like faces, hazy landscapes under a dust-sheet of paint, scrubby wayward calligraphy. Some Queensland paintings use the typical Nolan device of isolating a pattern – the bars of a uniform, a printed floral dress – as the one fixed spot in a shifting space. This borrowed clumsiness may have helped him overcome the graphic fluency of the Press cartoonist, a vital step.

In 1953, aged twenty-five, Blackman held his first exhibition. The paintings, a series, were on the theme of 'Schoolgirls': their flat paint, in unpleasant hues of brick-red and Reckitt's blue, lay stridently between thick, slack lines. They did, however, contain certain future elements of Blackman's work: the interest in silhouette, the figures cut off by the frame, and the occasional tentative use of positive shapes and negative shadows. His second Schoolgirl series, painted in 1954–5, did bring out some latent mystery in these secretive uniformed children: figures were levitated, the colours were

more subdued and subtle – black, brown, umber, white, blue – and a silhouetted clocktower with a luminous dial ticked suggestively along in the background.

His first significant paintings, however, came in 1957, and were on the theme of Alice in Wonderland. Though Tenniel would doubtless not have recognized them, Blackman moved straight into the candid world of children [100]. His colours had a picture-book freshness –

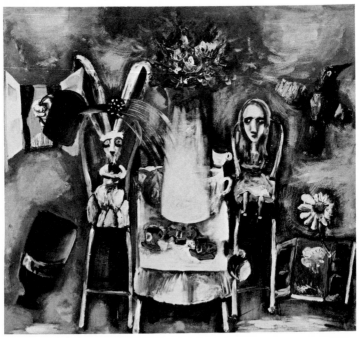

100. Charles Blackman: *Suddenly Everything Changed*, 1957

pale silvery blues, pinks, yellows, an occasional acid green; sweet, but rarely cloying. To heighten the fairyland atmosphere he used false attachments between forms; thus a cupboard door, seen open in perspective at one end of the room, extends past the legs of a chair in the foreground. Hands materialize in thin air; milk-white cups hover; the White Rabbit peers apprehensively from behind a teapot. Alice, grave and quiescent, sits rather bemusedly holding a bunch of flowers. As in other Melbourne paintings by men whose original source is the 'Angry Decade', these images are quite static. Even the

tea pouring from the pot's spout is arrested in mid-air. But the generally monochrome backgrounds did not always sustain themselves well; blue light breaks down into tentative patches of blue paint.

Other paintings of young girls were related to the Alice series: they became the staple of his art. Blackman's convention for their features – as it soon became – was gained partly from Picasso's female heads of the early thirties, partly from Nolan's portraits of the forties. The chiaroscuro in which he liked to shroud half the face deepened; the tonal shift became more dramatic, so that the features were simultaneously registered *en face* and in profile. This meeting-line of light and dark was developed into a boundary of geometrical precision; thence, it was a short step to his now familiar method of laying in the figure with silhouette black and then cutting in the bright-coloured highlights. This involved a loss of the tonal subtlety of his Alices. But a curious, and moving, tension was suggested between the hard encroachments of black shadow on the girls' faces, the crystalline forms, and the melancholy, slightly detached tenderness of the girls themselves. Many of them are based on his blind wife, Barbara. One smells a glowing bouquet of flowers; another touches her face; a third diffidently takes the hand of some companion; communication is extended through all senses but the eyes.

During 1958 Blackman experimented with suites of little drawings, either related in mood or strung on a common theme, pasted together on sheets of black paper. These eccentric comic-strips led to his large Suites of 1960, which consist of up to twelve panels isolated by heavy black bands; in each a different incident was happening. They have been called 'highly decorative and immensely effective', and there were several in his winning entry for the 1960 Helena Rubinstein scholarship. Yet generally they are uncohesive, because the personages – unlike those in earlier paintings – tend to lack presence; rather than active images, they come close to being passive rendezvous for whatever stray sentiments one may have about lonely or blind girls, and passivity leads to sentimentalism. Though their colour was sharper than the modulated, glowing hues of 1956-9, it was less subtly geared to mood and, with harsh superimpositions of yellow and red over black, often raw.

In 1961 Blackman went to London and held an exhibition. His paintings made perceptible gains over his Australian work. Their colour was richer and more allusive, while, at the same time, the forms were immensely clarified. One can see this in *The Meeting* [c] – but here, as if to offset it, a curious mannerism intrudes – the cross-hatched scratching of the background surface. This ornamental doodling, like a nervous tic, distracts from the architectonic serenity

of the forms while contributing nothing to the vigour of the space behind them. Blackman is best known for his figure-paintings – the blind girls, the children, the soft, half-dissolved 'presences' caught against a background of geometric stripes. But landscape has been an important part of his work, and these melancholy nocturnal distances, in which moonlit windmills silently turn, are directly in the tradition of lyrical vision which stems, originally, from Nolan's Dimboola paintings.

David Boyd is Arthur Boyd's brother, a potter of some skill but of no interest as a painter. Together with Dr Bernard Smith, he started the Antipodean Group in Melbourne in 1959.

This venture was launched to combat what its members felt was a dangerous ingrowth of abstract painting, and to redress the often unjust attacks that Melbourne figurative expressionism had had from Sydney critics. The group's members were Arthur and David Boyd, Perceval, Pugh, Brack, Dickerson, Blackman, and, as the non-painting member and theorist of the group, Dr Smith. Tucker, Nolan, Fred Williams and Jon Molvig were asked to join, but they refused. A group exhibition opened at the Victorian Artists' Society Gallery in Melbourne on 4 August 1959. In the catalogue was a brief manifesto of their shared aims, written by Dr Smith in association with each painter. It turned out to be a widely heard shot, and it proved in the end to be the most controversial document in recent Australian painting.

The Antipodeans were not, as some critics at the time mistakenly thought, trying to promote Australiana: 'We are not, of course, seeking to create a national style.' Abstraction, in all its forms, was the enemy:

Today we believe, like many others, that the existence of painting as an independent art is in danger. Today tachists, action painters, geometric abstractionists, abstract expressionists and their unnumerable band of camp-followers threaten to benumb the intellect and wit of art with their bland and pretentious mysteries. . . . It has become necessary therefore for us to point out, as clearly and unmistakably as we can, that the great Tachiste Emperor has no clothes – nor has he a body. He is only a blot – a colourful, shapely, and elegant blot.

Modern art has liberated the artist from his bondage to the world of natural appearances; it has not imposed upon him the need to withdraw from life. The widespread desire, as it is claimed, to 'purify' painting has led many artists to claim that they have invented a new language. We see no evidence at all for the emergence of such a language nor any likelihood of its appearance . . . we are witnessing yet another attempt by puritan and iconoclast to reduce the living speech of art to the silence of decoration.

The solution ? Defence of 'the image'. An 'image' was described as

a figured shape or symbol fashioned by the artist from his perceptions and imaginative experience

and,

As Antipodeans we accept the image as representing some form of acceptance of and involvement in life. For the image has always been concerned with life, whether of the flesh or of the spirit...we do seek to draw inspiration from our own lives and the lives of those about us. Life in this country has similarities to life elsewhere and also significant differences. Our experience of this life must be our material. We believe that we have both a right and a duty to draw upon our experience both of society and nature in Australia for the materials of our art. For Europeans this country has always been a primordial and curious land. To the ancients the antipodes were a kind of nether world, to the peoples of the Middle Ages its forms of life were monstrous, and for us, Europeans by heritage (but not by birth), much of this strangeness lingers. It is natural therefore that we should see and experience nature differently in some degree from the artists of the northern hemisphere.

We live in a young country still making its myths. The emergence of myth is a continuous social activity. In the growth and transformation of its myths a society achieves its own sense of identity. In this process the artist may play a creative and liberating role. The ways in which a society images its own feelings and attitudes in myth provides him with one of the deepest sources of art.

When the dust subsided, the two issues inherent in the Manifesto became clear – but there was a great deal of dust. Nobody in Sydney was prepared to admit that the Manifesto had a true point, over-stated as it was – the vacuity of so much Australian abstract painting, which was little more than a provincial reflection of École de Paris decorative abstraction, and no more dynamic or original than the Charm School's work had been. The error, of course, was to suppose that the paintings were weak because they were abstract.

The issues which the Antipodean Manifesto posed were vast and complicated: the relationship of art to life, and the consequent relationship of images to art. Unfortunately the Manifesto, in the way manifestoes have, was written in such a spirit of elevated rhetoric that the argument never became clear. (One feels Dr Smith would have done better without seven agitated painters prodding at his typewriter.) The Manifesto nowhere says what 'life' and 'art' mean. The first is used emotively, and apparently means 'the areas of experience which can be covered by an art based on realism'. Even taking abstract painting at its lowest denominator, design, the

Manifesto apparently implied that reaction to and celebration of pure form is not a meaningful activity. That may be true, but one would have liked to hear some evidence, especially when seven painters and an art historian were saying it. Abstract painting has failed because it does not transmit 'meanings' – but what *is* meaning in art? The Manifesto gave no clue. Its assumption seemed to be that art is a form of rational discourse. But as Sir Herbert Read observed, art is symbolic discourse, and its elements are not linguistic but perceptual. Within an Aristotelian system, which is still the framework of most education, communication through percepts instead of concepts seems impossible, though they work in different areas of human cognition. 'What we have to assert,' Read noted,

is that art is a cognitive activity – that it is not merely an intensification or embellishment of linguistic types of discourse; that it is not even a substitute for them; it is a unique mode of discourse, giving access to areas of knowledge that are closed to other types of discourse.

But many assume that the only 'real' way of knowing is discursive and rational. Painting must be conceptualized. Without going into the many issues which this question raises, I think one can see how this coloured the way 'meaning' was used in the Antipodean Manifesto. Significantly, the paintings of the group made no such assumptions – their debt to surrealism and expressionism was obvious, and I have traced it earlier.

This cloudiness about meaning in art made the Manifesto vague on what an 'image' was. It was defined, or rather described, as 'a figured shape or symbol fashioned by the artist from his perceptions and imaginative experience', arising from past states of mind and referring back to them. But this could fit abstract painting too. '*Shape* or symbol' is loose enough, and the ambiguity was prolonged by the word 'figured', which could mean figurative or simply 'made'. If the latter, Jackson Pollock's images of space and time fit the Antipodean definition of image well. If the former, we were invited to believe that only figurative images were valid, but what is the limit of figuration and where does abstract painting, so called, begin? With Graham Sutherland's abstracted hill-forms? Ben Nicholson's white reliefs? The gnawed slabs of Tapie's paintings? References to a shared world of human experience are always retained: Kline dealt with movement, energy, and the flow of matter on the most monumental scale: is this not a shared experience? What of Mondrian's *Broadway Boogie-Woogie*? Such paintings plainly indicate their artists' involvement with and sensitivity

to the richness of experience. Even under the Antipodean definition, then, they generate images.

But the Manifesto was rather exclusive; all not within its gospel were heretics, a tone of thought long a feature of Melbourne art polemics. There are significant contacts between Dr Smith's beliefs in 1945 and in 1959. His Marxist stance had mellowed away, but the championing went on in similar terms. In his 1945 book *Place, Taste and Tradition* the École de Paris was 'the consummation of the decadence', just as in 1959 the 'Tachiste Emperor' was 'a blot'. Social realism was praised thus in 1945:

> These paintings...have taken over much of the formal achievements of the moderns, but they are also very much interested as artists in what they have to say. They paint 'about' rather than just paint...this is just what an orthodox modern most objects to. For these paintings follow on tendencies laid down by Brueghel, Van Gogh, Goya, and Daumier; they often deal with squalid subjects, with poverty and slums, but they are also concerned with genre subjects of all kinds, with industry and the war... and if they have sympathies, those sympathies are with the people.

This was crude enough to make Marx wince. More complex forms of expression than social realism, and any feeling beyond formal admiration for Jude the Obscure, were rejected because they lacked 'communicability' or general appeal. In the Manifesto, the attitude moved up a few rungs. Abstract painting replaced surrealism and cubism as the bogey, while figurative painting (not necessarily social realist) became the Good Fairy. The social effect of art as morality-maker was still in view. Thus, in 1959,

> David and Arthur Boyd are giving expression to certain deep-rooted feelings of guilt which the majority of Australians possess towards the living members of Australia's native people. It is this tendency to probe into the more hidden parts of the national consciousness which is giving their art a dignity and authority quite lacking in the work of those local artists who are content to follow overseas fashion.

Perhaps Dr Smith's 'majority of Australians' is different from mine, but, within my own experience, most Australians neither think nor care about the plight of the aborigines; an account of how the Tasmanian settlers exterminated every black on that unhappy island strikes no deep chords of remorse in the citizens of Hobart today, and perhaps it would be unrealistic to expect that it would. You would need to be a cynic to doubt the intensity of the Boyds' feelings on the way the aborigines were served, but it is surely quite another thing to maintain that their images hooked on to a *deeper*

strand in the Australian psyche than (say) John Olsen's rollicking evocations of Stiffy and Mo, the Melbourne Cup, and the

> dirtier perfidy of publicans
> Groaning to God from Darlinghurst.

Neither myth nor history is a vital part of Australian awareness yet. The country is too amiably pragmatic for that, and too little exposed to the conflict of ideologies, cultures, dreams and fanaticisms which is the seedbed of great historical painting. One cannot imagine an Australian equivalent of David's *Death of Marat*, Goya's *Second of May*, or Delacroix's *Liberty Guiding the People*. The experiences that produce such paintings do not exist there. Neither does the genius.

Anyone who has followed the story of Australian art so far will have been struck by two themes that keep returning. One is the uneasy tension between the Australian painters' desire for originality on the one hand, and, on the other, their dependence on forms and ideas from overseas which they have not been able to digest. The other is related: their desire to enter the *Internationale* of modern painting without being able, unless they travel, to see it. Now these problems took an acute form with the development of an abstract idiom in Australia. It would be an exaggeration to say that no Australian painter has found his own style in abstract painting. But it is quite true that most local abstraction was only a remote gloss on what had been painted before in Europe or America. One detail of a de Kooning, seen in black and white in *Art News*, could (and did) supply enough forms for three exhibitions in Sydney. Australian art seems to be cursed by the fact that so often, when apparently original, it is incoherent as form; but when you see an organized picture surface, the image is just as often derivative. And this applies to abstract as well as to figurative painting.

The first Australian abstracts were painted by Roland Wakelin and Roy de Maistre in 1919. Does the abstract movement in Australia really start then? Hardly, in practice: both painters thought their synchromatist experiments were inconclusive; they were done in a vacuum; by the end of 1919 both men returned to figurative work. Isolation took care of the next twenty years. There are no abstracts in Australia between 1919 and the Klee-inspired linear paintings Samuel Atyeo produced, in Melbourne, between 1934 and 1937. Nor did Atyeo's flirtation with calligraphy attract younger painters. Nolan, influenced by Kandinsky and Klee, painted work superficially like Atyeo's in the late thirties, though he saw none of the older man's work until he met the Reeds. In any case Nolan dropped these experiments after the Schwitters-like Christmas Collages of 1940, and none of his fellow-painters in Melbourne cared to take up so apparently abstruse a form of expression. Moya Dyring, a fellow-student of Atyeo's at the National Gallery School,

became the first Melbourne artist in the thirties to experiment with cubism.

Figurative painting in Australia, no matter how confused its trends sometimes became, contains a broad dialectical thread of thesis and antithesis which, in landscape imagery only, runs from 1885 to the present day. Abstract art, like a balky car, hopped and jounced along until 1950, scarcely getting into gear for six years after that. Its erratic progress started quite early in the thirties, but the group of painters who then began consistent experiments were not close to the local movements out of which one might expect abstraction to develop. They had not seen Atyeo's work, for most of them lived in Sydney. Nor did they know the Wakelin–de Maistre synchromatist paintings. They contributed little to the Cézannist movement; Bell's followers, on the other hand, did not develop their own classical post-impressionism into cubism.

So the sources of Australian cubism and abstraction came direct from overseas. In 1932 two painters, Grace Crowley and Rah Fizelle, opened an art school in Sydney. It was geared to promote understanding of cubism and constructivism. Its teaching was closely directed to the organization of abstract, geometric form, and thus quite different from the pre-cubist methods of Bell's school.

Both Crowley and Fizelle had worked overseas, she under Gleizes and Lhote in Paris. Around the time their school opened, Dorrit Black (another Gleizes pupil) founded the Modern Art Centre in Sydney, where exhibitions and discussions were held. By 1934, the core of Sydney's cubist-constructivist group was Fizelle, Crowley, Black, Ralph Balson, Eleonore Lange, Frank Hinder, and Margel Hinder.

They met little fuss; years later the public found the work of Dobell and Tucker actively offensive, but it shrugged at the constructivists. Their abstraction was mild enough, for every painter was producing geometrical but semi-figurative work. The one exception was Frank Hinder. 'Abstraction' was merely a purification of essential forms. Contours were straightened, planes sharpened. Lurking in this geometrical foundation, one sometimes detects the mystical idealism of a Mondrian in embryo, with his belief in a principle of universal harmony to which art is the bridge. Certainly, there was a prevalent idea that abstract art, through formal perfection, could reflect the order and structure of the entire universe. Ralph Balson (much later) spoke of

Newton, with his mechanistic concept of the Absolute, absolute bodies in absolute Space, moving in absolute time and created by an Absolute God

...the next tremendous step is the concept of Einstein, the concept of Relativity, the destruction of the Absolute, the Static, a mathematical abstract concept, its parallel in painting Cubism with its breaking up of form.

Balson's art, until a trip to Europe in 1961 – when he began to imitate the younger Spanish painters and the abstract expressionists – was largely based on his tangled, woolly theories of a link between painting, mathematics and philosophy. From 1940 to 1956 he shifted away from the figurative image towards geometric abstraction. Then, in Sydney in 1957, he exhibited a group of near-pointillist canvases, the entire surface covered by an unbroken, exquisitely-modulated pelt of shimmering dots and dabs. These light-filled walls for keeping objects out seemed to extend for ever, beyond the edges of the frame [101]. No linear rhythms appeared; the paintings were in complete equilibrium, with flakes of colour vibrating like dust in sunlight or electrons in a molecular lattice. Balson explained that:

101. Ralph Balson: *Painting No. 9*, 1959

The concept of Relativity, the vision of it I get as a painter, fascinates me: a universe without beginning, without end, a continuous creating, destroying, and expanding movement, the Space Age, its one constant the speed of light.

I realize that the energy of the atoms that reach us from the Sun is the source of all the rhythm of existence, and the very narrow band the Spectrum is all we can ever hope to have to try and reach a small amount of the Rhythm and Relativity of the Universe with the substance of paint.

It is clear from pseudo-scientific verbiage of this kind that Balson knew very little about physics; he understood Einstein no better than Newton. Not that he was alone in this. The modern movement is full of painters who gabble mystically about quanta and Heisenberg's principle of molecular indeterminacy without having the slightest idea of what such concepts mean. Science, to them, is a metaphor, and they glue fragments of its ideas into their art theory the way a Sepik tribesman nails bottle-tops to his fetishes – as emblems of an unfamiliar, and therefore magical, world. It is ironical that in the twentieth century most painters are less able to relate their work to the known areas of scientific thought than they were in the fifteenth.

Rah Fizelle lived in Sydney. He was a delicate draughtsman but his work is only interesting – and then not very – within a local context. Paintings like *Morning*, 1941 [102] are academic cubism at its most mannered; Fizelle was not even able to make the whole picture

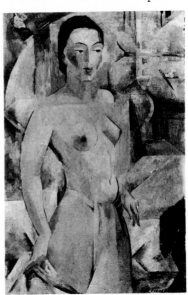

102. Rah Fizelle: *Morning*, 1941

255

stylistically consistent, as a glance at the different ways of painting
the head and the background space will show.

Frank Hinder is the only still-active painter who was a member of
this early group. Born in Sydney in 1906, he studied locally, and
toured Europe in 1927. Leaving for the U.S.A., he worked and
studied in Chicago in 1928, New York in 1931, and went to New
Mexico in 1933. In New York he attended the Master Institute of
Roerich Museum and the New York School of Fine Arts, under
Howard Giles and Emil Bisttram, friends of the artist–critic Jay
Hambridge. Hambridge's *Dynamic Symmetry* was a study in the
theory and effects of abstract form, which drew close attention to
movement and rhythm in art. It greatly influenced Hinder's think-
ing; now, having been indirectly steeped in Bauhaus teachings, he
proceeded directly to constructivism.

Fishermen Hauling Nets, 1939, is a basic attempt to relate move-
ment to structure, a chorus of complicated swinging movements
reduced to their simplest terms. The paint surface, as always in
Hinder's work, is clinically flat. Carefully developed, Hinder's geo-
metrical style persists today. His output is small, and, considering its
isolation (nearly all Australian abstract pictures are romantic, and
most of them pivot on landscape images anyway) and its real
quality, it has been too much overlooked. Hinder's works, like
Abstract Painting, 1951 [103], have been reproached for their 'cold'

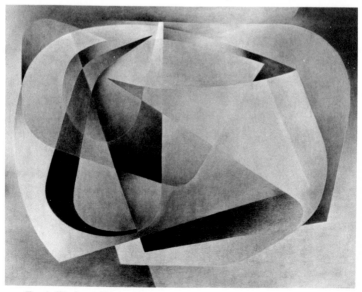

103. Frank Hinder: *Abstract Painting*, 1951

mathematical finality. But their remoteness is much warmed by the intellectual commitments they reveal.

In 1939, the cubists and constructivists mounted the first group show of abstract painting ever seen in Sydney. It was called Exhibition 1.

Paintings came from Hinder, Balson, Crowley, Fizelle, and Frank Medworth, sculpture from Eleonore Lange, Gerald Lewers, and Margel Hinder. They intended to have such surveys regularly, but the outbreak of war put paid to Exhibition 2. Four of them did exhibit again at the Macquarie Galleries in 1944, and a 'Constructivist Exhibition' was hung in David Jones's Gallery in 1948.

Painters outside the group also contributed to the first wave of abstraction. One in Melbourne was Eric Thake, whose abstract-surrealist exercises (*Archaeopteryx*, 1942, depicted a flying-machine shedding a feather) were formalized, rigidly drawn, and indebted to the English painter Wadsworth.

Eric Wilson's was a far richer talent. Wilson took the New South Wales Travelling Scholarship in 1937, and studied at the Westminster School in London under Meninsky and Gertler. Later he became a pupil of that forceful theorist of purism, Amédée Ozenfant. Wilson and William Dobell became close friends and worked together in London. Similar impressionist influences appear in their work throughout the thirties; light fell, in a luminous skin, over Wilson's London streetscapes and studies of the Seine [104]. His brushwork, effortlessly laying down glazes and scumbles, was sensuous yet unobtrusive. Wilson seldom turned on a wilful or flashy performance. When Dobell sought the emotional centre of a personality, Wilson's first thought was of structure. Massive forms inhabit his charming townscapes of 1937–40; in this respect at least, there was no inconsistency between his impressionist and cubist paintings.

Through Ozenfant, Wilson came under the influence of Braque and became absorbed in the problems of abstract volume. He simplified his technique and reduced his palette to a sober range of brown, grey, green, and white. Then, in a series of still-life themes painted between 1940 and 1942, Wilson penetrated further into the cubist aesthetic than any of his contemporaries except Hinder. *Hospital Theme, The Sterilizer*, 1942, with its clinical expanses of white and cold grey, is a forbiddingly intelligent painting, though the relationships of some forms are slurred. His major cubist composition was *The Kitchen Stove*, 1943 [105], a large, low-toned and severe collage of embossed cloth and sandpaper with oilpaint.

Soon after painting it Wilson returned to an impressionist idiom. But he died suddenly in 1946, aged thirty-five. It was a grave loss for

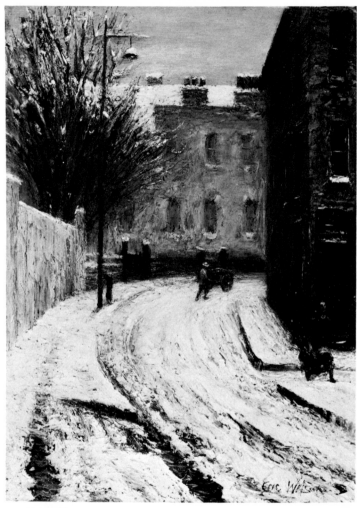

104. Eric Wilson: *Lambeth Street*, 1945

Australian art: Wilson might conceivably have changed the course of the local abstract movement, for Australia has not yet produced a hard-edge painter with cubist origins whose work stands comparison with today's dominant group of linear abstractionists. Had Wilson lived, he might have filled that gap. Few young Australian

105. Eric Wilson: *The Kitchen Stove,* 1943

259

painters can have come to abstraction with sensibilities as finely cultivated and disciplined as his. With only Hinder, Balson, and a handful of lesser painters left, the abstract movement in Sydney floundered to a virtual halt after the war. Nothing of its original constructivist bent was preserved in the new version, whose origins begin in 1950 with John Passmore's return from Europe.

The crucial year in this fresh development was 1956; the exhibition, Direction 1, at the Macquarie Galleries. It was a group show by John Passmore, John Olsen, William Rose, Eric Smith, and the sculptor Robert Klippel.

Direction 1 revealed that abstract painting had become a distinct force, a serious challenge to figurative modes in Sydney and not just the offshoot of a few disjointed experiments. In terms of its effect, it has some claim to be called the most important group show by local painters between 1945 and the Antipodean Exhibition in 1959. The curious thing was that it contained so few good paintings – its effect was out of all proportion to its quality, and none of the pictures that were in Direction 1 (except, perhaps, one or two of Olsen's and Rose's) bears comparison with what the same artists were producing a few years later. Moreover, it is hard to think of a show whose actual significance and purpose was more occluded by its critics, even the friendly ones.

This happened because the critical vocabulary to deal with abstract art did not exist in Sydney in 1956. Art criticism was a game of analogies, couched in a language so flowery and vague as to be barbarous. The critic would stroll through the gallery, cook up an extended metaphor and then twist every picture to fit it. Sometimes it would be an orchestra, sometimes a cocktail party, and once, memorably, an aviary: the *Sun*'s art critic, having noted that the 'voice' of a Jean Bellette was 'rich and full, like a nightingale with a cello in its throat', invited his readers to consider 'where will one find the ornithological equivalent of William Rose's *Study No. 12* or John Olsen's *Morning Seaport*...unless it is in some mechanical menagerie devised by an engineer who had studied Fabergé?' (He might have tried a few Paris galleries for painted equivalents, at least.) So when Direction 1 arrived, misinterpretations blossomed. At least one of these has entered the official canon. It is Paul Haefliger's idea that Direction 1 brought abstract expressionism to Australia.

This is not true. The nature of abstract expressionism was not understood in Sydney in 1956, either by the critics or by the painters themselves. Two months after Direction 1, Haefliger demonstrated this conclusively by writing a long piece on 'ab-ex' and citing

Morris Graves, of all people, as an abstract expressionist, along with Manessier, Singier, Soulages and a list of minor French *cuisiniers*. The painters had only the haziest inkling of what abstract expressionism involved, and the idea that painting was primarily an *act* never touched their work. Passmore had seen none of it. Olsen, Rose and Smith had never been abroad, and no pictures by members of the New York School were to be seen in Australia. They might have seen a Kline, a Still or a de Kooning in reproduction, but it is unlikely that they did, for the frantic scanning of tipsheets for the Parnassus Sweepstakes like *Art International*, which is now customary in Sydney, had not yet begun. Robert Klippel, who has since become the only first-rate sculptor to work in Australia, had lived in Paris and had seen abstract-expressionist paintings, though his interests then lay more in the direction of surrealism. Direction 1 was a gesture in the direction, not of New York, but of Paris – with the hesitant influence of John Passmore to give the show some kind of shape.

Rose and Olsen, Passmore's ex-students, had absorbed the idea of total experience implicit in his paintings. But it only became real to Olsen around 1955, after he read Dylan Thomas's *Under Milk Wood*. This play, with its narrative thread weaving backwards and forwards in time and space, drawing the complex happenings of people, emotions, and experience of one day in a Welsh seaside town together into a unified, many-layered totality, fascinated him; he began to think about Sydney Harbour in terms of it. So in 1955 Olsen began a small series of seaport paintings, which culminated in the Views of the Western World, 1956. 'The thing which I always endeavour to express is an animistic quality – a certain mystical throbbing throughout nature,' he wrote that year. His desire to clamber 'inside the landscape' and become wholly involved with its flux was shared, in a different way, by William Rose, with his tense, complicated linear abstracts. For Direction 1, the act of painting was a form of meditation in itself. Klee's idea that the artist is only the trunk that passes on the sap was accepted, in varying degrees of comprehension, by every member of the group.

Because the Sydney Group's intimism was based on an *exterior* view of reality, fixed at one moment of time in the contained space of a closed composition, Direction 1 had a revolutionary impact.

It was not an even show. Eric Smith, unable to fully grasp the ideas that Olsen, Rose, and Passmore promulgated, straddled uneasily between realism and a somewhat clogged set of abstract gestures. Nor did the abstract movement in Australia over the next decade spring from Direction 1, as some critics have suggested. The

261

show's direct influence on later painting, except for Gleghorn and Hodgkinson in 1957, was slight. But Direction 1 cleared the air. After 1956 the new talents in Sydney painting turned as enthusiastically to abstraction as, a decade before, they had to intimism. The market was admittedly nil, but critics, at least, were tolerant. The links between abstract painting and images of environment, which are the real basis of the abstract movement in Australia, began to take shape.

Olsen's paintings now began to influence Passmore, who had been most excited by Olsen's talk about evoking *all* aspects of a seaport in one picture. Passmore's canvases became more abstract, and their forms took on a freedom and amplitude only hinted at before. They began to lose their atmospheric quality. In *Newcastle Beach*, 1955, the lumpy shapes of landscape are submerged in a free drift of rectangles of colour, which refer obliquely to air, water, pier, and figure, but seem to be made of the one fluctuating substance. But over the next few years he showed little work apart from Direction 1. In 1959 Passmore won the Helena Rubinstein Travelling Scholarship with a panel of five large paintings, and left for Europe.

106. John Passmore: *Jumping Horse-Mackerel*, 1959

These pictures harked back to his favourite marine forms. But they were soft, waterworn, more ambiguous than the work Passmore had produced since Direction 1, which had been close to Olsen's architectonic Views of the Western World. Passmore's jointed line traversed the liquid encounters of grey, green, and white with fastidious awkwardness, hinting at objects but never defining them. His paintwork was stronger, and broad strokes of a spatula replaced the thin glazes of earlier paintings. 'There is a great force – an ambient sense of mass,' he wrote later, but in fact Passmore's mature work is not very forceful; his abstraction comes down on the side of tasteful reticence. A drawing, *Jumping Horse-Mackerel*, shows a group of figures around a flopping fish on the beach; in the final painting [106] the figures are all but lost on the periphery of a world seen from the centre.

Passmore's abstract work is beset by the problems of introspection – timidity, uncertainty about his own aims, and occasional failure to come to grips with the world of physical experience his images always imply. John Olsen, a rowdily physical painter, faces different problems, but his vision marked the early sixties in Australia as deeply as Passmore's did the fifties.

John Olsen was born in Newcastle in 1928, but came to Sydney in childhood; he joined the Julian Ashton School in 1947, and studied there under Passmore until 1953. He had his first exhibition in 1955, and his first significant paintings, the Bicycle Boys, were painted a few months later. In these half-lyrical, half-ironical paintings of racing cyclists, several later trends in Olsen's work appeared for the first time. The gawky angular gestures [107] may be a legacy from Passmore, but the spidery line, which rambles and jerks across a gay surface of ochre and white, has an immediacy and wit foreign to Passmore's work: this is the beginning of Olsen's linearism. (Do these puppets, perched on their rickety wire mounts, have some ironic reference to that favourite hero-image of the Renaissance, the equestrian figure?) The forms are written on to the canvas, almost cursively – a breakaway from Olsen's Cézannist training under Passmore. Figure and machine, imbued with life by the action of this nervous line, are united in one metamorphic image.

His 1956 work was more abstract; figures disappeared, but his interest in animist and metamorphic imagery grew – stimulated by Eliot's *Four Quartets* ('The river is within us, the sea is all about us') as well as by his reading of Dylan Thomas. *The Atman, Dry Salvages*, and the Views of the Western World were exercises in the poetics of total experience; no trace of 'scenic' space remained in these relaxed grids of colour, slung across a shifting background; the grey-greens

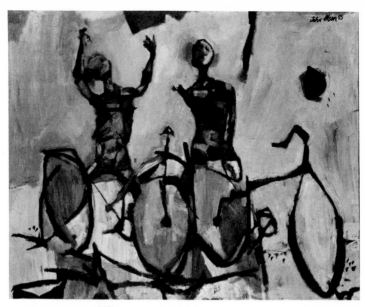

107. John Olsen: *The Bicycle Boys Rejoice*, 1955

of *View of the Western World No. 1*, 1956, ebb and flow, summoning up the tides and jetties of Sydney Harbour. More articulate than the Bicycle Boys, they were landscapes seen from within. Across them, Olsen explored the idea of experience as a sequence of events in time. But his interest in *irrational* imagery, hinted at the year before, was to develop later.

At the end of 1956 Olsen left for Europe, on a private scholarship. He lived in Majorca, visiting Paris – where he worked under S. W. Hayter at Atelier 17 – Italy, and London. There, he met Alan Davie and saw his work, and his influence was to be seen in some of the paintings Olsen sent out to Sydney in 1958. Olsen's vocabulary of images was now enriched by an interest in archetypal forms: mandalas, crosses, towers, thrusting arrows, magical emblems whose half-disclosed meanings confront us across a thousand years of Celtic twilight. The tower and spearpoints in Olsen's *Mediaeval*, 1957, are basic forms, whose shape and meaning are inseparable – not symbols, but meaningful objects – which Olsen was seeking to apply to his experience of landscape. Plastically, these paintings of 1957–8 were more inventive than his Australian work; the colour, in

its subtle greys and yellows caught between harsh opposites of black and white, was subtly geared to the moods of Cornwall and the Spanish plains, while the pigment itself, trowelled and cracked, suggested the growth of landscape.

Olsen's interest in archetypes led him to explore irrational imagery and child art. As a result, his work from 1958 to the present day is part of a general movement towards the irrational among certain European painters – Alan Davie, Jean Dubuffet, Corneille, Alechinsky, and especially Lucebert, whose work Olsen's often closely resembled.

Like Vassilieff in Melbourne, though on a more complex and articulate level of sensibility, Olsen has often been credited with an 'innocent eye'. This, of course, is a sentimental fiction. No eye is innocent. But some artists choose to adopt a mask of innocence, in order to reveal certain kinds of formal values or imagery which might otherwise be hidden. No matter how far a modern painter goes back to the primitive, his shapes will invariably end as style: you cannot become as a little child, you can only use the forms of child art. Few painters have displayed more cunning than Olsen in their use of an avid, bouncing infantilism. This he got from Dubuffet and the COBRA group – whose members he met in Paris, when he was working at Atelier 17.

They were all drawn to the school of Madrid; Hodgkinson, with his usual *élan*, assimilated it, but Olsen did not. The Spanish style was too sober and monumental to suit his peculiarly fey cast of mind. He is not capable of an art of silences. He produced a few unsatisfactory and mannered black textured walls, but his 1960 exhibition in Paris abandoned hard pastes and returned to the sprawling, informal linework which has been the basis of his style ever since. *Lorca's Country*, 1959, pulsates with intense rhythms; Olsen's muscular brush, dragging its harsh tracks of brown and black over a white ground, seems to extend its serpentine motions into the space outside the picture.

This refusal to accept a closed composition is one of the main features of Olsen's recent work. Paintings like *Spanish Encounter* or *The People Who Live in Victoria Street* (done after his return to Sydney in 1960) are not records, from one viewpoint, of a scene; the jostling incidents flow continuously outwards, so that 'the landscape is in me, and I am in the landscape.' They are route-maps of a journey *through* a landscape:

One is compelled to inhabit the landscape – become part of it, stop, pause, run with it, twist around – walk straight, lie in it. I say to myself

I shall walk from Victoria Street to William Street in the most direct manner. If I were a Mondrian I would say forget about the journey, just draw a straight line, but forgetting such admonitions, let's begin a simple adventure and see what might happen. I tipple down the stairway – it's morning in Victoria Street, and even with my good intentions I stop when I arrive at the street. I stop, walk back two paces for the sun is making the most gorgeous green through the plane trees and I find myself rolling with the sky – I am a little stunned by this and walk a little crooked on the foot-path, a mongrel dog barks at me and my route becomes curved and quicker.

I meet a friend – stop, pace back and forwards – and he gets excited and moves his hands a lot – good-bye – shaking hands I must hurry, I want to cross the street – taxis floating past and one stops in front of me and conks me on the mousetrap. Where I had in mind to walk a straight line I must walk round the cab in an angular fashion. Memories of such journeys lead to paintings like *Spanish Encounter*.

In these city pictures of 1960–62, Olsen cut to the centre of one aspect of Australian character, its irrationality, which can border on the absurdity of burlesque. His vision has some of the sardonic ebullience of Stiffy and Mo: consider, for instance, the title of a recent painting, *Entrance to the Siren City of the Rat Race*, 1963. His work is not simply a commentary on vulgarity, but a frank enjoy-ment of it: speaking of the vulgar, Olsen recently remarked:

I can rejoice in it. It has enormous vitality. Sometimes I put in a loutish kind of head, sneering and snarling. One has to be prepared to be a bit corny; I don't like international painting – the slick sort of abstraction one sees a surfeit of in Europe. If one is to really get down to the problem here one has to be banal even. The power of Australian society is this vulgarity . . .

But Olsen, though he has a streak of grease-paint on his palette, is not simply a vaudevillist. He does not deploy his swarming *grotes-queries* for laughs alone. A collector of primitive art himself, he is aware of the power, even the magical efficacy, of absurd imagery, though his own claim that he is not concerned with the beautiful but 'with the dark, the ugly, with the destructive' is exaggerated: the impact of his recent work comes, in fact, largely from its tension between the grotesque and the purely lyrical, the exquisitely observed landscape and the lurking beasties behind it. Olsen is no brutalist; though he loudly repudiates the intimists, he sticks to his *belle matière*. No Australian artist, at the time of writing, has a surer instinctive sense of surface and 'touch' than he, and no matter how dark the personages one encounters in Olsen's treks about the You Beaut Country may be, they are always elegantly painted. As with

his city paintings, so with his landscapes. They are humanized, and become a graph of human action and personality. Men leave their marks on the landscape's face [d]. Virginia Spate, in a recent monograph on Olsen, noted that

It is significant that Olsen's exploration of this landscape, by drawing it into his own being in the act of painting, should have come at a time when there has been a tendency for Australian writers 'to use an exploration of the bush as an analogy for the exploration of the individual soul. The bush becomes a metaphor for the soul.'

In the best of Olsen's landscapes, such as the series Journey into the You Beaut Country, several different levels of experience combine. Microscopic details of vegetation and insect life inhabit what might otherwise be an aerial view; at one moment in our progress around the landscape we are looking at it from afar, the next instant we are compelled to examine a pool or an unexpected face; the landscape becomes the sum of an infinite number of tiny incidents. *Dapple Country*, 1963 [108] epitomizes these natural forces within a landscape, where, bathed in the brown-green aftermath of summer, roots burrow, insects scurry, and fruit-trees push their way up

108. John Olsen: *Dappled Country*, 1963

through the hot darkness of soil. In his celebration of vitality, Olsen has invented one of the few original schemata for Australian landscape since 1885. In its worse moments, his work can be disorderly, often over-sweet, incoherent, and too dependent (in a special sense) on the personality behind it. But at its best, it stands honourably in the company of Roberts's Heidelberg studies, Streeton's *'Fire's On!'* *Lapstone Tunnel* [21], and Nolan's Wimmera landscapes. He has developed an art robust enough to face the breadth of the street.

William Rose's work, by contrast, is astringently cerebral. Perhaps one could force his intricate constructions of lines to make confessions about city buildings and dockside cranes, but it is pointless to try. Rose is purely an abstract painter, and the industrial symbolism often attributed to his paintings is simply not there: it has nothing to do with his aims either. Rose is an idealist, and a statement of his goes close to Mondrian's theory of a principle of harmony:

> I see our modern world somewhat chaotically misusing its acquired freedom – for never before has the artist experienced such freedom of thought and action as he does today. I am trying subjectively to abstract from this confusion a basically stable, complete, and plastic form that will function in its own right.

Rose was born in Newcastle in 1930. He had next to no formal training – three weeks at East Sydney Technical College, a fortnight at Julian Ashton's, and a great deal of drawing from the antique – but though he was mainly self-taught his contact with Passmore was close. Thus he was much influenced by Passmore and, through him, by Cézanne. But his distinctive linear style was formed quite early and was well established by 1956, when he took part in Direction 1. He had his first one-man show the following year. 'The influence of certain aspects of Vieira da Silva cannot be ignored, but...the broadly lyrical and poetical quality of da Silva's style has narrowed and sharpened to a single finely wrought instrument which Rose uses to translate his experiences of form into a personal kind of geometry,' a critic wrote.

Externally, Rose's art looks impersonal. His paint is thin, drawn on rather than painted, with none of the consciousness of *matière* his contemporaries celebrate; colour is restricted to mere washes of blue, yellow, red, and black. Line joins with line, tiny spaces shift and interlock unobtrusively, and the final construction has the swarming life of a beehive. The motif does not always extend across the painted surface, but hangs on neutral ground with blank areas all about it, like handwriting on paper. This fastidious, unshowmanlike performance deeply involves Rose in the articulation of space [109]. His

109. William Rose: *Painting*, 1961

work can seem arid, but it reveals an intellectual poise, a discipline and a concentration of image rare in Australian painting. The tensions and shifts generate their own frame of reference, which needs no figurative image to complete it.

110. Eric Smith: *The Sermon on the Mount*, 1954

Olsen and Rose started, with Direction 1, what is now spoken of as Sydney's linear abstractionist movement. Eric Smith's position is not as clear, for though he took part in Direction 1 he has only lately begun to use linear or calligraphic forms, and for three years after 1956 he worked through a phase of loose, atmospheric abstract impressionism.

Smith was born in Melbourne in 1919. He studied commercial art there in 1936-7, but the war interrupted his work; from 1947 to 1951 he took a diploma course in painting at the Melbourne Technical College. Shortly afterwards he moved to Sydney. A fine colourist, Smith was rapidly accepted by Haefliger and the Sydney Group. Indeed, it is hard to think of Sydney's art between 1952 and Direction 1 without Smith's glowing, monumental Christs [110] and gently abstracted still-lifes. His colour never took on the ingratiating sweetness of Kmit's or O'Brien's. His manipulation of paint was very rich; his ridged surfaces of glazed and impasted colour have a Manessier-like edibility.

Smith is a Catholic, and religious belief is the core of his art. His abstract work between 1956 and the present day records a continuous struggle to intensify religious experience through non-figurative techniques. The sacramental calm of his colour remained, but form became increasingly fragmented. *The Moment Christ Died*, 1958, is a slow explosion of flakes of colour, suggesting the separation of soul and body at the point of death. In *Christ is Risen*, 1959, a figure emerges from an ecstatic flurry of energy; Smith's human images seemed usually half-dissolved in light or blurs of motion, and their bristling clusters of line were far removed from the solid, deliberate forms of earlier paintings.

By 1960 the breakdown of form was complete. The bird-like agitations in space had softened into floating blurs of colour, tenuous abstract-impressionist exercises like enlarged details of a Monet lily-pool. In an effort to strengthen these vague drifts – dim religious light, minus the storeyed windows – he resorted, in 1960-61, to an ornate, rococo calligraphy. Thus with a series of paintings he did as commentaries on Patrick White's *Voss*; the influence of Olsen was apparent in a brown linear landscape, *The Hateful Earth*.

The paintings with which Smith won the 1962 Helena Rubinstein Scholarship are, in some ways, a return to the structural concentration of his 1955 religious paintings. But their intensity is amplified by a more complex space and an increased poignancy of emotion, as in a gravely conceived *Crucifixion*, 1961 [111]. As yet, Smith's work is diffuse; his association with Direction 1 seems to have made him nervous about linear abstraction, now attracted by it and now

111. Eric Smith: *Crucifixion*, 1961

repelled, so that his work oscillates between metamorphic figuration – his true *métier* – and Olsen's wiggles. But his lyrical sense is undeniable, and so is his interest in ideas. Leaving aside the gold-leaf-and-angel merchants, there is no doubt that Smith is the first Australian artist to meet his religious impulses on a serious level of inquiry.

By 1957, then, abstract art was well established in Sydney, though not as firmly entrenched as some writers now think. Though the critics were tolerant of the idiom, the natives were not: the only private sales from Direction 1, for instance, were a drawing and a maquette. But meanwhile, art prizes were proliferating.

The art prize seems a peculiarly Australian way of patronizing art, if only because there are so many of them. All at once, every country town, Moomba festival, municipal council, chain-store and sheep-dip manufacturer wanted to encourage *le beau et le bien*. The result, today, is an annually winnable total of £20,000 in prizes, more or less.

There are dangers as well as blessings in this competitive Land of Cockaigne. There *is* a difference between prizewinners and good paintings. It has been said, not unjustly, that a Goya in the Archibald or a Klee in the Tumut Festival of the Falling Leaf Competition would pass unnoticed. A cult of the eyebasher emerged – the Big Bomb, flaring with primary colours, aimed to hit the judges as soon as they walked in. Some painters began to ape the bullfrog in a competitive puffing-up of scale, the pictures getting emptier and emptier as they grew larger and more demonstrative. Little commissioning and next to no buying of *avant-garde* work was done by the local Medicis. They preferred to toss coins into the painters' pit and watch the scramble from a safe height. Meanwhile the Australian public, which dearly loves competitive sports, came to think that the number of prizes a painter won infallibly indicated his talent. Some artists therefore exploited the prize circuit with the beady-eyed finesse of professional golfers. Others remained aloof, but a powerful instrument of tastemaking had been forged and put in the hands of a small number of judges, and many of the besetting vices of Australian art – brashness, first-impact superficiality, and lack of serious thought – were aggravated by it.

Meanwhile, through 1957 and 1958, more abstract painters emerged in Sydney. Some, like John Coburn, Thomas Gleghorn, or Leonard Hessing, were new arrivals. Others, notably Frank Hodgkinson, were already established as figurative painters.

Hodgkinson was originally trained as a commercial artist. Born in 1919, he studied at the Dattilo Rubbo School, East Sydney Technical College and the Royal Art Society. During the war he served with

the Australian Army in Syria and New Guinea and was posted to Borneo as a war artist. Discharged, he went to Europe in 1947 and painted in London and Paris until 1952, when he came back to Sydney. His early figurative paintings, bright with rosy pinks and yellows, were charming and shallow. The portraits of his daughter Kate gave way, around 1955, to still-lifes with shrimps or crayfish, their vermilion carapaces handsomely set against pink or green backgrounds. Their uniformly *interior* light, and Hodgkinson's concentration on the object, remain in his textural paintings: but there they have found a more sober and dramatic form. And, as Elwyn Lynn noted of Hodgkinson's early abstract work, 'In 1956 he produced works where the thrust and tug of swathes of paint seemed engaged in reluctant battle. It is this tension within the cohesion that marks the texture paintings done since 1958.'

In 1958 Hodgkinson won the first Helena Rubinstein Scholarship. His panel contained further hints of his future development, for the fluent swing of his abstract forms had slowed; the movements were viscous and heavy. Though the pulsation of heavy browns, oranges, and white in *No. 1, April 1958* recalls Afro, the emphatic surface has none of the Italian's free-floating elegance. The shapes beat and blunder against one another, and the paint, heavily trowelled on, anticipates the brooding organic magma of his Spanish canvases. This surly lyricism held hints of landscape and, more auspiciously, of the materials of landscape.

In 1959 he settled in Deya, in Majorca.

His work there (1959–61) cannot be considered without its Spanish prototypes. It is intimately related to four Madrid painters – Canogar, Vela, Suarez, and Viola – and not far distant from Tapies. No informal elements appeared in Hodgkinson's new work: his aim, shared by the Madrid painters, was the containment of an obsessive image, a unique and dominant form which, directly projected, left no room for dispersion.

It is wrong to suppose that Hodgkinson's dead, baked and scraped textures, his piled-up layers of paint, wax and hessian, are merely ornamental or that they are passively meant to be *belle matière*. They dynamically extend the painting; contained in space (for Hodgkinson's space, unlike Olsen's, is closed and does not continue outside the frame, and his forms have a totemic stillness) they force the image backwards through time: their function is direct, not metaphorical. Layer after layer of substance is built up, cut back, riven, and cratered to expose the strata of its growth, and traversed by tremulous black graphs. Where Burri burns holes in the surface of his material to reveal an empty space behind, and Fontana dramatizes the void by

slashing his canvases, Hodgkinson's destruction of the painted surface – the hessian peeled back, the wax sliced away, the gouged clefts in the magma – serves only to reveal further surfaces pressing forward. He permits layers of past experience to stake their disruptive claims on the present. In fact, the drama of Hodgkinson's work is the drama of matter disclosing its own history.

An elegiac mood pervades these Spanish paintings. Elwyn Lynn – whose work, like Hodgkinson's, often projects images of death and stillness – has spoken of their 'moribund carnality' and observed that 'there is a concern with the metaphysical and death, with all the undisclosed myths behind paintings from Altamira to Tapies.'

No trace of his colour's earlier charm remains: dark reds and browns, ochres and burnt yellows are contained between the lugubrious incursions of black and white, and (as with Tapies) there is no way of separating colour and material. Hodgkinson is not an illusionist: so close is their relationship between gesture, material, and colour that his paintings are self-sufficient images. He wrote of his Spanish work:

For nourishment I continually return to the actual, but no longer use the seen even as a point of departure. Art is an act of divination by entrails, not a careful record of the obviously seen. The seen keeps me in contact with life and may enable the painting to identify itself. . . . In painting two things are important, the artist and the surface. Before he can find anything on that surface the artist must first find himself. . .to achieve this I find it necessary to sleepwalk a little. The cluttered vision must be freed of limiting material reality, the eye allowed to regain its lost innocence so that it may delight in the commonplace as fresh experience.

I like to create a surface, dig into it, penetrate behind the veil of reality, open it up to reveal new sensations of space, then enter and explore it. With every advance from the known to the unknown the mystery increases . . .this daily exercise of placing myself in the position of primitive man rather than be led by his findings brings me closer to my original self.

Hodgkinson's is an art of ecstatic or tragic silences, and its sophistication blunts none of its primeval impact. The last paintings he did in Australia, before returning to Majorca in 1963, are less withdrawn than his Spanish work; more references to landscape come in; their silence is full of the hum of the hot bush. Their massive trunk-like forms, traversed by wayward calligraphy, directly refer to the boles of scribbly-gums, and the abstraction begins from an exact close-up view of nature [112]. Their titles – *The Bruise of Summer*, *The Blonde Dark of Summer* – indicate an involvement with landscape; combined with this is a harsh eroticism of form and texture.

112. Frank Hodgkinson: *The Blonde Dark of Summer*, 1963

John Coburn's art also implies stillness. He assembles flat coloured shapes, in a much deliberated and essentially formal manner that has led critics to invoke Poliakoff and Manessier as his overseas mentors. But Poliakoff's forms inhabit an open space, and they continually

vibrate and fluctuate in light. Coburn allows his no movement what-
ever. His space is hermetically closed, permitting no flux of matter
or energy. Manessier's influence on Coburn, though demonstrable,
was slight.

Born in Queensland in 1923, Coburn joined the Navy during the
war and, from 1947 to 1950, studied painting at East Sydney Techni-
cal College under Wallace Thornton. His early work was semi-
figurative, its silhouetted forms cautiously stylized in overlapping
areas of flat paint. Coburn's use of this worn device gradually
became more sensitive, and meanwhile his forms lost their figurative
reference. *Enclosed Garden*, 1957, illustrates this transition. There
followed, in 1958 and 1959, a number of religious pictures – *The
Passion*, *They Gave Him Vinegar Mixed With Gall*, and others – their
motif a menacing lattice of black thorns behind which a pattern of
coloured rectangles glowed. In *Sunrise*, 1959, a silhouetted wall-like
shape is embellished with ideograms, culled from natural sources:
sun, twig, grass, leaf, man.

Coburn is an ideographic painter. He deals in signs which conjure
up memories of experience without greatly augmenting their sensual
impact. A coloured circle, pushed slightly out of shape, reads 'sun':
we are not made to feel its heat or power. This sign language enables
Coburn to pursue, diffidently but with an overriding commitment to
his final aim, his search for a visual equivalent to the underlying
order of nature – whatever it is that binds rocks, earth, fruit, flowers,
sky, and men into an immense whole. Coburn greatly admired
Mondrian, with his 'principle of harmony': 'Mondrian,' he said in
1959,

is at the other extreme from Rouault, but he has a far more profound
influence on this century because he goes deeper into the basic structure of
reality – he tries to investigate and paint what order actually *means*...
admittedly, abstract art has become more romantic now, but it still goes
beyond symbolism into the underlying order which gives all symbols
meaning. That is the order of God.

Cautious and deliberate, with none of the showy arpeggios of
Gleghorn's work, Coburn's methods have only recently begun to
leave room for spontaneous gesture. Gritty pastes of oilpaint and
sand were spread in an even, cement-like surface with few variations
of texture. The interlocking forms, almost cubist in their precision,
were slowly designed, transferred to the canvas, and filled in with
colour. This premeditated art excluded 'creative accidents'.
Coburn's line is slow and pensive. It does not fizz like Hessing's or
intricately dance like Olsen's. It is little more than a passive agent for

marking edges. When he pushes his geometrical pinks, greens, and rusty browns apart, they fall into place with the audible click of a jigsaw-puzzle.

But Coburn's images are not impoverished by their formality. It gives them, at best, a moving terseness and compression. His landscapes of 1961–2 are profound distillations of place; returning to the earth, he extracted its archetypal forms and basic structure, clothing them in sumptuous autumnal browns and golds. *Song of the Earth*, 1961, was one of the best of the strict-edged landscapes, and in *Wilderness I*, 1962 [113], the dynamic interplay of the heavy-legged forms is rendered more supple by an inherent freedom of gesture;

113. John Coburn: *Wilderness I*, 1962

the turn and dip of the earth, the ragged configurations of rock and tree, the sense of walking through an ancient land, are given heraldic form.

1958 also saw the ascent of Thomas Gleghorn, who became the first popular abstract painter in Australia. This was partly due to institutional backing. No abstract artist in Australia has been as strongly promoted by a State gallery as Gleghorn was by the Art Gallery of New South Wales, through its director Hal Missingham.

Gleghorn was born in Durham, England, in 1925. His family migrated to Australia and settled in a mining town on Lake Macquarie. He studied engineering, turned to painting in 1949, and afterwards became a freelance commercial artist. In 1955 he came to Sydney and began seriously to paint.

His early work is mannered. Engineering training had given him an interest in structural compressions and tensions, which he sought to work out in paint: orthodox views of shacks, prawn fishermen, crucifixions, and landscapes are traversed and cut into facets by a zippy, mechanical black line, but little real analysis took place. This tendency to look for an abstract image by stylizing a figurative one, instead of approaching the idea from within, has plagued his work; it makes unattainable the metamorphic quality he seeks in landscape, and when applied to the human figure (as in *Head of Christ*, which won the Blake Society's *Christus* Prize in 1958) it allows an intimist vision to lurk beneath the choppy bravura of colour and surface tension. His gestures – the nervy over-elaboration of surfaces, the bristling explosions of black lines – tended to be harsh and automatic, congesting his images but not animating them. This was aggravated by an extreme consciousness of the minutiae of technique. In short, his style was in constant tension against his innate lyricism.

Still, Gleghorn's paintings cannot be discounted. Many of his landscapes, such as *Evening, Nullarbor*, 1958 [114], are strong and, despite their stylism, direct responses to place. His colour, in its reds, oranges, turquoises, and velvety blacks, is seductive and personal. Though one can only smile at Max Harris's claim that de Staël might not have disowned Gleghorn's recent work, there is no doubt that Gleghorn has played a distinctive part in the synthesis of abstract and figurative which was so much a feature of Sydney painting between 1955 and 1965.

Leonard Hessing, being a linear abstractionist, is sometimes bracketed with John Olsen. But comparisons between the two expose more differences than similarities. Olsen is deeply involved with his regional images, but Hessing dismisses hints of place: 'I could go to Woop Woop, or I could sit in a square white room.' Against Olsen's rambling and disjunctive spontaneity, Hessing deploys an acquired discipline: 'You are not allowed to stand still. All you can practise is control, the way a Japanese swordfighter controls his sword.' Hessing's paintings are not done to make plain the experiences that first triggered them. He insists on their self-sufficiency, denying that there is any point in trying to deduce the artist's personality from his art. (But leaks happen: the sophistication, ruthless precision, and

114. Thomas Gleghorn: *Evening, Nullarbor*, 1958

wit of Hessing's work is redolent of the man.) Unlike Olsen's, his paintings are objects before they are anything else. This, of course, is part of Hessing's effort to make viewers face the painting rather than be attracted by a myth. Even the irrational content of his work is controlled: a mystification, a willed infringement on the *gestalt*, rather than an eruption of subconscious energies.

Hessing was born in 1931 in Czernowitz, in Northern Rumania. At the end of 1945 the family moved to Cyprus, and thence Hessing, in 1950, went to study art in Paris. He worked briefly under Léger,

met Le Corbusier and was influenced by Picasso, Braque, the sur-
realists, and Léger himself; but after nine months he rejoined his
parents in migration to Australia.

His work between 1951 and 1957 was only sporadic; between terms
of an architecture course in Sydney, he even went to Melbourne and
studied under the aged Max Meldrum for a month. He first became
known in Sydney with a number of small oils, completed between
1957 and 1959. Figurative elements slowly eased their way out of
them. *The Combatant*, 1957, a whimsical Quixote close in mood to
Klee's *Hero with a Wing*, retains traces of a figure, as does *Bride*,1959.
Fata Morgana, 1959, was Hessing's first experiment in enamels, a
medium he now uses exclusively. These paintings were promising
but mannered: their achievement was their colour – offbeat, jumping
from acidity to sweetness, and extremely lyrical. They were, how-
ever, hedged about with formal restrictions, which Hessing over-
came in 1960 with two canvases, *Charred Memories* ('Painted as a
consequence of a visit to the Museum where I once again saw the
collection of Pacific carvings': a totemic structure of ochres and
browns, hemmed in by gloomy areas of black) and *Alluvial Confine*

115. Leonard Hessing: *Alluvial Confine*, 1960

116 (*opposite*). Leonard Hessing: *Olive Precinct*, 1962

[115], which typifies òne aspect of Hessing's work, its effortless manipulative contrasts, on this occasion between the delicate interplay of forms below and the thick, sludgy, dun-coloured rectangle above.

Hessing exploits a poetry of opposites, and – unlike most local abstract painters – will unhesitatingly throw away a dramatic situation to keep that poetry on its toes. Thus in *Festivities Anguished by Yellow*, 1961, the tension between a gross black hump and its yellow surroundings is unexpectedly released by a rather cheeky passage of pink calligraphy. Such associative contrasts are probably a legacy from surrealism. His charcoal drawings, in which one critic confusedly observed 'primordial forms, rendered with the tense elegance of a Watteau depicting bristling banditti' are brilliantly articulated: the peppy rococo line darts about incisively amid dense encroachments of black. Such paintings as *Olive Precinct*, 1962 [116], with its exquisitely taut interplay of olive, brown, and smoky red, reveal Hessing to be a colourist unequalled in local romantic art. Sophistication has not impaired (why should it?) his naturalness as a painter. He commands an unobtrusive *belle matière*, quite unlike the

chemistry-ridden bravura which often passes for technical skill. The vitality of Hessing's surfaces proceeds, at least in part, from a tension between his sensuality and his fear of self-disclosure.

To some critics, the disturbing thing about Hessing's art is the ironical detachment this seems to imply. One is reminded of Cyrano de Bergerac's duel: the swordsman arrogantly pinking his flustered adversary while improvising a ballade: 'For I thrust as I end the refrain!' Still, Cyrano was no less a fencer for being a poet, as his opponent soon found out. Hessing's intellect only clears the ground for his images; the painting itself generates the metaphysics.

Properly speaking, Sydney has harboured only two abstract expressionists. They are Stanislaus Rapotec and Peter Upward, and Upward's work is the purer: his paintings refer only to their own condition, while Rapotec's have many figurative overtones.

Upward is now in his thirties. Having worked with John Olsen as a student at Julian Ashton's, he moved to Melbourne – an unhappy choice of air, since during the late fifties that city's view of non-figurative painting was, at best, jaundiced. In 1960 he returned to Sydney with the sculptor Clement Meadmore. Two years later he left for Europe and successfully exhibited in London.

Franz Kline has often been invoked as a parallel to, or an influence on, Upward's dramatic swathes of black polyvinyl acetate. But this is quite misleading. Upward is a calligraphic painter, Kline is not. Kline said of his work, shortly before his death,

> Critics also describe Pollock and de Kooning as calligraphic artists, but calligraphy has nothing to do with us. It's interesting that the Oriental critics never say this. The Oriental idea of space is an infinite space; it is not painted space, and ours is. In the first place, calligraphy is writing, and I'm not writing. People sometimes think I take a white canvas and put a black sign on it, but this is not true. I paint the white as well as the black, and the white is just as important.

Upward's flat white tablets are merely a neutral ground on which the black gesture happens. There is no painted relationship between sign and surface and, though the space has an Oriental infinity, no illusion of a third dimension arises from it. The paintings neither imply nor illustrate ideas. Communication with them is purely intuitive. There are no bridges. When his brush strikes the hardboard Upward is on his own in the middle of a self-made arena: his gesture's grace is automatically registered in a trance of speed, and the act of painting becomes a form of limited meditation. Proportionately then, Upward plays a harder gamble than Hessing or Rapotec: his aesthetic strips his sensibility to the quick: he knows the meaning of

117. Peter Upward: *June Celebration*, 1961

Auden's line, 'a poem should not mean but be'. The *tour de force* of his Australian work was *June Celebration*, 1961 [117].

The paintings of Stanislaus Rapotec are conspicuous for their brutal power. Rapotec was born in Yugoslavia, but, having joined the Allied Forces during the war, he did part of his military service in Egypt. Rapotec spent some time at Luxor, and it is to this experience that one may trace his interest in colossal scale. Seen in quantity, Rapotec's paintings are apt to give an impression of lumbering persistence, like an elephant forcing its way along a path which is slightly too narrow for its body. This is due to the small range of forms which Rapotec uses. The patterned squares of his early abstract collages grew out of the flat, oblong patterns of fields in the figurative landscapes which, immediately after his arrival in Australia, he painted in Adelaide; and they in turn evolved into the rectangular forms of his Tension series, a group of sixty paintings done between 1957 and 1960. Slow ovoids and turning forms appear in a later series, Disturbances. This system of heavy movements, slowed down by dark colour and heavily applied paint, suddenly acquired a figurative character in 1960–61, when Rapotec produced a number of large landscape paintings. A thunderous yellow light crouched over these lugubrious swamps of paint; thickets of black line rose from churned-up tracts of muddy brown, and shapes like huge bugs or turtles scurried through the undergrowth.

Rapotec is not an inventive painter. He rings the changes on a narrow range of shapes, all of them heavy, all slashed in with a

grumpy, dragging brush. This gives his output the merit of consistency; but its defect, of course, is that the endless *fortissimo* becomes meaningless. It is like watching a prolonged weight-lifting contest. A great deal of energy is devoted to forms which, though romantic in their implications, have no real romantic complexity. But when Rapotec's paintings do succeed, they are very impressive. Such a picture was *Meditating on Good Friday*, 1961 [118]. It won the

118. Stanislaus Rapotec: *Meditating on Good Friday*, 1961

1961 Blake Prize, thereby setting off a lively controversy about whether an abstract painting could transmit the complexity of meaning and sensation that one expects from a religious – or, at any rate, Christian – image. It seems probable that Rapotec *intended* to produce a religious painting in *Meditating on Good Friday*, and it is full of emotional clues about suffering and redemption of guilt – crosses, conflicts of light and dark, violent stress; but the question of Christian iconography does not arise, and all the painting conveys is a numinous, rather than religious, sense of impending catastrophe. But it is the kind of enormous, energetic statement in which one can lose oneself. It verges, like many another abstract-expressionist painting, on the romantic category of the sublime.

In the early sixties Daryl Hill contributed to the dominant tendency of Sydney painting: linear abstraction. Born in 1930, Hill worked and studied in Tasmania and lived briefly in Sydney; in 1953 he went to Paris and studied at the Académie Ranson under Singier, Chastel and Goetz. Later he moved to England and, for two years, worked as an assistant to Henry Moore. His paintings were widely exhibited in England and America.

Hill is not a calligraphic painter in Upward's sense; whether atmospheric or spare, his line always ends by evoking space; it is not a gesture on a neutral ground. One incident, a feathery explosion of peacock colours, is isolated against a veil of atmosphere and light. Of his work with Moore, Hill observed that 'You're either drowned in his ideas, or you fight them, or you find another channel.' While some Australian sculptors, like Stephen Walker or Alan Ingham,

119. Daryl Hill: *The Perimeter*, 1962

worked under Moore and have since been dominated by his style, Hill had painting as his 'other channel' and so could adapt metamorphic imagery to his own work in a wholly personal way. Returning to Australia in January 1960, Hill lived for some months in the salt-lake districts of Western Australia. His watercolours, which summarize the now harsh, now opalescent light of the saltpans, were exquisitely delicate; complex linear motifs rose through space, split into fragments, or disappeared altogether and left frail tracks of their passage on the washed background. These images of landscape soon disappeared, however; more recent paintings like *The Perimeter*, 1962 [119], despite their comparatively dense forms, are meant to disclose purely abstract tensions between mass and space.

Ross Morrow (b. 1932) looked more directly at the landscape; essentially a figurative painter, his emphasis on linear gesture relates him more to Olsen or Hill than to his teacher John Passmore. In 1961 a jeep trip through Northern Australia resulted in a number of landscapes whose rapidly scraped and flowing surfaces, in a narrow range of browns and reds, were indebted to Nolan; the blurred passage of the forms seemed linked with the experience of driving rapidly through a landscape rather than stopping to look at it from a fixed point. Later works like *Australian Landscape*, 1962 [120] are more complex and expansive in their movements; broad areas of ochre, white and red are pulled together by isolated marks.

Recent Australian figurative painting has thrown up several culture-heroes for the public: Dobell, Drysdale, Nolan, Godfrey Miller. As I have noted already, the essential prerequisite of a culture-hero's enthronement is the mystique used to veil his work from critical assessment. Whether the painter wants this mystique or not is beside the point; the audience does. It wants either a traditionsubstitute (Drysdale and Dobell), or a safe *avant-garde* which can give critics and collectors some kind of fixed point in the turbid and fluctuant currents of new painting: a Bureau of Standards peg to measure the tides without risking wet feet. This job, for several years, fell to Godfrey Miller's paintings. It has now, to a great extent, been taken over by Ian Fairweather's.

In 1962 Ian Fairweather, who was then seventy-one years old, held an exhibition at the Macquarie Galleries in Sydney. The critic of the *Sydney Morning Herald* acclaimed him as 'Australia's greatest living artist'. This may or may not have been true; but was it a useful judgement? What does the word 'great' mean in the context of Australian art? We say that Giotto is a 'great' painter partly because he changed the history of Western painting by introducing a fresh set

120. Ross Morrow: *Australian Landscape*, 1962

of conventions by which one's experience of space and form could be expressed. If you grant such terms of reference, it must be admitted immediately that Australia has never produced a great painter; indeed, that it has not even had the honour of harbouring one for a time, as Algiers did with Delacroix. But I think it is at least arguable that Ian Fairweather is the most gifted painter who has so far appeared in Australia; though even this kind of statement involves one in a distasteful role of tipster for the antipodean heat of the Parnassus Sweepstakes.

Moreover, Fairweather's reputation is confused by the fact that he is excellent copy: a picturesque sage living in a grass hut on a Queensland island. Australians have not failed to seize on this as evidence of his pure dedication to painting, in the mistaken belief that it is morally better to work in a hermit's cave, like Piero di Cosimo, than in a palace, like Rubens. Even Fairweather's imitators, like Rodney Milgate, are not criticized for their rather limp dependence on his style.

Ian Fairweather is a Scot; he was born in Bridge of Allan, near Stirling, in 1891. Educated in Jersey, he left school at sixteen and went to Switzerland. Presently he went back to Scotland and studied forestry in Edinburgh; but, when war broke out in 1914, he joined the Scots Greys and was sent to France. No sooner had he got his commission – as a second lieutenant – than he was taken prisoner at Mons. In the prisoner-of-war camp he began to study Chinese; at this time, he had no serious thoughts of becoming a painter. In 1917 Fairweather was made one of a batch of exchange prisoners; recuperating in Holland after his release, he began to study drawing at the Hague Academy. After the Armistice, he returned to England, intending to study forestry. The University advisers suggested that he study medicine instead, which he had no wish to do; so, as a third choice, he enrolled as an art student at the Slade School under Henry Tonks. He remained at the Slade for four years, and thirty more were to pass before he spent so long in any one place again.

In 1922, Fairweather went to Canada, worked on a farm in Saskatchewan, and wandered down to the west coast, where, on an island between Vancouver and the mainland, he managed to save up enough money for a third-class passage to Shanghai. He spent three years in Shanghai, working in a public garden and drawing ceaselessly, before heading south again in 1933. He lived on the island of Bali for six months, in a native community, but was eventually hustled off the island by its white administration. In Bali, he painted a picture entitled *Bathers*, which is now in the Tate Gallery. In 1934

Fairweather took ship for Australia. He settled for a time in Melbourne, in a studio provided by a fellow-artist; the city so grated on his nerves that he left almost at once for Ceylon. The ship docked, but Fairweather had no money for his landing fee, and the authorities shipped him back to Melbourne. When he was able to leave Australia again, he moved north to the Philippines, and then back to Shanghai, where he was refused his old job as a gardener; then he set off for Peking, where he stayed two years. In 1938 he returned to Australia, rented a disused cinema in Brisbane as a studio, and moved to Cairns just before war broke out. The war failed to impede his wanderings, nevertheless; he spent most of it in the East. There is perhaps no need to describe all Fairweather's comings and goings, but their climax came in 1952. Living in Darwin at the time, miserably poor, sheltering under an upturned boat on the waterfront, he was seized by an intolerable nostalgia for Bali. And so Fairweather built himself a crude raft of aeroplane wing-tanks with a plank deck, stocked it with a few gallons of water and some cans of bully beef, and set off. He misjudged the winds, and the raft was so flimsily made that it could not tack cross-wind without opening like a concertina. Eventually, after sixteen days of exposure to tropical gales and intense heat, he was blown ashore on Indonesian Timor. The Indonesian military police sprang to the conclusion that he was a spy, and so, to Fairweather's rage, they shipped him back to the country he had been trying to escape from for the last thirty years – England. Now sixty years old, he had to labour for a year digging ditches before he could raise the fare back to Australia. When he got back, he settled in a thatched hut on Bribie Island, off the coast of Queensland north of Brisbane, where he still lives.

So, in a real sense, Fairweather's life has been a prolonged flight from Western society. He is a loner, an eccentric: the very pattern of the wandering hermit. Now travel is one of the staple themes of romanticism – English romantic literature is primarily a literature of *movement*, whose personages are the lost traveller, the recluse, and the mysterious Child who appears in remote places – and the wandering artist (Turner in Italy, Byron at Missolonghi, Delacroix in Algiers, Wordsworth in the Lake District, or even Augustus Earle on Tristan da Cunha) was, and is, a familiar figure in Western sensibility. But Fairweather's travelling was not so much a hunt for the exotic as an attempt to understand something of which he was already aware when he began to study Chinese in 1917: the implications of Oriental culture. Apart from painting, his two main interests are still Chinese calligraphy and the translation of Chinese books into English.

Travel is freedom; an opening of the unencumbered self to continuous experience. This freedom is the first mark of Fairweather's art – not anarchic licence, but the disciplined, relaxed poise that is born of self-knowledge, when the picture 'comes out of the end of your hand'. The act of painting becomes a way of meditation. 'I'm not concerned with other people when I paint...although I'm very pleased when I do communicate. To me, painting is a personal thing. It gives me the same kind of satisfaction that religion, I imagine, gives to some people.' The painting becomes irrelevant to him when the process of making it is finished; hence, incidentally, his choice of flimsy materials, which makes the conservation of Fairweathers a nightmare for curators. Fairweather is not concerned to produce permanent objects, but to articulate visual experiences in all their transience.

Fairweather's work has always been linear. The vitality of his line encompasses, and determines, the life of the image. It was around 1934, in paintings like *Native Group*, that he managed to free himself from 'Slade' drawings and concentrate on the purely expressive resources of line, which runs and twines across the surface, describing the form of heads and the folds of garments with decorative elegance. Within a few years, all the forms in Fairweather's paintings were governed by this play of linear activity. The landscape in *Hillside, China, c.* 1949 [121] becomes a linear image, snatched from a

121. Ian Fairweather: *Hillside, China, c.* 1949

flux of experience and registered with a peculiarly relaxed, sinuous brush. Fairweather's linework is influenced by Chinese calligraphy but it is not, in fact, calligraphic; it is not energetic enough for that, and has little of the thrust and nervousness of (say) Tobey's 'white writing', or the whiplash lines of a Pollock. The line drifts across the paper and images form within it.

The most rapid development in Fairweather's art has happened in the last decade. This is rare in Australia; most local artists are sprinters, not milers, and the last sixty years are studded with painters whose early talent leaked away in middle age. Most of the best Australian paintings have been done by men under forty-five – which may have something to do with the impression of bounce and exuberance which Australian art tends, at least on a quick glance, to give. Fairweather is the only living artist in the country whose work has kept developing late in life – consider, by contrast, the collapse of Dobell's talent in the same ten years.

Why is this so? The reasons must belong to the individual painters, but one may broadly speculate that the lack of staying-power comes from two things. The first is a general reluctance among local artists to consider the philosophical implications of their art. (One could adduce many examples of this: one, which soon proved to be a dead end, was the illusion of the 'innocent eye'; another, the manufacture of non-existent myths and fictional archetypes.) The second reason is their tendency to jib at significant content. Australian painters are too ready to don the useful mask of the naïve visionary; hence the predominance of sensational painting, and the lack of a corresponding classical movement. When classicism appears, it is never more than a gesture in the direction of ideal form, without a basis of philosophical belief. Thus it becomes etiolated (Frank Hinder) or merely an insipid copy of an overseas prototype (Bell, Frater, Wakelin and the rest of the Australian post-impressionists). Metaphysics, in Australian painting, has tended to stop at the immature stage of folk-myth, real or fake. Even when I look at Nolan's first Kelly series, I am reminded of an observation by Karl Marx: that the epic is the art form of an undeveloped society.

Fairweather looks for other values. His images are projected through a philosophy of experience; herein lies his value to Australian art.

Over the decade between 1950 and 1960, Fairweather's work became increasingly abstract. (In his most recent work, like his illustrations to the *Drunken Buddha*, figurative images have come back once more.) The cursive, open lightness of *Hillside, China* was replaced by a denser space, reminiscent of cubism; the structure was

122. Ian Fairweather: *Woman at Window*, 1956

more complex and formal; *Woman at Window*, 1956 [122] is an intri-
cate sequence of overlapping images, reflections and echoes. The
forms become compartmented; one looks into the picture surface

as if into a colony of cells, in each of which a ritual of poly-morphic lines is taking place.

Fairweather's best images have the authority of a Sung pot; their forms inhabit 'the still point of the turning world', a kind of abso-lute centre towards which experience converges. Figures move gravely in a frieze of ochres, greys, and whites; the line moves with them, the line *is* the figure, not merely a description of it. A com-plicated, balanced metamorphic process lies behind paintings like *Monsoon*, 1962, *Monastery*, 1960–61 [123], and *Epiphany*, 1962 [e]. The line begins, casually but firmly, to trace its journey over the canvas; its progress is mixed with memories of rain in Bali, temples in India, a carving in Peking, the gesture of a figure in a jungle, the pine-trees of Bribie Island filtering the green light, the winding roots of mangroves; these experiences are assimilated into his knowledge of Taoism, Christianity and primitive mythology; and at last an in-exhaustibly rich image comes forth, whose many elements are not merely overlaid but fused in a uniquely *visual* form. Fairweather's art

123. Ian Fairweather: *Monastery*, 1960–61

goes effortlessly from impulse to image, drawing its sustenance from the mystery which lies at the heart of all imaginative experience. Yet the mystery is never fully revealed; for, as Lao-Tse put it,

> The *tao* is something blurred and indistinct,
> How indistinct! How blurred!
> Yet within are images,
> How blurred! How indistinct!
> Yet within are things.

By 1961, the linear abstractionists were fast becoming a strong group in Sydney; various skirmishes broke out with the Society of Artists, with East Sydney Technical College and the Art Gallery of New South Wales; a campaign for higher prices and 'more professional' standards began. People began to talk about something called the Victoria Street Group – Olsen, Rapotec, Rose, Upward, the sculptor Clement Meadmore, and Leonard Hessing. The *Bulletin* greeted this with an article called 'Flare-Up in the Art War', and in Victoria Street the idea of a collective exhibition was mooted. After much backing and filling, punctuated by the usual jealousies, compromises and conspiratorial hoo-ha, the 'Sydney 9' group was formed. Its members were Rose, Hessing, Upward, Olsen, Rapotec, Meadmore, Eric Smith, Carl Plate and Hector Gilliland. They held a large show in Sydney and then took it to Melbourne.

'Sydney 9' went inter-state to answer the Antipodeans. A ludicrous tension now existed between the 'abs' and the 'figs'. Shrieks of 'international bandwagoners!' and 'cottage industry!' were exchanged north and south, across a mutually observed Mason–Dixon line that painters seldom and exhibitions rarely crossed. Though one critic optimistically likened this isolation to the rivalry between Florence and Siena in the fifteenth century, it did much to debilitate the art climate. In this context, the only effect of 'Sydney 9' was to break the ice. What began as an ideological war-party (symbolically, Rapotec, Olsen and Hessing descended from the skies of Melbourne in a helicopter, clutching their pictures) turned into a diplomatic mission.

The exhibition itself was no more coherent than Direction 1 had been. Gilliland's rather pedestrian post-cubist abstractions did not fit it at all; and Carl Plate was distant, both in age and in style, from the other exhibitors. Plate (b. 1909) had been one of the Australian students who returned from Europe during the war; his book and print shop, the Notanda Galleries, was to Sydney what the Leonardo Bookshop had been to Melbourne. Having turned to abstraction through a series of horse-and-rider images painted in 1955–6, he developed an art of sophisticated implications which, nevertheless, tended to look like academic abstraction, the sort of *cuisine* one associates with minor School of Paris abstractionists. Soft, gently

295

ragged masses emerged from an atmospheric matrix, fluctuating quietly, while lines strayed across them as if looking for the contours of a landscape form [124]. Shifts of rhythm were given by clusters of leaf-like shapes, breaking away from their parent masses. The colours – bluish greens, browns, whites and elegiac greys – gave a calm face to images beneath which an implied world stirred uneasily.

124. Carl Plate: *Destructive Paradox No. 7, Moment*, 1960

'Sydney 9', as a group, did not survive its first exhibition. But meanwhile, other preoccupations were developing in Australian art. Sexual imagery was one of them. Now sex had not been a common subject of celebration for Australian artists. One exception was Norman Lindsay, whose puffy It-girls were not real enough to be convincing. In more recent paintings, the head that sex raised was nearly always an ugly one. Generally, Australian painters, like Australian writers, are simply unable to present a sexual image with any degree of tenderness, completeness or joy. One gets puritan genitality (John Brack's nudes) or an exploration of the irrational possibilities of *graffiti* (Olsen, and Colin Lanceley's earliest assemblages), or disquisitions on troubled conscience (Pugh, Arthur Boyd, or Tucker), or ambiguously erotic landscape images like Frank Hodgkinson's. But direct images of sex were introduced into Australian painting of the sixties by a young artist, born in 1939: Brett Whiteley.

125. Brett Whiteley: *White Painting with Collage,* 1961

Various critics have interpreted Whiteley's earlier work as a fusion between nude and landscape. To some extent, this is true of a small group of gouaches that he painted at Sigean, in the south of France, in 1962. Otherwise, before 1963, he was producing purely erotic images which inhabited a scenic space, suggested by a rather arbitrary horizon line [125]. The forms lay within a conventional spatial format, without, needless to say, perspective or chiaroscuro. Fat meaty shapes, richly painted in a narrow range of creamy whites, ochres and reds, rubbed and slithered over, through and into one another with elegant lubricity. Whiteley's line was precise, a little bland, but brilliantly articulate. (To see where these fluid, interlocking forms come from, look at some details of Piero della Francesca's frescoes in Arezzo. Piero's formal system was the decisive influence on Whiteley's style.) These early, close-up anatomies are, curiously enough, closer to photographers' than to painters' images of the nude. The ideal photographic nude (Steiglitz's, for example) is

126. Brett Whiteley: *Christie and Hectorina MacLennan*, 1964

impersonal, a vessel of form over which light plays. It is set a little aside from its normal associations of sex. Under the lens, a close-up of one part of a body – the curve of a breast, an armpit, a few ribs – can be exploited as abstract form. Whiteley has applied this process to painting; in one picture which he exhibited in Sydney in

1963, he made this clear by sticking a row of nude photographs across the top of his canvas, partly to exploit the tension between 'real' and 'painted' form, and partly to show how one clear image can be read alternately as abstract and figurative.

In 1963–4 Whiteley painted a series of nudes in the bath. They were, in one sense, tributes to Bonnard: thoroughly enjoyable, optimistic, sensual images, full of the shared subjectivity which exists between lovers [f]. They seemed coherent on every level – not only as form – because Whiteley was painting an experience which he completely understood. This was not the case with his next series, the Christie paintings of 1964–5. In these, Whiteley's formal powers had, if anything, increased. No Australian painter possesses, so far as I am aware, Whiteley's precocious instinct for making marks on surfaces, the magical procedure of good drawing which turns a blank sheet of paper into a live space by the pull of two scribbles in opposite corners. The Christie paintings [126] were a highly polished exercise in this kind of figure–field relationship. But their weakness was in the experience that began them. Whiteley has no vision of evil. His comments on the monster of Rillington Place were, therefore, tinged with artificiality: the act of painting was a way of gathering vicarious experience. One did not feel that Whiteley knew anything about the agonies and horrors he was painting; on the other hand, one knew that he had read Colin Wilson and Ludovic Kennedy, and seen Francis Bacon's pictures. By this I do not mean to imply that Whiteley's paintings were trivial or vulgarly kinky – only that he was not equipped to deal with the experience with which they were ostensibly concerned: moral anarchy, necrophilia, total despair, the collapse of personality. So his innate bounce and sensuality filled the gap, quite incongruously.

Charles Reddington (b. 1929) is an American painter, originally from Chicago, who exhibited in Australia for several years. For some time he lived in South Australia, in the Coromandel Valley, outside Adelaide; the almost voluptuous look of this landscape, with its mild light, rolling hills and orchards, permeated his work. His paintings exhale an unmistakable sense of fruitfulness. The movement of their big blunt forms is slow and deliberate; a turning movement here, a friction there, the gradual tug of organic forces. The space is less defined than Whiteley's; it is conceived in terms of gesture and motion. The fleshy shapes and melting areas of light separate momentarily to expose ravines of darkness beneath, or they are stitched together by energetic passages of black line. Reddington's forms are atmospheric; they alternate between haze and solidity, and this pulsation is increased by the careful working of paint

127. Charles Reddington: *Shoshan Celebration*, 1962

textures. Reddington, as his *Shoshan Celebration*, 1962 [127] indicates, is one of the few painters in Australia who felt at home in the grand manner of abstract expressionism. Since 1964, however, his forms have tended increasingly towards hard-edge abstraction.

Lawrence Daws [128, 129] was born in 1927, in Adelaide; in 1945 he began to study architecture, and later geology, at Adelaide University. Later he moved to Melbourne and studied painting for four years at the National Gallery School. His studies were punctuated by geological survey trips to remote parts of Australia and New Guinea. This travelling in the outback, which John Pringle once compared to the young Englishman's Grand Tour, is an important part of the background of many young Australian painters. It gave Daws, in particular, a most intimate sense of landscape, rock formations, strata, vegetation and light. Gradually this animistic feeling for landscape as

128. Lawrence Daws: *Mandala IV*, 1962

129 (*opposite*). Lawrence Daws: *Lovers in a Room*, 1964

a 'presence' merged into his growing interest in archetypal forms. Figures dissolve into opalescent landscapes; moons float by in equinoctial procession; mandalas hang in the sky like planets. Daws is perhaps the best colourist of his generation in Australia, except for Olsen. The reservation one might have about his work, in terms of its imagery, is that the Jungian archetypes are a little wilfully used. Or, more precisely, that they do not work when they are used as heavenly apparitions; they become ornamental. The energies of the collective unconscious are not, perhaps, so easily tapped.

In the early sixties, not much abstract or even semi-figurative painting was done in Melbourne; what there was, was usually pedestrian, except for the work of Ian and Dawn Sime. Forms were dull: Leonard Crawford (b. 1920) is, to my mind, a stilted, academic painter, though one much praised by some critics for his musical analogies. Some artists, Donald Laycock, Asher Bilu and Leonard

French, concerned themselves with an imagery which, though partly abstract, was specifically religious or sacramental. Of these, the most interesting figure is French.

Leonard French was born in Melbourne in 1928. At sixteen he became a signwriters' apprentice, a trade which gave him his present virtuosity in gilding and glazing, and taught him to think naturally on a mural scale. In fact, two murals were among his first works: *Fresco to War Dead*, and *One World*, 1948, in the Congregational Church in Melbourne. With these, in a heavy official-Mexican manner influenced by Orozco and Léger, French tentatively explored the image which is central to his work as a whole: the hero.

In 1949 he went abroad. He met Alan Davie in England, and lived for some time in Ireland, where he studied Celtic art: it is not diffi-cult to see a connexion between the heavy, intertwined shapes of Celtic carving, the forms of rood-crosses, and the shapes of French's

mature work. Later, on a trip to Belgium, he was attracted to Permeke's work, but the most permanent influence on him was Delaunay's investigation of the circle as an 'ideal' form.

All the formal elements of French's style were gathered on this first trip to Europe. He came back with a fixed vocabulary. This is important in any consideration of French's work, because the forms he took over in 1949–50 substituted for his quite extraordinary lack of talent as a draughtsman. To look at French's early drawings is to see how incapable he was of inventing a shape. The best he could do, therefore, was to get his stereotypes fixed as early as possible and then monumentalize them. But this insensitivity to form relationships is the weakness of French's art, and, when seen, it can make his elaborate, ritualized paintings, with their glossy, crusty, enamelled surfaces, their gold leaf and archaizing self-importance, look curiously pompous. One sometimes feels ready, in front of a painting by French, to swap all that rigid solemnity for a few square inches of Matisse, for French's colour is never more than decorative and it has no more structural function in the picture space than a ruby in a necklace. French's paintings are grand rhetoric, and they often achieve an undeniable religious force; but any investigation of his work should start with the warning that he is not, in any acceptable sense of the word, a plastic artist.

Much of French's inspiration is drawn from literature. The *Iliad*, the *Odyssey*, the Book of Genesis, the works of James Joyce, William Faulkner and Herman Melville, and Evelyn Waugh's biography of the Jesuit martyr Edmund Campion: these are the sources of his conception of the hero, which is, as I remarked before, his main theme. Now heroic images in Australian painting are rare, and French's are unique. Nolan's Kelly is an existential hero, whose life and death is a document of absurdity. With French, as the Australian writer Vincent Buckley put it, 'at the centre of his vision is an awareness of an egotism at once grand, dangerous, representative and exemplary': and this egotism of the hero, who pits himself with all his strength against a totally hostile situation, both distinguishes French's images from those of Nolan or Tucker, and relates them to his literary sources. The difference between Campion and Kelly is the intervention of morality. French sees heroism, not as a gratuitous act, but as the inevitable consequence of fulfilling one's natural human capacities.

French spent three years in Europe and returned to Melbourne in 1952. He exhibited a series of paintings based on the *Iliad* that year; in 1955, another series on the *Odyssey*. Some of these were monumental in scale: flat, mechanized forms, in thick black and white

303

enamel, battled against one another. By 1958 the shapes were both
more static and more fluent, built from a series of motionless geo-
metric forms – circles, leaves, pyramids, rectangles, and formalized
serpentine shapes – and the basic figures in his iconography had
appeared: the fish, the vine, the serpent, the heroic figure which
appeared as king, queen, artificer, orator, or actor. French was not,
at this stage, concerned with specific heroic figures, but with heroic
qualities. The paintings were marred by a certain coldness and
impersonality of surface and form: none of the richness of French's
later treatment was visible.

In 1960 French exhibited a panel of five paintings in the Helena
Rubinstein Scholarship. Technically, if not thematically, these were
the precursors of his Campion series. They were based on the Book of
Genesis, and were concerned with a cycle of creation and destruction,

130. Leonard French: *Genesis*, 1960

from the unfolding of the world to Cain's murder of Abel. But, essentially, they are a celebration of life, of vitality. *Genesis*, 1960 [130] is an icon of evolution, as French's verbal worknotes show:

The water – movement of life – the creation of fishes. The serpent – the fish – from fish into bird – from bird into man – man thrusting up – man against the sky alive.

Man, here, is not an isolated hero. He is part of a natural order of things, and if heroic content is to be read into the 'Rubinstein' paintings it lies more in their monumental scale and extreme solemnity than in any specific meaning.

Later in 1960, French turned his attention to a *specific* hero, Edmund Campion. This martyr's suffering, death and triumph became the stem of a new series of paintings: not narratives (though some of them start from incidents in Campion's life, such as his trial or torture) but meditations on heroic action [g]. In this series, French expanded the reach of his iconography. Its basic forms remained. Campion appears successively as a man on horseback, a missionary in a boat, a figure aflame, a cross, a tower and a fish. But the cross-play of symbols is very complicated. Thus in *Death and Transfiguration*, Campion, as a fish, is raised in the sky; fragments of winding-sheets fly from his body. But in *The Crossing*, the winding-sheet becomes a sail, and French's notes read:

From the land journey to the sea voyage – the birds and open sea – crossing the sea knowing there is no physical return – the sail already a windblown winding-sheet – a cross against the sky – symbols of chalice, fish and flagellator decorate his gown – a man in movement – fish alive in the sea.

The fish-image, standing alternately for Campion and Christ, is taken from the classical Ichthys of early Christianity. But in later paintings it is removed somewhat from both contexts; it becomes a symbol of life, regeneration and resurrection, as in *A Rain of Fishes*, 1962:

Soft sky full of fishes – protected, alive in the air – descending as rain – a miracle protected – a column of sea – a replenishing – a sky full of movement – earth burnt full of holes – fish falling in an order – crystalline in pattern – each related to the whole – a flood of fishes – the earth full of life.

[11] Epilogue

Late in the fifties, texture-painting received some impetus in Sydney. While Frank Hodgkinson, in Majorca, was influenced by the Spanish painters, other artists picked up the style from art magazines and their own visits to Europe. The most prominent of these was Elwyn Lynn (b. 1917), who began to work in hard pastes and collage after a trip to Europe and the U.S.A. in 1959. His paintings, once influenced by Marchand, now became indebted to Tapies [131],

131. Elwyn Lynn: *Across the Black Soil Plains*, 1961

and involved the same kind of metaphorical allusions to steles, dolmens, slabs of earth, tombs and half-effaced inscriptions; to objects mythologized by time. Lynn's paintings of the early sixties are too derivative, perhaps, to form tragic images – the only experience to which they are really close is that of other art – but they do

reveal an interest in tragedy which has been one of his contributions, partly as artist but mainly as critic and reporter of trends, to the Australian scene. As editor of the Contemporary Art Society's broadsheet since 1955, and more recently as art critic of the *Australian*, Lynn kept up a running skirmish with prevalent attitudes in Sydney – the gentility of the Charm School came under constant attack – and stimulated discussion about international issues in art. (The discussion, of course, could not go on at a very informed level, since the pictures could not be seen in Australia; but at least it gave painters the impression of progress.) The only immediate result of Lynn's airing of Dubuffet and *l'art brut*, neo-Dada, the Spanish painters, Jasper Johns and Robert Rauschenberg, seemed to be an insidiously creeping rash of polyvinyl acetate in the Contemporary Art Society's next few shows, but an atmosphere favourable to experiment had been created; for the first time in more than a decade, the idea of an international 'mainstream', however ill-understood its implied issues were, began to animate the thinking of local artists. Some, like William Peascod or Thomas Gleghorn, merely fed textural painting back into the conventional Australian landscape-abstract. But at least one young collagist, Emanuel Raft (b. 1938), showed a promising sensibility in his edgy, dramatic images composed of glazed newspaper, burnt sisal and hessian [132].

132. Emanuel Raft: *The Totem Worshippers,* 1964

There were a few Dada manifestations. Their worth should not be over-estimated. In the late fifties and early sixties, the flatness and conformity of Australian society would have appalled a European radical. And the artists, instead of being exacerbated, were drugged by it. It seemed then that radicalism was dead in Australia; politics and art alike had been swallowed by the all-embracing bourgeois pattern. The timidity engendered by such conditions may account for the very mild and self-conscious nature of Australian Dada; when, for instance, Elwyn Lynn, Oscar Edwards, Henry Salkauskas, John Coburn, Roy Fluke and John Ogburn put on a neo-Dada show called 'Muffled Drums' in 1959, it was clear that they had been digested by their own subject-matter; even an exhibition put on three years earlier by students at Sydney University, entitled 'Oogoo' and attended by a spate of Dadaist publicity, was harsher than this. The only Australian who ever understood the Dada principle of *provocation* was the actor Barry Humphries, who organized two Dada shows in Melbourne and (before leaving for England in the late fifties) performed a number of gratuitous public acts whose ferocity and point might have pleased Tristan Tzara.

Assemblage came into being in Australia in 1962, when a group known as the Annandale Imitation Realists exhibited their sprawling artifacts in Sydney and Melbourne. The Imitation Realists were three previously unheard-of young painters, Colin Lanceley, Michael Brown, and Ross Crothall.

Confronted by the lolly-pink, grinning totems, the *graffiti*, the bottle-tops and rusty tin cans, the plastic toy cars, the Woolworth's panties, the beads and Flit-guns and Captain Marvel helmets, the nudie-cutie photographs, spaghetti labels and mousetraps, the private demonology of heroes like Captain Orpheus, the house-eating Krusch-Orph, and Mirg ('Mirg is a beaut. He is friendly, and never morose'), a good many observers laughed at what they took to be a joke and then went home. The invention, they agreed, was remarkable, but it was anti-art. And if it was anti-art, it couldn't *be* art; it was, instead, humour, satire or farce. In retrospect, however, the first Annandale Imitation Realist show seems to have been one of the few significant statements made in Australian art in the early sixties – if only because the three artists turned their back, decisively, on the 'poetic' elements of Australian painting, with all their conventions, whether in abstract or figurative art. The Imitation Realists projected their sensibility by mauling the materials of poetry. No effort was made to dignify their crazed icons of junk; whereas Eduardo Paolozzi embedded his found objects in wax and

133. Michael Brown: *Mary-Lou*, 1962

then cast them in bronze, thus cloaking their original identity in a unifying material and presenting them as 'pure' form, the Imitation Realists' forms were grossly *im*pure, each raucously existing on its own independence; the homogeneity of the surface was torn to shreds by surrealist contrasts. Nor were the images always funny; some were distinctly alarming. Michael Brown's *Mary-Lou*, 1962 [133] can be seen, on one level, as straight visual wit and ingenuity: ukuleles for legs, a head-dress made of a dated living-room mirror, baby-doll arms, a torso of red-headed nails, all surrounded by a spawning profusion of collaged nudes, plastic holy-water stoups and so forth. But under the playful exterior, a monstrous totem takes form; the instincts of the artist merge with those of the primitive fetish-carver who sticks nails and bottle-tops into his effigies precisely because of their strangeness to his culture. (As a matter of record, Brown's interest in assemblage was born in New Guinea, where he was able to see fetishes of this type.)

This disquieting streak ran through the work of all three members of the group. At first, their assemblages were compared to those of Robert Rauschenberg – though Brown, Lanceley and Crothall insisted that they had never seen a Rauschenberg even in reproduction, which, given the state of communications at that time between Australian and overseas art, is quite possibly true. But there was an element of violence, discontent and *social* commitment in the Imitation Realist show which is foreign to Rauschenberg; it was, perhaps, closer to the convulsive black humour of a west-coast artist like Edward Keinholz.

Like most painters' groups in Australia, the Annandale Imitation Realists split up after their first show. A splinter group, the Eastern Suburbs Illuminators, was formed, but no exhibition came out of it.

Since then, Colin Lanceley (b. 1938) has shown the most interesting development. (Indeed, he and Brett Whiteley are the only two Australian artists in this age-group whose work stands up well outside a merely local context.) For two years after the Imitation Realist show, he continued to make assemblages. These often had a distinct narrative content – sardonic images of generals, orators or nightclub strippers – but the narrative elements of assemblage became less and less important, and sometimes a narrative interpretation was misleading. Thus his *Altar*, 1963 [134], a panel whose centrepiece was a grotesquely elaborate old poker-machine, surrounded by grinning mouths and fragmented organisms, could perhaps have been read as a satire on the Returned Soldiers' League's gambling clubs; in fact, what attracted Lanceley in the poker-machine was its baroque 'otherness', its look of a ritual object whose ecclesiastical

134. Colin Lanceley: *Altar*, 1963

purpose had been lost. In such works, he developed an acute tension
between paint, collage and found object, in which the more self-
indulgent aspects of surrealist method were gradually purged away.
But there remained the danger of sentimentality – falling in love
with the original identity of the found object and not changing it
enough, so that it carried too many of its original associations and
became a memento rather than an image. For this reason, Lanceley's
work since 1963 has become tighter: more abstract. The main
influence on his recent work is Joan Miró, whom he admires for 'the
absolute conciseness of his formal language – the way he can pare
down a shape to the last degree of formal exactness and still keep its
conceptual ambiguity'. In 1964 Lanceley discovered a mass of dis-
carded engineers' patterns – the wooden prototypes made for
mechanical parts, from which the moulds were to be made – in a
warehouse in Sydney. These forms had no 'history', in the sense
that a battered plate or a discarded toy has; no aura clung to them; at

the same time they could be directly assembled and the unexpected shapes that resulted reflected the element of provocation and spontaneous discovery which, before, had drawn Lanceley to assemblage. Incorporated into a construction, such objects ceased to be *things* and became abstract forms.

An exhibition of these painted wooden sculptures won Lanceley the Helena Rubinstein Travelling Scholarship in 1964; he left Australia permanently, for London, the following year. In London, he developed a second preoccupation: with relationships between three-dimensional sculpture and two-dimensional paintings. Take, for example, his construction *Free Fall*, 1965 [h]. It appears to grow in and out of the painted panel on the wall behind it. The sculpture is fixed at a definite point in space and hence in one specific relationship to the painting. It cannot be walked around – the spectator's viewpoint is determined for him in advance, an essentially Baroque idea. The construction and the picture are linked by imagery (cross-references to aeroplanes, between the old Hispano-Suiza propeller and the absurd, delicate frame-like forms in the painting), by colour, and, not least, by the play of shadows cast on the painted surface by the gesticulating wooden shapes. Some of the forms in the painting are tracings of the cast shadows of the sculpture – memories of it, so to speak; a device invented by Marcel Duchamp in *Tu M'*, in 1918. It is this play of shadows, with their echoes of form, which Lanceley most often uses (not wholly successfully) to bridge the gap between three dimensions and two. But if the integration of his images, in their corner 'between painting and sculpture' (to quote the title of his exhibition in London in early 1966) is not complete, Lanceley's work has other virtues, paramount among which is its intellectual complexity, which coexists with an odd, capricious tenderness. There are no painters living in Australia at the moment, so far as I know, who are as concerned with the conceptual side of art – whether, for instance, a formal *language* as such can exist or be developed – as he is; the question of self-expression, in the vulgar and theatrical guise of undisciplined romanticism under which it usually goes in Australia, is not relevant to Lanceley's work.

*

At this point, a general question is pertinent. When does one stop talking about *Australian* art? Has it any identity? And is it a useful classification for art historians?

To classify art by region is a crude process with limited uses. In the twenties, as we have seen, some Australian critics believed that there was a *genius loci* – presumably some exhalation from the wheat

and wool – which shaped the personality of Australian painters. In 1931, J. S. MacDonald described how

> we are not only a nation, but a race, and both occupy a particular territory and spring from a specific soil. The racial expressions of others will not be ours.... We will be mainly contented with our own imagery expressed in our own independent-minded sons, and of these, in landscape, Streeton is the protagonist.

This was a current idea at the time – internationally so, in fact, as becomes painfully clear if you compare it to an essay written by one of Dr Goebbels's propaganda chiefs, Kurt Eberlein, in 1933:

> Artists have the landscape in their hearts, because they contemplate, because their soul becomes landscape, and their landscape becomes soul. German art is homeland and homesickness and therefore always landscape even in the picture, the land of the soul becomes and grows into soul... either one speaks German and then the soul speaks, or one speaks as an alien tongue, a cosmopolitan, fashionable, Esperanto language...

Most of the innumerable attacks delivered on the bogey of inter-national art styles in Australia have been couched in this kind of rhetoric, and still there is considerable evidence that the *genius loci* definition of Australian painting is seriously believed by Australians today.

On the other hand, a regional classification may be simply descrip-tive. For instance, the words 'sixteenth-century Roman painting' refer to the paintings which were made in Rome between 1500 and 1600, irrespective of style. Used in this way, 'Australian art' means no more than the sum of art objects which have been produced in Australia.

But that is not what Australians who talk about 'Australian art' have in mind, either. Their intention falls somewhere between the two poles of mystique and simple description. They use the phrase as if it denoted *some* kind of shared relationship to an environment among painters, whether physical, social or ideological. The exact nature of that relationship is, and always has been, left vague.

Yet I have tried to make it clear that Australian painters – especi-ally today – have no such common attitudes. Instead, they seek to discover a relationship with other works of art: with the history that flows on outside. The cliché of Australian painting today is neither a pair of gum-trees with a sheep, nor a red desert with eroded roots and stringy pioneers. Those, too, are clichés, but they are no longer relevant ones. The cliché is an earnest imitation of Kenneth Noland, Robert Rauschenberg or Richard Smith.

We now live in a linear culture. As soon as a work of art is produced, it is effortlessly disseminated all over the world, through reproductions, films, television, newspapers and studio gossip. Within the context of modern Western art, it is pointless to speak of isolated cultural pockets where regional styles may develop in a nostalgically admired purity. Australian painters are no more immune to this instant exposure than anyone else. That can readily be seen in the unstable eclecticism and nervily inefficient digestive system from which most painting done in Australia suffers. But, at the same time, very few foreign exhibitions reach the country. This in turn means that the guesses local artists may make about shifts in style and fresh ideas cannot be verified from looking at the works themselves. Painters therefore live on a diet of paper. They are afflicted with a sense of inferiority – of being constantly left behind; and their occasional truculence about decadent Europe is their obvious mask.

In the strict sense, the words *avant-garde* have no aesthetic meaning in Australia, since no revolutionary style has ever been initiated there. They retain their social significance, for, as we have seen in the history of Australian culture in the 1940s, the pseudo-innovators excited the same violent reactions from their society as the real innovators did in Europe twenty years before. Three decades passed between the cubist revolution in France and the first efforts to grasp its meaning in Australia. Since then, the time gap has narrowed. But it has never closed.

Now the artist's need to relate his work to prototypes cannot, as Ernst Gombrich demonstrated in *Art and Illusion*, ever be dispensed with: for development is impossible without it. One of the painter's first problems is always to bring himself into a coherent relationship with art history. To ignore this problem, and paint as if nothing existed north of Cape York Peninsula or west of New Zealand, is to succumb at once to provincialism. But the problem of historical relationships is distorted by the kind of prototypes available in Australia. To a young painter in Sydney, the Florentine *quattrocento* is little more than a fantasy which rises, fitfully, from the pages of art books. None of the actual paintings or sculptures are there to be seen. But he will have been told that it is good for him to examine them. And so he will be drawn into the expressionistic world of mirrors and mirages which constitutes André Malraux's 'museum without walls'; a flux of works of art which drift in reproduction, cut off from their historical location, united only by rhetorical theories about the Absolute. No works of art which are not Australian will seem to have a context in his experience; instead, the painting from

the past is a memento, which bears about as much relationship to its tribe as the stuffed stag's head on the wall does to the rest of the herd. This curious status of past works of art even tinges those which actually are in the museums. I well remember my own mixed feelings of joy and frustration while studying the Rembrandt self-portrait in the National Gallery of Victoria: appetite awoken but not satisfied, because all the other major Rembrandt oils were 12,000 miles away.

And so this hypothetical young painter will probably find that the only situation to which he can whole-heartedly relate himself is a contemporary one; but even to this, as we have seen, his position is that of Tantalus. Where before the prototypes were meagre, now they are misleadingly dense. The pace at which information about new stylistic shifts is fed to him by a magazine culture, coupled with the low level of analytical thinking in Australian criticism and art teaching, breeds insecurity. And this insecurity is rooted more deeply in Australian art than most Australians care to think.

Australian art, then, is the fly on the chariot-axle of art history. But this does not mean that Australian painters have not been able to produce inventive and moving pictures. Repeatedly they have done so. Still less does it mean that Australian painting cannot discover an identity for itself – as American art did in the forties. But it does hint at the defensiveness of certain Australian claims for local painters. From time to time, one reads observations like Craig McGregor's (in *Profile of Australia*, 1966):

> Australians tend to paint in a direct, unselfconscious way, unworried by too great an acquaintance with self-debilitating doubts and the metaphysics of many overseas artists; the result is a certain bravura and confidence, a readiness to grapple with the major theme and to make the large statement. . . there is a breadth and yet an innocence about much Australian painting which helps it to avoid mere pattern-making and the dangers of form to the exclusion of all else . . .

The truth is nearly the exact opposite. Australian painting is very self-conscious; it is obsessed with the problem of what its identity ought to be. To be free from doubt and indifferent to 'metaphysics' – by which, presumably, the author means 'aesthetics' – is not necessarily praiseworthy in artists. The 'readiness to grapple with major themes' (in a state of 'innocence', perverse as that may seem) and the fondness for 'large statements' (for which, all too often, one has only to thank the mills which supply Masonite in 6 x 4 foot sheets) are often nothing more than masks for the existing doubt. Australians are certainly fond of heroic themes, and all their heroes are pre-Freudian. Yet when the pictures are lined up, with all their explorers,

stockmen, suffering Campions and half-caste brides, there seems to be more adventure and peril in the way a black silhouette and a jagged grey line act against an ochre field in a Braque still-life; more authentic lyricism in the passage of light over the loins of a Bonnard girl; more tragedy in a Giacometti bronze no bigger than your thumb. Innocence can be one of the faces of rhetoric.

'The fact is,' one painter said to me in 1966, 'you can't begin to grow up until you've left the place.' Brutal though this remark may be, it represents, fairly accurately, the way many Australian artists feel about the environment which they have inherited. Australian painting is probably about to experience the change which befell American writing in the twenties, when the expatriates moved to Paris. Some Australian critics see this as a shrugging-off of responsibility; they assume that the task of a painter is to define the collective imagination of his country, or, at least, to contribute to it on 'Australian' terms. Otherwise, the cliché goes, he will 'lose his vitality', ailing like a lonely panda in some foreign zoo. This is a chauvinistic assumption. Whether it presents itself neat – 'Ah, Jack lost his touch when the Poms got hold of him' – or under a more sophistic guise, as in the arguments of antipodean Robert Pitmans like Max Harris, it ought to be resisted. And all the more so, because this illusion suits the terms on which the Australian public wants to take its art. In Australia, you hear interminable references to an 'art boom', and the very phrase betrays itself. Australians now look at art with the slightly bemused delight of speculators who have a corner in a new commodity. Art presents itself to them as an investment, which, before 1960, would have been inconceivable. An ebullient bourgeois society which loves culture as a badge, but lacks discrimination, has developed a desire for a homogeneous and self-contained – that is, purely Australian – art. It gets what it wants; but to speak of an Australian cultural explosion, for no reason but that a lot of Australians are painting, is meaningless. Australia also has a knitting explosion and a cooking explosion, equally to be accounted for in terms of the abundance of Australian wool and steak. The struggle for identity goes on, for, as the prophetic Ern Malley wrote twenty-five years ago:

> I had read in books that art was not easy,
> But nobody told me that the mind repeats
> In its ignorance the vision of others. I am still
> The black swan of trespass upon alien waters.

Bibliography

The bibliography is not meant to be exhaustive, but it lists the principal works consulted by the author in the preparation of this book.

GENERAL

BADHAM, H.E., *A Study of Australian Art*, Sydney, 1949
BONYTHON, K. and THOMAS, L., *Modern Australian Painting and Sculpture*, Adelaide, 1960
HUGHES, R., 'Painting', chapter in *Australian Civilization* (ed. Peter Coleman), Melbourne, 1962
MOORE, W., *Story of Australian Art* (2 vols.), Sydney, 1934
PRINGLE, J.M.D., *Australian Painting Today*, London, 1963
SMITH, B., *Place, Taste and Tradition*, Sydney, 1946
SMITH, B., *European Vision and the South Pacific*, Oxford, 1960
SMITH, B., *Australian Painting, 1788–1960*, Oxford, 1962
SMITH, B., *Australian Painting Today* (the John Murtagh MacCrossan lectures, 1961), Queensland University, 1962
SMITH, B. (ed.), *Education through Art in Australia*, Melbourne, 1958
TURNBULL, C., *Art Here*, Melbourne, 1947

CATALOGUES

Catalogue of Australian Oils in the National Art Gallery of New South Wales, 1875–1952 (Sydney, 1953)
Catalogue of the National Gallery of Victoria (Melbourne, 1948: with appendixes added in 1950 and 1954)
Catalogue of the National Gallery of South Australia (Adelaide, 1956)
Catalogue of Australian Paintings and Drawings, Tasmanian Art Gallery (Hobart, 1956)

Also catalogue introduction to the following survey exhibitions:

Exhibition of Australian Art in London, 1923
Art in Australia, Sydney, 1923
Art of Australia 1788–1941 (ed. S.Ure Smith), Museum of Modern Art publication, New York, 1941
Jubilee Exhibition of Australian Art, 1951
Pacific Loan Exhibition of Australian Painting, 1956
Arts Festival of the Olympic Games, Melbourne, 1956
Modern Australian Art, Museum of Modern Art and Design of Australia, 1958
The Antipodean Manifesto (ed. Bernard Smith), Melbourne, 1959
Recent Australian Painting, Robert Hughes and Bryan Robertson, Whitechapel Gallery, London, 1961
Australian Painting Today, Robert Hughes, 1963

PERIODICALS

Art in Australia, Quarterly, 1916–42, ed. S.Ure Smith (1916–38) and later by Peter Bellew

Manuscripts, 1931–5, ed. H. Tatlock Miller

Meanjin, 1940– , ed. Clem Christesen

Contemporary Art Society Broadsheet, ed. since 1955 by Elwyn Lynn

Art and Australia, ed. Mervyn Horton, Sydney, 1963–

Angry Penguins, ed. John Reed and Max Harris, Adelaide, 1941–2; Melbourne, 1943–6

Quarterly of the Art Gallery of New South Wales, 1958–

Also various articles in *Southerly*, *Australian Letters*, *Australian Book Review*, *Encounter*, *The London Magazine*, *Texas Quarterly*, *Overland*, *Westerly*, etc.

[1] *The Colony*

ANGAS, G.F., *Savage Life and Scenes in Australia and New Zealand; being an artist's impression of countries and people at the Antipodes* (2 vols.), London, 1847

ANGAS, G.F., *South Australia Illustrated*, London, 1847

BANKS, SIR JOSEPH, *Journal of the Right Hon. Sir Joseph Banks During Captain Cook's First Voyage* (ed. Sir Joseph Hooker), London, 1896

BARTLETT, T., *New Holland: Its Colonization, Productions, and Resources*, London, 1843

COOK, J., *The Journals of Captain James Cook* (ed. J.C.Beaglehole), Cambridge, 1955

CRAIG, C., *The Engravers of Van Diemen's Land*, Hobart, 1961

CROSSLAND, R., *Wainewright in Tasmania*, Melbourne, 1954

DAMPIER, W., *A New Voyage Around the World* (ed. N.M.Penzer), London, 1927

DUTTON, G., *The Paintings of S.T.Gill*, Adelaide, 1962

GLADSTONE, H., *Thomas Watling, Limner of Dumfries*, Scotland, 1938

GLOVER, J., *A Catalogue of Sixty-eight Pictures, Descriptive of the Scenery and Customs of the Inhabitants of Van Diemen's Land...painted by John Glover*, London, 1835

HAWKESWORTH, J., *An Account of the Voyages undertaken by Order of His Present Majesty for Making Discoveries in the Southern Hemisphere* (3 vols.), London, 1773

LEWIN, J.W., *Prodromus Entomology*, London, 1805

LEWIN, J.W., *Birds of New Holland*, London, 1808

LEWIN, J.W., *Birds of New South Wales*, Sydney, 1813

LINDSAY, LIONEL, *Conrad Martens, The Man and His Art*, Sydney, 1920

LYCETT, J., *Views in Australia*, London, 1824

MARTENS, C., *Sketches in the Environs of Sydney*, Sydney, 1850

MARTENS, C., *Lecture Upon Landscape Painting*, MS. in the Mitchell Library, Sydney. Delivered at the Australian Library, 1856

PICKERING, G.F. and BALCOMBE, T., *Gold Pen and Pencil Sketches*, Sydney, 1852

PROUT, J.S., *Sydney Illustrated*, Sydney, 1844

PROUT, J.S., *Tasmania Illustrated*, Hobart, 1844

REYNOLDS, SIR JOSHUA, *Discourses* (ed. R.Fry), London, 1905

TENCH, W., *Narrative of the Expedition to Botany Bay*, London, 1789

TENCH, W., *A Complete Account of the Settlement at Port Jackson*, London, 1793

WATLING, T., *Letters from an Exile at Botany Bay to his Aunt in Dumfries*, Penrith, 1794

[2] *The Heidelberg School*

ASHTON, J., *Now Came Still Evening On*, Sydney, 1941
CAMPBELL, R., *Paintings of Tom Roberts*, Adelaide, 1963
CROLL, R.H., *Smike to Bulldog: letters between Streeton and Roberts*, Sydney, 1946
CROLL, R.H., *Tom Roberts*, Melbourne, 1935
GIBSON, F., *Conder: His Life and Work*, London, 1914
HOFF, U., *Charles Conder: His Australian Years*, Melbourne, 1960 (National Gallery Society of Victoria publication)
ROTHENSTEIN, J., *The Life and Death of Conder*, London, 1938
SPATE, V., *Tom Roberts*, MS. in the possession of the Art Gallery of New South Wales
(STREETON, A.), *The Art of Arthur Streeton*, Sydney, 1919

[3] *Landscape, with Various Figures*

ASHTON, J., *J.J. Hilder, Watercolourist*, Sydney, 1916
GRIFFITHS, H., *The Life and Art of Walter Withers*, Melbourne, *c.* 1913
(HILDER, J.J.), *The Art of J.J. Hilder* (ed. S. Ure Smith), Sydney, 1918
LINDSAY, JACK, *The Roaring Twenties*, London, 1960
LINDSAY, NORMAN, *Creative Effort, An Essay in Affirmation*, 1924
LINDSAY, NORMAN, *Elioth Gruner*, Sydney, 1941
LINDSAY, NORMAN, *The Art of Elioth Gruner*, Sydney, n.d.
MACDONALD, J.S., *The Art and Life of David Davies*, Melbourne, n.d.
MACDONALD, J.S., *Australian Painting Desiderata*, Melbourne, 1958
(YOUNG, B.), *The Art of Blamire Young* (ed. S. Ure Smith), Sydney, 1921

[4] *The Expatriates*

LAMBERT, A., *Fifty Years of an Artist's Life*, Sydney, 1938
(LAMBERT, G.W.), *The Art of George Lambert, A.R.A.* (ed. S. Ure Smith), Sydney, 1924
MACDONALD, J.S., *The Art and Life of G.W. Lambert*, Melbourne, n.d.
MELDRUM, M., *The Science of Appearances* (ed. R. Foreman), Sydney, 1950
MELDRUM, M., *Max Meldrum: His Art and Views* (ed. Colin Colahan), Melbourne, 1919
TURNBULL, C., *The Art of Rupert Bunny*, Sydney, 1948
VIDLER, E.A., *The Art of H. Ramsay*, Melbourne, n.d.

[5] *Post-impressionism*

LAWLOR, A., *Arquebus*, Melbourne, 1937
LAWLOR, A., *Eliminations*, Melbourne, 1939
LINDSAY, L., *Addled Art*, Sydney, 1942

[6] *The Angry Decade*

No books have so far appeared on this period. The reader is referred to the issues of *Angry Penguins* between 1941 and 1946, especially 1942–4; to John Gooday's introduction to *Rebels and Precursors*, an exhibition touring the Australian State galleries in 1962–3; and to various articles by the present author, especially 'Irrational Imagery in Australian Painting', *Art and Australia*, Vol. 1, no. 3, November 1963.

[7] *The Stylists*

Little documentation apart from magazine articles and general references listed earlier.

FRIEND, D., *Gunner's Diary*, Sydney, 1943
FRIEND, D., *Painter's Journal*, Sydney, 1946
(LYMBURNER, F.), *Fifty Drawings by Francis Lymburner*, Sydney, 1946
PENTON, B., *The Art of William Dobell*, Sydney, 1946
THOMAS, D., *Sali Herman*, Melbourne, 1962
　Present Day Art in Australia, Sydney, 1945

[8–10] *Figures and Images – Myths and Personae – Abstract Painting*

As above. Few individual studies of painters have been published.

BUCKLEY, V., *Leonard French, The Campion Paintings*, Melbourne, 1962
HENSHAW, J., *Forty Drawings by Godfrey Miller*, Sydney, 1962
HUGHES, R., *Donald Friend*, San Francisco, 1965
LYNN, E., *Australian Drawings*, Sydney, 1963
MACAINSH, N., *Clifton Pugh*, Melbourne, 1962
MACINNES, C., *Sidney Nolan*, London, 1961
O'SHAUGHNESSY, B., *Arthur Boyd*: introduction to catalogue of artist's retrospective exhibition at Whitechapel Gallery, London, 1962
REED, J., *New Painting 1952–62*, Sydney, 1963
SPATE, V., *John Olsen*, Melbourne, 1962

Index

Bold figures indicate illustration number

Some other books published by Penguins are
listed on the following pages.

Contemporary British Art

Herbert Read

Since its first publication in 1951, this Pelican has come to be regarded as the standard concise work on the subject. For this new edition Sir Herbert Read has completely revised the illustrations, which form the core of the book, and re-written his text to include a new generation of artists. His study of the present state of British painting and sculpture now runs from Ben Nicholson to Peter Blake, and from Henry Moore to Anthony Caro, with biographical notes on the artists mentioned. The author's mastery of the subject allows him to isolate the major trends among the many stylistic possibilities open to British artists as well as to describe the background and influences behind modern art.

In selecting the seventy-two plates (eight in colour) which are now included Sir Herbert Read has tried 'to be as representative as possible of the various trends ... and where a choice was inevitable between two or more representatives of the same trend, to give preference to the young'.

Also in Pelicans

Style and Civilization

This series interprets the important styles in European art in the broadest context of the civilization and thought of their times. It aims, in this way, to achieve a deeper understanding of their character and motivation.

Pre-Classical

John Boardman

The power and personality of King Minos or Agamemnon are shrouded in legend. But from surviving art and artefacts we can begin to draw pictures of the real quality of life in the Bronze Age palaces of Crete or Mycenae, or in the world of Archaic Greece after the Dark Ages. This book portrays through their art the civilizations that stand at the beginnings of the Western tradition.

Gothic

George Henderson

Every age has held its own vision of the Gothic world – a world of barbarism, or of chivalry, or of piety. Here is an attempt to reach a deeper understanding of the Gothic style by examining its many forms in the context of contemporary religious or philosophical attitudes, and against the background of the social and political order of the Middle Ages.

Early Renaissance

Michael Levey

Humanity and the human form dominate Early Renaissance art – from the intensely realistic figures portrayed by Van Eyck to the sophisticated beings created by Dürer or Leonardo. New techniques, discovery of visual perspective, fresh interest in the antique past, all combined to make art a fully rational activity, incorporating truths of human nature and the universe. In place of Gothic mystery came clarity – reflected in the calmly ordered space of Renaissance buildings. This book emphasizes that persistent preference for sober, logical, harmonious art – true to experience and yet optimistic – which characterizes the Early Renaissance. *(Awarded the Hawthornden Prize).*

and

Mannerism
John Shearman

Neo-Classicism
Hugh Honour